Graven Images

MARY AND LEIGH BLOCK GALLERY

Northwestern University, 1993

Graven Images

THE RISE OF

PROFESSIONAL PRINTMAKERS IN

ANTWERP AND HAARLEM,

1540-1640

TIMOTHY RIGGS

Ackland Art Museum

University of North Carolina, Chapel Hill

LARRY SILVER

Department of Art History

Northwestern University

"Graven Images: The Rise of
Professional Printmakers in Antwerp
and Haarlem, 1540-1640" is published
in conjunction with an exhibition
of the same title on view at the
Mary and Leigh Block Gallery, North-
western University, from May 6
through June 27, 1993, and at the
Ackland Art Museum, University of
North Carolina, Chapel Hill, from
August 15 through September 26, 1993.

Distributed by Northwestern
University Press.

Cover illustration:
Detail from *Bellona Leading the Armies
of the Emperor Against the Turks* by Jan
Muller after Bartholomeus Spranger,
1600, engraving (see cat. no. 78, p. 192).
The Minneapolis Institute of Arts, The
Ethel Morrison Van Derlip Fund, 1974

Illustration credits:

Page x:
Detail from *Mankind Before the Last
Judgment* by Jan Sadeler after Dirck
Barendsz., about 1580, engraving
(see fig. 7, p. 29). Museum Boymans-
van Beuningen, Rotterdam

Page 46:
Detail from *Annunciation* from the
Life of the Virgin by Hendrick Goltzius,
1594, engraving (see fig. 3, p. 59).
The Baltimore Museum of Art:
Garrett Collection

Page 70:
Detail from *Bacchus, Ceres and
Venus* by Jan Saenredam after
Hendrick Goltzius, 1600, engraving
(see fig. 5, p. 90). Museum Boymans-
van Beuningen, Rotterdam.

Page 100:
Detail from *The Virgin and Child
in a Niche Adorned with Garlands
by Angels* by Cornelis Galle the Elder
after Rubens (and Frans Snyders),
engraving, (see cat. no. 89, p. 201).
The Art Museum, Princeton Uni-
versity, Gift of Charles Scribner III

Design by Diane Jaroch

Library of Congress Cataloging-in-
Publication Data

Graven images: the rise of profes-
sional printmakers in Antwerp
and Haarlem, 1540-1640/[edited by]
Timothy Riggs, Larry Silver.

p. cm.
Exhibition catalog.
ISBN 0-941680-11-8

1. Prints, Flemish–Belgium–Antwerp–
Exhibitions.
2. Prints–16th century–Belgium–
Antwerp–Exhibitions.
3. Prints–17th century–Belgium–
Antwerp–Exhibitions.
4. Prints, Dutch–Netherlands–
Haarlem–Exhibitions
5. Prints–16th century–Netherlands–
Haarlem–Exhibitions
6. Prints–17th century–Netherlands–
Haarlem–Exhibitions.
I. Riggs, Timothy A., 1942- .
II. Silver, Larry, 1947- .
III. Mary and Leigh Block Gallery.

NE673.A58G73 1993
769.9492´35–dc20

92-27840
CIP

Contents

Introduction

There are no guideposts to determine the direction that must be taken in the search for those gradual shifts in history that define fundamental change. Noted historian Daniel Boorstin talks of the search for creativity in those regions he terms "the fertile verge," where encounters between disparate forces meet and manifest themselves in change: Geographic, political, technological, cultural and generational forces combine and give definition to a new means of existence.

Graven Images: The Rise of Professional Printmakers in Antwerp and Haarlem, 1540-1640 is a product of research into a series of "verges" that gave rise to a new direction in printmaking in sixteenth- and seventeenth-century Northern Europe. The flow of ideas between Italy and the North, the gathering of artists for the first time in a workshop environment, the development of the notion of reproducing a work of art to give that work greater visibility, the growth in the market for images of previously produced works, and the rise of truly great artists engaged in new aesthetic endeavors are among those subjects addressed in *Graven Images.*

The presentation and organization of the exhibition itself was a coming together of disparate parts. The origins of the project are known to none better than Larry Silver, professor of art history at Northwestern. Shortly after I arrived as new director of the Mary and Leigh Block Gallery in 1987, I asked Larry to help me determine the parameters of the old master print collection. Larry discovered among an uncataloged group of sixteenth-century prints a substantial subgroup of distinguished reproductive engravings. He assisted me in writing the initial National Endowment for the Arts proposal to fund the research and execution of an extensive exhibition addressing a neglected subject in Baroque prints. Larry wrote two distinguished essays in this catalogue that break new ground in our understanding of the reproductive print, and of Hendrick Goltzius as reproductive printmaker. He selected many of the works for the exhibition and assisted in the organization of a symposium. He also recommended bringing Timothy Riggs

and Walter Melion onto the project. If there is anyone to whom this catalogue should be dedicated it is Larry Silver. He has been a seminal force in bringing all aspects of this project to fruition.

Timothy Riggs, the main curator of *Graven Images*, gave direction and definition to the structure and content of the exhibition. His knowledge of sixteenth-century prints, artists and workshops is renowned. His essay, the fourth chapter in this catalogue, provides a key to understanding the organization of the exhibition and its major themes. Tim has been an intellectual tour de force for the almost four years it has taken to organize this exhibition. If there are sequels to exhibitions, as there are to films, I hope we will be able to work with him as curator again.

With all exhibitions there is a cast of thousands who are of key importance. Walter Melion, professor of art history at Emory University, was integral to the exhibition not only for his advice in its organizing stages but also for his contribution of an essay to the catalogue. Charles Millard, the Director of the Ackland Art Museum and a friend of long standing, gave support and encouragement from the outset. The public and private lenders to this exhibition, recognized in the preceding pages, are part of a distinguished tradition in sharing their collections for the advancement of knowledge and education. It is my pleasure to thank them for their trust, and for their recognition of the importance of the ideas in this exhibition.

The National Endowment for the Arts has been of seminal importance in funding the research and implementation of *Graven Images*. Regardless of public controversy or the criticism of a recalcitrant few, the NEA continues to be the backbone of much excellence at the Block Gallery and other museums across the country. The Consulate General of Belgium, and that of the Netherlands, also assisted the exhibition and its programs. The Alumnae of Northwestern University deserve special credit as they funded the initial stages of the research for this project.

Additionally, the Friends of the Mary and Leigh Block Gallery have consistently supported our research, publication and exhibition endeavors. Without their annual support we would not be able to sustain the tradition of excellence we cherish.

In the end it is the staff of the Block Gallery who determine the outcome of our endeavors. It is a pleasure to recognize Jennifer Holmes for her efforts in the design and installation of the exhibition, Lynne Remington for her assistance in the promotion of the exhibition, Corinne Granof for her organization and implementation of the symposium and exhibition programs, and Gina Green for her administrative and fiduciary skills. It is also my pleasure to give special recognition to Liz Seaton, the Block Gallery's Graduate Fellow. Her diligence with many aspects of this project, her ability to handle tasks that took her to the far corners of the museum world, her attention to detail as well as to the needs of art history, and her skills in the management of diverse personalities have insured that this exhibition, and especially this catalogue, have become a reality. It has been an honor to have had her at the Gallery this past year.

DAVID MICKENBERG
Director
Mary and Leigh Block Gallery
Northwestern University

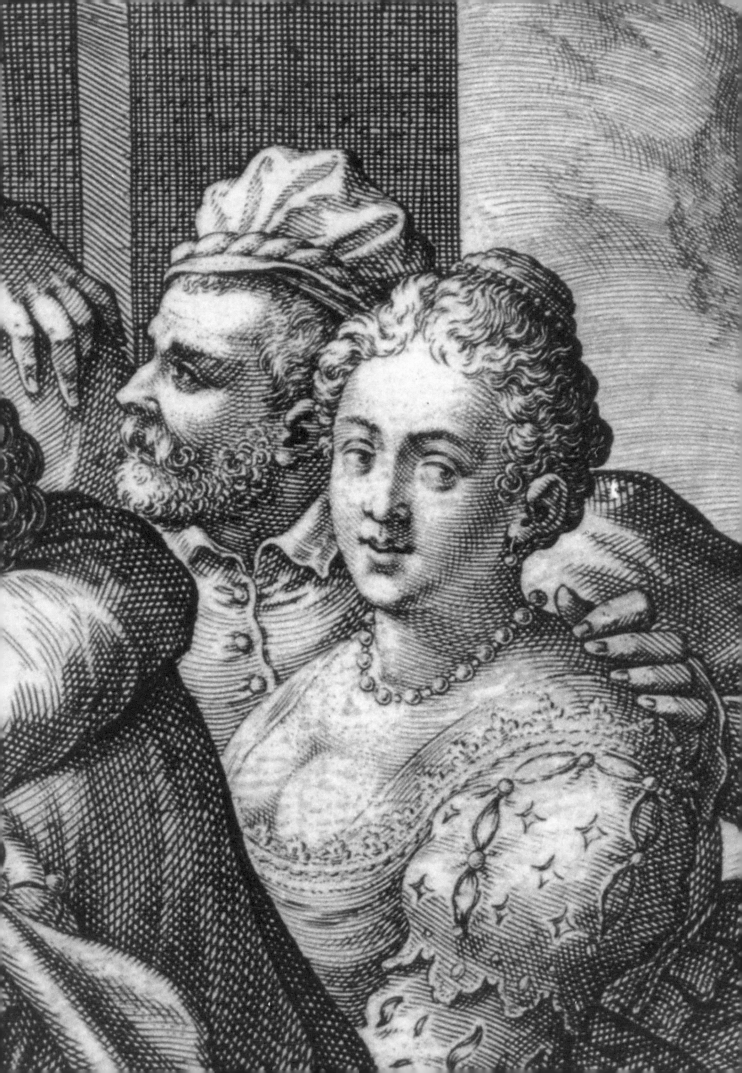

Graven Images

REPRODUCTIVE ENGRAVINGS AS

VISUAL MODELS

LARRY SILVER

From the earliest period of printmaking, engravings served as a visual intermediary for the spread of designs. The anonymous Master of the Playing Cards, an upper Rhenish engraver, copied animal motifs found in the margins of manuscripts during the second quarter of the fifteenth century; these motifs, in turn, return among manuscript border decorations shortly after 1440 as well as in the margins of the Gutenberg Bible shortly after mid-century in Mainz.[1] This early instance of replication points to a workshop repertory of designs, a model book, which in turn served as the source for the series of engravings. With the roots of engraving in the luxury metalwork trade, it is not surprising that both pictorial and ornamental motifs would be standard elements of the repertoire for use by master craftsmen in a metalworking workshop or in the related workshop tradition of manuscript illuminators.[2] Moreover, early engravers clearly copied from one another. The most notorious appropriator of prior images is Israhel van Meckenem from Bocholt on the Lower Rhine (act. 1465-1503), whose copies after Master ES, Schongauer, and the Housebook Master are much more numerous than his own original designs.[3]

Hence using engravings as visual models was already an established tradition among the earliest Northern printmakers, and the traffic in those models stretched along the entire length of the Rhine. Something similar could be said for the use of Italian engraved designs during the fifteenth century.[4] *Nielli*, engravings made from silver plaques, provide the first preserved records of the designs by goldsmiths in Florence and Bologna. (These, in turn, provided inspiration for later artists outside Italy, such as Albrecht Altdorfer of Regensburg, act. 1505-38.) What Italian artists initiated during the late fifteenth and early sixteenth century, however, was the use of engravings by specialists to preserve and disseminate figural drawing designs by renowned painters.

Perhaps the earliest painter-designer to utilize engravings to distribute his drawing ideas was Andrea Mantegna of Mantua (1431-1506).[5] Although the execution of Mantegna plates

sometimes are ascribed to the artist himself, sometimes to professional engravings following his drawings, later Italian artists realized the value of delegating the process of engraving plates after their designs to specialists. In this case, the great master-designer was Raphael (1483-1520), who assigned his drawings to the professional engraver, Marcantonio Raimondi (ca. 1480-1534).[6] Marcantonio began his career in Venice, where his engravings after Dürer woodcuts led to a lawsuit when the German artist visited the city in 1505-06 and accused his Italian epigone of plagiarism or forgery.[7] Marcantonio also used his talents with the burin to record Michelangelo's grandest drawing, the cartoon of the Battle of Cascina for the Florence Palazzo Vecchio (begun 1504, cut up in 1512) for distribution in 1510.[8] By 1510 Marcantonio was firmly established in Rome and executing engravings after Raphael drawings, both studies for paintings (such as the fresco of *Parnassus* in the Vatican, Stanza della Segnatura, or the *Galatea* for the Palazzo Farnesina) and non-executed designs (such as the *Massacre of the Innocents* or *Judgment of Paris*). The print of *Parnassus* bears the inscription, "Raphael pinxit in Vaticano," but the engraving records an earlier stage of the design in drawings rather than the final figural composition.[9] Moreover, the prints of Marcantonio served as a valuable resource in themselves for the designs of Raphael, particularly for Northern artists.[10]

In dividing up the roles of "invention" and "execution," Raphael distinguished between the original ideas of an artist-genius and the lesser craftsmanship of the engraver who reproduced his concepts.[11] Of course, this premise also led to the systematization of production of reproductive engravings as well as the Latinate designations of their separate responsibilities: invenit (designer), sculpsit (engraver), excudit (publisher). Later Roman publishers, Antonio Lafreri (1512-1577) and Antonio Salamanca (ca. 1500-1562) incorporated the lessons of the Raphael-Marcantonio collaboration and developed their own print houses akin to Aux Quatre Vents (The Four Winds) of Hieronymus Cock in Antwerp.[12]

Dividing up the labors of artist-creators from craftsman-executors, however, assigned lesser significance to the engraver as the mere reproducer of designs by others. This discrediting view had long repercussions for both the collecting and the study of such engravings as works of art in their own right. Nineteenth-century scholars, led by Adam Bartsch and later generations of printroom curators, emphasized "peintres-graveur," printmakers such as Dürer who executed their own prints and often worked in the more exalted medium of painting. As a result, the achievements and purposes of reproductive engravers were overshadowed by a cult of originality. These print-copies were studied primarily for their documentary value, as in the case of Raphael's lost earlier drawings for the *Parnassus*, as preserved by Marcantonio; otherwise such prints were measured (and devalued) only in relation to the surviving drawings that gave rise to them, as in the case of Raphael's *Massacre of the Innocents*. Only in a modern art-world, where collaborative efforts have come to be recognized anew, do we turn again for a fresh look at the qualities inherent in the professional talents of reproductive engravers. The essays in this catalogue by Timothy Riggs and Walter Melion should suffice to remind us of the inherent beauty and distinctive aesthetic of Netherlandish reproductive prints.

However, the prior tradition of utilizing engravings as sources for visual ideas or artistic models can provide yet another means of access to these reproductive works. Both in forms and subjects, engravings still offered a vast world of visual information for artists in the Netherlands. When during the sixteenth century Netherlandish artists developed a keen interest in Italian styles and themes, reproductive engravings helped to meet that need. Moreover, Netherlandish artist-designers strove to emulate the example of Raphael with Marcantonio by producing their own drawings as designs for prints.

In order to survey the broad phenomenon of reproductive printmaking as a collection of visual resources, this essay will address a set of case studies, particularly from around mid-century:

one pioneer engraver (Cornelis Bos), two dominant designer-artists (Frans Floris and Maarten van Heemskerck), and Europe's leading print publisher (Hieronymus Cock). Thereafter, the state of printmaking at the end of the century will be addressed through the versatile, prodigious productivity of Hendrick Goltzius in Haarlem.

Northern Novelties: Cornelis Bos

It is surely no accident that the earliest reproductive engravings in the Netherlands were also produced after Italianate models created by Dutch artists with Roman experiences. The principal purveyor of these early reproductions was Cornelis Bos, or Cornelis Willem Clauszoon from 's-Hertogenbosch, who enrolled as a citizen in Antwerp in 1540 and was active there until 1544 as both an engraver and a dealer in books and prints.[13] However, his career in Antwerp ended abruptly with his expulsion and exile for heterodox religious views (documents record his death in 1556 in Groningen). His contact with Italian designs appears already in the 1530s, but it might well have come through the mediation of a Haarlem artist who had himself been to Rome (1532-36): Maarten van Heemskerck. Bos issued his first print after Heemskerck, *Justice and Prudence*, in 1537; his last dated work after the artist is 1555. Bos returned to Heemskerck's mythologies in 1546 shortly after his exile from Antwerp. *Venus and Amor in the Forge of Vulcan* is based on a Heemskerck 1536 painting (now in Prague).[14] The Heemskerck theme itself derives closely from a recent Roman fresco in the Farnesina: Baldassare Peruzzi's *Forge of Vulcan* (ca. 1530; Sala delle Prospettive) in addition to other antique and Renaissance models.[15] What both early engravings after Heemskerck offered, therefore, was a use of current, heroic Italianate style for large nude figures, whether as an allegorical subject (1537) or as a mythic narrative with a moralizing overtone about the adulterous theme and its humiliating outcome. The appearance of the allegory right after the return of Heemskerck

from Rome suggests that Bos acted in emulation of the precedent of Marcantonio's engravings after Raphael designs, a working relationship that the Dutch painter surely discovered during his Roman sojourn—and would continue to practice throughout his entire subsequent career, using such printmakers as Coornhert, Philipp Galle, and Harmen Muller to reproduce his designs (see below).[16] It is worth noting that initially Bos worked after Heemskerck freely and/or utilized a separate, lost drawing; his *Justice and Prudence* shows more animated nude female bodies and a completely different composition from the surviving Heemskerck grisaille (preserved as a fragment; Vienna).[17] By 1546, his replica of the 1536 Prague canvas is quite exacting and close with a few alterations and omissions.[18]

Bos reproduced other Heemskerck works with a Roman flavor, such as the 1543 engraving (in three plates; fig. 1) after the *Triumph of Bacchus* (now Vienna; the source was doubtless a drawing separate from that painting, probably made afterwards).[19] Akin to the didactic power of the Vulcan myth's warning about the vice of lechery, the Bacchus subject uses Italian forms and pagan gods to castigate the vice of intemperance, a frequent concern in Netherlandish art and literature of the sixteenth century.[20] As in the case of other Heemskerck images, sources from the Italian Renaissance (such as Raphael's Farnesina *Galatea* or Agostino Veneziano's engraved *Procession with Silenus*) or antique Rome (Dionysus sarcophagi, Temple of Vesta, colossal foot fragment), based on the artist's careful drawings made during his stay in Rome (1532-36), present a new visual vocabulary for these moralizing messages.[21] Some figures also derive from the pre-1494 Mantegna engraving, *Bacchanal with Silenus* (Hind 5).[22]

Polymorphous perversity as the image of vice seems to have held considerable appeal for Bos, if only as a negative example in Renaissance garb. His rare instance of a copy after a renowned Italian model is the undated engraving (cat. no. 2) after Michelangelo's *Leda and the Swan*, in France after 1532 (at Fontainebleau after 1536).[23]

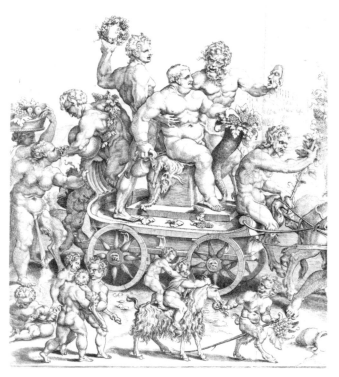
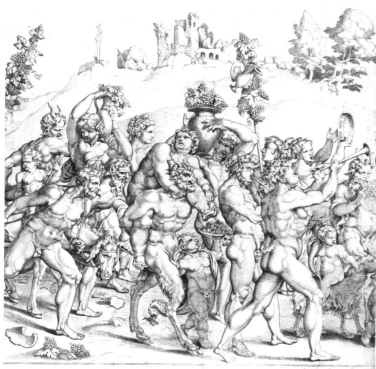

Figure 1.
Cornelis Bos after
Maarten van Heemskerck:
Triumph of Bacchus,
1543, engraving on three
plates, 32 x 86.5 cm.
Rijksmuseum, Amsterdam.

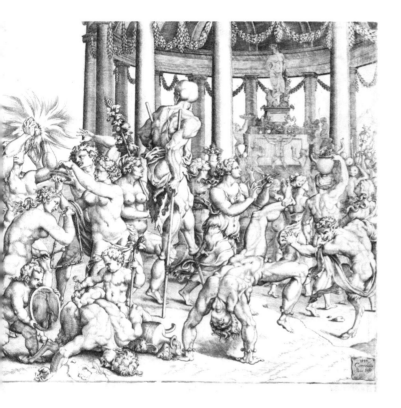

In contrast to a mystical and positive Italian contextual reading of this image, Bos again may have used his mythic subject to suggest a critical viewpoint, tied to the sexual explicitness of the image, either because of the descent (hence humiliation) of the god into animal form or else because of the long-range destruction produced by Leda's offspring, Helen and Clytemnestra as well as the twins Castor and Pollux.[24] While the Bos engraving of *Leda* provides no accompanying text to aid in the assignment of contemporary readings to this image, the prior prints after Heemskerck for Venus and Bacchus suggest a negative role for this sensuous god as well.[25]

Moreover, when Karel van Mander interprets the Leda story and Jupiter's metamorphoses in general in his 1604 *Wtleggingh* (Interpretation) of Ovid (fo. 49-50), his reading, partly euhemeristic, considers Jupiter to be an ancient monarch, while it continues the moralizing of this theme after the tradition of the late medieval *Ovide moralisée*.[26] Van Mander claims that the mighty Jupiter gave himself over to "lust and unchastity...disorderly [*ongeregelde*] love...using all disguises, alterations, and tricks." He cites the Greek association of swans with beautiful song, so that the seduction of Leda must be ascribed to "sweet-sounding, love-rich words and voice of song." Van Mander also contrasts the image of the swan to Jupiter's more customary role as eagle, stressing the restraint of his true nature in the wooing of Leda. While Van Mander's reading is not tied to a specific image, such as Michelangelo/Bos, his reading suggests an ongoing attitude of a Dutch audience to such a work. Once more the emphasis of this print after Michelangelo seems to serve a dual, characteristically Northern function: On the one hand, it appropriates the grandeur of Italian forms at their most heroic and physical, while at the same time it represents their message as an allegory, to be read within a conservative and moralizing context of middle-class values.

The use of Italianate designs by Northern artists who had been to Rome continued to be one of Bos's artistic interests, even after his exile from Antwerp. In 1545 he published a *Lamentation*

after Lambert Lombard (ca. 1505/06-1566), whose design drawing is preserved.[27] In this instance, the toga-like costumes of the biblical figures derive from Lombard's study sheets, penned after ancient reliefs and Renaissance models during his own sojourn in Rome during the period 1537-38.[28] Part of the reason for the connection between Lombard and Bos might stem from Lombard's earliest print design, *The Raising of Lazarus*, ca. 1544, produced by Hieronymus Cock in Antwerp (cat. no. 13; see below). Thus the artist's newly-awakened interest in disseminating his religious images through prints coincided with Bos's own interest in developing a clientele for his talents as an engraver. Unfortunately for Bos, his exile from Antwerp interrupted what might have become a fruitful collaboration with Lombard (Cock's workshop would continue to produce the lion's share of Lombard designs until the death of the artist in 1566). In all likelihood this *Lamentation* was produced while Bos was renewing his ties to Heemskerck in Haarlem. As a print, it too has the virtue of a stamp of Roman authenticity, with an emphasis on classical gestures and drapery, applied here to biblical narration.

Despite his personal difficulties, Bos obviously continued to strive ambitiously to make his mark as an engraver. In 1547 he published a massive, four-plate biblical narrative, *The Passage over the Jordan*, after Jan van Scorel (1495-1562).[29] Scorel, an Utrecht painter who had succeeded Raphael as papal artistic consultant under Adrian VI, the short-lived Dutch pontiff (1522-24), also spent several years in Haarlem (1527-30), where he met and mentored the younger, ambitious Heemskerck. Hence, the new connection between Jan van Scorel and Cornelis Bos probably happened thanks to the intervention and ongoing support of Heemskerck. The same subject is recorded as a painting in Van Mander's life of Scorel; it is unclear whether this print stems from the missing painting or else from a separate design, possibly from the late 1530s or early 1540s. The style of the active, muscular figures and their antique armor recalls the models of Giulio Romano and

Peruzzi, which Scorel would have seen during his Roman stay.

Bos continued his association with Heemskerck during the later 1540s and into the 1550s, possibly after a visit to Italy around 1548.[30] The subjects of his engravings varied, though a cluster of them feature didactic moral subjects. A 1547 *Lazarus and the Rich Man* and a 1555 *Assiduous Wife* derive from scripture, the former from a parable of Christ (Luke 16, 19-31), the latter from Proverbs, detailing the virtues of weaving and the significance of weaving as the very image of virtue (Proverbs 31, 13, 19).[31] Already in 1543 Bos prepared an engraving for Heemskerck after a parable (Luke 15, 13) in his *Prodigal Son Among the Whores*.[32] In these instances, the didacticism already discerned among the mythologies and allegories after Heemskerck reappears in the negative and positive figures of biblical roles. Pure allegory appears in Bos's engraving after Heemskerck, *Christ Delivering Man from Sin* (1554), where the heart of man is bound to worldly temptation (and its symbols of crown, scepter, naked woman, and moneybags) with ropes, but is unbound by Christ Himself by means of a fiery sword.[33] But Bos also seems to have participated in more worldly assignments; the scene of the capture of King Francis I of France by Emperor Charles V as part of the series of engravings, *The Victories of Charles V*, published for Heemskerck in 1555, has been ascribed to Bos.[34]

The main engraver, however, for the Charles V cycle as well as the image of the Virtuous Wife was not Bos, but rather a younger associate in Heemskerck's Haarlem: Dirck Volkertsz. Coornhert (1519-90).[35] No explicit evidence ties Coornhert's activity as a printmaker to Cornelis Bos, but the affinity of their crisply linear engraving style, coupled with the activity of Coornhert for Heemskerck around the time of Bos's departure for Rome in 1548, strongly suggest that Bos first trained, and later was supplanted by, the younger engraver. When Bos returned to Groningen after his trip south, Coornhert shared the work for Heemskerck cycles for which he now had become

the principal producer. In his last years at Groningen, Bos accepted commissions from a print publisher who remained in Antwerp, Hans Liefrinck (ca. 1518-1573), whose documented purchase of printing materials from the estate of Bos marks the death of the exiled printmaker from within Antwerp. Several works mediated by Bos for Liefrinck stem from designs by the popular Antwerp painter, Frans Floris (about 1518-1570): a 1554 *Entombment*, a *Gathering of Manna*, and a *Holy Trinity* (cat. no. 3).[36] Once more the traits of Lombard, Floris's teacher, emerge as the hallmarks of a kind of "authentic" biblical narration, complete with classical costumes, figure types, and dramatic gestures deemed appropriate to the gravity and antiquity of the sacred stories.

As an engraver Bos made one other contribution of Italianate forms to Northern imagery: "grotesque" scrollwork ornament. After his flight from Antwerp and subsequent stay in Haarlem, Bos went briefly to the source of the imagery of Heemskerck, Lombard, Scorel, and Michelangelo—to Rome, where some of his 1548 prints derive from drawings made directly after Raphael ornamentation in the Loggie of the Vatican, a major early instance of grotesque ornament. This particular type of ornament is named for the scroll-like forms that serve as a frame for the disposition of hybrid, emphatically pagan creatures of fantasy, such as satyrs, griffins, or herms, as well as bacchantes and a profusion of floral and fruit ornament redolent of abundance. The source of this kind of decorative imagery had the sanction of antiquity; Pinturicchio and Raphael derived their versions of it from the subterranean excavations of the Golden House of Nero in Rome (the "grotto" of Nero, which also served as the origin of the name of this ornament, "grotesque"). In France at the royal palace of Fontainebleau (1533-35) the expatriate Florentine, Rosso Fiorentino, used grotesque ornament with stucco bands resembling leather straps used to join figures into his ornamental framework.[37] This "strapwork" became the basis during the 1540s for Cornelis Floris (1514-1575; cat. no. 40)

and Bos, who created whimsical grotesque printed inventions without the direct experience of Italian models.[38]

Bos's earliest dated grotesques bear the year 1546, presumably made in Haarlem but surely not his earliest experiments in the idiom; he produced some 120 inventive variations on this basic theme, including some spectacular triumphal chariots and panels dated 1550.[39] Through the use of prints by both Bos and Cornelis Floris, this Flemish grotesque form of antique ornament quickly spread throughout Flanders and Holland during the 1540s.[40] As in the previous century, then, engravings served again as the source of decorative patterns for artists in other media as well as subsequent inventions by other printmakers.

Looking over the sporadic career of Cornelis Bos reveals many of the essential traits of the careers of later reproductive engravers over the remainder of the sixteenth century. His chief designers seem to have been Dutch (Heemskerck, Scorel) and Flemish (Lombard, Floris) painters who had been to Rome and brought back an art whose use of classically nude or draped figures was a singular novelty in the Netherlands. His subjects included biblical scenes but also mythologies and allegories, and his interest in Italian forms extended to the innovations of the "grotesque," probably via Fontainebleau and the Antwerp variants by Cornelis Floris. Engravings offered a means for these designers to spread their Italianate pictorial ideas—and their reputations—more widely. Of course, the interest in Italian form also extended to replications of Italian originals when Bos could find them. Michelangelo's *Leda* is just the most notable example, now that the original has been lost, but Bos also made copies and variations of a number of Italian prints that came his way.[41]

Bos does not ever seem to have been able to establish a fixed publishing house of his own, though Hans Liefrinck's purchase of press materials from his Antwerp estate suggests that he may have continued to hold hopes of returning there

one day to fulfill that goal. One of his prints after Heemskerck, published at Groningen, even has a German inscription, tied to its intended market, possibly a heterodox religious community in Friesland.[42]

The working relationship that Bos established with Heemskerck did not become permanent for him, but it did serve to introduce Heemskerck to the process of print designs, leading to two decades of print production by the Haarlem master. In addition, Bos's apparent training of Coornhert as an engraver facilitated one of the great collaborations, where Heemskerck's graphic designs of Coornhert's religious philosophy in the form of allegories were eventually realized in turn by Coornhert's own engravings of Heemskerck's designs (see below). Meanwhile, Bos ended his career as an exile in the backwater of Groningen as a lesser collaborator of Heemskerck and Coornhert in Haarlem and as an extended appendage of Hans Liefrinck's publishing ventures in Antwerp. Heemskerck's Haarlem and Floris's Antwerp would emerge as the great centers of reproductive engraving for the remainder of the century and beyond.

Graphic Worlds of Floris and Heemskerck

Frans Floris

"Michel[angelo] more than a man, angel divine, And Flores, whom the Flemings greatly praise..."

Ariosto, *Orlando Furioso*, Canto 33
translation by Sir John Harrington (1591)

Once the patterns of design for engravings had been established in the Netherlands, ambitious artists hastened to provide subjects for printmakers. In Antwerp, Frans Floris (about 1518-1570) followed the model of his teacher, Lambert Lombard, in producing a range of print designs that emphasized Italian Renaissance and classical vocabulary.[43] He was aided in his campaign to spread his compositions by the greatest print publisher in mid-century Antwerp, Hieronymus Cock (about 1510-1570).[44] Cock also frequently published engravings after Heemskerck in Haarlem.[45]

The career of Floris is instructive, both for the history of print production and for the range of themes. Floris began to produce prints himself for Cock through etchings, of which his 1552 *Victoria* (Riggs 68; Van de Velde P77) is the most celebrated, in part because it replicates Floris's painted decoration on the triumphal arch of the Genoese for the Antwerp Joyous Entry of Philip II in 1549.[46] He also produced a series in 1550-51 of the *Liberal Arts with Apollo, Pallas, and Industry* (Riggs 67, Van de Velde P107-116), where he presumably delineated the figural allegories while Cock added landscape backgrounds (including the Roman ruins and hillsides for which Cock was celebrated) and supervised the technical production of the etchings.

In both instances Floris strove to realize his classicizing figural drawing style in the form of marketable reproductions without the necessity of intermediaries except for his publisher, Cock. In this ambition, he may have been prompted by the Italian model of Parmigianino, whose art he would have encountered during his prolonged stay in Rome (1541-47).[47] His own scratchy outline style for figure contours and hatchings remains tentative and deliberate in his first efforts, but the *Victoria* reveals his rapid mastery of shading and contrasts to suggest volume and activity for his crowded figures.

However, like Raphael, Floris went on to delegate his print production to a cluster of engravers, supervised by Cock as publisher. We have already noted that as early as 1554 he employed Cornelis Bos as engraver for his *Entombment* through the agency of an Antwerp rival publisher to Cock, Hans Liefrinck. In all likelihood the source for all three prints produced by Bos after Floris was drawings, easily shipped to remote Groningen, rather than paintings. Around this same time, ca. 1553-55, Floris developed a workshop practice of delegated designs that closely came to resemble the organization of Raphael for painting as well as for printmaking.[48] The clearest indication of this self-conscious delegation is Floris's adoption of a distinction

between his design ("invenit") and execution ("faciebat") of works signed with his FF monogram. The principal engraver after designs by Frans Floris was Cornelis Cort (1533-36-1578), particularly during the period 1560-65, at which time Cort emigrated to Italy, where he became celebrated for his reproductive engravings after Titian, Barocci, and other Italian masters.[49] Other printmakers, including Pieter van der Heyden, Balthasar Bos, Frans Menton (after Cort's departure), and Heemskerck's favorites from Haarlem, Dirck Coornhert and Philipp Galle (1537-1612), also produced prints after Floris for Cock in Antwerp.

Cort's principal engravings after Floris took the form of print series, cycles of related subjects dominated by classical figures. Cort had already completed a pair of series after Heemskerck for Cock: *The Story of Noah* (6 plates, ca. 1559; Riggs 117), *David and Abigail* (6 plates, 1555; Riggs 118), and *Story of Tobit* (10 plates, ca. 1555; Riggs 119).[50] In 1560 Cort produced a set of eight *Virtues* after Floris (Riggs 82; Van de Velde P80-P87). One drawing for this series has survived (Berlin); according to Van de Velde, it is not by Floris himself but rather a workshop assistant; however, it makes a linear design out of what was originally a more painterly drawing by Floris— on blue tinted paper with white highlights.[51] Thus the print cycle figures were derived at a two-step remove from a Floris drawing, transposed for the printmaker by the Floris workshop. The same technique informed Cort's 1561 cycle of five plates, the *The Five Senses* (cat. no. 12; Riggs 83; Van de Velde P135-39). In each case, Cort has elaborated upon Floris's personification to produce a print with a defined setting and distant background behind a solidly sculptural figure.[52] Each image symbolizes its sense through both a female personification and a characteristic animal, derived from medieval tradition. This combination had a long influence, especially in Antwerp, where Martin de Vos produced several variants on this Floris formula.

In 1563 Cort produced a series of prints after a painting cycle by Floris on canvas: *The Labors of*

Hercules (1565; cat. no. 24; Riggs 78, Van de Velde P46-55), documented as painted around 1554-55 (S69-78) for the Antwerp collector Nicholas Jongelinck.[53] The one surviving canvas from this cycle, *Hercules and Antaeus* (S75; Brussels, private coll.) reveals once more what liberties Cort took in amplifying the figural group (reversed) with an added setting; in this case, the printmaker altered the vertical format of the canvas into a horizontal landscape (P53) with additional dynamism through a strong diagonal recession into deep distance (reminiscent of Bruegel landscape formulas). According to Van Mander (I, fo. 298) these prints were made after drawings copied faithfully from Floris's paintings by his disciples; Van Mander had good reason to rely on this information, since his informant was one of those workshop disciples who also made prints after Floris for Cock: Frans Menton.[54]

The Cort series of prints was accompanied by a lengthy Latin poem, composed by Domenicus Lampsonius and dedicated to Jongelinck, the owner of the painted cycle.[55] The aesthetic achievement of Floris—and Cock as his copyist in prints—as successful rival to Italian art is extolled and clarified in these verses:

...ut iam Belgicae
Docta inuidere Italia, & ereptam sibi
Dolere palmam debeat.
Quod illa si negabit, haec tantum uidens,
Quae non magis, quam corpori
Exilis umbra, Flori operibus aureis
Sunt digna compararier...

Like the mythological subjects of Heemskerck, Hercules and his labors returns Netherlandish art to its favorite theme of virtue battling (here triumphing over) vice through heroic personification.

Also engraved by Cort after famed Floris canvases in the collection of Jongelinck is the lost series of the *Liberal Arts*, ca. 1555-56, produced in 1565, shortly before Cort left Antwerp for Italy (Riggs 81, Van de Velde P117-P123).[56] Once more the personifications of these elevated activities are seated females in classicizing garb who act out their roles before witnesses. In several cases, antique references are included on the spines or

pages of books included within the print, as tributes to the learning of Floris and Jongelinck. *Rhetorica*, for example, cites Cicero, Quintilian, Demosthenes, Isocrates, Quintus Hortensius, and Aeschines. Thus both the subject and its allegorical figuration can be seen to emerge from the revival and study of classical learning shared by both artist and patron. This reference to humanist culture is considerably augmented from Floris' own first, etched cycle of the Liberal Arts, published by Cock in 1551.[57]

The importance of this tribute to classical learning as the foundation of his own art of painting can also be seen in other Floris compositions for prints of Apollo and the muses: Jan van Stalburch's *Apollo and the Muses* (1555; P42), Frans Huys's *Apollo and the Muses* (1565; P41), and Balthasar Bos's *Awakening of the Arts* (1563; P133), a work which survives in a painting as well as a composition drawing.[58] In the case of this latter work, the seven liberal arts have been supplemented by a trio of female personifications essential to the claims of the visual arts to be liberal arts in their own right: Architecture, Painting, and Sculpture.

Even more important is the print series published posthumously in Antwerp (by the anonymous engraver TG) and representing allegories of the *Qualities of the Artist* (Van de Velde P95-P102).[59] This series preserves a suite of allegories painted on the facade of Floris's own home. Identified through inscriptions above their heads on a drawing ca. 1700, these figures correspond to the allegories of the print series: Diligentia, Usus, Poesis, Architectura, Labor, Experientia, and Industria. The scene above the entrance door serves as an engraved prelude to the allegories, representing the same visual triad of Pictura, Sculptura, and Architectura (P95) as active female figures in classical drapery. Taken together, the entire series pays homage to the visual arts, as the inscription on the first sheet (perhaps taken from Floris's own facade) attests: "Humanae societati necessaria." On the easel of Pictura is a female nude, the staple of Floris's figural art, based

on classical models yet embodying abstract principles.

Van de Velde has hypothesized that one other Floris print series, Philipp Galle's 1574 *Human Activities* (P124-32), might derive from a canvas cycle from within Floris's house.[60] Each of these allegories depicts one of the traditional mechanical arts, often distinguished from the liberal arts in medieval programs: Agriculture, Cattlebreeding, Weaving, Building, Navigation, Warfare, Medicine, and Politics.[61] The manual activities of painters and sculptors (as well as architects, already included among the traditional mechanical arts) relegated them to this craft status rather than their preferred association with the more intellectual pursuits of the liberal arts.[62]

Cort went on to execute two additional cycles, dedicated to *Rural Goddesses* (1564, 8 plates; Riggs 76, Van de Velde P63-P70) and *Rural Gods* (1565, 6 plates; Riggs 77, Van de Velde P57-P62) and called "peasant gods" (*boeren goden*) in the estate inventory of Cock's widow (Van de Velde, doc. 104). In effect, these images extol the virtues of agriculture and rural life but do so through personification rather than through vulgar, laboring peasants like those which Bruegel painted for Jongelinck in the cycle, *Labors of the Months* (1565).[63] Singled out for attention are such figures as Vertumnus ("god of gardens"), Autumnus ("fruitful time"), and Sylvanus ("god of groves"). Another Cort series (P71-74) of 1565, the *Story of Pluto and Proserpina*, may also allegorize the change of seasons through the learned use of classical myth rather than the landscape cycles used by Bruegel.[64]

Both biblical and mythological subjects were produced as single sheets and as series after the designs of Floris. Cort alone produced such works as: *Adam and Eve Lamenting the Death of Abel* (1564; fig. 2; Riggs 72, Van de Velde P2), *Lot and His Daughters* (Riggs 73, Van de Velde P7), *Story of Jacob* (1563, 6 plates; Riggs 74, Van de Velde P9-P11), *Saint Jerome* (Riggs 75, Van de Velde P40), *Hercules and the Pygmies* (1565; Riggs 78, Van de Velde P56), and allegory of *Rewards of*

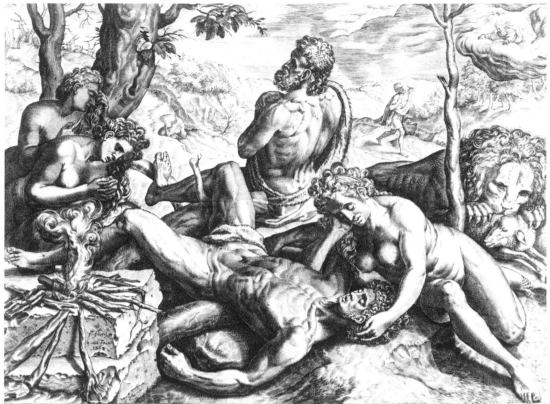

VNGVIBVS VT TENERVM LEO FORMIDABILIS AGNVM ECCE MANVS MACVLAT FRATERNO SANGVINE FRATER,
DILACERAT: SIC HEV LACHRIMANTE VTROQ. PARENTE, IDQ. ODIO SATANÆ, QVI TANTI EST FVNERIS AVTOR

Virtue (1564; Riggs 80, Van de Velde P78), and the ancient history of the *Horatii and Curiatii* (cat. no. 15; Riggs 84; Van de Velde P140). To that basic roster Coornhert contributed a pair of Solomon images (1556-57), followed by Philipp Galle, who added a large set of titles for Cock from 1557 onwards.[65] After 1565 Galle went on to open his own publishing house, a rival to Cock's that eventually took over plates from Cock's widow. These individual sheets further demonstrate the profound interest in the new Italianate style for subjects of the highest seriousness, visual exempla for moral instruction. Like the prints already circulated by Cornelis Bos, these engravings attest to the importance of the imported style of classical and (Renaissance) Roman models, now more widely disseminated through the mass medium of engravings.

Decorum and dignity, based on classical models and the figural style of Italy, were accorded great esteem in the circle of Frans Floris, as a verse by his pupil and epigone, Lucas de Heere, makes clear.[66] Published in 1565 and in direct Dutch rather than the learned Latin of Lampso-

nius, de Heere's "Invective against a Certain Painter" praises Floris by criticizing defects of skill in his rival. Floris produces works that are "adorned, becomingly, and rich" (*verciert, becamelijc en rijcke*) and decorus (*betaemt*) as well as skilled (the certain painter is reviled as unskilled, *onghemaniert*). Floris receives praise for his absorption of the models of Italy, from Rome and the antique (*Roomachtig noch och antijcx*). The ideal of the learned painter, who like de Heere could write and study poetry or even philosophy, remained the model to which Floris and his circle aspired. De Heere's own poem in direct praise of "M. Franchois Florus, excellent Schilder," extolls his "divine knowledge" (*Goddelicke scientie*) and compares him to the Greek paragon of painters, Apelles.

What emerges from a survey of the cycles after Floris made by Cort and other engravers is their systematic presentation of allegory: Virtues, Senses, Liberal Arts, Rural Gods, Elements, Virtues and Vices. The very comprehensiveness of these personifications suggests that they were intended to have an intellectual as well as an aes-

thetic ambition. Taken together, these elements of form and content can be considered related to the Italian Renaissance conception of "eloquent" painting or pictorial *poesie*.[67] This is painting (or design) in the "high" style, founded on study of classical figures appropriate to the learned treatises of verbal rhetoric or philosophical learning and applied to lofty subjects of abstract categories and concepts. From this attitude of visual and intellectual superiority come the terms of praise for Floris from Lampsonius and de Heere as well as the latter's invective against the vulgarities of his target, the inferior "certain painter."

This attitude towards painting, derived from Italy and ultimately highlighting the superior role of drawing to reveal "hidden ideas," was codified for the Netherlands at the beginning of the seventeenth century by Karel van Mander in his treatise *Den Grondt der Edel vrij Schilder-const* (1604).[68] Drawing of abstract concepts is considered to be the wellspring of all pictorial artistry, indeed of artistry itself (perhaps underlying the relationship of apparent opposition between the liberal arts and the mechanical arts, as designed in successive series by Floris). The human body is taken to be the foundation of drawing—hence the emphasis in Floris on embodied personifications or heroic figures of gods and biblical protagonists. In sum, this is the origin of the academic ideal as developed in late-sixteenth century Italy around the figures of Vasari in Florence, Federico Zuccaro in Rome, and the Carracci in Bologna.[69] In this context, Van Mander praises Floris (fo. 179) for his learning and his ability to create imagery "uyt den gheest," constructed from his memory, and to transmit it to his pupils.

Inscriptions on Floris's prints were doubtless added by Cock in his publishing house rather than provided by the artist himself. Sources for most of those inscriptions, moreover, have not yet been identified. However, in the case of one series, the *Five Senses*, we do know that the prints were augmented with fairly physiological Latin inscriptions about the physical nature of each of the senses. The source is Juan Luis Vives, *De anima et vita* (Bruges, 1538), and the inscrip-

tions suggest that these classical personifications formed a means of gathering knowledge in the form of images. For example, the Vives inscription on *Sight* reads in translation: "The external organs of Sight are the eyes; the internal ones are two nerves leading from the brain to the eyes."[70] (We shall consider the systematic organization of knowledge in terms of visual groupings as an element of Heemskerck's publishing enterprise and late sixteenth century intellectual history, below).

Connections between Floris in Antwerp and Heemskerck in Haarlem are numerous: common ties to Cornelis Bos, Coornhert and then Philipp Galle as engravers for both men's works, even a common Antwerp publisher in Hieronymus Cock. Antwerp remained the dominant center for publishing of all kinds, so it is hardly surprising that Haarlem printmakers turned up there on occasion. Indeed, there are signals that the ties between the two centers remained closer than most art histories of today suggest (due to the modern separation of the Low Countries into Belgium and the Netherlands, an anachronism followed by historians and art historians of both modern countries).

Maarten van Heemskerck

In the case of Heemskerck, his very first print commission had an indirect Antwerp connection. He and Coornhert were commissioned by Haarlem authorities to produce a poster for a 1547 lottery, but they were superseded by the church of Saint Andrew in Antwerp.[71] Simon Claesz. Bybel, the Haarlem printer for the poster, had purchased his lot of paper from Antwerp sources, and he sold the largely unused portion to Coornhert, who seems to have used it to produce the important early prints that he etched and engraved after Heemskerck designs beginning in 1548. Coornhert went on to make prints for Cock in Antwerp (as well as on his own in Haarlem, according to Ilja Veldman's persuasive hypothesis).[72] Moreover, Cock continued to maintain some of the connections to Haarlem on his own, employing Cort to produce prints after Heemskerck: *Noah* (6 plates, after 1558-59 drawings),

David and Abigail (1555; 6 plates), and *Tobit* (10 plates, after 1554), and the *Cycle of the Vicissitudes of Human Affairs* (1564, 9 plates).[73] During this initial period of printmaking, Heemskerck never made the attempt like Floris to create his own, original etchings, relying instead primarily on Coornhert—who in all probability was trained in graphics by Bos—to take over the role previously reserved for Bos.[74]

As Veldman has convincingly demonstrated, Coornhert's collaboration with Heemskerck produced a consistent series of ethical allegories, closely tied to the eventual religious publications by Coornhert himself.[75] Coornhert can in fact be considered as the "intellectual partner" of Heemskerck rather than as his engraver-amanuensis. In this respect, then, the early print series of Heemskerck differ in kind from the more detached learned cycles designed by Floris. Instead, they provide a program for human salvation, a didactic-moralizing vision of the world and of humankind's proper role in it: control of passion by reason, rejection of riches, and a stoical practice

of patience offer the surest paths towards human godliness. The Latin inscription on the 1557 *Democritus and Heraclitus* offers a case in point: "And you, do not shed tears like Heraclitus, nor roar with laughter like Democritus; endure and forbear, as is proper." Moreover, the emphasis by Coornhert and Heemskerck in their shared images lies less with the display of learning as such (despite the Latinity of both the subject and the inscription of *Democritus and Heraclitus*) and much more with the underlying ethical program. The earliest prints by the two men carried Dutch inscriptions by choice, because of Coornhert's commitment to instruction in the vernacular (Coornhert acquired Latin some time after the last Dutch inscription in 1553).[76]

The two-plate etching, *Allegory of Human Ambition* (1549; fig. 3) offers a prototypical early collaboration between Coornhert and Heemskerck (indeed, possibly the first of their numerous collaborations). It depicts the contrast between proud and striving persons in search of honor or fame, whose passage over a narrow

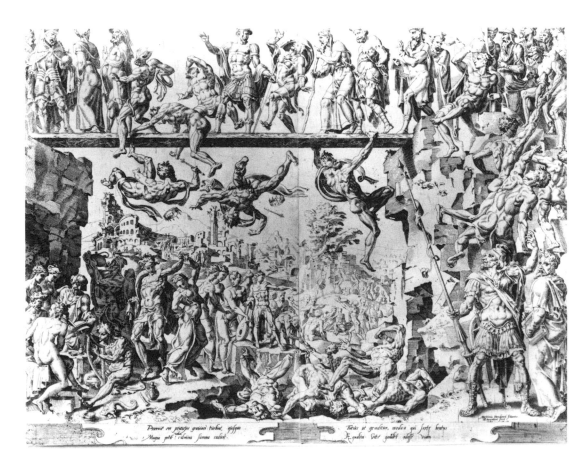

Figure 3.
Dirck Volkertsz.
Coornhert after Maarten van Heemskerck:
Allegory of Human Ambition, 1549,
etching on two plates,
43.6 x 28.7 (left half)
and 43.8 x 28.6 cm
(right half). Museum Boymans-van
Beuningen, Rotterdam.

plank between lofty cliffs can lead to tragic falls, versus the modest yet productive and carefree lives of humble figures, who remain close to the earth. Among the vainglorious are popes and bishops, kings and emperors, military generals, and even scholars. Crowns and scepters can still be glimpsed hanging in the air above the yawning pit of misfortune, evoking the traditional medieval image of the Wheel of Fortune. The Latin text declares: "All who strive for lofty things tumble down head over heels in a mightly whirl. As the highest of the high fall, so it is with everything. Happy is he who has met with a modest lot, for he rejoices in a smooth road through life." As Veldman has pointed out, Coornhert's theo-logy took particular aim at the remediation of the primary Christian sin of Pride, so this print introduced a variety of other Coornhert-Heemskerck collaborations dedicated to moral betterment.

Coornhert, however, increasingly withdrew from his collaboration with Heemskerck, finding surrogates to produce the ongoing stream of didactic images. First he ceased to be both printmaker and publisher after the manner of Bos, using Cock in Antwerp as his publisher and distributor for the Heemskerck prints. Then just as Bos seems to have trained Coornhert, so does Coornhert appear to have trained his successor as the favored printmaker of Heemskerck: Philipp Galle.[77] The Cock series of *The Unhappy Lot of the Rich* (1563; 6 plates) was not engraved by Coornhert but by Galle, even though the preliminary drawings date to 1560, around the time that Coornhert was still actively concerned with making prints.[78] In 1560 Coornhert, along with Jan van Zuren (later the burgomaster of Haarlem) and two other citizens, applied for a license to start a book publishing house, the beginning of his eventual career as an author of religious tracts.[79] In the 1560s Coornhert began also to assume public office in Haarlem: notary in 1561, town clerk in 1562, secretary to the burgomaster in 1564. Hence he was able to delegate fully his printmaker's association with the prolific Heemskerck to both Cock and Galle.

Heemskerck's projects published by Galle resemble Floris's systems of allegories much more than the previous works that he had just produced with Coornhert. In most of these series for Galle Heemskerck's prints received added inscriptions as well—by the Haarlem humanist, Hadrianus Junius, as Veldman has shown.[80] These texts seem to have come afterwards, as verbal reactions to the visual elements of the drawing design rather than as an integral element of the allegory itself, as was the case with Coornhert and his didactic program. Veldman states, "Junius had little to do with the actual composition of the theme." (p. 105) These captions were collected and published posthumously among Junius's verses, the *Poemata* (Leyden, 1598) in a section titled *Pinaces* (Illustrations).

Galle, as mentioned, began his career as an engraver in the manner of Coornhert, in works such as Heemskerck's allegorical series, *The Unhappy Lot of the Rich* (1563). After 1571 Galle officially took over Cock's publishing house in Antwerp, but in all likelihood he operated an unlicensed print publishing house for Heemskerck and others during the 1560s in Haarlem. Galle's earliest dated print for Cock bears the date 1557. That his house had its own Antwerp connections prior to 1571 can be seen in Galle's 1565 print after Pieter Bruegel, based on a lost drawing: *Parable of the Good Shepherd.*[81]

The subjects of Galle's Haarlem prints after Heemskerck, spanning the years 1562 to 1572, include subjects from the Old and New Testaments as well as allegorical cycles akin to the series by Floris: *Four Seasons* (1563), *Four Last Thing* (1569), *Seven Wonders of the World* (1572), *Triumphs of Petrarch* (6 plates, undated).[82] In addition, Cort produced cycles for Heemskerck at precisely the same time that he was working on analogous imagery for Floris under the auspices of Cock's Antwerp publishing house, especially the allegory, *Cycle of the Vicissitudes of Human Affairs.*[83]

A third engraver worked after Heemskerck designs during the 1560s after the departure of Cort, and many of the same thematic concerns emerged for him as well. Harmen Jansz. Muller produced

cycles of the *Nine Worthies* (3 plates, drawing 1567) and *Seven Planets* (undated) for Cock, along with a host of additional series not tied to Antwerp and probably published in Haarlem: *Christ as Good Samaritan* (1565), *Seven Sorrows of Christ* (1565), *Four Temperaments* (1566), and the undated series of *Athaliah* (4 plates) and *Eight Beatitudes*.[84]

The marketing of prints in series clearly played a role in producing multiple images in cycles of related subjects; however, Heemskerck's designs were not solely the result of an initiative from a single publisher, for Cock in Antwerp and Galle in Haarlem seem to have divided up these subjects between them. Unlike Floris, Heemskerck also included among his series Christian subjects, such as the Sorrows of Christ, the Beatitudes, and the Four Last Things, which seem to continue the religious-didactic purpose of his projects with Coornhert, though within a more conventional and dogmatic theological structure.

As an example, *The Vicissitudes of Human Affairs* (Cort after Heemskerck, 1564) ends its procession of allegorical floats with an image of *The Last Judgment* and the following inscription:

"So shall it be seen that Riches, Pride, pernicious Envy, War, Want, Humility, and Peace, the begetter of Riches, shall follow each other in turn as in a circular motion until the Final Day shall break upon the world...."[85]

Once again, the cycle of prints is tied to a systematic inclusion of knowledge in visual form— in this case tied to a cycle of life presented as a procession of allegorical personifications. Heemskerck once again seems to have depended quite literally on a literary program, this time devised in 1561 by the Antwerp Chamber of Rhetoricians (*rederijkerkammer* "De Violieren") for the annual *ommegang*, or civic procession, in honor of the holiday of Circumcision Day in the city of Antwerp.[86] Moreover, the first print in the *Vicissitudes* series, dedicated to the allegory of Mundus (World) employs many of the cosmological symbols later worked out in detail in separate Heemskerck series: the four elements, the four winds, a transparent globe of the zodiac, and night and

day.[87] Visual grouping of the cosmic elements of the seasons, planets, and temperaments (including the fusion of the four seasons with the four ages of mankind or the four temperaments with the four elements and allied signs of the zodiac) gathers the range of human and natural elements within a manageable, almost diagrammatic, system of codified knowledge. In this respect, the print series corresponded to a larger organization of knowledge as a system, based upon the theory that the human body is a microcosm—a model in miniature—for the universe as a whole.[88]

Not by chance the year 1565 marks the appearance of the first plan for organizing a print collection: *Inscriptiones vel tituli theatri amplissimi*, published in Munich for Duke Albrecht V by a Flemish scholar and bibliophile, Samuel Quicchelberg (1529-1567).[89] Quicchelberg's schematic organization of engravings serves in the creation of a "universal theater," a visual system analogous to the famed memory theater of Giulio Camillo at the end of the sixteenth century.[90] Such collectors' cabinets, or *Kunstkammer*, became the pride of subsequent princes, such as the Holy Roman Emperor Rudolf II in Prague.[91] Encyclopedic in scope, this universe of knowledge can efficiently be represented in the form of print cycles such as the series of Floris and Heemskerck; the small size (large prints were to be avoided because of space considerations), scholarly inscriptions, as well as allegories provide a ready compendium of knowledge for classification.

Divided into five large classes, this imaginary collection features the following topics: religious art and history; sculpture, archaeology, and decorative arts; natural history; science and mechanics, games and sports, arms, costume; and the fine arts proper—painting and engraving, plus textiles, heraldry, and portraits. Quicchelberg clearly regarded engravings as works of art and therefore classified them with paintings as objects within the fifth and final category of his ideal collection. However, he also recognized that engravings could serve as illustrations, and he organized the collection of engravings by their titles or subjects, three shelves with as many as eleven

titles per shelf. In some respects, these subdivisions of the print collection proper correspond to the principled organization of the universal theater as a model, once again as if demonstrating the harmony between microcosm and macrocosm.[92]

Notably, one of the few preserved sixteenth-century bound engravings collections to have been preserved intact, the prints of Ferdinand, Archduke of Tyrol, are organized by subjects in bound volumes akin to the schema advanced by Quicchelberg.[93] In both cases, the importance of print collecting as a literal form of learning remains paramount, at a time when prints come to be credited as artworks in their own right rather than merely illustrative means to an end or media for transmitting external, prior pictorial ideas.

Looking back over the increasingly comprehensive and ambitious printmaking designs of Heemskerck suggests a clear reformulation of what purpose prints are supposed to serve. Initially prints after Heemskerck appeared erratically, seemingly on the initiative of a would-be publisher, Bos. Bos contented himself with modifying completed Heemskerck paintings after their completion, although in a few cases the artist may have provided a reworked composition after his own painting in the form of a drawing (the best case is the *Triumph of Bacchus*). With the advent of Coornhert in place of Bos in the late 1540s, Heemskerck drawings emerged as the consistent preparatory design for supervised engravings, and printmaking became a substantial enterprise of the artist, completely separate from his work as a painter. Heemskerck's first drawings made for Coornhert were quite linear in concept, akin to the etchings of Renaissance Italy, with shading created within outlined figures entirely by hatching and cross-hatching, leaving large open areas.

However, Coornhert and Heemskerck began to collaborate more fully as equals, with Coornhert first providing allegorical subjects for the artist to visualize and then engraving—rather than etching—the designs for printing. Wiry etched lines and hatchings in the earlier prints eventually give way later to a more disciplined, less calli-

graphic coordination of tones. Coornhert may well have learned this new technique of engraving within the framework of Cock's Antwerp publishing house, for which he worked in the middle 1550s (see Riggs, this volume). The catalyst for this visual shift of emphasis seems to have been Giorgio Ghisi, an Italian who worked for Cock by 1550 and made his name by producing reproductive engravings after such famous Roman frescoes as Raphael's *School of Athens* (1550; cat. no. 11; Riggs 179) and *Disputa* (1552; Riggs 178).[94] Ghisi's gradations of tone through meticulous, even hatching create volume through a sense of constructed shading rather than outline.

With this alternative technique before him, Coornhert responded with new effects in his prints issued by Cock.[95] Chiaroscuro effects and description of surfaces already come to the fore in the designs for the 1555 series, *Victories of Charles V* (cat. no. 21). Eventually, Coornhert's prints for Cock after Lombard (*Deposition*, 1556, Riggs 161) and Floris (*Queen of Sheba Before Solomon*, 1557, Riggs 71) emphasize tonal range in the manner of Ghisi for a richness of modelling, even to the point of omitting the very contours that had characterized his works less than a decade earlier.

Heemskerck himself adapted to the new techniques practiced by his collaborator Coornhert. Already in the mid 1550s he uses more short hatchings and dotting to create tonal effects and more atmosphere around his commanding figures. Spatial settings take on new importance, and the figures are set further back, as the narrative unfolds with a larger cast over a greater expanse. By the time Heemskerck began to work with Galle in the 1560s, he composed primarily in terms of coordinated patterns of dots, with details carefully modulated for reduced clarity in the atmospheric perspective of distance. Sensitive to the technique of Galle as reproductive engraver, Heemskerck's ultimate drawing designs employ a style of meticulous yet delicate hatchings. Eventually the engraving techniques of Galle and Cort after Heemskerck designs for Cock closely resemble one another, despite Galle's training with Coornhert, just as Bos and Coornhert seem to

have followed closely upon a common model of engraving.[96] The reason for these convergences lies in the truly collaborative nature of the reproductive printmaking process, where engravers and designer mutually instruct each other. During the 1560s Heemskerck managed to produce a consistent visual product, whether his engraver was Galle, Cort, or Harmen Muller. He was able to accomplish this consistency because he learned in his own right to respond to his engravers' technical interests and the emphases of their new, tonal style.

Pioneer Publisher: Hieronymus Cock

Running through the accounts of both Floris and Heemskerck engravings appears the name of their publisher: Hieronymus Cock, proprietor of the printing house, "[At the Sign of the] Four Winds" in Antwerp as of 1550.[97] Cock (active 1546-70) was not the only major publisher in the international port city of Antwerp during the age of Floris, Heemskerck, and Pieter Bruegel; his chief rivals were Hans Liefrinck (whose father, Willem, began as a block-cutter for Emperor Maximilian I in Germany before he settled in Antwerp in 1528; active 1538-73) and Gerard de Jode (active 1547-91; noted as a printer of maps).[98] Yet Cock held the same dominance in print publishing in Antwerp and Northern Europe that Christopher Plantin of Antwerp and his publishing house "The Golden Compass" held in book publishing.[99]

Shortly after the experimental phase of Cornelis Bos in Antwerp and Haarlem, Cock began in 1550 the more systematic organization of a print publishing house, including the early publication of ornament prints by Cornelis Floris, Frans's brother in 1548.[100] Cock's own career had begun as an etcher, and his early (1551; cat. no. 35) prints of images of the Colosseum and other Roman ruins reinforce the notion that he had visited Italy.[101] Those ruins and a set of landscapes with mythological subjects, issued in 1558 after designs by his brother, Matthys Cock, are the principal etchings by Hieronymus himself to be published

by his print house, presumably during the era when he did not yet have a large team of designers in his employ.[102] He also seems to have collaborated on the set of the *Liberal Arts* with Frans Floris (1551), supplying the designs for the landscape backgrounds to Floris's figures.[103]

After 1550 the new venture was truly launched. In 1550 Cock published a most momentous engraved reproduction of a masterwork of the Italian Renaissance in Rome: Raphael's *School of Athens* (two plates; cat. no. 11). The engraver was also an Italian, Giorgio Ghisi of Mantua, and he would go on to collaborate with Cock for six years, producing five large engravings in all.[104] Before coming to Antwerp, Ghisi had clearly been in Rome as well, for in the mid-1540s he produced (in ten plates!) a printed replica of Michelangelo's *Last Judgment* in the Sistine Chapel; perhaps Ghisi met Cock in Rome.[105] Ghisi went on to reproduce designs by Lambert Lombard (*Last Supper*, 1551), Raphael (*Disputa*, 1552), Bronzino (*Nativity*, 1553), and Giovanni Battista Bertani (*Judgment of Paris*, 1555) for Cock during his tenure there. Ghisi codified the visual syntax for reproductive engraving in a manner analogous to the linear network of contours and shadows by Marcantonio Raimondi, which would shape the printmaking enterprise of Cock's workshop for the next two decades. His true successor would be Cornelis Cort, active with Cock between 1552 and 1565, whose career eventually took him, in turn, southwards to Italy, where he produced engravings after such masters as Titian and Barocci.

What the subjects and the technique of Ghisi brought to Cock was the authority of Italy as a model. Together with his own images of Roman ruins as well as the Italianism of figures and costume transplanted to Flanders by Lombard and Floris, Cock's prints had something distinctive and "imported" to offer the print collectors of Antwerp.[106] Soon afterwards, beginning in 1552, Heemskerck's art provided the same "authentic" contact with Italy.

Heemskerck's contact with Rome would also prove essential because of his drawings of antique ruins in Rome, utilized by Cock for a second

ruins series, issued in 1561 (cat. no. 36).[107] Cock's ruins are often labeled with the name of each particular monument; the 1551 title page stresses both the authenticity and liveliness of these views, "vivis prospectibus, ad veri imitationem affabre designata."

Related to the heroic subjects and fulsome forms of Italian art in Cock's output is his extensive attention to ornament prints, particularly classicizing or "grotesque" ornaments. Although Cornelis Bos preceded Cock in this enterprise and had the advantage of being able to reproduce his own ornament designs, Cock enabled Cornelis Floris (cat. no. 40) and later Hans Vredeman de Vries to disseminate their pictorial inventions in the form of engravings.[108] Both Cornelis Floris and Vredeman de Vries issued ornaments in different categories: grotesques, ornamental vessels, and tomb designs.

Vredeman also extended his design invention (1560, 1562) to the creation of imaginary architectural views, in part derived from the architectural treatises of Sebastiano Serlio and their evocation of stage sets and scenes but amplified through inventive architectural fantasy, augmented by a mastery of perspective. Later, amplifying Serlio, Vredeman would also produce books on the classical orders (1565). Riggs refers to Vredeman's architectural views as essential "cityscapes," defined by their "emancipation from any external practical necessity" (pp. 182-83). Characteristic of their playfulness amid pictorial invention is the first print produced after Vredeman by Cock for the 1560 series (fig. 4). There the building in the corner foreground of a sharply receding street bears the name of Cock's house, "iiii vens" (i.e. Quatre Vents). A man standing in the door and a woman visible inside are surely intended to be Cock and his wife (named Volck, who as his widow would continue the publishing of prints), because beneath them appears their favorite punning motto on the names of both Volck and Cock: "Let the cook cook according to the will of the people" (*Laet de Cock coken om tvolckx Wille*).[109] Vredeman produced over 200 designs for Cock, more than any other artist (Heem-

skerck's contributions number around 175; Pieter Bruegel around 70).

Vredeman's ornaments and cityscapes offer repeated variations on a formal theme, often intended as patterns for emulation by craftsmen in other media, in the tradition of earlier, fifteenth-century engravings-as-models. Ornaments, of course, could be utilized in virtually any context; a particularly frequent application was in the cartouches and title frames of sixteenth-century maps, such as those of an Antwerp contemporary, Abraham Ortelius.[110] Presumably his architectural views could have been utilized by painters as scenographic settings for narratives; Vredeman himself occasionally collaborated with figure painters in the production of such images.[111] Van Mander's biography of Vredeman contends that the architectural designs were intended as sources for intarsia work.

In similar fashion, Cock produced figurated landscapes where the outdoor settings seem separable from the figures who appear within them. Such a formulaic use of landscape appears already in his early etched narratives after Matthys Cock, mentioned above. The title page of the full set, issued in 1558, makes this combination explicit: "Various orders of landscapes, with fine histories ordered within, from the Old and the New Testaments, and [from] some merry Poesies [i.e. myths], very convenient for painters, and other art-lovers."[112] In the case of one surviving drawing (Amsterdam, Van Regteren Altena Coll.), whose landscape tallies well with the etching of *Hero and Leander* (Riggs no. 45), the figure group—Saint Christopher with Christ—differs from the final narrative.[113] In a more famous example, a 1554 Pieter Bruegel landscape drawing without figures (but with bears) was adapted by Cock for an etched narrative, *Landscape with the Temptation of Christ* (cat. no. 37).[114] Later Cock produced a series of landscapes after Bruegel designs that contained few narrative figures, the so-called *Large Landscapes*.[115] On the other hand, Bruegel did make his own designs for some religious narratives within the expansive landscapes in the series: *The Way to Emmaus* (Lebeer no. 9; surviv-

Figure 4.
Lucas and/or Jan
Doetechum after Hans
Vredeman de Vries:
City View from series
*Scenographiae sive
Perspectivae*, 1560,
etching and engraving,
22 x 26.7 cm. Museum
Boymans-van
Beuningen, Rotterdam.

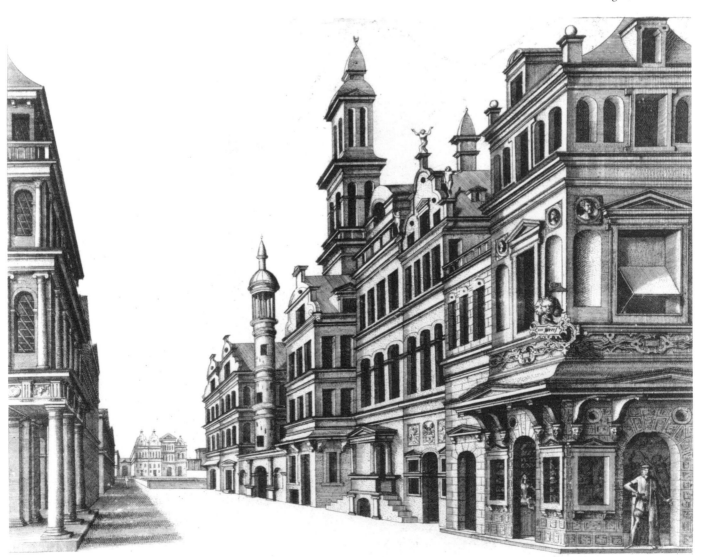

ing drawing in Antwerp) and images of Saint Jerome and Mary Magdalene in the wilderness (Lebeer nos. 2 and 3).[116] Pilgrimage and hermitage activities require landscape settings, and the Bruegel landscape designs with religious figures conform fully to the Netherlandish heritage of landscapes with holy figures, as inherited from Joachim Patinir and other sixteenth-century Antwerp artists.[117]

Nonetheless, the dominance of non-narrative landscapes issued in the "large" series by Cock is confirmed by the later, anonymous "small" landscapes of rural views with country villages in 1559 and 1561. The 1559 title page reads: "various houses, farms, fields, roads, and such like, arrayed with all sorts of animals. Everything drawn from life, mostly around Antwerp." Faithful rendering "from life" (*naer dleven*) now dominates over any inclusion of biblical histories or mythical "poesies" in Cock's first landscape series. Bruegel's visit to Italy had inspired him to compose illusionistic and harmonious mountain landscapes in his drawings; these distinctly non-Netherlandish settings led to the printed versions of the *Large Landscapes*. What distinguishes the *Small Landscapes*, by contrast, is their scrutiny of local scenery, usually only a portion of the overall compositions of Bruegel's designs, such as *Resting Soldiers*, or *Milites Requiescentes* (cat. no. 39; Lebeer 12) or *Rustic Solitude* (Solicitudo Rustica, Lebeer 7). A major and novel exception is Bruegel's close-up vision of a rural village, *Wooded Region* (Pagus Nemorosus), seen not from Bruegel's usual bird's-eye overlook but instead from close-up and on a level plane. Here the intimacy later developed by the *Small Landscapes* emerges, as well as an incipient contrast between nature and culture, between the wild forest at the right and the cultivated hamlet at the center of the image.[119]

Whether Cock's use of landscape was a marketing strategy tied to the general pleasure (especially for urban citizens of crowded Antwerp) of contemplating nature, or whether his printed landscapes were still intended to serve as patterns for "painters and other art-lovers," his shift toward the indigenous countryside would have important consequences for the conception of landscape in the Low Countries in the coming century.[120]

What needs to be stressed here is the degree to which inventiveness in landscape had its origins in the Cock workshop, At the Four Winds. Prior to his mid-century initiatives with Bruegel and others, including Hans Bol (from nearby Mechelen, 1534-93) as well as Matthys Cock and the Master of the Small Landscapes (Joos van Liere?), the use of mythological figures in landscapes was quite rare; and the idea of making peasant labors or the activities of the four seasons the subject of their own landscape images could be found only within the pages of illuminated manuscripts. Bruegel's own painted versions of these landscapes only date from a decade after his print designs, so Cock's role in this long-term development remains fundamental.[121]

Cock seems to have realized that his prints were oriented towards different clienteles. On the one hand, an Italy-oriented group of collectors purchased what later, academic traditions would label "high culture," the history themes and heroic figures of Lombard, Floris, and Heemskerck. But another set of collectors seemed, like Bruegel himself (who, despite a trip to Rome in the period 1551-54, rarely revealed any vestiges of influence from Italy in his work), to promote an art of the ordinary, whether in terms of landscape or of human figures in action. This conflict of pictorial imagery and taste did not go unnoticed by contemporary artists.[122] When Floris's pupil, artist and poet Lucas de Heere, wrote his "Invective against a Certain Painter" around 1565, he equated his anonymous artist target with ancient Momus, critic of the gods, and called him a bungler and oaf incapable of understanding the beauty of Floris's creations. In contrast to the graceful figures of Floris that "certain painter's" own creations are likened to "carnival puppets" (*kaeremes poppen*). Whether or not that painter who went to Rome without effect is to be equated with Bruegel, the grounds of contention are spelled out by de Heere, and Bruegel clearly belongs in the enemy camp.

Indeed, Bruegel's own learned admirer, cartographer Abraham Ortelius, singles him out for praise in a posthumous encomium precisely by means of the opposite terms, stressing his naturalness and avoidance of prettiness or artificiality:

...Bruegel, whose pictures I would not really call *artificiosae*, but rather natural... Painters who paint pretty young people and wish to add some charm and grace of their own completely destroy the image presented to them and stray from the exemplar set before them and from true form. From this fault our Bruegel was free.[123]

The merchandising of Bruegel's designs as an antipode to the Romanism of Floris and Heemskerck formed the other mainstay of Cock's output. During the 1550s in particular Bruegel made a variety of designs for Cock intended for a distinctly Netherlandish clientele. On the one hand, he produced images within the familiar and popular idiom, already widespread in paintings, of Hieronymus Bosch, while at the same time, he designed prints of subjects drawn from ordinary life—another form of the "natural" imagery praised by Ortelius—and often tied to Netherlandish proverbs or speech.

Bruegel was called in his own era a "second Bosch;" already in 1572, the Latin verses by Domenicus Lampsonius accompanying his portrait bear the following inscription:

Who is this this new Jerome Bosch come into the world, who imitates his Master's clever dreams... Pieter gains in spirit just as his art grows more fruitful: and the wit and inventiveness of his painting in the manner of his old master is certainly worthy of laughter...[124]

What this passage makes clear is that Bruegel's art was seen to be a retrospective emulation of the famous formulas of Bosch but also that such works were to be seen in a comic vein, evocative of the follies of humankind rather than as the sombre and serious moral castigations perceived by most modern scholars. Van Mander calls the artist "Pieter the Droll" in his 1604 biography and claims that the viewer cannot look at his works without breaking into a smile; this is the character of Bruegel following Bosch advanced by

Lampsonius.[125] "Ingenious dreams" (*ingeniosa somnia*) of a demon-filled world, based on the inventions of Bosch, overwhelm the subjects in which they appear and link these imaginative images to the concept of *Grillen*, or "whimsies," a critical category most fully developed during the seventeenth century but related to the medieval concept of "drolleries" in the margins of manuscripts or church decorations.[126]

Bruegel's Boschian designs began early. His unsigned drawing, *Big Fish Eat Little Fish* (1556; Vienna, Albertina) was replicated in a print of 1557 (Lebeer 16), engraved by Pieter van der Heyden (whose monogram appears in the lower left corner) and issued by Cock; however, the print was ascribed to "Hieronijmus Bos. inventor" rather than to the less famous Bruegel. It features a number of characteristic Bosch fantasies of flying or walking fish as well as surprising gigantic fish in foreground and background. Characteristic of Bruegel's orientation towards the Netherlandish vernacular in both language use and proverbial wisdom, the subject of the print comes from a native saying, which is didactically explicated in Dutch as well as in Latin beneath the image, as if issuing from the mouth of a depicted father explaining the facts of life to his small child.

Bruegel had also designed a pair of religious subjects for Cock engravings, produced by Van der Heyden: *The Temptation of Saint Anthony* (1556; Lebeer 14; original drawing at Oxford, Ashmolean) and *Patience* (1557; fig. 5; Lebeer 15). In these works the use of monsters explicitly to represent evil, specifically the vices and heresies that tempt saintly Christian exemplars from their faith and virtue, respectively.[127] Boon has called attention to the veiled criticisms of church officials and clerics within *Patience*; monk's habits, cardinal's hats, and a papal bull read by a man at left on horseback all suggest that the Church establishment is a threat to, rather than a support of, the personified virtue of the foreground (his specific identification of the oversized cardinal with Cock's patron—and a later collector of Bruegel paintings—the regent of the Nether-

lands, Cardinal Granvelle, seems overly precise (even dangerous to the publisher).[128] By contrast, Saint Anthony in the other print is himself a monk in retreat from worldly temptation; only a banner with cross, hanging from a dry tree atop a monstrous, giant floating head with hollow fish, suggests the association of the Church with demonic corruption. Both images suggest the importance of bearing afflictions stoically and steadfastly in the confidence of true faith. These two Bruegel visions can be contrasted with the elaborate personifications of Heemskerck, as engraved by Coornhert and later by Cort for Cock (e.g. *The Triumph of Patience*, 1559, no. 1; or the early *Jacob's Ladder*, 1550, no. 10, whose muscular, bearded male personifies the doctrine that "Patience [*Tolerantia*] in adversity engenders knowledge of God"—a message like Bruegel's print but with fully Romanist presentation and a sense of Patience as active rather than passive in the life of a true Christian).

Continuing in the Bosch pictorial idiom but curbing his overt criticism of the Church, Bruegel went on to produce a cluster of designs for Cock on religious themes. First he designed a series, seemingly growing out of the *Patience*, of *The Seven Deadly Sins* (1558; Lebeer nos. 18-24; all drawings survive) and quickly followed with a Boschian *Last Judgment* (Lebeer 25) and *Christ in Limbo* (cat. no. 30; Lebeer 38).[129] In the latter prints theological issues have become generalized into the basic confrontation of good and evil, crystallized into the separation of the damned from the blessed at Judgment. However, most of these prints in the Bosch idiom focus like the Deadly Sins series more on the fantastic combinations of different species into single monsters or on improbable gigantism of figures or objects, emphasizing the rich diversity of the created world of fantasy and the often comical antics (not to mention the rubbery limberness) of the scores of active demons. This inventiveness can be compared to the hybridization that provides fantasy combinations in grotesque ornament patterns, as practiced by Cornelis Bos, Cornelis Floris, and Hans Vredeman de Vries, although the classical,

Neronian origins of grotesque ornament still align these prints with the Romanist creations of Cock.

After completing the Seven Deadly Sins series, Bruegel's first venture into a Virtue cycle also extends his early rendering of *Patience* into a combat of knightly, armed virtues and demonic vices before a fortress of faith in *Fortitude* (Lebeer 36; 1560, original drawing in Rotterdam). Again the inscription suggests that true fortitude is stoical: "To conquer one's impulses, to restrain anger and the other vices and emotions: this is true fortitude." Some scholars have associated these views emphasizing reason and the governing of the passions with the theological teachings of Coornhert, whom Bruegel could well have met through the printing connections of Cock, though there is no documented encounter of the two men.[130] Regarding the print itself, the depiction of virtue unfolds in a clear and uncomplicated opposition of good vs. evil, with little theological complexity. In an era increasingly fraught with religious controversy and the threat of inquisition against any heterodoxy, Bruegel's Boschian images conjure up a theologically neutral and easily assimiliated message that could give no offense to either party. Moreover, most of the Vices are presented through standard allegories, represented by a single female personification figure with the attributes and accompanying animals codified already during the fifteenth century.[131]

Whether or not Bruegel actually derived his concept of theology from Coornhert, his outlook of religion as essentially an ethical domain, to be a lived practice in daily life, emerges from much of his work, particularly the remaining prints from the Seven Virtues series of 1559-60.[132] In these images, the exemplification of a virtue (though possibly its perverse exaggeration) is literally acted out—around the central, female allegorical figure with standard symbolic attributes—by a host of ordinary individuals in worldly settings. Faith unfolds within a church setting, replete with both sermon and sacraments; Charity shows the traditional Seven Acts of Mercy from the Sermon on the Mount enacted

Figure 5.
Pieter van der Heyden
after Pieter Bruegel:
Patience, 1557,
engraving, 34 x 44 cm.
Museum Boymans-van
Beuningen, Rotterdam.

Figure 6.
Philipp Galle after
Pieter Bruegel:
Temperance from the
series, *The Seven
Virtues*, 1560, engraving,
22.3 x 28.7 cm.
Museum Boymans-van
Beuningen, Rotterdam.

PATIENTIA EST MALORVM QVÆ AVT INFERVNTVR, AVT ACCIDVNT, CVM ÆQVANIMITATE PERLATIO · Lact. Insti. Lib. 5

VIDENDVM, VT NEC VOLVPTATI DEDITI PRODIGI ET LVXVRIOSI
APPAREAMVS, NEC AVARA TENACITATI SORDIDI AVT OBSCVRI EXISTAMVS

around a village square. Around a civic center a plethora of gruesome punishments embodies Justice, leading some modern scholars to think that Bruegel's depiction of excess here is intended to cast an ironic light on the other practices shown (esp. Faith, assuming Bruegel to be heterodox) in his Virtues.[133] However, most of the other Virtues show the practice of mundane activities, linking the theological concept to a new, "common sense" understanding and practice of a specific virtue. This vision is particularly pertinent for the images of Prudence (home repair, storage of food for winter, fire prevention, and seeing both doctor and priest about illness) and Hope (comfort for prisoners, sailors, firefighters, fishermen and farmers, as well as pregnant women).[134] The most unusual combination of activities involves Temperance (fig. 6), where measurement, the basis of musical tempo and of the other arts (drama, architecture, and drawing are shown), is also fundamental to (ac)counting, geography, ballistics, and the traditional medieval Liberal Arts (besides Music, Arithmetic, Astronomy, Geometry, Grammar, Rhetoric, and Dialectic).[135] In this print especially the development of all of these mental activities seems to emanate from a central principle, quite analogous to the traditional Children of the Planets series; to compare Heemskerck's *Mercury*, engraved by Harmen Muller and issued by Cock (undated but after Bruegel's series), reveals many of the same activities, arts and sciences, arrayed in similar fashion: musicians, painters, sculptors, writers, scholars, a doctor, and a merchant counting his coins.[136]

The development of a concept of ordinary wisdom, a moral version of the modern concept of common sense, was a cornerstone of Coornhert's campaign for a vernacular and universally understandable theology, as expressed in his major work, the *Zedekunst dat is wellevenkunst* (The Art of Morals, i.e. The Art of the Good Life), and the identification of everyday virtues and vices is a major element in that campaign. Just as many of the Coornhert-inspired Heemskerck prints focused on human ambition, vanity, and greed,

so do many of Bruegel's moral designs for Cock. His *Elck* (Everyman; Lebeer 26; original drawing of 1558 in London, British Museum) is essentially a Heemskerck allegory in new clothing, closer to the labelled costumes of contemporary theater allegories.[137] A bearded, bespectacled old man, with his title on his hem, ranges through the world on a search with a lantern. The Latin inscription points out the moral instruction of this print:

[There is] no one [who] does not seek his own advantage everywhere, no one [who] does not seek himself in all that he does, no one [who] does not look everywhere for private gain. This one pulls, that one pulls, all have the same love of possession.

In similar fashion, another Bruegel print design for Cock, the *Alchemist* (Lebeer 27; original drawing of 1558 in Berlin) shows a specific instance of vain striving for material goods, ending in a background scene of the entire family reduced to poverty and seeking aid at an almshouse.[138] And Bruegel returned to the theme of avarice at a later moment in his *Battle of the Money Bags and Strong Boxes* (Lebeer 54; engraved by Van der Heyden).[139]

Closer to the tone of burlesque in the comedic farces of the Antwerp *rederijkers* are a host of Bruegel designs for Cock prints of human folly.[140] A pair of related images with grotesque figures, akin to the types of the *Alchemist*, are the *Fat Kitchen* and the *Thin Kitchen* (Lebeer 55-56, 1563; engraved by Van der Heyden). In each case an intruder of the opposite condition has stumbled into the wrong kitchen and is being expelled. Here the inscriptions are in French and Flemish, and an attack on social inequity seems to be conveyed through comic exaggeration of feast vs. famine. As is so often the case with Bruegel, beginning with *Big Fish Eat Little Fish*, there is also an implied use of a local proverb: "there Bare Bones stirs the pot" (*daer roert magherman de pot*).[141]

In similar fashion, the *Ass at School* (1557; Lebeer 17; original drawing, dated 1556, Berlin), underscores the futility of teaching the uninterested,

here with a foolish teacher dressed in the manner of the ambitious scholar in the *Alchemist*.[142] In this crowded and unmanageable classroom the children largely have to teach themselves, and few of them seem interested (in contrast to the teaching of letters in *Temperance*). Another expression of folly is the quack operation, the excision of the "stone of folly" from a gullible simpleton in the so-called *Witch of Mallegem* (1559; Lebeer 28). Her secret accomplice, lips padlocked, hides under her bench, ready to supply more stones for the crowd of dolts with cartoon faces that presses forward for her services. The combination of comical folly and *rederijker* allegory is finally fused in a *Festival of Fools* (Lebeer 29), which like the Stone of Folly is a comical allegorical topos, intended to represent the universality of human folly.[143]

Bruegel's prints for Cock, then, partake of the satirical yet vernacular verbal structures of urban Antwerp. They are tied to notions of proverbial wisdom as a didactic source for living, and they offer an analogue to the collection of vernacular proverbs by learned scholars and their publishers during the sixteenth century.[144] Bruegel also made use of humble yet didactic subjects from everyday life in his use of Christ's parables as the themes for his paintings and prints, specifically the engraved *Wise and Foolish Virgins* (Lebeer 39) and the *Good Shepherd* (1565; Lebeer 59; not by Cock).[145] Throughout, the treatment of humankind shows the artist consistently advocating the bourgeois virtues of diligence and industry in contrast to the vices of sloth, luxury, and avarice.

The measure of the distance between Bruegel and his rival, Frans Floris, can be seen by a basic contrast of their Virtues series, both issued in the same year, 1560. Whereas Bruegel shows the enactment of the virtue through a host of tiny figures behind a standing, central foreground personification, Floris isolates his figure in classical dress, together with her animal attribute but animates her pose and gestures.[146] In similar fashion, Bruegel's image of *Summer*, a drawing of 1568 (Hamburg) later engraved for Cock in 1570 after Bruegel's death by Pieter van der Heyden (Lebeer 78), shows not an allegory but rather an

activity: massive farm laborers in the wheat fields, harvesting under the heat of the summer sun.[147] By contrast, in Galle's engraving of *Summer* after Heemskerck, the muscular personification of the season stands front and center, dominating the rural labors that unfold behind him.[148]

Bruegel's figural prints, then, started out less to be models for emulation by local artists than activities for emulation, in contrast to the "academic" prototype figures, imported from Rome, of Floris or Heemskerck (or even Bruegel's own continuation of the local traditions in his landscapes or Bosch fantasies). Instead, they offered models (often through negative example) of righteous conduct and moral instruction, finding the overlap between religion and daily life that would be so richly developed by Netherlandish art in the following century.[149]

Yet in view of printmaking's wide reach as well as its own history of inspiring copies, we cannot be too surprised to learn that Bruegel's gangly figure types as well as his landscapes (particularly the innovative forest landscapes) were copied in their turn and exploited in a host of copies. This imitation was particularly marked around the turn of the seventeenth century, which has been characterized by various scholars as a "Bruegel revival."[150] That the popularity of Bruegel was already high shortly after his death can be seen from the fact that print copies were made after his paintings of the 1560s, such as the 1567 *Land of Cockaigne*; moreover, Cock's widow issued three posthumous Bruegel prints, some presumably after drawings of an earlier era (*Fight of the Money-Boxes*) and others adapted from later Bruegel paintings (*Wedding Dance*, close to a painting, dated 1566, now in Detroit).[151] Hence by means of the prints after his designs and paintings, Bruegel, too, established his pictorial formulas as a visual model for imitation.

Diffusion from Antwerp

When Hieronymus Cock died in 1570, his widow continued the business, which then passed into the hands of Bartholomaus de Momper, who had

already engraved one early Bruegel print, the *Kermis at Hoboken*.[152] Meanwhile, Philipp Galle, who had begun his career as an engraver for Cock from 1557 until 1563, left to go into the publishing business in Antwerp for himself (and took Heemskerck as a client with him, just as he also made some later engravings after Bruegel). Until Cock's death in 1570, however, the Quatre Vents business in prints bestrode the geographical as well as the stylistic range of the Netherlandish art world, chiefly centered on Antwerp and Haarlem.

We have seen how Ghisi brought the engraving techniques of Italy, while Italian artworks were reproduced in engravings for the Low Countries. Ancient ruins as well as ancient inspired modern grotesque ornament served as visual models for copyists in various media. Italian-inspired artists from Lombard to Floris and Heemskerck formed a staple commodity for Cock, and he assigned each of them a favored printmaker (though some switching of the match between designers and engravers took place): Ghisi and then Hans Collaert for Lombard; Coornhert and then Galle and then Harmen Muller for Heemskerck; Coornhert and then Cornelis Cort for Floris. For more local and Netherlandish subjects, Bruegel collaborated with the brothers Doetechum for landscapes, with Galle and Pieter van der Heyden for secular and religious subjects, and with Frans Huys (who also worked for Hans Liefrinck) for a series of eleven plates of sailing vessels (Riggs 54).

Such a productive yet collaborative process was never very stable, and the continued departure of engravers continually shifted the balance of Cock's output. Ghisi was the first to depart, after six years. Coornhert suspended his engraving activity after 1559. Galle left in 1563, and Cort (who began his career with Cock in 1552) set off for Italy in 1565, which was also the last year Frans Huys worked for Cock.[153] As Riggs points out, in engraving a remarkable convergence of style emerged during the early 1560s, particularly between Galle and Cort, who jointly engraved Heemskerck drawing designs during that peri-

od.[154] Both use bold, controlled hatching to model surfaces and volumes and render shadows through tight spacing and fineness of line. At the same time, the etchers Jan and Lucas van Doetechum, who like Cort received their principal training from Cock, standardized and systematized an etched line whose rich darks add to their otherwise meticulous emulation of the graded tones and even lines of engraving (and who supplemented their etching with burin work).[155]

Cock's house style was disseminated into the international sphere through the travels of his engravers abroad—first Ghisi, to France and back to Italy; then Cort, to Venice and Rome.[156] The role of Cort (1533-78) in Netherlandish printmaking, however, was only enhanced by his incorporation of Italian designs into his prints, for Cort engravings exercised an ongoing fascination back home with his countrymen, having the same authority as Ghisi's replications of Raphael and Michelangelo. In the case of Cort, the new Italian images were generated by Titian (who housed the engraver and sanctioned him as the authorized printmaker after his designs), Muziano, and Barocci. Cort also added a major new technical innovation to the craft of engraving: he managed to convey both rounded volume and shading through the swelling of his engraving line, a technique indispensible to the later masterworks of Goltzius in Haarlem (see below). A principal landmark of Cort's absorption of Italian designs with his new engraving style is his pair of prints after Federico Barocci: *Rest on the Return from Egypt* (1575), and *Madonna of the Cat* (1577).[157] In particular these prints would serve as the inspiration for Goltzius in subject as well as technique: the former for a 1589 *Rest on the Flight* (Strauss 264), the latter for one of his "master engravings," the 1593 *Holy Family with Saint John* (Strauss 317; here a cat in a window signals the connection).

Galle also maintained long-distance ties with Italy through the designs of the emigre Bruges artist, Jan van der Straet, or Johannes Stradanus (1523-1605), who had already left the Low Countries for Florence by 1550 but contin-

ued to have prints after his designs issued in his homeland.[158] A series of "New Discoveries" (*Nova reperta*) includes among its twenty designs not only the manufacture and technology of optics, watches, and weapons, but also features Jan van Eyck's discovery of oil painting technique and the publication of engravings on printing presses.[159] Of course, the latter image, engraved by Galle (others in the series are the work of Hans Collaert) is a reflexive presentation of its own origins, showing the subdivision of skills required to turn a design into a finished, printed reproductive engraving. At the right a master shows the apprentice how to use the burin to engrave, just as the learned teacher of the trivium works with students in Bruegel's *Temperance*, while at the left foreground another youngster copies a drawing in ink. The image vividly captures the collaborative, craftsman environment of the print dealerships of both Galle and his own master, Cock.

Cock projects continued to have long-term effects even after his death. Published posthumously, his proposal for the first retrospective collection of Netherlandish artists' portraits, including portraits of Cock himself, Bruegel, Floris, and Lombard, appeared as an engraved series, *Pictorum aliquot celebrium Germaniae inferioris effigies*, in 1572 and pointed the way to a later era in Antwerp printmaking.[160] While both the Latin verses and the portraits of this Lampsonius publication were intended to serve for greater glory of Netherlandish painting in general, the long-term effect was to introduce a new print category, the celebratory artist portrait as tribute. Here once more printmaking acts in the service of painting, reproducing a prior portrait or drawing of a painter's features as well as serving as agency for his fame or publicity for the artist-"inventor." A similar artistic celebration was created for Heemskerck by Galle in 1569 as the frontispiece to a print cycle, *Clades*, or *Inventiones Heemskerckianae ex utroque testamento*.[161] Its Latin inscription reads: "Maarten van Heemskerck, painter, a second Apelles—that of our age—the father of [these] inventions, depicted from life." At the

turn of the century during the height of the "Bruegel revival," the Antwerp-trained engraver, Aegidius Sadeler, produced a tribute to Bruegel that literally trumpets the fame of the artist around his likeness (see below).[162]

The printmakers of the portraits in the Lampsonius cycle were virtuoso professional engravers, the brothers Wierix, Jan (1549-1618?), Hieronymus (1553-1619), and Antoine (1555/59-1604).[163] Beginning as exacting copyists after Dürer originals, they went on to dominate the output of religious prints in Antwerp for the next quarter century, working particularly after the designs of Martin de Vos, as well as Jan van der Straet and Crispin van den Broeck. Their meticulous, fine linear style of engraving extends the mature Cock print style as exemplified by Galle, and their output was prodigious—over two thousand prints! In addition to working for Galle and Cock's other major rival publisher, Gerard de Jode, the Wierixes produced prints for Hans Liefrinck, Jan Sadeler (see below), Peter Baltens, Edward van Hoewinckel, Hans van Luyck, and Jan-Baptist Vrints—this list alone suffices to show the active printmaking trade in Antwerp after 1570.[164]

The Wierixes also exemplify another of the major developments in the engravings industry, particularly in Antwerp: the rise of family firms. In some respects, Cock's widow initiated this development by taking over and running the Quatre Vents after her husband's death. Philipp Galle's splinter shop, moreover, extended this consolidation, by passing his business on to his son, Theodore Galle, whose career began as an engraver in house. As noted above, the Wierixes also worked for Galle at times, as did his sons-in-law, Karel de Mallery and Adriaen Collaert (ca. 1560-1618)—probably a relative of Hans Collaert, who already worked for Cock. In one respect, this kind of family link should hardly come as a surprise. Printmaking, like the metalwork engraving that gave birth to it, was often a craft passed on father-to-son like other guild-based crafts. This circumstance, however, also points to another sense of the concept of a

"model" to be added to the uses already explored in this paper, viz. a pattern for copying like ornaments or landscapes, or else a "role model" for didactic, especially moral, instruction. In this case the model is an extension of "house style" achieved through literal home instruction, apprenticeship of son(s) with father.[165]

One of the most productive engraver families and publishers was the Sadelers: Jan the Elder (1550-1600), his brother Raphael (about 1560-1632), and his nephew Aegidius (whose Bruegel portrait print was mentioned above; 1570-1629).[166] The Sadelers were trained in Antwerp, but like Cort, they took their talents abroad. Jan Sadeler was trained by his father as an engraver of arms and armor; he entered the Antwerp artists' guild the same year as the Wierix brothers, 1572. However, political events forced him to flee Antwerp. Following the 1580 conquest of the city by Protestants, Jan took refuge in Cologne, and then after a brief return to Antwerp in 1585 he emigrated permanently. Mainz, Cologne, and Frankfurt formed Jan's waystations on his eventual path to Munich, where he found a firm post as court engraver for Wilhelm V of Bavaria and close contact with the Munich painter-designers Peter Candid, Hans von Aachen, and Friedrich Sustris. Following bankruptcy of the Munich court in 1595, Jan departed for Italy, where after 1597 he signed his prints from Venice. His most ambitious prints derived from designs by fellow emigrés to Italy from the Low Countries, chiefly Van der Straet (from Bruges) and Dirck Barendsz. (from Amsterdam, 1534-92).[167]

Much of Barendsz.'s painted work does not survive in the original, but his extensive collaboration with Jan Sadeler has permitted reconstruction of his *oeuvre*. Surviving designs for engravings, however, often consist of small oil sketches on paper, often in grisaille, or brushed drawings produced during the early 1580s. The sketchy models of Barendsz. and the meticulous, fine engraved tonalities of Jan Saenredam suggest a close and ongoing relationship akin to the precedent of Frans Floris and Cornelis Cort some two decades earlier. Barendsz. probably learned

the technique of the oil sketch from his time in Venice in the studio of Titian.[168] Other Barendsz. designs reveal festive figural influences via Veronese from his earlier stay in Venice: *Venetian Wedding* (engraved by Goltzius, 1584; see below) and *Mankind Before the Last Judgment* (Sadeler, drawing of 1581 in London, Victoria and Albert Museum, fig. 7).[169] The latter print retains much of the didactic power for moral instruction that underlay the production of such models of conduct as Bruegel's Virtues; at the same time, they seem to strike a balance between the heroic figures of Heemskerck and the everyday anonymity of Bruegel's actors.

Aegidius Sadeler followed literally in the footsteps of his printmaker uncle Jan.[170] After an Antwerp apprenticeship of 1585 and guild membership in 1589, by 1590 he had joined Jan in Munich. Aegidius followed his uncle further on trips to Italy, notably to Rome in the period 1591-93. There he met Joseph Heintz, court painter to Emperor Rudolf II of Prague, and the connection stood him well, as he emigrated to Prague in 1597. Aegidius served in turn a succession of three Holy Roman Emperors as their official engraver, including Rudolf, Matthias (1612-19), and Ferdinand II (reigned 1619-37).

Aegidius Sadeler was one of the virtuoso technicians of engraving. However, because like the other artisans covered by this exhibition, he did not originate the designs of his prints, Aegidius remains virtually unknown today (Goltzius is an exception because of the degree to which he dominated the design of both his own prints and those of his followers; see below). What particularly emerges from the roster of Aegidius's engravings is the sheer variety of his themes and the range of his graphic adaptations for handling them.[171] At the same moment that Jan Wierix was completing his extraordinary replica of Dürer's master engraving, *Melencolia I*, in 1602, Sadeler was fully engaged in the fervent Germanic Dürer revival around the court of Prague.[172] A striking instance is his *Head of an Angel*, copied from a drawing on blue paper made by Dürer in 1506 for his painting in Venice, *Madonna of the Rosegar-*

Figure 7.
Jan Sadeler after
Dirck Barendsz.:
*Mankind Before the Last
Judgment*, about 1580,
engraving, 34.6 x 45.5 cm.
Museum Boymans-van
Beuningen, Rotterdam.

ITA ERIT ET ADVENTVS
FILII HOMINIS. Matt.24

lands; another example is his *Madonna with the Many Animals* after a 1503 pen and watercolor composition (cat. no. 81).[173] In both cases, Aegidius follows his designs as if they had been specifically intended for reproduction as engravings, in the manner of the Antwerp workshops. For Aegidius's *Way to Calvary*, inscribed "ex prototype Alberti Dureri," he made his own original composition in emulation of both the engraved version and the burin technique of Dürer from almost a century earlier.[174] What these distinctions reveal about Aegidius is his fastidious respect for his design models as well as his deep empathic response to both the style and technique appropriate for the replication—or even for original emulation—of his models.

When Aegidius Sadeler, like the Doetechums following Bruegel, turned his hand to replications of landscapes, his designer was a major figure of the Bruegel revival and a Netherlandish emigré at the Prague court: Roelandt Savery (1576-1639).[175] Savery produced both small paintings and drawings in the mountains of Central Europe, both Bohemia and the Tyrol, in the period 1606-07, adopting aspects of the pen technique as well as the dense forest motifs of Bruegel (see above); a large production of oil works on copper date from 1608. It was apparently (according to Sandrart, 1675) Rudolf II who sent Savery off to the Tyrol to record the unspoiled Alpine nature, possibly with a particular interest in natural cycles and processes. A few of the engravings bear an early date, 1609, and compositions that accord with the oils of 1608; most carry the imperial privilege accorded to Sadeler as the official court engraver to Rudolf II. Exact models in oil or in drawings are rare. Several of the engravings appeared in series. Aegidius's engravings are extraordinary evocations of the range of light and darks, particularly stressing Savery's fondness for silhouetted and picturesque dark, dead tree trunks, backlit by a bright middle ground and often punctuated by brilliant whites of glowing leaf clusters.

For the svelte and mannered mythological and allegorical figures of other Prague School artists,

Sadeler combined his talent for chiaroscuro with a dense, yet systematic network of parallel and cross-hatched burin work, closely tied to the virtuoso model of Goltzius in Haarlem (see below). The main artists who elicit such technical bravura from Sadeler are Bartholomeus Spranger and Hans von Aachen.[176] Spranger produced the design, noted above, for the portrait of Bruegel with its frame of classical gods and allegories (1606). An even more elaborate tour de force is the memorial double portrait designed by Spranger in memory of his deceased wife (1600; cat. no. 80).[177] Here areas with descriptive concerns, such as the two portraits or the material on the artist's sleeve, achieve a self-effacing naturalism, akin to the Savery landscapes; however, in the remainder of the image, given over to allegorical personifications, still rich in chiaroscuro, Sadeler provides his own assertive technique of dense linework with great sweeping curves.[178] Taken together, this print provides a tribute to the learning of Spranger as well as the timelessness of his fame amid the momentary outburst of his grief. Within the Latin inscription at the bottom of the image, Sadeler signals his own friendship and condolence with Spranger as artist and mourner.[179] Amid the crowded personifications the artist sits, facing the viewer with Death and Time on one side and the Pictorial Arts on the other, as Fame and her trumpets hover above, flickering against the dark background. On the other side of the print a memorial portrait of Christina Muller sits atop a bier between the figures of Faith and Wisdom (Minerva); at the feet of her tomb an hourglass lies amid the tools of painting and sculpture, and a glowing torch has toppled.

Bartholomeus Spranger (1546-1611) was another native of Antwerp who ventured far beyond his homeland to become a figure of European stature at the end of the sixteenth century.[180] He left Antwerp for Paris and then northern Italy in 1565, arriving in Rome in 1566. In Rome he served Cardinal Alessandro Farnese and Pope Pius V until the pontiff's death in 1572. In 1575 he went to Vienna to be court artist for Emperor Maximilian II, predecessor of Rudolf II. By 1580

he moved to Prague and the service of Rudolf II, where he would remain as a painter and designer, particularly of mythologies and allegories, for the rest of his life. Spranger was granted a title of nobility by the emperor in 1588, a coat of arms in 1595. Nonetheless, he maintained close contact with Karel van Mander and other artists in Haarlem, and his designs were engraved by Goltzius and others in Haarlem (see below). Those ties were confirmed by a visit to Antwerp, Haarlem, and Amsterdam in 1602.

To gauge the significance of the allegories in Spranger's double portrait as well as the contribution of both Spranger and Sadeler to the production of what we might call visual "models of knowledge" in the Rudolfine court, we can consult one of their most powerful print collaborations: *The Triumph of Wisdom* (cat. no. 79). Reproducing a Spranger painting (ca. 1591; now in Vienna), this print takes as its subject what Kaufmann calls the "intellectual nature of the visual arts, specifically the academic ideal."[181] The key figure is Minerva, goddess of Wisdom, triumphing over Ignorance. She is a surrogate for Rudolf II in both her martial and her learned aspects, and she is surrounded at her feet by representations of the liberal arts and letters. In 1595 the emperor issued a Letter of Majesty to the artists in Prague, decreeing that they were freed of any guild organization or designation as a craft. In the process he accorded to painting a higher status, symbolized by the ennobling of Spranger and other artists in his court, associating the visual arts with learning and the traditional educational role of the liberal arts.[182] An allegory of this relationship was produced by Sadeler after Hans von Aachen in *Minerva Leads Painting into the Circle of the Liberal Arts*.[183] Ultimately, for the Prague painters (and later for Rubens), as Kaufmann has pointed out, the academic ideal of the learned artist found personification in a fusion of Minerva and Mercury in the combined divinity of Hermathena (Hermes/ Athena).

That notion of the learned artist and pious artist is conveyed through the figure of Minerva into both of Sadeler's portrait image after

Spranger: Spranger himself (1600) and Pieter Bruegel (1606, where Mercury also appears along with Fame). And a similar allegorical cast of characters carries over into Sadeler's portrait of Rudolf II (1603), after a painting by Hans von Aachen.[184] Taken together this allegorical framework credits the emperor as a military victor, a patron of the arts, and both wise and fortunate.

As the creator of original engravings (including an architectural view of Vladislav Hall, 1607, inside Rudolf's palace),[185] as well as his wide-ranging reproductive prints of portraits, landscapes, religious subjects, allegories and mythologies, Aegidius Sadeler seems to encapsulate almost the entirety of projects published during his youth by Hieronymus Cock. Coming at the end of the century into a cosmopolitan court with close ties with both Italy and the Low Countries (particularly Haarlem), Sadeler's work in Rudolfine Prague also bestrides and even consolidates the confluence of styles that issued from Antwerp in the eras of Cock, Galle, and even his uncle, Jan Sadeler. As official court engraver, Aegidius Sadeler also shows increased prestige and responsibility, the expanded role of the printer-publisher as an indispensable purveyor of imperial pretensions and accomplishments. Sadeler was also the valued colleague of high status, ennobled artists, whose designs and compositions served to demonstrate their learning and eloquence. With his career, reproductive printmaking reaches its apogee, though at a remove from his Antwerp origins. Back in the Low Countries, in Haarlem, the only comparable success and variety of accomplishment was attained by the most influential—and independent— of all reproductive engravers: Hendrick Goltzius.

Notes

1

Anne H. van Buren and Sheila Edmunds, "Playing Cards and Manuscripts: Some Widely Disseminated Fifteenth-Century Model Sheets," *Art Bulletin* 56 (1974), 12-30. A similar thesis had already been advanced by Herbert Kessler in his review correcting an earlier study of this phenomenon: Hellmut Lehmann-Haupt, *Gutenberg and the Master of the Playing Cards* (New Haven, 1966); the review is in *Library Quarterly* 37 (1967), 399-400. On the Master of the Playing Cards in general and a special emphasis on this issue of his engraving as a medium of motif transmission, see Martha Wolff, The Master of the Playing Cards: An Early Engraver and His Relationship to Traditional Media, unpublished Ph.D. diss., Yale University, 1979; also Wolff, "Some Manuscript Sources for the Playing-Card Master's Number Cards," *Art Bulletin* 64 (1982), 587-600.

2

On the general tradition of medieval modelbooks, R. W. Scheller, *A Survey of Medieval Model Books* (Haarlem, 1963); Ulrike Jenni, "Vom mittelalterlichen Musterbuch zum Skizzenbuch der Neuzeit," in *Die Parler und der schöne Stil 1350-1400*, exh. cat. (Cologne, 1978), III, 139-50.

3

For Israhel van Meckenem, Max Geisberg, *Verzeichnia der Kupferstiche Israhels van Meckenem* (Strasbourg, 1905); Alan Shestack, *Fifteenth Century Engravings of Northern Europe from the National Gallery of Art* (Washington, 1967-68), nos. 154-249. The more than 200 exact copies of Master ES prints as well as the 41 reworked copper plates by ES issued by Meckenem suggest that the younger artist apprenticed with ES. On the general phenomenon of reproduction in early engraving, see Fritz Koreny, Über die Anfänge der Reproduktionsgraphik nördlich der Alpen, unpublished Ph. D. diss. (Vienna, 1968); idem, "Spielkarten und Musterbuch in der Spätgotik," *150 Jahre Piatnik* , exh. cat. (Vienna, 1974), 45-50. See also Jan Piet Filedt Kok, "The Development of Fifteenth-Century German Engraving and the Drypoint Prints of the Master of the Amsterdam Cabinet," in *Livelier than Life. The Master of the Amsterdam Cabinet or the Housebook Master ca. 1470-1500*, exh. cat. (Amsterdam/ Maarssen, 1985), 23-39, esp. 35f. on the use of Housebook Master drypoints as models.

4

Jay Levenson, Konrad Oberhuber, Jacquelyn Sheehan, *Early Italian Engravings from the National Gallery of Art*, exh. cat. (Washington, 1973).

5

Levenson, Oberhuber, and Sheehan, 165-233. Ronald Lightbown, *Mantegna* (Berkeley/Los Angeles, 1986), 234-41, 488-93. Botticelli also seems to have sold some of his drawings for use by engravers, such as Francesco Rosselli (Levenson, Oberhuber, and Sheehan, 47-62). Controversy surrounds the authorship of Mantegna engravings, specifically about whether the artist himself ever executed the engravings, but there is no doubt that his drawings served as the model of numerous engravings, and some of those surely were produced under his direct supervision (though others, often posthumous, were surely not supervised by Mantegna). Here a systematic study of watermarks and surviving drawings offers a pressing subject of study. See further David Landau, "Mantegna as an Engraver," *Prints by Mantegna and his School*, exh. cat. (Oxford, 1979); *Andrea Mantegna*, exh. cat. (New York and London, 1992), 44-66, essays by Landau and Suzanne Boorsch.

6

Catalogue by Francoise Gardey, Gisele Lambert, and Mariel Oberthür, "Marcantonio Raimondi: Illustrations du catalogue de son oeuvre grave par Henri Delaborde publié en 1888," *Gazette des Beaux-Arts*, 6th ser. 92 (1978), 1-52. Innis Shoemaker and Elizabeth Broun, *The Engravings of Marcantonio Raimondi*, exh. cat. (Lawrence, Kansas; 1981). A basic reference remains Bernice Davidson, Marcantonio Raimondi: The Engravings of his Roman Period, unpublished Ph.D. diss., Harvard University, 1954.

7

Shoemaker and Broun, 5, 62, no. 6. The lawsuit, recorded by Vasari, resulted in the Italian only having to omit his fraudulent use of Durer's famous monogram in his prints.

8

Shoemaker and Broun, 6f., 90-93, no. 19. The background landscape of this print was borrowed, in turn, from another recent engraving: Lucas van Leyden's 1508 *Mohammed and the Monk Sergius*.

9

Roger Jones and Nicholas Penny, *Raphael* (New Haven/ London, 1983), 72. The drawing records a compositional scheme prior to the addition of the figure of Sappho at the lower left and the new arrangement of tragic poets at the lower right, as well as numerous other alterations of details. On the *Massacre of the Innocents*, Shoemaker and Broun, 96-99, no. 21; Jones and Penny, 84f.; J.A. Gere and Nicholas Turner, *Drawings by Raphael*, exh. cat. (London, 1983), no. 123.

10

Albert Oberheide, *Der Einfluss Marcantonio Raimondis auf die nordische Kunst des 16. Jahrhunderts* (Hamburg, 1933).

11

On the history of this ideology in the Renaissance, see Erwin Panofsky, *Idea*, trans. Joseph Peake (New York, 1968).

12

Study of these neglected print publishers in Italy remains a major lacuna in both sixteenth-century graphic history and the more specialized realm of reproductive engravings. For the current state of research, see the bibliography by Caroline Karpinski, *Italian Printmaking Fifteenth and Sixteenth Centuries* (New York, 1987), 200-02, 242.

13

Sune Schéle, *Cornelis Bos, A Study of the Origins of the Netherlandish Grotesque* (Stockholm, 1965).

14

For the 1546 print, Schéle, 130-31, no. 51; the 1537 print is 141, no. 67. On the general association with Heemskerck, 21, 26-27, 36-37, nos. 24, 67, 90-91, 114a. Rainald Grosshans, *Maerten van Heemskerck. Die Gemälde* (Berlin, 1980), 119-24, no. 21, fig. 176. Ilja Veldman, *Maerten van Heemskerck and Dutch Humanism in the Sixteenth Century*, trans. Michael Hoyle (Maarsen, 1977), 21-42, discusses this image as part of the "Vulcan Triptych" and argues for a separation of the associated panels from a hypothetical original ensemble.

15

Veldman, Dutch Humanism, 28, fig. 9; Grosshans, 120, fig. 170; Beeldenstorm, 224, no. 105, fig. 105a. On Peruzzi, Christoph Frommel, *Baldassare Peruzzi als Maler und Zeichner* (Vienna/Munich, 1967-68), esp. 87 ff., no. 51. Veldman and Grosshans also cite analogous antique figures for Vulcan (Capitoline sarcophagus; Torso Belvedere) and Venus and Cupid (the Belvedere Venus felix) as well as Marcantonio's celebrated *Judgment of Paris* engraving. The cyclops at right clearly replicates the body and torsion of the *Laocoön*.

16

Ilja Veldman, *Leerrijke reeksen*, exh. cat. (Haarlem, 1986), itemizes many of the cycles after Heemskerck by these and other reproductive printmakers.

17

Grosshans, 125, no. 22, calls the engraving design a "Vorstufe" for the painting. Veldman, 34, opines that "Heemskerck could well have made the design expressly for a print—a foretaste of the prolific production to come." Analogous disparities exist between Raphael drawings, engraved by Marcantonio, and his later, painted ideas. The engraving credits "Martinus Heemskeric inventor."

18

Grosshans, 122, itemizes the changes between painting and print. He also plausibly attributes to Coornhert a 1549 engraving after Heemskerck of *Vulcan Forging the Wings for Cupid*.

19

Kunst voor de beeldenstorm, exh. cat. (Amsterdam, 1986), 224-25, no. 106. Schéle, 126-28., no. 49. Grosshans, 126-30, no. 24, fig. 185. The influence of this composition on later artists includes a painted copy by Otto van Veen, Rubens's teacher, at the end of the century, signalled by Van Mander; see Grosshans 129, notes 19-23. For the influence of a *Silenus Procession* engraving by Agostino Veneziano, see Beeldenstorm, 225, fig. 106b.

20

Konrad Renger, *Lockere Gesellschaft. Zur Ikonographie des verlorenen Sohnes und von Wirtshausszenen in der niederländischen Malerei* (Berlin, 1970). See the allegory of the Prodigal Son and the "Sorgheloos" woodcut cycle by Cornelis Anthonisz., Renger, 42-65; Beeldenstorm, 271-75, nos. 151-52; Christine Armstrong, *The Moralizing Prints of Cornelis Anthonisz* (Princeton, 1990), esp. 60-70.

21

Mantegna's own earlier *Bacchanal* engraving was copied by Durer in a drawing of 1494 (Vienna, Albertina; W. 59).

22

Levenson et al. 182-85, no. 73; Lightbown, 490, no. 209.

23

Schele, 24, 134-38, no. 59a. The engraving is inscribed "Michael/Angelus/Inventor" in a rectangle in the lower left corner. For a recent discussion of the Leda, Howard Hibbard, *Michelangelo* (New York, 1974), 223-26; also Johannes Wilde, "Notes on the Genesis of Michelangelo's Leda," *Fritz Saxl 1890-1948. A Volume of Essays*, ed. D. J. Gordon (London, 1957).

24

Leonard Barkan, *The Gods Made Flesh* (New Haven, 1986), 192, reads the Michelangelo image not as "beastly sexuality" but rather in the context of a mystical, perhaps Neoplatonic reading as "an atmosphere of dream and imagination." On the more chauvinist and politically charged associations of rape with political conquest, Margaret Carroll, "The Erotics of Absolutism: Rubens and the Mystification of Sexual Violence," *Representations* 25 (1989), 3-30.

25

For the ambivalence towards Italian forms as the bearer of sensuality, even sexuality, see Larry Silver and Susan Smith, "Carnal Knowledge: The Late Engravings of Lucas van Leyden," *Nederlands Kunsthistorisch Jaarboek* 29 (1978), 239-98; Silver, "*Figure nude, historie, e poesie.* Gossaert and the Renaissance Nude in the Netherlands," *Nederlands Kunsthistorisch Jaarboek* 37 (1986), 1-40. Veldman, "Vulcan Triptych," 37-42, makes the same argument for Heemskerck's use of mythology in the works used by Bos for his engravings. On the general phenomenon of reading the erotic elements of both mythology and the Bible critically, see Eric Jan Sluijter, *De 'Heydensche Fabulen' in de noordnederlandse schilderkunst circa 1590-1670*, Ph. D. diss., Leiden University, 1986, esp. 265ff. Sluijter cites Coornhert (*Zedekunst dat is wellevenkunst*, 1586, I, vi, 13) on p. 270 to the effect that viewing paintings of the nude Venus only leads to "fiery unchastity, burning desires, and hot love [*minne*]." He also cites (p. 271) the classicizing Dutch theorist de Lairesse, whose *Groot Schilderboek* (1712) still warns against "unsuitable" images, including Bos's very subject, Michelangelo's *Leda*, criticized by him (I, 106-07) as a "grievous error."

26

On the *Ovide moralisée* and euhemerism, Barkan, Gods Made Flesh, 103-17, esp. 105-07.

27

Schéle, 26, 120, no. 30. *Lambert Lombard et son temps*, exh. cat. (Liège, 1966), 74, no. 231. The drawing, from the Liège Cabinet des Estampes, is 63, no. 166, pl. 28. According to Schéle, the original drawing is at Warsaw University.

28

Lambert Lombard et son temps, nos. 159-215; *The Age of Bruegel*, exh. cat. (Washington, 1986), 206-09, nos. 76-77. The *Resurrection of Lazarus* drawing, now in Dusseldorf, was engraved by Hans Collaert for Hieronymus Cock. On Lombard and antiquity, Ellen and Wolfgang Kemp, "Lambert Lombards antiquarische Theorie und Praxis," *Zeitschrift für Kunstgeschichte* 36 (1973), 122-52. More generally, Wolfgang Krönig, "Lambert Lombard—Beiträge zu

seinem Werk und zu seiner Kunstauffassung," *Wallraf-Richartz Jahrbuch* 36 (1974), 105-58.

29

Inscribed on the plate "Josue 3." Schéle, 27, 115-16, no. 19. Beeldenstorm, 239-40, no. 119.

30

Schéle, 29-38, esp. 36-37 for Heemskerck.

31

Schéle, 27, no. 27; 37, no. 24. On the latter, Grosshans, 92; Ilja Veldman, "Lessons for Ladies: A Selection of Sixteenth and Seventeenth-Century Dutch Prints," *Simiolus* 16 (1986), 113-27.

32

Schéle, 14, 119, no. 27; Grosshans, 219, fig. 233 and 234-35. Heemskerck's continuing interest in this parable can be seen in his 1548 woodcut cycle and a 1562 engraved series by Philipp Galle. On the significance of this subject within the moralizing prints against drinking and other vices, see Renger, Lockere Gesellschaft, esp. 23-70.

33

Schéle, 25, no. 34. Veldman, Humanism, 85. The print has a German inscription, presumably tied to its principal market from Bos's Groningen printing house.

34

The second sheet of the series. Schéle, 37, no. 114a.

35

On Coornhert and Heemskerck, Veldman, Humanism, 55-93; Grosshans, 52-54. On Coornhert and Bos, Schéle, 27. The basic study of Coornhert is H. Bonger, *Leven en werk van Dirk Volkertsz Coornhert* (Amsterdam, 1978).

36

Schéle, 37, 114-15, 120-21, nos. 31-32, 15. Carl van de Velde, *Frans Floris* (Ghent, 1975), 395, 402-03, nos. P166, P35, P38.

37

On the origins and early applications of the grotesque ornament style in Italy, Nicole Dacos, *La Découverte de la Domus Aurea et la formation des grotesque à la Renaissance* (London/Leyden, 1969). The later Fontainebleau ornament of Rosso Fiorentino was disseminated through prints by Antonio Fantuzzi, active 1537-50. See Henri Zerner, *The School of Fontainebleau. Etchings and Engravings* (New York, 1969), 17-21.

38

Beeldenstorm, 241-42, no. 121. Schéle, 39-59, considers the claims of Bos to priority over Cornelis Floris as the local Antwerp inventor of scrollwork grotesque and decides firmly in favor of Floris. The distinct possibility remains that Bos was initially an engraver after designs by Floris. Schéle also discusses, 60-82, earlier Italianate ornament style in Flanders and points out the vital role of French printed books and their ornamental frames (citing especially Scève's *Delie*, printed in Lyon in 1544 by Sulpice Sabon) in diffusing the strapwork ornament of Fontainebleau to a wider audience.

39

Schéle, 35, nos. 115-16, 124-26; see p. 22 for the discussion of evidence for Bos's visit to Italy in 1548 in the form of draw-ings after Raphael's Vatican Loggie, but these images post-date the earlier, important grotesque prints, presumably derived form the inspiration of Cornelis Floris in Antwerp. In addition to Schéle's catalogue, now see *Ornamentprenten in het Rijksmuseum I* (The Hague, 1988), for Bos nos. 7-27, for Cornelis Floris, nos. 74-79.

40

Art Before the Iconoclasm (Amsterdam, 1986), 83-106; in general for the North Netherlands, Ric Vos and Fred Leeman, *Het nieuwe ornament* (The Hague, 1986), esp. 12-14. A major monument in the new style is the chimney mantel carved for the town hall of Kampen in 1543 by Colijn de Nole, originally from Cambrai but resettled in Utrecht after around 1530; see Art before the Iconoclasm, 93; Beeldenstorm, 300-01.

41

His 1539 *Judith* (Schéle, no. 22) depends on Marcantonio's *Two Sibyls* and Agostino Veneziano's 1518 engraving. Another cycle of caryatids (nos. 72-77) follows Penni's prints after Raphael, and in 1546 Bos issued copies of Italian prints: *River Nile* (no. 50), *Venus in a Car* (no. 52), *Juno in a Car* (no. 53).

42

Coornhert himself served a period of religious exile in Xanten and Cleves in 1567, and the Calvinist community as well as the Family of Love maintained a large enclave at Emden in Friesland. See Phyllis Mack Crew, *Calvinist Preaching and Iconoclasm in the Netherlands 1544-1569* (Cambridge, 1978); for the Family of Love, Alistair Hamilton, *The Family of Love* (London, 1981); H. de la Fontaine Verwey, *Uit de wereld van het boek I. Humanisten, dwepers en rebellen in de zestiende eeuw* (Amsterdam, 1976), 91-92.

43

On Lombard and prints, around seventy in number, beginning in 1544 with a *Resurrection of Lazarus* (no. 230), published by Cock. Lombard et son temps, xxiv-vi, 73-98, nos. 226-411. On Floris, van de Velde, 93-96, 389-434.

44

Lydia De Pauw-De Veen, *Jerôme Cock*, exh. cat. (Brussels, 1970); Timothy Riggs, *Hieronymus Cock* (New York, 1977); *In de Vier Winden*, exh. cat. (Rotterdam, 1988).

45

The catalogue of Cock prints after Floris totals 34 (Riggs, 327-35, nos. 67-100); after Heemskerck 42 in all (Riggs 337-46, nos. 107-48). The basic monograph on Frans Floris is Carl van de Velde, *Frans Floris (1519-20-1570)* (Ghent, 1975), with catalogue of prints 389-434, nos. P1-P145. On Heemskerck, see also Veldman, Leerrijke reeksen. As yet, no systematic study of Heemskerck prints has been produced.

46

Van de Velde, 30, 416-17. Riggs, 134-35. Inscribed: "frac floris fecit Cock exudebat 1552." Also accompanied with a Latin tribute to Philip as conqueror of the Turks. See also Konrad Oberhuber, *Zwischen Renaissance und Barock*, exh. cat. (Vienna, Albertina, 1967), 90, no. 102. A. Corbet, "L'éntrée du Prince Philippe à Anvers en 1549," in Jean Jacquot, *Les Fêtes de la Renaissance II. Fêtes et cérémonies au temps du Charles Quint* (Paris, 1960), 297-310, 460-61; E. J.

Roobaert, "De Seer Wonderlijcke Schoone Triumphelijcke Incompst van den Hooghmogenden Prince Philips...in de Stadt van Antwerpen...Anno 1549," *Bulletin Musées Royaux des Beaux-Arts de Belgique* 9 (1960), 56.

47
Riggs, 134, n.15. On Parmigianino as an etcher, Sue Welsh Reed and Richard Wallace, *Italian Etchers of the Renaissance and Baroque*, exh. cat. (Boston, 1989), 3-17.

48
Van de Velde, 4-5, 102-03; on the atelier in general 99 ff.

49
On Cort, Riggs, 90-94, emphasizing his stylistic derivation from the engraving techniques of Cock's Italian graver, Giorgio Ghisi. More generally, J. C. J. Bierens de Haan, *L'oeuvre gravé de Cornelis Cort* (The Hague, 1948). For Cort after Barocci easel paintings, Edmund Pillsbury and Louise Richards, *The Graphic Art of Federico Barocci*, exh. cat. (New Haven, 1978), 106-07, nos. 76-78.

50
The drawings for the latter two series survive in Copenhagen, Statens Museum for Kunst, and their dates provide the terminus post quem for the print series. See Jan Garff, *Tegninger af Maerten van Heemskerck*, exh. cat.(Copenhagen, 1971), nos. 34-43 (Tobit, 1554-55); 50-55 (Noah, 1558-59).

51
Van de Velde, 86-87, 94-95. Riggs, 330-31. The Berlin drawing is fig. 342. Other surviving drawings are in Braunschweig (*Memory, Intelligence*). Citing a document of 1659, the inventory of Archduke Leopold Wilhelm (doc. 145), van de Velde deduces that a missing *Perseverance* drawing for this cycle (equivalent to Cort's P85) was originally executed in ink on blue tinted paper with white highlights (akin to the Budapest drawing, T46, of *Feeling*, for the Cort series of the *Senses* of the following year, 1561, P137). From that drawing a more linear design, such as the Berlin drawing of *Sobriety*, was produced. The Berlin drawing retains signs of having been traced in order to align the composition on the plate to print in the original sense of the drawing.

52
Carl Nordenfalk, "The Five Senses in Flemish Art before 1600," in Görel Cavalli-Björkman ed., *Netherlandish Mannerism* (Stockholm, 1985), 135-54, emphasizes the importance of the Floris-Cort series for later allegories of the Five Senses.

53
Van de Velde, 58-59, 218-27, 407. See also Carl van de Velde, "The Labours of Hercules, a Lost Series of Paintings by Frans Floris," *Burlington Magazine* 107 (1965), 114-23; idem, "Hercules en Antaeus, een teruggevonden schilderij van Frans Floris," *Album Amicorum J. G. van Gelder* (The Hague, 1973), 333-36.

54
The Van Mander citation is fo. 298. On Menton, van de Velde, 93, 111-12. The drawings after the two cycles owned by Jongelinck are ascribed to Simon Kies of Amsterdam, a former pupil of Heemskerck, by Van Mander (on whom see van de Velde, 110). Menton's print cycles include the 1568 *Elements* (P103-P106) and a 1575 edition of the *Seven Deadly Sins*, published by Adriaan Huybrechts (P88-P94).

55
Quoted in full by van de Velde 219-20, n.2. On Lampsonius, Jochen Becker, "Zur niederländischen Kunstliteratur des 16. Jahr-hunderts: Domenicus Lampsonius," *Nederlands Kunsthistorisch Jaarboek* 24 (1973), 45-61.

56
Van de Velde, 58-59, 239-44 (S93-S99), 426-28 (P117-23).
57 On the significance of the subject itself, derived from the curriculum of study in medieval schools, see Ernst Curtius, *European Literature and the Latin Middle Ages*, transl. Willard Trask (New York, 1953), 36ff.; Emile Mâle, *The Gothic Image*, transl. Dora Nussey (New York, 1958), 75-90.

58
The painting, ca. 1560, is in Ponce, Puerto Rico, Museo de Arte (S120); the drawing is in Stockholm, Nationalmuseum (T44). Van de Velde, 262-65, 377-78, drawing the plausible hypothesis that a political message is being conveyed, endorsing the official peace treaty between Spanish Flanders and France, the Treaty of Cateau-Cambresis in 1559. The subject of Apollo and the Muses has been related to Floris's decorations on the Genoese triumphal arch in the 1549 Triumphal Entry of Philip II. On the muses, Curtius, 228-46.

59
Van de Velde, 307-13 (S168-S175), 421-22, fig. 328; idem, "The Painted Decorations of Floris's House," in Görel Cavalli-Björkman ed., *Netherlandish Mannerism* (Stockholm, 1985), 127-34.

60
Van de Velde, 428-31; idem, "Floris's House," 132..

61
A letter from Seneca (Epistle 88) serves as a *locus classicus* for the manual arts as distinct from the liberal arts. Curtius, 37. A Hans Burgkmair print, combining the seven mechanical arts with Apollo and the nine muses, has a similar but divergent list: Weaving, agriculture, architecture, hunting, navigation, cooking, and metallurgy. See *Hans Burgkmair. Das graphische Werk*, exh. cat. (Stuttgart, 1973), no. 17. One can also compare the mechanical arts allegorized by Andrea Pisano on the Campanile relief decorations of the Duomo in Florence: architecture, medicine, hunting, weaving, navigation, agriculture, lawmaking. See John Pope-Hennessy, *Italian Gothic Sculpture* (London, 1972), 192-93.

62
For the ongoing claims of painting to equal status with poetry, see Rensselaer Lee, *Ut Pictura Poesis* (New York, 1967); Jean Hagstrum, *The Sister Arts* (Chicago, 1958); Paul Kristeller, "The Modern System of the Arts," *Renaissance Thought II* (New York, 1965), 113-227.

63
On Bruegel's series, Walter Gibson, *"Mirror of the Earth." The World Landscape in Sixteenth-Century Flemish Painting* (Princeton, 1989), 69-74; Fritz Novotny, *Die Monatsbilder Pieter Bruegels des Älteren* (Vienna, 1948); *Flämische Malerei von Jan van Eyck bis Pieter Bruegel d. Ä.* (Vienna, 1981), 86-104.

64

Included in this series is the unusual subject of the nymph Cyane, companion of Proserpina metamorphosed into a fountain, as recounted by Ovid, vi, 409ff.

65

On Galle, Riggs, 100-13, esp. 100-04, nos. 86-92. The two Coornhert Floris prints are the *Judgment of Solomon* (1556; Riggs 70, van de Velde P17) and *Solomon and the Queen of Sheba* (1557; Riggs 71, van de Velde P19). The subjects by Galle include: *Lot and His Daughters* (1558, Riggs 86, vdV P8), *Sacrifice of Abraham* (Riggs 87, vdV P5), *Solomon Anointed King* (Riggs 88, vdV P16), *Solomon Building the Temple* (1558; Riggs 89, vdV P18), *Adoration of the Shepherds* (1564; vdV P21), *Massacre of the Innocents* (Riggs 90, vdV P26), the allegorical *Rewards of Virtue* (for Maarten Peeters, vdV P79), *Tabula Cebetis* (1561; vdV P134) and the ancient history *Mucius Scaevola* (1563; Riggs 91, vdV P141).

66

Publication and discussion of this passage by van de Velde, 1-2, with an additional praise of Floris by de Heere on p. 3 and discussion of de Heere within the Floris atelier, 109-10. Further discussion of the de Heere passage by David Freedberg, "Allusion and Topicality in the Work of Pieter Bruegel: the Implications of a Forgotten Polemic," *The Prints of Pieter Bruegel the Elder*, exh. cat. (Tokyo, 1989), 62-65, identifying "a certain painter" being attacked in the verses as Bruegel himself. On de Heere in general, Jochen Becker, "Zur niederländischen Kunstliteratur des 16. Jahrhunderts: Lucas de Heere," *Simiolus* 6 (1972-73), 113-27, esp. 124-25.

67

Lee and Hagstrum (as cited, n. 62). Thomas Kaufmann, *The School of Prague* (Chicago, 1988), 61-2, 91-99; idem, "The Eloquent Artist: Towards and Understanding of the Stylistics of Painting at the Court of Rudolf II," *Leids Kunsthistorisch Jaarboek* 1 (1982), 119-48. The literary theory background of such concepts is given by Bernard Weinberg, *A History of Literary Criticism in the Italian Renaissance* (Chicago, 1961).

68

See the edition with commentary by Hessel Miedema (Utrecht, 1973), regarding Chapter 2: II, 423ff. On allegory as the expression of rhetorical invention, Chapter 5, 65-68: II, 486. The Italian background to this theory is outlined by Erwin Panofsky, *Idea*, transl. Joseph Peake (New York, 1968).

69

Nikolaus Pevsner, *Academies of Art Past and Present* (Cambridge, 1940); Charles Dempsey, "Some Observations on the Education of Artists in Florence and Bologna during the Later Sixteenth Century," *Art Bulletin* 62 (1980), 552-69; *Children of Mercury. The Education of Artists in the Sixteenth and Seventeenth Century*, exh. cat. (Providence, 1984), esp. 20ff., 81ff..

70

The Vives source was discovered by Hans Kauffmann, "Die Fünfsinne in der niederländischen Malerei," *Festschrift für Dagobert Frey*, ed. J. Tintelnot (Breslau, 1943), 133-57, esp. 137. See also Nordenfalk, "Five Senses," 135-39; also Jan Briels, *Vlaamse Schilders in de noordelijke Nederlanden in het begin van de Gouden Eeuw* (Antwerp, 1987), 22-24.

71

Veldman, Humanism, 55, 106, is the source for this entire narrative of the Haarlem lottery and its Antwerp connections.

72

For Coornhert after Heemskerck as published by Cock, Riggs, 337-39, nos. 108-116: 1554 *Balaam and the Angel* (2 facing plates), 1554 *Parable of the Unmerciful Servant* (4 plates), 1559 *Parable of the King who Made a Banquet* (6 plates), *Calvary* (2 facing plates), 1553 *Saint Paul Baptising in Ephesus*, 1557 *Democritus and Heraclitus in a Landscape*, *Triumph of Patience* (8 plates), and the 1556 *Victories of Charles V* (Title page and 12 plates; one of the plates engraved by Bos, as mentioned above). Added by Veldman, Humanism, 74-76, n. 78, is the *Allegory of Good and Bad Music* (1554), cited by Riggs, 368, no. 258, as "Allegorical Procession," by Cort after an unidentified artist. Riggs, however, now accepts Veldman's identification of the work as Coornhert after Heemskerck.

73

On this later cycle, Veldman, Humanism, 133-41; Veldman, Leerrijke reeksen, 47-57, no. 6. Two further unsigned Cort prints after Heemskerck include the cycle of *Bel and Daniel* (1565) and the *Parable of the Unmerciful Servant* (Bierens de Haan, 42-44, 84).

74

On Bos as the trainer of Coornhert, besides stylistic affinities, there are the later, attributed shared projects of 1554-55 (*Victories of Charles V*; *Virtuous Wife*) as evidence of their overlap. Moreover, the sensitive vision of Mariette in the late 18th century credits Bos with the training of Coornhert. Schéle, 27, who also argues that the 1548 association of Coornhert with Heemskerck was probably prompted by Bos's visit to Rome in that year.

75

Veldman, Humanism, 44-93; idem, Leerrijke reeksen. See also Grosshans 52-55. For Coornhert's religious philosophy, H. Bonger, *Leven en werk van Dirk Volkertsz Coornhert* (Amsterdam, 1978).

76

Veldman 90-91. The non-Cock series with Coornhert inscriptions on Heemskerck prints include: *Allegory of the Road to Eternal Bliss* (1550; 14 etchings), *Allegory of the Unbridled World* (1550, 4 etchings), *Allegory of Hope for Gain* (1550, 4 plates), *Adoration of an Idol of Isis* (1549), *Fortune and the Sleeper*, *Allegory of Human Ambition* (1549), *Allegory on the Use of Wine* (1551), *Dives and Lazarus* (1551, 4 plates); plus *Apollo and the Muses* (1549) and *Venus and Cupid in Vulcan's Forge* (1549), and *Youths from the Sistine Chapel* (1551, 20 plates), works that more closely resemble the subjects previously realized by Cornelis Bos. For the *Allegory of Human Ambition*, see also Veldman, 81; Beeldenstorm, 261-2, no. 143.

77

On Galle and Heemskerck, Veldman, Humanism, 104-05, n.41-42. See also the volume on Galle in the *Illustrated Bartsch*.

78

Veldman, Humanism, 85-90; Veldman, Leerrijke reeksen, 26-35, no. 4.

79

Veldman, Humanism, 55-56, n.8, 99, 106. The first publication of that house appeared in 1561, the year in which Coornhert also became a notary.

80

Veldman, Humanism, 97-112, esp. 104, n. 40-41 for a chronological list of the prints and print series. On Galle as a printmaker, ibid., 106-07.

81

Other, earlier Bruegel prints, published by Cock, are attributed to Galle as engraver: *Alchemist* (drawing 1550), *Seven Virtues* (drawings 1559-60), *Parable of the Wise and Foolish Virgins, Resurrection of Christ.* See Louis Lebeer, *Catalogue raisonné des estampes de Pierre Bruegel l'ancien* (Brussels, 1969), nos. 27, 31-37, 39, 84. The engravings with Galle monograms or inscriptions, including the works after 1571, based on grisaille paintings as well as drawing designs are nos. 59, 85-87: *Christ and the Apostles on the Road to Emmaus* (1571), *Death of the Virgin* (1574), and *Triumph of Time (Saturn)* (1574). Galle also produced a *Last Supper* (1570) after the Antwerp painter Anthonie van Blocklandt.

82

Biblical cycles or single prints by Galle after Heemskerck include: *Job* (8 plates, 1563), *Washing of the Feet* (1564), *Judith* (8 plates, 1564), *Esther* (8 plates, 1564), *John the Baptist* (6 plates, 1564), *Christ the Light of the World* (1564), *Isaiah* (1564), *Fiery Furnace* (4 plates, 1565), *Jonah* (4 plates, 1566), *Ahab and Elijah* (4 plates, 1567), *Fall of Babylon* (1569), *Landscape with Elisha* (1571). Mythological cycles include: *Landscape with Hero and Leander* (1562), *Landscape with Cephalus and Procris* (undated), *Landscape with Pyramus and Thisbe* (undated). See Veldman, Leerijke reeksen, nos. 7 (Petrarch), 8 (Seasons), 12 (Wonders of the World). Galle biblical cycles after Heemskerck for Cock in Antwerp include: *Samson* (6 plates, undated), *Amnon and Tamar* (6 plates, 1559), *Ahab and Naboth* (6 plates, 1561-62), *Jonah before the Wall of Nineveh* (1562), *Adoration of the Magi* (undated), *Prodigal Son* (6 plates, 1562), *Four Evangelists* (4 plates, 1562), *Saints Peter and John* (=Acts 3-4, 6 plates, 1558). See Riggs, 341-42, nos. 121-28.

83

Veldman, Humanism, 133-41; idem, Leerrijke reeeksen, no. 6. See above, notes 50, 73. Also Sheila Williams and Jean Jacquot, "Ommegangs anversois du temps de Bruegel et de van Heemskerck," in Jacquot, ed., *Les fêtes de la Renaissance II,* 359-88. The biblical themes by Cort after Heemskerck include: *Noah* (6 plates, drawings dated 1558-59), *David and Abigail* (6 plates, 1555), *Tobit* (10 plates, 1556); see Riggs, 339-40, nos. 117-19.

84

Riggs, 342-43, nos. 130-32; Veldman, Humanism, 104, n. 40; idem, Leerrijke reeksen, 73-81, no. 9 (Planets); 82-87, no. 10 (Temperaments), 89-94, no. 11 (Nine Worthies). See also Veldman, "Seasons, Planets and Temperaments in the work of Maarten van Heemskerck: Cosmo-astrological Allegory

in Sixteenth-Century Netherlandish Prints," *Simiolus* 11 (1980), 149-76.

85

Veldman, Humanism, 141, n. 44; idem, Leerrijke reeksen, 56-57.

86

The program for that occasion, the *Ordinancie,* still survives in the Brussels Royal Library; see Veldman, Humanism, 134-35, notes 36-38. Heemskerck's drawing designs date from 1562, the following year.

87

The inscription reads: "Time, the charioteer of the World, tirelessly whips on the winged horses of Night and Day in a cycle. With him he carries the sisters Fire, Air, Earth, and Water and the brothers South, North, East, and West Winds, equal in number. How swiftly do immutable laws on earth engender rotary motion which reveals everything in its turn." Quoted by Veldman, Humanism, 136-37, n. 40. See also Veldman, "Seasons, Planets, and Temperaments."

88

For the microcosm/macrocosm idea and its manifestations in medieval and Renaissance thought, Leonard Barkan, *Nature's Work of Art* (New Haven, 1975). For the broader system of which this specific idea is a major part, see the handbook by C. S. Lewis, *The Discarded Image* (Cambridge, 1967).

89

Elizabeth Hajós, "The Concept of an Engraving Collection in the Year 1565: Quicchelberg, *Inscriptiones vel tituli theatri amplissimi,*" *Art Bulletin* 40 (1958), 151-56. Se also *Sets and Series,* exh. cat. (New Haven, 1984); William W. Robinson, "'This Passion for Prints,' Collecting and Connoisseurship in Northern Europe during the Seventeenth Century," *Printmaking in the Age of Rembrandt,* exh. cat. (Boston, 1981), xxvii-xxviii.

90

Frances Yates, *The Art of Memory* (London, 1966). See also Richard Bernheimer, "Theatrum Mundi," *Art Bulletin* 38 (1956), 225-47. On the principle of organization, Joseph Mazzeo, "Universal Analogy and the Culture of the Renaissance," *Journal of the History of Ideas* 15 (1954).

91

On the *Kunstkammer* of Rudolf II, Thomas Kaufmann, *The School of Prague* (Chicago, 1988), esp. 16-17; idem, "Remarks on the Collections of Rudolf II: The *Kunstkammer* as a Form of *Representatio,*" *Art Journal* 38 (1978), 22-28; Eliska Fučíková, "The Collections of Rudolf II at Prague: Cabinet of Curiosities or Scientific Museum," in Oliver Impey and Arthur MacGregor, eds., *The Origins of Museums* (Oxford, 1985), 47-53. The classic study remains Julius von Schlosser, *Die Kunst- und Wunderkammer der Spätrenaissance* (Leipzig, 1908). That the bourgeoisie could also ape the collections of princes is clear from the case of Rembrandt, discussed insightfully by R. W. Scheller, "Rembrandt en de encyclopedische kunstkamer," *Oud Holland* 84 (1969), 81-147.

92

Hajós, 153: First shelf (Bible; New Testament; Apostles and Evangelists; Saints; Studies in Theology; History of Christianity; Miracles; Warfare; Portraits; Genealogy), Second shelf (Naturalia; Philosophy; Charts and Tables; Music; Ancient History; Poetry; Loves of the Gods; Sports and Pastimes; Spectacles and Processions of Antiquity; Modern Customs and Ceremonies, such as Hunting; Festivals; Costume; Heraldry), and Third Shelf (Geography; Topography; Architecture; Ancient Monuments; Numismatics; Machinery and Ships; Tools; Furnishings; Pottery; Ornament designs). The sheer range of these subjects suggests the explosion of topics taken up by engravings during the sixteenth century. Of course, the division of the theater into four parts plus the arts is at odds with the tripartite scheme for the prints collection proper under the rubric of the arts.

93

Preserved in the Kunsthistorisches Museum, Vienna, Sammlung für Plastik und Kunstgewerbe. Approximately one quarter of the original prints collection is estimated to have been lost. Peter Parshall, "The Print Collection of Ferdinand, Archduke of Tyrol," *Jahrbuch der Kunsthistorischen Sammlungen in Wien* 78, n.s. 42 (1982), 139-84. See also Stephen Goddard, "The Origin, Use, and Heritage of the Small Engraving in Renaissance Germany," in Goddard, ed., *The World in Miniature. Engravings by the German Little Masters 1500-1550*, exh. cat. (Lawrence, Kan., 1988), 13-29, esp. 18-23. The prints from Ferdinand were a complement to his own massive *Kunstkammer* at Ambras in Tyrol, discussed by Alphons Lhotsky, *Die Geschichte der Sammlungen von den Anfängen bis zum Tode Kaiser Karls VI. Festschrift des Kunsthistorischen Museums* (Vienna, 1941-45), 179-202; see also *Die Kunstkammer*, exh. cat. (Innsbruck, 1977). One other large sixteenth-century print collection survives: a roster of some 7000 prints in El Escorial, Spain. J. A. Lasarte and A. Casanovas, "Catalogo de la collecion de grabados de la Biblioteca de El Escorial," *Anales y boletin de los Museos de Arte de Barcelona* 16 (1963-64), 1-397; 17 (1965-66), 1-103.

94

Riggs, 77-79. See also *The Engravings of Giorgio Ghisi*, exh. cat. (New York, 1985), nos. 11, 13. In between these two Raphael reproductions, Ghisi reproduced a Lambert Lombard *Last Supper* for Cock in 1551, no. 12. This technique can be readily compared to Coornhert's one engraving after Lombard: the 1556 *Deposition* (Riggs no. 161). For the influence of Ghisi on Coornhert while the latter worked for Cock, Riggs, 81-82: "Coornhert...went through a notable stylistic transformation during the years he worked for Cock, which was undoubtedly influenced, at least in part, by Ghisi's prints."

95

For the evolution of Heemskerck's drawing style, the best cross section is the vast collection of Heemskerck drawings in Copenhagen, arranged chronologically and catalogued by Garff. For the evolution in Coornhert's technique/style, Riggs, 77, 81-85. See also *The Age of Bruegel*, exh. cat. (Washington, 1986), 188-97, nos. 69-72.

96

For the styles of Cort and Galle, emphasizing their common attention to sculptural qualities as well as their relationship to the precedent in the Cock atelier of the engravings by Ghisi, see Riggs 90-94, 100-08, who describes Galle's 1558 series, *Sts. Peter and John*, as "intermediate in style between those of Cort and Coornhert" with fine hatchings like the later, Cock-inspired Coornhert combined with plainer, more sculptural surfaces like Cort. Riggs also notes that "Galle's style approached Cort's more closely during the years he worked for Cock, although his larger prints remain clearly distinguishable from Cort's....Galle's closest approach to Cort's style comes in his prints after Heemskerck." (p. 103)

97

The indispensible source work on Cock is Timothy Riggs, *Hieronymus Cock. Printmaker and Publisher* (New York, 1977), referred to throughout this text as Riggs. In addition, a valuable overview, esp. of the range of Cock's products can be seen in two exhibition catalogues: Lydia De Pauw-De Veen, *Jerôme Cock. Éditeur d'estampes et graveur 1507?-1570* (Brussels, 1970); *Bilder nach Bilder* (Münster, 1976), 1-96.

98

For the larger picture, see A. J. J. Delen, *Histoire de la gravure dans les anciens Pays-Bas et dans les provinces belges* (Paris, 1935), esp. II, part 2; Riggs, 20-21. De Jode is the first member to be listed in the artists' guild as a "printseller" (*printvercooper*); see the guild records P. Rombouts and T. van Lerius, *De Liggeren en andere historische archieven der antwerpsche Sint Lukasgilde* (Antwerp, 1864-76), I, 159.

99

The definitive study of Plantin is Leon Voet, *The Golden Compasses* (Amsterdam, 1969); see also Colin Clair, *Christopher Plantin* (London, [1960]).

100

Riggs, 43-44, 327, no. 63; engraved by Balthasar Bos.

101

Riggs, 29-30, 256-66, nos. 1-25.

102

Riggs, 33-35, 273-79, nos. 38-50.

103

Riggs, 33-34, 267-69, nos. 26-35.

104

Riggs, 46-7, 356, no. 79; on Ghisi in general, Riggs, 77-79, and *The Engravings of Giorgio Ghisi*, exh. cat. (New York, 1985), with the *School of Athens* as 61-3, no. 11.

105

Ghisi, 53-57, no. 9.

106

On Cock as purveyor of "Italian and Antique Art," Riggs, 156 ff. He points out, however, "that the sixteenth-century engraver, reproducing a print or drawing, did not regard it as an immutable entity to be copied in its entirety as exactly as possible." (p. 162) Besides Raphael and Bronzino, Andrea del Sarto and Giulio Romano are especially well repre-

sented in Cock's output. The full roster of Italian designers for Cock prints is given by Riggs, 163-64, who also notes that the "Romanist" artists who emulated Lombard and Floris become increasingly close to Italian models. Hence "it is not always possible to determine whether an unidentified composition was created by an Italian or by a Flemish Romanist. Cock probably would have considered such a distinction immaterial." (p. 163)

107

Riggs, 166, 296-99, nos. 98-109. The major study of Heemskerck's Roman vistas is Christian Hülsen and Hermann Egger, *Die römischen Skizzenbücher von Marten van Heemskerck im Königlichen Kupferstichkabinett zu Berlin* (Berlin, 1913-16; reprint 1975); see the review by Ilja Veldman, *Simiolus* 9 (1977), 106-13. Riggs characterizes Cock's interest in antique ruins as more "picturesque" than archaeological, featuring anonymous and fragmentary ruins and landscape settings rather than isolated famous monuments, such as the Pantheon or Arch of Constantine (except for the Colosseum, Palatine Hill, or baths; p. 167). See also Jerôme Cock, 69-77, nos. 162-82, where the author observes that these ruin views are etched, which conveys a suggestion of spontaneity and atmosphere.

108

Riggs, 180-81, nos. 64-66 (C. Floris), 209-17 (Vredeman); Jerome Cock, 78-83, nos. 183-98. Vredeman designs were first published by Gerard de Jode in 1555 but thereafter by Cock until 1565. See Hans Mielke, *Hans Vredeman de Vries*, Ph. D. diss. (Berlin, 1967).

109

Riggs 63-64, fig. 95, with analysis of the degree of reality of the lower zone of the print in relation to the appearance of Cock's original shop in Antwerp.

110

Kunst in kaart, exh. cat. (Amsterdam, 1989), 22-29.

111

See Thomas Da Costa Kaufmann, *The School of Prague* (Chicago, 1988), 287-91, esp. no. 25.9, an *Annunciation* (Vienna), with figures painted by the court painter of Emperor Rudolf II, Hans von Aachen.

112

Quoted from citation in Riggs, 173, no. 38-50: "VARIAE VARIARUM REGIONUM TYPOGRAPHICAE ADUMBRATIONES / IN PUBLICUM PICTORUM USUS A / HIERONIMO COCK DELINEATAE...Veelderleye ordinantien van lantschappen, met fyne historien / daer in gheordineert, wt den ouden ende niewen testamente, / ende sommighe lustighe Poeterereyen, seer bequaem voer Schil- / ders, ende andere liefhebbers der consten. . ."

113

Riggs, 275-76, no. 45, figs. 51-52.

114

The drawing is in Prague, Národní Galerie, inv. no. K4493; as noted by several authors, it has been traced over with a stylus for reproduction. Riggs, 131-32, 270-71, no. 36, figs. 31-32. On the drawing, Karl Arndt, "Unbekannte Zeichnungen von Pieter Bruegel d. Ae.," *Pantheon* 24 (1966), 207-16; see also Arndt, "Pieter Bruegel d. Ä. und die Geschichte der 'Waldlandschaft,'" *Jahrbuch der Berliner Museen* 14 (1972), no. 3; also *Bruegel. Une dynastie de peintres*, exh. cat. (Brussels, 1980), no. 11 (hereafter cited as Bruegel, Brussels).

115

Riggs, 50-51, 318-19, nos. 28-29. Louis Lebeer, *Catalogue raisonné des estampes de Pierre Bruegel l'ancien* (Brussels, 1969), 29-52, nos. 1-13 (hereafter cited as Lebeer). The prints are undated, although a preparatory drawing in the Louvre (no. 20720) for Lebeer no. 4 bears the date [15]55; see Ludwig Münz, *The Drawings of Peter Bruegel* (London, 1961), 209, no. 13 (hereafter cited as Münz). Hence most current scholars agree on a date for the prints of ca. 1555-56. Biblical staffage was added by an artist other than Bruegel, possibly Cock himself, to produce the Flight into Egypt figures of Lebeer no. 10 or the wiry figures of *Rustic Market* (Nundinae Rusticorum; Lebeer no. 8).

116

For the Antwerp drawing, Bruegel, Brussels 76, no. 12 . First published by Karl Arndt, "Frühe Landschaftszeichnungen von Pieter Bruegel d. Ae.," *Pantheon* 25 (1967), 100; also Arndt, 1972, 90; *Pieter Bruegel d. Ä. als Zeichner*, exh. cat. (Berlin, 1975), no. 37 (hereafter cited as Bruegel, Berlin).

117

For this Netherlandish tradition, see most recently Walter Gibson, *Mirror of the Earth* (Princeton, 1989), as well as the survey by H. G. Franz, *Niederländische Landschaftmalerei im Zeitalter des Manierismus* (Graz, 1969). On the religious content of Patinir's landscapes, Reindert Falkenburg, *Joachim Patinir: The Landscape as an Image of the Pilgrimage of Life* (Amsterdam, 1988).

118

Riggs, 185-86, 370, nos. 231-32; on the landscapes in general, see also Jerôme Cock, 59-66, nos. 142-158. The surviving drawings for the *Small Landscapes* are discussed by Riggs, 252-54, no. R-16. An identification of the anonymous artist as Joos van Liere was advanced by Egbert Haverkamp-Begemann, "Joos van Liere," in *Pieter Bruegel und seine Welt*, ed. by Otto von Simson and Matthias Winner (Berlin, 1979), 17-28; see also *The Age of Bruegel: Netherlandish Drawings in the Sixteenth Century*, exh. cat. (Washington, 1986), 228-30, no. 87.

119

The development of the forest landscape, already implied in Bruegel's Prague drawing of a forest with bears, used as the setting for Cock's *Temptation of Saint Anthony* (see above), would have along afterlife in the second half of the sixteenth century, for which see: H. G. Franz, "Das niederländische Waldbild und seine Entstehung im 16. Jahrhundert," *Bulletin des Musées Royaux des Beaux-Arts de Belgique* 17 (1968), 15-35; K. Arndt, "Pieter Bruegel d. Ä. und die Geschichte der Waldlandschaft," *Jahrbuch der Berliner Museen* 14 (1972), 69-121; Johannes Briels, *De Zuid-nederlandse bijdrage tot het onstaan van de Hollandse landschapschilderkunst circa 1600-1630*, Ph.D. diss. (Louvain, 1967), and Briels, *Vlaamse Schilders in de Noordelijke Nederlanden in het begin van de Gouden Eeuw* (Antwerp, 1987); Ulrike Hanschke, *Die flämische Waldlandschaft* (Worms, 1988).

120

The significance of the *Small Landscapes* for later Dutch landscape painting is assessed by Christopher Brown, *Dutch Landscape. The Early Years*, exh. cat. (London, 1986), esp. 18-19. The republication of Cock's series in Antwerp (1601) and Amsterdam (1612), when they were credited erroneously to Bruegel, led to their greatest influence. See also David Freedberg, *Dutch Landscape Prints* (London, 1980), 21-22.

121

An exception is Bruegel's 1557 landscape rendering of the *Parable of the Sower* (San Diego, Timken Foundation), which is tied to the traditions of religiosity in landscapes but is also an important early painting of peasant labor on the land, necessitated by the subject itself. Increasingly, scholars are reexamining the previous consensus that gave an early date to Bruegel's *Icarus* (Brussels), a damaged image on canvas whose sailing ship, peasant characters, and sophisticated inversion of the usually dominant myth into obscurity—as well as elements of paint handling and tonalities, despite the condition—all suggest a later date, around 1565-66. For these two works, see Fritz Grossmann, *Bruegel's Paintings*, 2nd ed. (London, 1966), nos. 5, 3a.

122

For what follows, see the useful essay by David Freedberg, "Allusion and Topicality in the Work of Pieter Bruegel: The Implications of a Forgotten Polemic," in Freedberg, *The Prints of Pieter Bruegel the Elder*, exh. cat. (Tokyo, 1989), 53-65. J. Muylle, "Pieter Bruegel en Abraham Ortelius. Bijdrage tot de literarische recepite van Pieter Bruegels Werk," *Archivum artis Lovaniense. Bijdragen tot de Geschiedenis van de kunst der Nederlanden, opgedragen aan Prof. Em. Dr. J. K. Steppe*, ed. M. Smeyers (Louvain, 1981), 319-37. The original Ortelius passage is in Cambridge University, Library of Pembroke College, published in facsmiile as A. Ortelius, *Album amicorum*, ed. J. Puraye, *Die gulden Passer* 45-46 (1967-68); reprint Amsterdam, 1969. The verses by Lucas de Heere were first published in his 1565 *Den Hof en boomgaerd der poesien* (ed. W. Waterschoot, Zwolle, 1969) and analyzed by Carl van de Velde, *Frans Floris* (Brussels, 1975), I, 1ff., and by Jochen Becker, "Zur niederländischen Kunstliteratur des 16. Jahrhunderts: Lucas de Heere," *Simiolus* 6 (1972-73), 113-27.

123

Melion, Shaping, 64-5, 172-82.

124

Quoted in Freedberg, *The Prints of Pieter Bruegel the Elder*, 23. On the painted imitations of Bosch in the generation before Bruegel, see Gert Unverfehrt, *Hieronymus Bosch. Die Rezeption seiner Kunst im frühen 16. Jahrhundert* (Berlin, 1980), esp. 67-72. Also Helmut Heidenreich, "Hieronymus Bosch in some Literary Contexts," *Journal of the Warburg and Courtauld Institutes* 33 (1970), 171-99.

125

Melion, Shaping, 181, 303, n. 18.

126

Best introduction by Paul Vandenbroeck, "Zur Herkunft und Verwurzelung der 'Grillen,'" *De Zeventiende eeuw* 3 (1987), 52-84; for Bruegel in particular, see also Muylle, 'Pier den Drol.' Karel van Mander en Pieter Bruegel. Bijdrage tot de literarire receptie van Bruegels werk ca. 1600," in H. Vekeman and J. Müller Hofstede, eds., *Wort und Bild in der niederländischen Kunst und Literatur des 16. und 17.Jahrhunderts* (Erfstadt, 1984), 137-44. See also the series of articles in *Proef* 1974: Hessel Miedema, "Grillen van Rembrandt," (74-75); J. Bruyn, "Problemen bij grillen;" Miedema, "De grillen;" and B. Ruurs, "Adrianus Brouwer, Gryllorum Pictor," (82-88). Most systematic is the overview by Hans Raupp, *Bauernsatiren* (Niederzier, 1986), 304-05, 307-10 on the implications of Van Manders term "droll." The term "grylli" comes from Pliny's description (Nat. Hist. 35. 114) of the comical genre of grotesque figures practiced by an Alexandrian painters, Antiphilos. The term is associated with Italian words like "fantastica" and "capriccio" by Vasari in his description of the work of Bruegel (Vasari-Milanesi V, 439).

127

On the aspects of religious commentary implicit in Bruegel's *Patience*, see Karel G. Boon, "*Patientia* dans les gravures de la Réforme aux Pays-Bas," *Revue de l'Art* 56 (1982), 7-24, esp. 18ff.

128

Riggs, 47-49, mentions that both the *Roman Ruins* and Ghisi's *Last Supper* after Lombard are dedicated to Antoine Perrenot, the future Cardinal Granvelle, in 1551; for references to Granvelle as patron and regent, see his notes 6-7. Eight Cock publications between 1551 and 1562 were dedicated to Granvelle. Perhaps a print like Bruegel's *Patience* belonged to a different enough subject group and/or style group to have escaped the cardinal's scrutiny, or perhaps the allusions were sufficiently generic or veiled to evade his wrath. Nonetheless, as Boon points out (adding a later, undescribed state to Lebeer's catalogue) in his note 105, a subsequent, censored version of *Patience* eliminates the keys on the hat of the cardinal and refashions the monks into fools, so the subsequent climate of the Counter-Reformation in Flanders was either more observant or less tolerant of criticism than Bruegel's original audience.

129

Each of these engravings was cut by Pieter van der Heyden and bears his monogram. For the drawings, dated 1556 (*Avarice*; London, British Museum) and 1557, see Bruegel Drawings, nos. 130-36: *Gluttony* and *Pride* (Paris, Lugt coll.), *Luxury* (Brussels, Bibliotheque Royale), *Anger* (Florence, Uffizi), *Jealousy* (ex-coll. von Hirsch, Basel), and *Sloth* (Vienna, Albertina). The 1558 *Last Judgment* (Münz no. 137) and *Christ in Limbo* (Münz no. 149, dated 1561 by another hand) are both also in the Albertina. The other principal Boschian print pair by Bruegel is *Saint James and the Magician Hermogenes* and *The Fall of the Magician* (1565; Lebeer nos. 57-58; the original drawing from the latter survives, dated 1564, in the Rijksmuseum, Amsterdam).

130

The principal proponent of Bruegel as disciple of Coornhert is C. G. Stridbeck, *Bruegelstudien* (Stockholm 1956), and the thesis is endorsed by Fritz Grossmann, esp. in his "Bruegel's

'Woman Taken in Adultery' and other Grisailles," *Burlington Magazine* 94 (1952), 218-29. It is important to remember that Coornhert was a highly eccentric theologian and that others whose tolerant yet heterodox views have been associated with Bruegel, particularly by Grossmann, such as Plantin and Ortelius, were particularly secretive about their unconventional opinions. Hence, seeing Bruegel's work as "illustrating" either Coornhert (in the same sense as Heemskerck did) or the secret Family of Love overstates the connection, if only for the sake of the safety of all concerned. However, it should also be recalled that Van Mander's biography of Bruegel mentions that the artist ordered destroyed several of his works with inscriptions because "Some of these were all too biting and satirical" and he feared that his wife might suffer because of them. On the Family of Love in particular, see B. Rekers, *Benito Arias Montano (1527-1598)* (London, 1972); Alistair Hamilton, *The Family of Love* (Cambridge, 1981); H. de la Fontaine Verwey, "Het Huis der Liefde en zijn publicaties," in idem, *Uit de wereld van het boek I. Humanisten, Dwepers, en rebellen in de zestiende eeuw* (Amsterdam, 1976), 85-111. The related secret Protestant movement of Nicodemists is surveyed by Carlo Ginzburg, *Il Nicodemismo* (Turin, 1970). On Calvin's attacks against Nicodemites, see Carlos Eire, *War Against the Idols* (Cambridge, 1986), 234-75.

131
Emile Mâle, *Religious Art in France. The Late Middle Ages*, ed Harry Bober (Princeton, 1986), 301ff. For more on the iconography of the Vices, Morton Bloomfield, *The Seven Deadly Sins* (East Lansing, 1952); Rosemond Tuve, *Allegorical Imagery* (Princeton, 1966). On the Virtues, Mâle, 285-300.

132
Probably engraved by Philipp Galle. Once more, all of the drawings have been preserved: *Faith* (1559; Amsterdam, Rijksmuseum), *Hope* (1559; Berlin), *Charity* and *Temperance* (1559, 1560; Rotterdam, Boymans-van Beuningen Museum), *Justice* and *Prudence* (1559, Brussels, Bibliotheque Royale); see Münz, Bruegel Drawings, nos. 142-48. A detailed study of these prints and their inscriptions is given by Nina Serebrennikov, "Peter Bruegel the Elder's Series of Virtues and Vices," Ph. D. diss. (U. of North Carolina, 1986). Particularly valuable in this investigation is the detection that the inscriptions on the Virtues are rather neutral "commonplaces," rhetorical tropes rather than pointed didactic instructions derived from a distinctive point of view.

133
The view of Charles de Tolnay, *Pierre Bruegel l'Ancien* (Brussels, 1935), and, following him, Irving Zupnick, "Appearance and Reality in Bruegel's Virtues," *Actes du XXIIe Congrès International d'Histoire de l'Art* (Budapest, 1972), 745-53. See, however, the violent tenor of representation of punishment in an era with more commonplace torture in public places: Samuel Edgerton, *Pictures and Punishment: Art and Criminal Prosecution during the Florentine Renaissance* (Ithaca, 1985); idem, "*Maniera* and the *Mannaia*: Decorum and Decapitation in the Sixteenth Century," in F. W. Robinson and S. G. Nichols, jr., eds. *The Meaning*

of Mannerism (Hanover, N.H., 1972), 67-93, and the remarks on judicial depictions and theory in Serebrennikov.

134
Ingvar Bergström, "The Iconological Origins of 'Spes' by P. Bruegel the Elder," *Nederlands Kunsthistorisch Jaarboek* (1956), 53-63.

135
For the arrangement of this composition into personfied clusters of different brances of learning, Bruegel may have depended on the model of Raphael's *School of Athens*, engraved, we remember by Giorgio Ghisi for Cock and issued in 1550 (see above). For this suggestion, I am indebted to Jane Goldsmith. Some scholars have taken this print as suggesting that painting belongs in the company of the Seven Liberal Arts, a frequent contention by Italian theorists and their Northern followers, as noted above in the context of Floris.

136
Veldman, "Seasons, Planets, and Temperaments," 1980, 164-65; idem, *Leerrijke reeksen*, 76-77, no. 9.2, fig. 41. The inscription reads: "Mercury makes intelligent, insightful, ambitious, generous and mathematical children, whose prayers are answered; interpreters, slim in body, pale, honest in look, and marvelous in their temperance concerning drink [*potus temperantia mirabiles*]. Here the other tradition of Temperance and alcohol is invoked, but the overlap between Mercury and Temperance is made explicit.

137
On allegorical theater in Bruegel's Netherlands, see W. M. H. Hummelen, *De Sinnekens in het rederijkersdrama* (Groningen, 1958). Such plays were tied to the world of artists through common membership of the Rhetoricians, or *rederijkers*, who composed these works, and painters in the Antwerp guild of Saint Luke. Bruegel's *Temperance* shows a dramatic allegory with well-dressed protagonists and a fool as well as a watcher, or *wachter*, above. See J. J. Mak, "De Wachter in het rederijkersdrama, naar aanleiding van de tooneelvertoning op Bruegels Temperantia," *Oud Holland* 66 (1949), 162-74. Also see in general Mak, *De rederijkers* (Amsterdam, 1944).

138
Matthias Winner, "Zu Bruegels 'Alchemist,'" in Otto von Simson and Winner, eds., *Pieter Bruegel und seine Welt* (Berlin, 1979), 193-202. Engraving ascribed to Philipp Galle. The Latin inscription, sounding another call to stoical resignation and awareness of one's limits, reads: "The ignorant should suffer things and labor accordingly. The law of the precious, cheap but at the same time rare stone is the only certain, worthless but everywhere discovered thing..."

139
This is a print—one of three—that was published posthumously by Cock's widow after 1570; see Riggs, "Bruegel and his Publisher," *Pieter Bruegel und seine Welt*, 165-73. The drawing design does not survive. Inscriptions in both Latin and Flemish with the sentiment that "Booty makes the thief."

140

On this comedic genre among the *rederijkers*, Walter Gibson, "Artists and Rederijkers in the Age of Bruegel," *Art Bulletin* 63 (1981), 426-46; idem, "Some Flemish Popular Prints from Hieronymus Cock and his Contemporaries," *Art Bulletin* 60 (1978), 673-81.

141

On Bruegel and proverbs in general, J. Grauls, *Volkstaal en volksleven in het werk van P. Bruegel* (Antwerp, 1957); more recently see the discussion by Alan Dundes and Claudia Kibbe on Bruegel's Berlin painting of *Netherlandish Proverbs*. Within *Elck* proverbial wisdom already makes a triple appearance: "each seeks himself in the world; each tugs for the longest end; and nobody knows himself." Grauls, 175-86; Gibson, "Arists and *Rederijkers*," 440.

142

Engraved by Pieter van der Heyden. The inscription is in both Latin and Flemish: "Although the ass goes to school to learn, since he is an ass, he will not come back a horse."

143

The *Festival of Fools* was published posthumously by Cock's widow. Keith Moxey, "Pieter Bruegel and the Feast of Fools," *Art Bulletin* 64 (1982), 640-46. The literary topos of universal folly is conveyed in *rederijker* "folly verses" (*int sotte*), such as the one titled "All fools and none carry bells." Such poems also refer frequently to the Stone of Folly, as in "The Stone hidden under the exposed lump." This subject was painted by both Bosch and Jan de Hemessen before the Bruegel print. See Larry Silver, *The Paintings of Quinten Massys* (London, 1984), 146-47, with references.

144

This practice, with greatest attention on France, is outlined by Natalie Davis, "Proverbial Wisdom and Popular Errors," *Society and Culture in Early Modern France* (Stanford, 1975), 227-67. A prime example of the phenomenon, slightly later than Bruegel's own visual collections is F. Goedthals, *Les Proverbes anciens flamengs et francois correspondant de sentence les uns aux autres colliges & ordonnés par M. François Goedthals* (Antwerp: Plantin, 1568). On the broader subject of popular culture and its study then and now, Peter Burke, *Popular Culture in Early Modern Europe* (New York, 1978).

145

The paintings include: *Parable of the Sower* (1567; San Diego, Timken coll.), *Blind Leading the Blind* (1568; Naples, Capodimonte), as well as the controversial attribution of the *Good Shepherd* (Brussels, Kronacker coll.); see Grossmann, Bruegel Paintings, 190, 203-04. For the latter, see *Bruegel. Une dynastie de peintres*, exh. cat. (Brussels, 1980), 58, no. 6. Bruegel's paintings with a popular folk subject include: *Netherlandish Proverbs* (1560, Berlin), and *Land of Cockaigne* (1567, Munich, Alte Pinakothek); Grossmann, 191, 202. The latter work was later engraved by van der Heyden, probably not for Cock (Lebeer 63).

146

The Floris series, dated 1560, was engraved by Cornelis Cort; Van de Velde P80-87 (=Riggs 82). Drawings for the series survive in Berlin (*Sobriety*) and Braunschweig

(*Memory, Intelligence*). A comparable single print is Cort's engraving after Floris for Cock in 1564, *Allegory of the Immortality of Virtue* (Van de Velde P 78 = Riggs 80).

147

Bruegel Drawings, no. 152. Bruegel's drawing of *Spring* (1565, Vienna, Albertina; no. 151) was produced earlier, but Cock commissioned the remaining two seasons images from Hans Bol of Mechelen (Riggs 6). Of course, the Bruegel images, derived from the manuscript tradition of calendar illustrations of the activities of the months, can also be compared to his own 1565 painted cycle of the *Months*, where the New York (Metropolitan Museum) *Harvesters* most closely resembles the Hamburg drawing. On the painted cycle, see the full bibliography in *Flämische Malerei von Jan van Eyck bis Pieter Bruegel d. Ä.* (Vienna, 1981), 86-104; Walter Gibson, *"Mirror of the Earth"*, 69-74.

148

Veldman, "Seasons, planets, and temperaments," 150-51. The prescription and description of that allegory is given in the Latin inscription below him: "There stands Summer, unclad, with a wreath of wheat on his head, his features those of a full-grown man, holding heavy stalks of wheat. The wheat sheaves fall to the scythe, the grass in the meadow is mowed, and the horned ram yields up the glory of his fleece."

149

Peter Sutton, *Masters of Seventeenth-Century Dutch Genre Painting*, exh. cat. (Philadelphia, 1981); Linda Stone-Ferrier, *Dutch Prints of Daily Life: Mirrors of Life or Masks of Morals?*, exh. cat. (Lawrence, KS, 1983), which includes Bruegel's Virtue, *Prudence*, 159-60, no. 42.

150

See most recently Jan Van der Stock, "The Impact of the Prints of Pieter Bruegel the Elder," in David Freedberg, *The Prints of Pieter Bruegel the Elder*, 89-102. On the landscapes, several articles by Teresz Gerszi remain significant: "Bruegels Nachwirkung auf die niederländischen Landschaftsmaler um 1600," *Oud Holland* 90 (1976), 201-29; idem, "Pieter Bruegels Einfluss auf die Herausbildung der Niederländischen See- und Kunstlandschaftsdarstellung," *Jahrbuch der Berliner Museen* n.s. 24 (1982), 143-87. See also Arndt, "Pieter Bruegel d.A. und die Geschichte der 'Waldlandschaft.'" Clever forgeries after Bruegel designs were executed by the artist brothers, Jacob (ca. 1565-1603) and Roelandt Savery (1576-1639), for whom see most recently the wonderful entries by William Robinson in *The Age of Bruegel*, exh. cat. (Washington, 1986), 251-66. Jacob's landscape forgeries, inscribed with Bruegel's name and plausible dates, escaped detection until a decade ago, while Roelandt's figure studies, "naer het leven," were long considered a staple of Bruegel's interest in ordinary peasant figures until they were exposed as imitations in a classic detection by Joaneath Spicer, "The 'Naer het Leven' Drawings: by Pieter Bruegel or Roelandt Savery?" *Master Drawings* 8 (1970), 3-30; corroborated by Frans van Leeuwen, "Iets over het handschrift van de 'naar het leven'-tekenaar," *Oud Holland* 85 (1970), 25-32; idem, "Figuurstudies van 'P. Bruegel,'" *Simiolus* 5 (1971), 139-49.

151

On the dating of Bruegel prints, including posthumous works, Riggs, "Bruegel and his Publisher," *Pieter Bruegel und seine Welt*, 165-73. For the Detroit *Wedding Dance*, Grossmann, Bruegel Paintings, 200-01.

152

Lebeer 30, based on a drawing of 1559 (London, Courtauld Institute). For the Antwerp documents concerning Cock's widow, see Lydia De Pauw-De Veen, "Archivalische gegevens over Volcxken Dierckx, weduwe van Hieronymus Cock," *Bijdragen tot de geschiedenis van de grafische kunst opgedragen aan Prof. Dr. Louis Lebeer. De Gulden Passer* 53 (1975), 215-47.

153

For the chronology of the Cock workshop and for the characteristics of the individual printmakers, Riggs, 43-155.

154

Riggs, 109-11.

155

Riggs, 140-49.

156

On Ghisi, Boorsch; on Cort, J. C. J. Bierens de Haan, *L'oeuvre grave de Cornelis Cort* (The Hague, 1948)

157

Edmund Pillsbury and Louise Richards, *The Graphic Art of Federico Barocci*, exh. cat. (New Haven, 1978), 105-07, nos. 75-77.

158

G. Thiem, "Studien zu Jan van der Straet, genannt Stradanus," *Mitteilungen des Kunsthistorischen Institutes in Florenz* 8 (1957-59), 88-111. Van der Straet was trained in Antwerp and admitted to the artists' guild there in 1545, shortly before he departed for Italy. He is recorded primarily in Florence, after 1557 as a cartoon designer for tapestries for the Medici. Van der Straet was noted for his numerous series of designs on the hunt, esp. of exotic animals, for which see W. Bok-van Kammen, *Stradanus and the Hunt*, Ph. D. diss. (Johns Hopkins University, 1977); also discussed in Arnout Balis, *Rubens Hunting Scenes*, Corpus Rubenianum Ludwig Burchard XVIII.II (Oxford, 1986).

159

Uta Bernsmeier, *Die Nova Reperta des Jan van der Straet*. Ph. D. diss. (Hamburg Univ., 1986).

160

Riggs, no. 269. See Marie Mauquoy-Hendrickx, *Les Estampes des Wierix. III* (Brussels, 1982), 3345-48, nos. 1741-49. For the texts by Domenicus Lampsonius accompanying these portraits, see Jean Puraye, *Dominque Lampson, Les Effigies des peintres celebres des Pays-Bas* ([Bruges] 1956).

161

Veldman, Humanism, 149, fig. 98. The preliminary drawing, without inscriptions, is in Berlin. Apelles is the celebrated Greek artist who painted Alexander the Great; he was held up as the standard of excellence for Renaissance painters by humanist eulogists, because of the status that he held in the ancient accounts of painting, chiefly Pliny the Younger.

162

Dated 1606, modelled after a portrait of Bruegel produced by the Prague court artist Bartholomeus Spranger. See J. B. Bedaux and A. van Gool, "Brueghel's Birthyear, Motive of an Ars / Natura Transmutation," *Simiolus* 7 (1974), 133-56. On Sadeler in general, Dorothy Limouze, "Aegidius Sadeler (1570-1629): Drawings, Prints, and the Development of an Art Theoretical Attitude," *Prag um 1600. Beiträge zur Kunst und Kultur am Hofe Rudolfs II.* (Emsland, 1988), 183-192.

163

Marie Mauquoy-Hendrickx, *Les Estampes des Wierix conservées au Cabinet des Estampes de la Bibliothèque Royale*, exh. cat. (Brussels, 1978-1983). For the biographies and the documents concerning the Wierix brothers as well as their later family followers, see vol. III. 2, by Carel van de Velde.

164

For a survey of a variety of engravers and artists, including the Wierixes and their favorite designer, Martin de Vos, working on religious subjects for a publication of Gerard de Jode, see Hans Mielke, "Antwerpener Graphik in der 2. Hälfte des 16. Jahrhunderts," *Zeitschrift für Kunstgeschichte* 38 (1975), 29-83.

165

On the relationship of Jan Brueghel to the model set by his father, Pieter, as extolled in Sadeler's print of Pieter Bruegel after Spranger, see Bedaux and van Gool, as cited above, n. 162, which likens imitation to an alchemical transmutation of the copy into the original or of art into nature itself. That metaphor could also be applied to the activity of the reproductive engraver, especially within these family practices where the son carries on the craft tradition of the father. For a modification of this argument, relevant to another member of a reproductive engraver family practice, see Dorothy Limouze, "Aegidius Sadeler," 187-89, citing the precept of Seneca against slavish copying of models to be imitated: "I would have you resemble him (the model) as a child resembles his father, and not as a picture resembles its original, for a picture is a blind thing."

166

On the Sadelers, see Ruth Edquest, *Sadeler Catalogue* (Melbourne, 1990).

167

On Barendsz., see J. R. Judson, *Dirck Barendsz., 1534-1592* (Amsterdam, 1970); also *Kunst voor de Beeldenstorm*, exh. cat. (Amsterdam, 1986), 367-68, 412-19, nos. 302-310.

168

Linda Freeman Bauer, "'Quanto si disegna, si dipinge ancora.' Some Observations on the Development of the Oil Sketch," *Storia dell' arte* 32 (1978), 45-57. However, as noted in the 1986 Amsterdam catalogue, Barendsz. returned from Venice to Holland in 1562, whereas most of the Venetian oil sketches, associated especially with Tintoretto, date around 1580, the same time as the oil sketches by Barendsz. himself. *The Age of Bruegel* (Washington, 1986), 59-61, no. 9, compares the figural style as well as the brushwork of these oil sketches to El Greco's early, small paintings as well as Tintoretto and Palma Giovane.

169

Kunst voor de Beeldenstorm, 415-17, nos. 308-309.2. For the drawing, incised for transfer to the printing plate, see *Age of Bruegel* (Washington, 1986), 62-62, no. 10. The pendant print of *Mankind Before the Flood* features nudes at table akin to the popular subject at the end of the sixteenth century of the Wedding of Peleus and Thetis. It owes much to the precedent of Heemskerck, as translated by Galle, though the Amsterdam catalogue signals the mannered nudes of Fontainebleau, such as those of Primaticcio. Both prints follow the text of Matthew 24: 37-39, linking God's punishment to mankind in the Flood to the wrath of His coming Judgment.

170

See the catalogue overview by Dorothy Limouze, *Aegidius Sadeler, Philadelphia Museum of Art Bulletin* 85 (Spring, 1989).

171

In addition to the surveys by Limouze, cited above, see *Prag um 1600*, exh. cat. (Essen, 1988), 412-27, nos. 308-11, 313-14, 322-23.

172

For the Wierix, see *Vorbild Dürer. Kupferstiche und Holzschnitte Albrecht Dürers im Spiegel der europäischen Druckgraphik des 16. Jahrhunderts*, exh. cat. (Nuremberg, 1978), 157, no. 190. The earliest dated Jan Wierix engraving, from 1562 when the engraver was only 13 years old (!), is also an exacting copy after a Dürer master engraving, *Saint Jerome in His Study* (1514); shortly afterwards, Jan produced a reversed 1564 copy of *Knight, Death, and the Devil* (1513). For these works and those of Aegidius Sadeler that follow, see *Bilder nach Bilder*, exh. cat. (Münster, 1976), 98ff., nos. 69-71 for Wierix, nos. 72-73 for Sadeler. On the Rudolfine Dürer revival, Thomas D. Kaufmann, "Hermeneutics in the History of Art: Remarks on the Reception of Dürer in the Sixteenth and Early Seventeenth Century," in Jeffrey C. Smith, ed., *New Perspectives on the Art of Renaissance Nuremberg* (Austin, 1985), 22-39, esp. 25-28.

173

Bilder nach Bilder, nos. 72-73. Inscribed according to the terminology of designer and graver utilized in Antwerp. Dürer "fecit" and Sadeler "sculpsit" in the case of the *Angel*, while in the *Virgin and Animals* Dürer is "inventor" and Sadeler "sculptor," credited as follows: "S. C. Mtis. Sculptor Aegid: Sadeler Sculpsit," that is, indicating that Sadeler is the official engraver to the Holy Roman Emperor. The two drawings both survive in the Albertina coll., Vienna. See Walter Koschatzky and Alice Strobl, *Dürer Drawings. The Albertina Collection* (Greenwich, CT; 1972), nos. 57 (W. 385) and 26 (W. 296), respectively. See *ibid.*, 15 ff., on Rudolf's acquisition of the great Willibald Imhoff collection of 93 Dürer drawings, the foundation of the Albertina trove.

174

Limouze, *Beiträge*, 188-89, fig. 9, comparing this creative imitation of a famous earlier engraver to Goltzius's experiments in the styles of master engravers during the 1590s, the *Meisterstiche*, for which see below.

175

Age of Bruegel (Washington, 1986), 260-62, no. 101. See especially Joaneath Spicer-Durham, *The Drawings of Roelant Savery*, Ph.D. diss. (Yale Univ., 1979); *Roelant Savery in seiner Zeit (1576-1639)*, exh. cat. (Cologne, 1985), 206-217, nos. 114-43. Another important designer of landscapes after the model of Pieter Bruegel was Pieter II Stevens, for whom the basic study (supplemented by a series of updates) is An Zwollo, "Pieter Stevens. Ein vergessener Maler des Rudolfinischen Kreises," *JKSW* 64 (1968), 119-80. For both artists and the Prague context, Thomas D. Kaufmann, *The School of Prague* (Chicago, 1988), esp. 85-89, 228-48, 280-85.

176

For these artists and the Prague School in general, Kaufmann, *School of Prague*, esp. 53-54 (fig. 37), 59-65, 90-96; for von Aachen, 133ff.; for Spranger, 249ff.

177

Prag um 1600, 420-21, no. 313.

178

Limouze, *Beiträge*, 185, was the first to note the wide range of Aegidius's techniques and how they are tied to the demands of his visual models: "While Sadeler is sometimes classified as a follower of Goltzius, in actual fact he emulated the 'Goltzius Style' only in his engravings after Spranger and much later in the series of twelve *Roman Emperors and Empresses* which reproduce the works of Titian and one or more Mantuan late Mannerist painters."

179

"Privatas lacrymas Bart. Sprangeri Egid. Sadeler miratur artem et amantem redamans, publicas fecit: et promutua benevolentia dedicavit." On the scroll hanging from the trumpet, a Latin phrase suggests that Spranger's fame springs from "[divine] will and [his] name" (*vivit numine et nomine*).

180

Kaufmann, *School of Prague*, 249 ff., with bibliography; *Age of Bruegel*, 274-81, nos. 107-109.

181

Kaufmann, *School of Prague*, 44f., 265-66, no. 20.50, plate 8. See also Kaufmann, "*Eros et poesia*: La Peinture a la cour de Rodolphe II," *Revue de l'Art* 18 (1985), 29-46, esp. 40-41.

182

Kaufmann, *School of Prague*, 42-43; also Kaufmann, "The Eloquent Artist: Towards an Understanding of the Stylistics of Painting at the Court of Rudolf II," *Leids Kunsthistorisch Jaarboek* 1 (1982), 119-48.

183

Prag um 1600, fig. no. 319, misidentified as the 1618 print by Haarlem engraver Jan Muller after Spranger (design of 1592) with the related theme and title, *Mercury Presents a Young Artist to Minerva* (Kaufmann, figs. 37 vs. 58). On Jan Muller, see below. The same two figures of Minerva and Mercury appear atop the gateway to the garden of Rubens's house in Antwerp, for which see Elizabeth McGrath, "The Painted Decorations of Rubens's House," *Journal of Warburg and Courtauld Institutes* 41 (1978), 245-77, esp. 275f. Also Jeffrey Muller. *Rubens: The Artist as Collector* (Princeton, 1989), 26-30.

184

Bilder nach Bilder, 104-05, no. 75. Kaufmann, *School of Prague*, 147-48, no. 1.43. Also Rüdiger An der Heiden, "Die Porträtmalerei des Hans von Aachen," JKSW 66 (1970), 135-227. According to the labels at each of these allegories, different qualities of the emperor are depicted: he stood fast, he advanced, he abided, he was present, and he pursued.

185

Limouze, *Beiträge*, fig. 7.

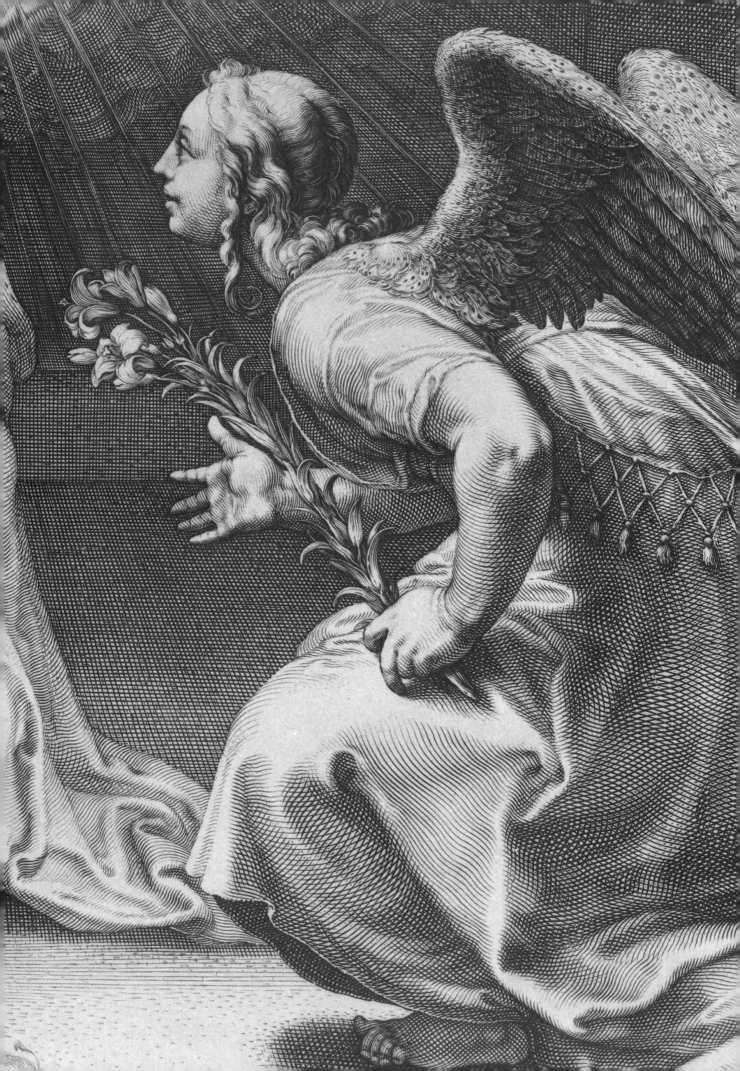

Theory & Practice

REPRODUCTIVE ENGRAVINGS IN THE

SIXTEENTH-CENTURY

NETHERLANDS

WALTER S. MELION

In his essential study of the Antwerp print publisher Hieronymus Cock, Timothy Riggs observes that Cock's firm, Aux Quatre Vents, aimed to consolidate a learned audience for its publications.[1] Cock sold to scholars such as Dirck Volkertsz. Coornhert, Benito Arias Montano, and Abraham Ortelius, but also to *rederijkers* (rhetoricians), members of the artisanal elite who exercised their interest in the literary and dramatic arts by participating in civic chambers of rhetoric. Other dealers, such as the royal typographer Christopher Plantin, sought to appeal to such buyers, for whom familiarity with the graphic arts became a component of erudition. Their interest in prints was incorporated into their larger concern to justify the vernacular by codifying Flemish forms and usage. Coornhert, Ortelius, and Plantin, united within an epistolary network that included scholar-painters, such as Lambert Lombard, Domenicus Lampsonius, and Lucas de Heere, exchanged views on local masters, using prints to define pictorial formats and functions and to enter into discussion on the power of images. Their texts form the basis of this essay, which surveys a coherent body of critical writing composed in the second half of the sixteenth century, in response to the proliferation of reproductive prints executed by specialist engravers and issued by houses such as Aux Quatre Vents.

I start at the end, so to speak, turning first to Karel van Mander, the great Flemish critical historian for whom prints played a key role in establishing categories of pictorial interest fundamental to the theory of northern art. After introducing Van Mander's account of prints, I will turn to the sources from which that account arose, concentrating on the letters and publications of an earlier critical historian, Domenicus Lampsonius. Through Lampsonius and his correspondents, we can better understand the high status conferred on printmakers; we learn, too, why Netherlandish engravers were deemed superior and what distinctive technical resources they were believed to possess. I then discuss the reproductive engraver Hendrick Goltzius, whose print series, the *Life of the Virgin,* published in

1594, summarizes and revises earlier appraisals of the Flemish burin-hand. I close by asking why Van Mander praised these prints as among the highest achievements of northern art.

Prints occupy a privileged place in Karel van Mander's *Schilder-Boeck* (*Book on Picturing*) of 1604, the critical text that provided Netherlandish readers with an alternative to Vasari's *Vite* of 1568, offering them a regional history of art within which Dutch and Flemish masters could be examined and their accomplishments evaluated.[2] Reproductive prints by Cornelis Cort, Aegidius Sadeler, and Hendrick Goltzius function as points of reference, cited throughout the *Schilder-Boeck* to justify inclusion in the canon of northern painters, draftsmen, and engravers assembled by Van Mander. Relying on the circulation of such images, which disseminated crucial information about pictorial manner, he defines critical categories that mediate entry into this canon. In the "Life of Bartholomeus Spranger," for example, the subject whom Van Mander especially champions but whose service to Rudolf II had made his works largely inaccessible to the Netherlands, Goltzius' engraving of 1587 after the *Wedding of Cupid and Psyche* (cat. no. 61) serves to exemplify Spranger's incomparable *pen-handelen* (penmanship) and command of *gracelijckste actie* (the most graceful movement).[3] Van Mander depends even more on prints in Book III of his *Schilder-Boeck*, devoted to Italian masters. Exempla by contemporary masters such as Federico Barocci were unavailable outside Italy, and the reader's visual experience of their accomplishments derived entirely from expert prints by Cort and the Sadelers, which Van Mander carefully describes.[4]

Two passages from the *Schilder-Boeck* clarify the status of reproductive prints, confirming not only their illustrative function, but also their pivotal effect as catalysts that shaped the very nature of Netherlandish art. Toward the close of Book III, Van Mander discusses the Lombard master Girolamo Muziano, praising in particular his landscapes, executed in a "powerful, secure, and excellent manner different from that of the Netherlands" and adorned by trees whose beautiful foliage consists of signature strokes of the brush.[5] His drawings are likewise exemplary, as is evident from the prints of Cort, who has admirably captured Muziano's handling of both the stylus and the brush: "Just as [Muziano] painted landscapes artfully, handling colors extraordinarily, so too did he draw expertly with pen and chalk. Which manner and handling our Cornelis Cort of Hoorn could imitate exceptionally well and truly with his burin, as can be seen in several of his engravings published by Muziano, that is, two landscapes with Saint Francis, and twelve others, vertical in format, which depict hermits and saints in the wilderness. For these prints are seldom to be seen, except among painters. In them appear beautiful trees and terrain, as well as a bit of distance."[6] Van Mander continues by indicating that Muziano himself recognized the superiority of northern engravers, later attempting to enlist Goltzius.[7] The reference to Cort makes clear what Goltzius had to offer—a burin-hand trained to imitate every aspect of Muziano's pictorial manner, even his brushwork and penmanship. In the *Schilder-Boeck*, northern engravers alone possess the ability to imitate in this degree, which earns Goltzius the sobriquet "Proteus" and allows Van Mander to discuss prints after masters such as Bruegel as if he were discussing works in their hands.

A second passage, taken from the "Life of Michiel Cocxie," concerns the effect of reproductive prints on the standard practice of imitation and memory. In Rome Cocxie had been impressed by the frescoes of Raphael, after which he had drawn diligently, committing them to memory for future reference. These memories were ultimately put to remedial use: "Since [Cocxie] lacked special facility at pictorial composition, he made use of Italian things. Wherefore he was displeased when Hieronymus Cock published the print after Raphael's *School of Athens* (cat. no. 11), which he had studied [in Rome] and put to much use in the altarpiece of the *Death of the Virgin*, painted for St. Gudule's in Brussels,

where it was visible to all."[8] Cocxie is abashed for several reasons, foremost that his model, once embedded in memory for his exclusive use, has now entered the public domain, where it circulates in the marketplace, available to all. Issued by Cock, Giorgio Ghisi's print after Raphael has abrogated Cocxie's control over Italian exempla, control based on powers of memory which are themselves reduced in value. Van Mander tells us that Cocxie took great pride in his ability to remember images precisely, but the reference to Cock suggests that that pride, previously justified, is henceforth misplaced.[9] Moreover, the *Death of the Virgin* is exposed as a symptom of Cocxie's deficient *ordinantie* (invention, in the sense of the ability to compose pictorially). Reproductive prints, then, enforce new standards of pictorial accomplishment, revising the practice of imitation and memory.

In the "Life of Hendrick Goltzius," Van Mander explains precisely what this revised practice entails, using the *Life of the Virgin* as his lodestar. For the moment, however, I want to postpone discussion of this print series, turning instead to the discourse on prints that underlies the "Lives" of Muziano, Cocxie, and Goltzius. Van Mander's basic assumptions about Netherlandish reproductive engravers—that they distill *handelingh* itself (pictorial manner, as rendered by the hand) and that they implement new criteria of imitation and memory, criteria peculiar to the Netherlands—are neither new nor idiosyncratic. Rather, they are consonant with assumptions voiced earlier by writers on the visual arts, chief among them Lampsonius. Their texts are the preliminaries within which Van Mander's can be situated.

Let us begin with a basic question: what was the status of prints vis-à-vis the other visual arts? In posing this question, I use the term "prints" in its larger sense, including both "originals" by Dürer and "reproductions" by Cort. In his long letter of 1589 to the antiquarian Ludovicus Demontiosius, Domenicus Lampsonius, secretary to the prince-bishop of Liège, provides a surprising yet typical response.[10] Though intricate, Lampsonius' argument is worth unfolding, for it sheds light on the high valuation of engraving in the late sixteenth-century Netherlands.

Written in macaronics, the letter opens with a powerful critique of Demontiosius' reading of Pliny's *Naturalis historia*, specifically of the passage on the contest between two great ancient painters, Apelles and Protogenes, who competed to inscribe the *linea summae tenuitatis* (line of finest breadth). Lampsonius reads Pliny literally, interpreting the contest as a demonstration of *adresse* (sureness and dexterity of hand): Apelles, finding an empty panel in Protogenes' studio, had brushed a single line which, though painted freehand, was straight and uniform along its entire length. Protogenes then painted a second line in a different color, so fine that it bisected Apelles' line. Taking up the brush again, Apelles inscribed a third line in yet another color, which could not be bettered, for it bisected Protogenes' line.[11]

Demontiosius, finding it inconceivable that such celebrated painters could have battled over mere lines, argued that the panel in Protogenes' studio must have depicted something, perhaps figures, and that Apelles and Protogenes competed to show their mastery of *harmogen*, the ability to mix colors and tones seamlessly.[12] Lampsonius contests this interpretation on technical and philological grounds. More important to us, he uses northern prints to strengthen his case, calling attention to Albrecht Dürer, who was so adept *in graphice* (in the graphic arts) that he wielded even the brush as if it were a burin or stylus.[13] Lampsonius cites wood and copper engravings as paragons of Dürer's astonishing *adresse*, his uncanny command of line, attested too by his ability to draw freehand a perfect circle. If Dürer's brush testifies to his power as a delineator, Lampsonius continues, why should we not take Pliny at his word and conclude that Apelles and Protogenes vied to paint the "line of finest breadth," using brushes as if these instruments were by nature rigid and precise.[14]

Lampsonius expands upon this last point, developing a *paragone* between the graphic arts—engraving and drawing—and painting, whose prime exponents are Dürer and Michelangelo: "In truth Dürer was a great man, marvelously skilled *in graphice*; as he has shown surpassingly and indeed astonishingly in images engraved by his burin, and also in those drawn on wood and afterward engraved....But as for myself, howsoever much I agree that he had a fearsomely adroit hand (and in this I speak not only of the burin, but also charcoal, quill, and all other sorts of stylus, as well as the brush, which he used with pleasure), yet I do not esteem his way of painting, for his works reveal too much of his manner and do not really express things naturally, as do the Italian masters with prodigious skill. (I speak specifically of his nude and clothed figures, as of his drapery. For he expresses all other things divinely well.)....his *disegno* does not satisfy me as much as that of Raphael and, even more, that of the divine Michelangelo."[15] The term *disegno*, derived from texts by Benedetto Varchi, Benvenuto Cellini, and Vasari, refers not simply to drawing, but even more to the ability to depict the mobile human body, the main conveyor of narrative action and of the passions.[16] Whereas Michelangelo's paintings are epitomes of *disegno* in this sense, Lampsonius avers, Dürer is unsurpassed in his command of linear means, as his prints especially demonstrate. Implicit in this assertion is the notion that it is legitimate to compare prints and frescoes, the burin and the brush, a northern master printmaker and an Italian master painter. This notion further underlies Lampsonius' reference to Dürer's *main terriblement adroicte* (fearsomely adroit hand), which ascribes to his burin-hand the *terribilità* that Vasari had discerned in Michelangelo's painting, sculpture and architecture. Indeed, in his *adresse*, Dürer proves closest to the ancients, reprising the *linea summae tenuitatis* of Apelles and Protogenes.

Lampsonius shared his high regard for Dürer with correspondents such as Plantin and Ortelius, who themselves dealt in the master's prints.

In the well-known letter of 19 July 1567, sent by Plantin to Francesco Gentile of Padua, a friend and client, we learn how sophisticated the market was for Dürer's prints. Collectors were sensitive to distinctions between impressions and states: "In response to your inquiry, having visited all the print dealers of this city in search of the images listed in your letter, and having been unable to find the twelve months of the year in copperplate, I immediately ordered them from Paris, where such plates are very precisely engraved, and will deliver them to your brother as soon as they arrive, just as I am about to do with three prints by Dürer, that is, the *Saint Eustache*, which cost me 30 patars, the *Saint Jerome in His Study*, and the *Melancholia* (two very beautiful pieces), which cost me 15 patars apiece, the total amounting to 3 florins. For, Sir, it will please you to learn that there are certain old specimens of the *Saint Eustache* that sell for up to 6 florins apiece, others for 4 florins, and still others for 3 florins, even though all were pulled from the same plate by Albrecht Dürer's hand; these extreme variations in price originate in the judgment and passion of painters and connoisseurs of such prints, who sometimes value a specimen (though printed on the same day and in the same hour by the same hand, from the same plate) two, three, or four times as much as another, and double that again, a state of affairs that will seem very strange to those who have not experienced it and who would therefore wonder, were they to receive [such specimens] without advance notice."[17]

Prints by Dürer and Lucas van Leyden were especially admired, and there is no reason to believe that reproductive prints received this kind of attention. Yet, Plantin's letter suggests the context within which such prints were appreciated, and there is in fact much evidence that collectors and patrons took stock of the reproductive engraver's burin-hand, his control over the burin, attested by the precision of his hatches and crosshatches, and concomitantly, his ability to translate faithfully from originals. Experienced viewers attended to the act of translation itself, which was

seen as a complex form of negotiation between model and print, the manner of the former and the linear means of the latter.

Two letters can help show how this is so. On 15 July 1578, Coornhert, himself a reproductive engraver famed for his prints after Maarten van Heemskerck, wrote to Ortelius, thanking him for the gift of Philipp Galle's print after Bruegel's *Death of the Virgin* (fig. 1; cat. no. 26). Coornhert composed his letter as a poem of thanks: "Thinking back gratefully [upon prior gifts],/ I received your [latest] gift, good Ortelius./ Which from top to bottom/ I happily scanned with wonder,/ both for its artful drawing and patient engraving./ Bruegel and Galle have surpassed themselves./ Neither could, I believe, have done better./ So did the favor of their friend Abraham [Ortelius]/ incite their respective arts:/ And so, this artful work shall artfully gladden/ For all time, art-loving masters./ Never have I seen (it seems to me) more able draftsmanship/ nor engraving to match that in this sad chamber./ But what am I saying? Seen? The ears heard/ (so it seemed) the lamentations,/ The sighs, the tears, the miserable cries..../ Though the chamber

seemed deathly, it seemed, too, as if alive."[18] Coornhert takes care to bestow equal praise on Bruegel and Galle, commending the draftsmanship of the one and the burin-work of the other, and ultimately complimenting Ortelius for having instigated their collaboration. His poem maps his careful viewing of the print, viewing that involves acknowledgment of both Bruegel and Galle; Coornhert thereby certifies that Ortelius' gift, being worthy of the viewer's effort, is excellent.

We gain more detailed information about the criteria applied to reproductive engravers in the letter of 4 November 1586, sent to Plantin by Jean Moflin, Abbot of Bergue St. Winoc. Through Plantin, Moflin hoped to find an engraver capable of executing a dedication plate, destined for the Grand Almoner Garcia Loaysa. To this effect, he had forwarded an image of *Our Lady of Sorrows*, which Plantin then commissioned Crispin van den Broeck to redraw as a modello. Moflin writes: "As concerns the image of Our Lady, I fervently wish that you should have it engraved by the best master to be found in Antwerp, at the same size and scale as the original;

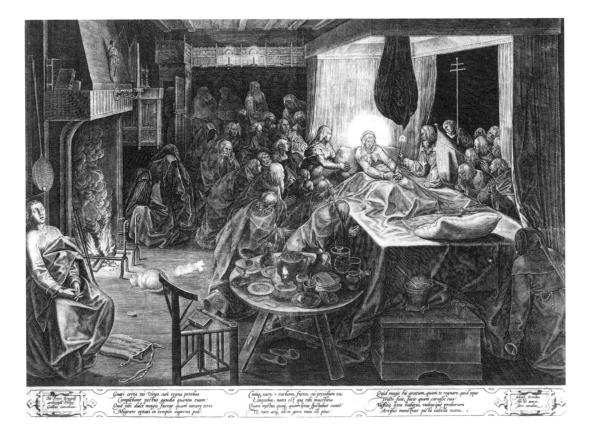

Figure 1.
Philipp Galle after Pieter Bruegel: *Death of the Virgin*, 1574, engraving, 31 x 42 cm. By permission of the Trustees of the British Museum, London.

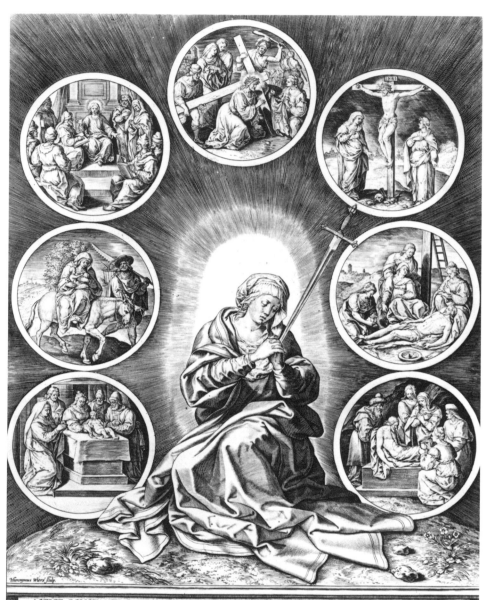

Figure 2.

Hieronymus Wierix

after Crispin

van den Broeck:

Virgin of Sorrows, about

1588, 44.6 x 30.6 cm.

Bibliothèque Royale

Albert Ier, Brussels.

if the master who engraves the image is excellent, he will also be able to engrave the surrounding roundels, which do not correspond to the workmanship of the principal image, having been done by diverse hands. I leave to your discretion the cost, which I will immediately remit. You will find in this image a snail, upon which you will place my devise—*tecum habita Joannes Moflin.*"[19] Plantin eventually hired the engraver Hieronymus Wierix, charging Moflin 6 florins for the modello, 6 florins for the copperplate, and an advance of 2 livres to go to Wierix, who was to receive an additional 14 livres upon completing the plate (fig. 2). Numerous sources testify that Plantin was deeply ambivalent about the Wierix brothers, who seem to have been dipsomaniacs; yet they remained his engravers of choice for commissions such as Moflin's, presumably because they were prodigies of imitation.[20] Having successfully imitated many of Dürer's signature plates as an adolescent, Hieronymus Wierix could fulfill Moflin's key criterion of excellence, translating with his burin the various hands displayed in the roundels of the original.[21] As we shall see, this criterion, so clearly enunciated by Moflin, was later adopted by Goltzius, for whom it functioned as the ultimate sign of virtuosity.

Elsewhere in the Plantin correspondence, there are indications that Antwerp was perceived to have a monopoly on reproductive engravers of the Wierixs' caliber. In a letter of 12 September 1579, Philippe Laiquier asks Plantin to hire the most expert engraver available in Antwerp to execute an image of St. Jerome as sweetly and delicately as possible; Laiquier explains that he has seen books and maps issued by Plantin with illustrations whose subtle engraving has impressed him and prompted him to write.[22] Earlier, in a letter sent from Vienna on 13 August 1578, the antiquarian Jacopo Strada writes to inquire whether Plantin might be willing to collaborate on a number of publications, among them a description of Italy embellished with maps, city plans, and armorials; if so, Plantin would need to have Strada's illustrations engraved in Antwerp, "since there are no master engravers in Vienna."[23]

The corollary of these and other inquiries of this sort is Plantin's conviction, voiced in a letter of 5 September 1581 to Gabriel de Cayas, stating that his publishing house is the best in Europe, not simply because it possesses every conceivable sort of die, matrix, and printing type, but even more because it is abundantly furnished with figures and ornaments, that is, engraved plates and blocks.[24]

Indeed, the use of reproductive engravers as illustrators was a prerogative jealously guarded by typographers, as is evident from Plantin's petition of 9 January 1576 to the Council of Brabant.[25] On behalf of his fellow printers, he lodges a complaint against Gille vanden Bogaerde's widow, who has been printing playing cards engraved with fine images. These are wood engravings, but Plantin's point of contention—that only printers authorized by the state should be allowed to issue *fine pourtraicture et taille* (finely engraved images)—encompasses copper engraving as well. Plantin argues that engravers practice *une science et mestier à part* (a distinctive skill and trade), and that their employers must therefore comply with the ordinances governing such trades. When engravers work as illustrators, they come under the jurisdiction of laws regulating the printers.

Learned collectors of prints, too, identified reproductive engravers as practitioners of a distinctive skill and trade. In the *Batavia*, the history of Holland written between 1565 and 1570 by the distinguished humanist Hadrianus Junius, Coornhert and Galle are included among the masters whose practice of art is noteworthy. These also include the painters Jan van Scorel, Antonis Mor, and Heemskerck, who is also praised for his modelli, drawings executed for translation into prints. As the scholar Ilja M. Veldman has noted, Junius takes care to discern the technical character of engraving and etching, differentiating them from the other graphic arts. In extolling Coornhert and Galle, for instance, he distinguishes them from masters such as Heemskerck, specifying that they are illustrious not for drawing in pen and ink, but rather for engraving with the burin. Their images, cut in reverse into

copper and other metals, depict every variety of scene and history.[26]

Like Plantin, Lampsonius, and other humanists, Junius devoted time and energy to the study of reproductive prints, engaging in the composition of *emblemata*. The term had several meanings in the sixteenth century, but as Veldman has persuasively argued, Junius uses it to refer to prints elucidated with his verses.[27] Junius' *Pinaces liber unus*, a collection of short poems published posthumously in 1598 as part of the *Poematum liber primum*, is in fact a compendium of such verses, taken largely from prints after Heemskerck by Coornhert and other engravers.[28] These poems are descriptive, adhering closely to the images they clarify. Within this minor genre of literary activity, the poet might also have chosen to diverge explicitly from the image inscribed, as Elizabeth McGrath has recently shown.[29] In this case, the verses compete with the image, striving to figure more affectively or wittily what the print shows. Whichever course the poet took, however, the very existence of such poems ratified the status of reproductive prints as a category of pictorial interest that offered the opportunity for scholarly diversion.

Reproductive prints also offered scholars a chance to assess a large body of work by a single master and to appraise the nature of his accomplishment. In the *Batavia*, Junius especially admires Heemskerck's ability to depict landscape panoramas into which the eyes might roam.[30] These panoramas recall those of the ancient painter Ludius, into whose landscapes the eyes could wander leisurely from farmlands to coastal cities, encountering strollers, laborers, and marketgoers. Although Junius assimilates Heemskerck to Pliny's account of Ludius, his familiarity with Heemskerck's landscape art must have derived almost entirely from his familiarity with prints issued by Cock, such as *Saint Jerome in a Landscape with Ruins* of 1552 and *Balaam and the Angel* of 1554.[31] That works such as these—the former etched by Cock, the latter engraved by Coornhert—could form the basis of Junius' assessment of Heemskerck suggests the degree to

which prints were trusted as conveyors of information about pictorial invention and manner.

I have been surveying sources that allow us to deduce the status of prints, and more particularly the esteem for reproductive prints. In closing this section, I want to ask why Junius and his peers placed their trust in prints, seeing through them to the art of masters such as Heemskerck, while at the same time valorizing printmakers such as Coornhert. There are two answers, I think, the first having to do with technique, the second with the labor of engraving. Prints executed by Coornhert, Galle, and especially Cort are rendered in a distinctive way, featuring curved hatches that swell and taper gradually in response to changes in the angle at which the burin meets the surface of the plate.[32] Laid in concentric series, these hatches and cross-hatches were ideally suited to delineating musculature as well as transitions of tone and light. By 1560, this burin-hand, perhaps derived from the engravings of Ghisi and the late engravings of Lucas van Leyden, had come to be associated with the firm of Hieronymus Cock, many of whose publications feature clearly legible networks of parallel arcs. It was precisely these linear means that appealed to scholars such as Junius, who had available a rich fund of Latin terms, originating mainly in Pliny and Quintilian, with which to appreciate and describe a master's command of line. We have already encountered one such source—the anecdote concerning the *linea summae tenuitatis*—but there were many others. In the *Batavia*, for example, Junius casts Heemskerck as a latter-day Apelles when he praises him for not letting a day pass without drawing a line.[33] These are the same terms in which Pliny had endorsed Apelles' diligence. In the *Opus chronographicum orbis universi* of Petrus van Opmeer, published posthumously in 1611, Heemskerck receives praise once again for his control of line; Van Opmeer compares his *lineas formarum* (contour lines) with those of Protogenes, recalling the latter's contest with Apelles.[34] Similarly, in his letter to Demontiosius, Lampsonius not only compares Dürer to Apelles and Protogenes, but

also implies that Dürer wields lines as masterfully as Parrhasius, whose contour lines were acclaimed for seeming to disclose what lay beyond the forms they demarcated.[35] What these scholars share, is a predisposition toward line, stimulated by the linear means that form the basis of the burin-hand promoted by Cock.

In fact, these heightened responses to engraved line have an illustrious lineage, going back to the terms of praise applied by Erasmus to Dürer in the *Dialogus de recta latini graecique sermonis pronunciatione* of 1528.[36] Stressing the affinities of drawing and writing (drawing trains the hand to form letters well), Erasmus then eulogizes Dürer whose *Treatise on Geometry* contains a useful section on lettering and whose *monochromata* (prints) portray effects more easily achieved in paint—*umbras, lumen, splendorem, eminentias, depressiones* (translated by Erwin Panofsky as "shade, light, radiance, projections, depressions").[37] As Panofsky notes, Erasmus redefines Pliny's term *monochromata*, which designates monochrome painting in the *Naturalis historia*, but which Erasmus uses to describe works executed *nigrae lineae* (in black lines).[38]

There were also moral grounds for the esteem accorded to engravers. Matthias Winner has shown how strong the theoretical and artisanal investment was in the virtues *sedulitas* (diligent exertion) and *solertia* (the skill and dexterity that result from *sedulitas*).[39] Supporting Winner's claims, Hans Mielke has called attention to Jan Snellick's drawing, engraved by Hans Collaert, which depicts *Sedulitas* as source of the visual and liberal arts.[40] In another image published by Mielke—drawn by Martin van Cleve and engraved by Hieronymus Wierix—*Solertia* punishes the lazy, while granting fame to those who diligently practice the arts.[41] These prints are of course self-reflexive, for engraving, being a strenuous and difficult art, itself requires extraordinary resources of both *sedulitas* and *solertia*. In a culture that placed a premium on such virtues, the engraver's burin would have been honored even above the draftsman's stylus and painter's brush. This may explain why Junius felt compelled to commend Coornhert and Galle, why Plantin regularly paid reproductive engravers two and three times as much as he paid draftsmen, and why Van Mander characterizes reproductive plates as the highest examples of Goltzius' *teyckenconst* (art of delineation).[42]

It is Lampsonius who provides the fullest and most nuanced account of the burin-hand of Antwerp. Focusing on the prints of Cornelis Cort, whom he came to treat as a virtual protégé, Lampsonius discusses the potentialities of reproductive engraving in a series of letters, dated 1565, 1567, and 1570 and addressed respectively to Vasari, Titian, and Giulio Clovio.[43] This epistolary campaign was precipitated by an earlier project, the research and writing of Lampsonius' biography of the painter Lambert Lombard of Liège. Lampsonius portrays Lombard as the founder of the Flemish school of reproductive engraving based in Antwerp.[44]

Published in 1565, the *Lamberti Lombardi apud Eburiones pictores celeberrimi vita* attributes to Lombard the instruction of engravers trained to specialize in the translation of his modelli. Lombard, according to Lampsonius, was following the example of Mantegna and Raphael, who had entered into collaboration with engravers whose prints disseminated their inventions: "Being besides very generous by nature and ever ready to render assistance, as had been Mantegna, Dürer, and Raphael, great masters who endeavored always to put their art in the public domain, [Lombard] willingly relinquished his drawings to colleagues less gifted than he in invention and design, who colored and then sold them. He gave drawings, too, to glass painters and common sculptors, eventually having a large number engraved and printed in order to expedite and facilitate their transfer. One still finds these prints here and there. It is surely due to him that one sees in Antwerp and other cities a large number of artisans occupied with engraving on copper, and not without merit, the contemporary works of great masters. It is he who first established at his home a school for the instruction of youths

in drawing and engraving after his drawings and those of other masters. Indeed, this activity entailed more expense than gain, from which one may judge his generosity and, so to speak, his dogged determination to be magnanimous."[45]

What, we might ask, prompted this commitment to reproductive engraving? At the start of the *Vita*, Lampsonius recounts an anecdote that illustrates Lombard's investment in prints and specifically in the dissemination of visual information that prints enable. Early in his career, Lombard was visited by Michel Zagrius, city secretary of Middelburg, who happened to introduce him to Pliny's writings on the visual arts, citing in particular Pliny's remarks on contour lines (that is, on Parrhasius).[46] Filled with enthusiasm, Lombard attempted to learn Latin and Greek, but seeing how penurious many scholars were, and judging how long it would take him to reach their fluency, he gave up his attempt, relying instead on translations in French and Italian. And yet, though these translations were often mediocre, "through constant application Lombard managed to penetrate to the core of the texts, just as if he had succeeded in reading them in the original."[47] Lombard proceeded in this way to read ancient historians, poets, and moral philosophers, finally achieving a reputation for prodigious erudition, "in spite of having been deprived of learned languages."[48] It is surely significant that Lombard was impelled to his study of the classics in translation by his desire to understand better Pliny's remarks on Parrhasius' lines; his reliance on translations can be seen as consonant with his trust of prints. Just as he achieved erudition through the study of vernacular imitations of the classics, so too, through trained reproductive engravers, he offered viewers access to originals they could not actually acquire. Or put syllogistically, French and Italian translations were to his knowledge of Parrhasius as reproductive prints were to viewers' knowledge of works by him and other masters. It is as if Lampsonius were asking us to extend the logic of translation by claiming that it applies not only to words but also to images.

In his letter of 1565 to Vasari, Lampsonius explores the connection between reproductive prints and canon-formation.[49] He observes that the circulation of mediocre engravings poses a problem to the reader of Vasari's *Vite*; such prints contravene the information supplied by Vasari's *ekphrases*, his use of rhetorical convention to describe images to the mind's eye. If the images imprinted by *ekphrases* are in conflict with the images circulated as prints, Lampsonius asks, how is one to achieve a secure grasp of the canon of masters enshrined within Vasari's history of Tuscan art? Having formulated this problem, Lampsonius suggests that its solution lies in the intervention of excellent Flemish engravers who have been trained to imitate the works esteemed by Vasari. These engravers would have to enter into conversation with Michelangelo and other masters, collaborating with them as had Marcantonio Raimondi, Marco Dente da Ravenna, and Aeneas Vico with Raphael and Baccio Bandinelli. Only then would Vasari's project of canon-formation be ensured.

In his letter of 1567 to Titian, Lampsonius expands upon the nature of the transaction between the reproductive engraver and the master whose works he translates.[50] Prints are no longer seen as counterparts to *ekphrases*; rather, they convey kinds of visual information that elude rhetorical description. Lampsonius refers in particular to Titian's *colorito*, his manipulation of color, tone, and the texture of paint, which has been brilliantly captured by the engraver Cornelis Cort in a print series recently acquired by Lampsonius. Lampsonius encourages Titian to employ Cort again, saying that the latter's plates disclose the full scope of Titian's pictorial manner. But even more, Cort realizes the full potential of the reproductive print, which is to negotiate between the engraver's manner—his bold, rapid, and dexterous handling of the burin—and the painter's manner—his *inventione* (invention), *disegno* (manner of line and command of the human figure), and *colorito*. Submerged in the letter to Titian is a critique of Vasari, who privileges

Tuscan style in the *Vite*, depriving Venetian and Lombard masters their due. Through reproductive engravers like Cort, Lampsonius implies, pictorial categories such as *colorito*, in which the Venetians and Lombards excel, finally receive their complement of honor.

In viewing a reproductive print, then, the beholder is party to a conversation between the manner of the engraver and of the draftsman or painter. Lampsonius elaborates on this assertion in his letter of 1570 to Giulio Clovio, the celebrated illuminator who served the Farnese in Rome.[51] Through Clovio, he invites the Farnese to hire Cort to engrave the exemplary works of the Roman masters. By publishing Cort's prints the Farnese could consolidate their reputation as shapers of the Roman canon, a reputation tarnished by Giulio Bonasone's dedication to Cardinal Farnese of his inferior print after Michelangelo's *Last Judgment*.[52] As in the letter to Titian, Lampsonius states unequivocally that Cort's burin can translate directly from paintings. This is why Cort should visit Rome to work after Michelangelo and Venice to work after Titian. Indeed, Lampsonius emphasizes that Cort is incapable of drawing copies of the paintings he engraves; though the Farnese must provide him with such drawings as referents, Cort's engravings will prove more complex than mere drawn copies. As we have seen, his prints mediate between the engraver's burin-hand and the painter's *inventione*, *disegno*, and *colorito*, allowing the viewer to grasp all these components simultaneously. In making this point, Lampsonius uses terms learned from the *Vite*; but whereas Vasari's terminology is calculated to describe actions of the human figure in the *istoria* (narrative history), Lampsonius' usage focuses on the disposition and mobilization of the engraver's lines. By reassigning terms in this way, Lampsonius grants prints the prestige of the painted *istoria*.

Many of the key assumptions voiced in Lampsonius' *Vita* and letters inform Karel van Mander's "Life of Hendrick Goltzius," an incomparable summa of the reproductive engraver's essential means and ends. Van Mander declares Goltzius an unrivalled exponent of *teyckenconst*, supporting this claim by directing the reader to the artist's print series of 1593-94, the *Life of the Virgin*.[53] Produced not long after Goltzius' return from a study tour of Italy, the series is seen to issue from mimetic impulses that rule his life and work: his love of disguising himself from his peers,[54] his drive to imitate the *handelinghen* (manners) of celebrated draftsmen,[55] and his desire to embody his vivid memories of Italian *colorito*, as epitomized in the works of Raphael, Titian, Correggio, and Veronese.[56] The *Life of the Virgin*, for which Goltzius won a gold chain from his dedicatee, Duke Wilhelm V of Bavaria, consists of six plates: the *Annunciation* (fig. 3), *Visitation* (fig. 4), *Adoration of the Shepherds* (fig. 5), *Adoration of the Magi* (cat. no. 66), *Circumcision* (fig. 6), and *Holy Family with the Infant Saint John* (cat. no. 65). Van Mander's discussion concentrates on the *Circumcision* and *Adoration of the Magi*, engraved respectively in the manner of Dürer and Lucas van Leyden.[57] Emphasizing that these prints distill *handelinghen*, rather than copying prior modelli, Van Mander relates how Goltzius altered several impressions, removing his monogram and aging the paper. He then sent them to the major European book fairs, where they were purchased by fellow engravers and connoisseurs, who took them for previously unknown originals by Dürer and Lucas. Van Mander's point is that the *Circumcision* and *Adoration of the Magi* could indeed pass for originals. Not only did they implement the manner of these great printmakers; they seemed to have been invented by them. Goltzius, in other words, had so succeeded in assimilating their practice of art that he could impersonate their very mode of invention, creating new works that could be legitimately perceived as old ones. Like Cort, he produces prints that are more than mere copies. But whereas Cort, as portrayed by Lampsonius, transmits other masters' inventions, Goltzius subsumes invention itself into the process of imitation, inventing in the manner of Dürer and Lucas. This is a new form of reproductive

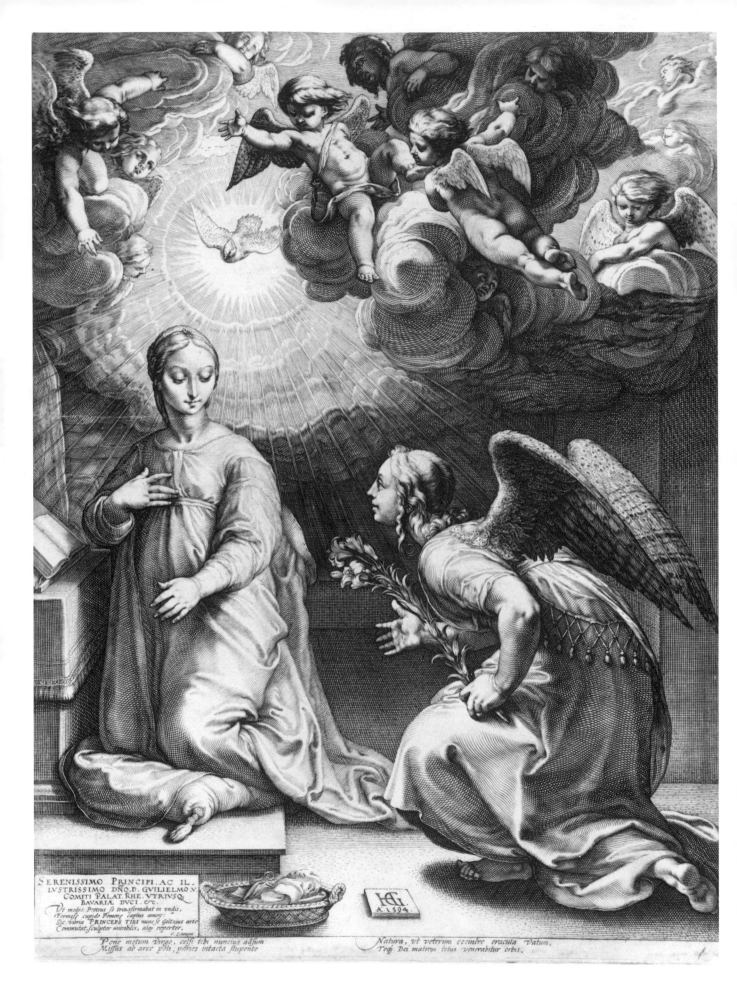

SERENISSIMO PRINCIPI. AC IL
LVSTRISSIMO DÑO. D. GVILIELMO V.
COMITI PALAT. RHE. VTRIVSQ.
BAVARIÆ DVCI. &c.

Vt modo Proteus se transformabat in vndis,
Formosæ cupido Pomonæ captus amore:
Sic varia PRINCEPS TIBI nunc se Goltzius arte
Commutat, sculpter mirabilis, atq; repertor.

c. Schonæus

Pone metum Virgo, celsi tibi nuncius adsum
Missus ab arce poli, parens intacta stupente

HG
A. 1594.

Natura, vt veterum cecinêre oracula Vatum,
Teq; Dei matrem intus venerabitur orbis.

Figure 3.
Hendrick Goltzius:
Annunciation from the
Life of the Virgin,
1594, engraving,
46.5 x 35 cm. The
Baltimore Museum of Art:
Garrett Collection.

Figure 4.
Hendrick Goltzius:
Visitation from the
Life of the Virgin,
1593, engraving,
46 x 35.1 cm. The
Baltimore Museum of Art:
Garrett Collection.

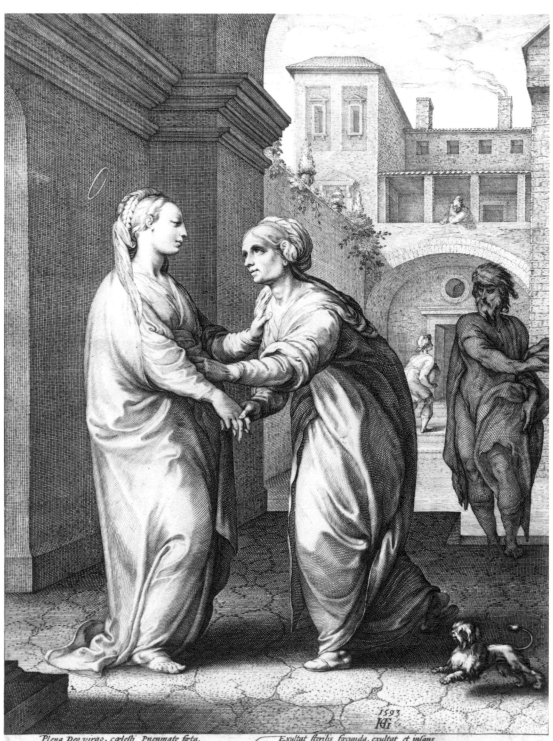

Plena Deo virgo, cælesti Pneumate fœta,
Cognatam Helysaben montana per aspera visit;

Exultat sterilis fœcunda, exultat et infans
Iam tunc in grauidæ genitricis ventre Prophetes.

Figure 5.
Hendrick Goltzius:
*Adoration of the
Shepherds* from the
Life of the Virgin, 1594,
engraving, 46.1 x 35 cm.
The Baltimore
Museum of Art: Garrett
Collection.

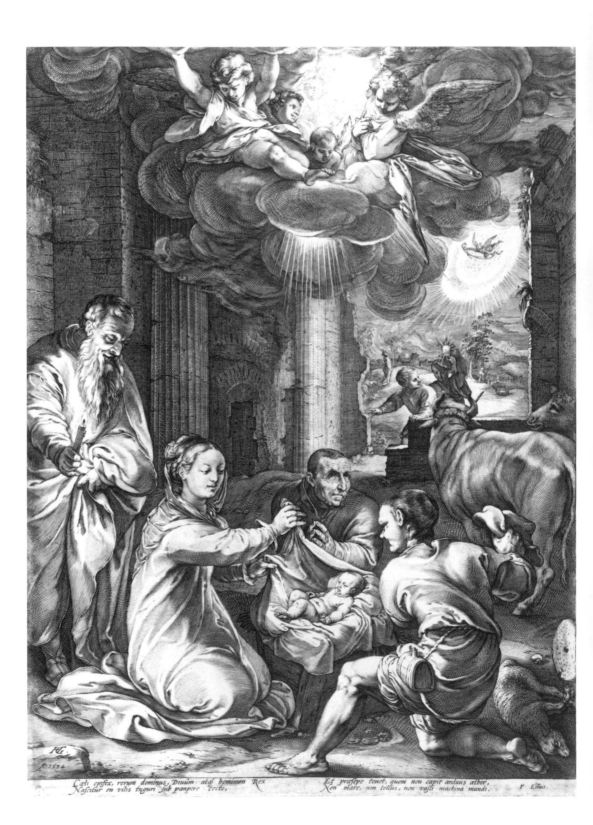

Figure 6.
Hendrick Goltzius:
Circumcision from the
Life of the Virgin, 1594,
engraving, 46.5 x 35.1 cm.
The Baltimore
Museum of Art: Garrett
Collection.

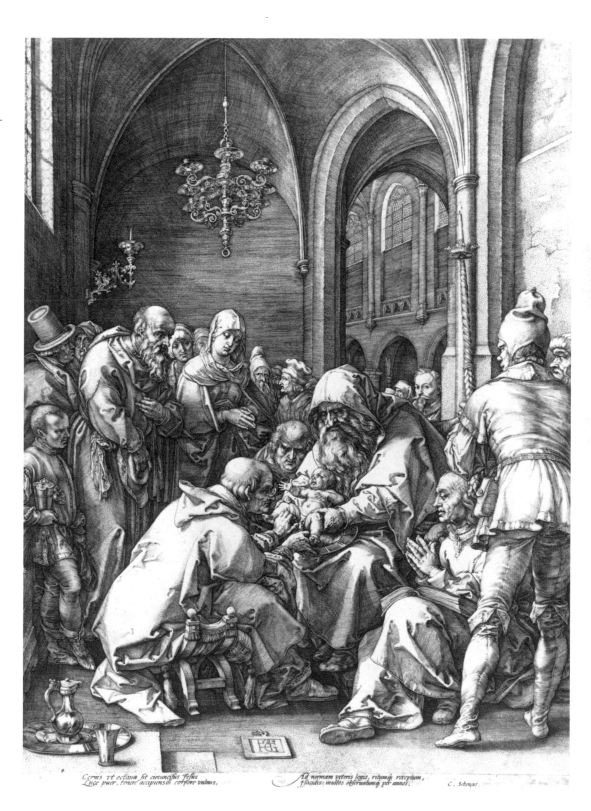

engraving, one that earns Goltzius the title "Proteus-Vertumnus" and confirms his reputation for *teyckenconst*, but it issues from standards articulated by Plantin, Lampsonius, and other proponents of the Flemish burin-hand.[58]

The epithet Proteus-Vertumnus derives from the dedication quatrain inscribed on the *Annunciation*, the opening plate of the *Life of the Virgin*. Composed by Cornelius Schoneus, rector of the Latin school of Haarlem, the dedication purposely mixes metaphors, claiming that "just as Proteus, captivated by eager love for the graceful Pomona, transformed himself in the midst of the waves," so too, "through his mutable art Goltzius, astonishing engraver and inventor, transforms himself."[59] The *Holy Family with the Infant Saint John*, also known as the *Rest on the Flight*, can serve to illustrate Schoneus' meaning, exemplifying the imitative mode personified by Proteus and activated by Goltzius (cat. no. 65). The figures are based on Federico Barocci's *Madonna del gatto*, while the setting and the cherries held by the Christ child recall his *Rest on the Flight* (cat. no. 58), images Goltzius would have known from the famous prints by Cort. These prints, as we have seen, were held to convey Barocci's *wel verwen* (*colorito*), and Goltzius was undoubtedly also familiar with the *Visitation* of 1583-86, painted for the Chiesa Nuova, Rome. Using linear means reminiscent of Cort's, Goltzius incorporates two signature features of Barocci's graceful *handelingh*, later discussed in Van Mander's "Life of Federico Barocci": sweetness of expression distilled in *seer natuerlijck lachende tronien* (very natural, smiling faces) and sweetness of execution seen *in zijn schilderen seer vloeyende* (in his very flowing brushwork), especially his habit of dissolving contours by scumbling at the edges of forms.[60] Yet Goltzius also diverges from Barocci, suggesting the master's pictorial lineage by gathering the Holy Family into a pyramidal group reminiscent of Raphael's *Holy Families*[61] and by using gestures of touch to unite the Virgin, Christ, and John, thereby evoking the *vleesachticheyt* (*morbidezza*, that is, suppleness) of Correggio.[62] By invoking Raphael

and Correggio, Goltzius not only identifies them as Barocci's forebears, he also elucidates Barocci's emulative practice, showing how the master takes possession of regional pictorial paradigms, assimilating elements from the Tuscan Raphael and the Emilian Correggio. These elements, symptomatic of Tuscan and Emilian style—or better, pictorial diction—are fully integrated, forming part of Barocci's characteristic pictorial style. What Goltzius imitates, then, is neither a specific modello nor simply the pictorial manner of Barocci, but rather Barocci's method of emulation, a method whose *locus classicus* is the famous passage from Erasmus' *Dialogus Ciceronianus*: "Now take painters. Suppose that Apelles, who was the supreme portrayer of gods and men of his age, by some chance returned to life in our time. If he now painted Germans as he once painted Greeks, and monarchs as he once painted Alexander, since people are not like that any more, wouldn't he be said to have painted badly?"[63] Painters, in other words, must lay claim to their own authorial identity. They may pay homage to revered paragons such as Apelles, but must refrain from slavish copying, a point made even more strongly later in the dialogue, when Erasmus writes: "I approve of imitation—but imitation of a model that is in accord with, or at least not contrary to, your own native genius, so that you do not embark on a hopeless enterprise, like the giants fighting against the gods. Again, I approve of imitation—but imitation not enslaved to one set of rules, from the guidelines of which it dare not depart, but imitation which gathers from all authors, or at least from the most outstanding, the thing which is the chief virtue of each and which suits your own cast of mind."[64]

The Proteus-Vertumnus metaphor promulgated by Schoneus offers a powerful alternative to the emulative paradigm set forth in the *Ciceronianus*. It alerts us to Goltzius' very different ambition, which is to transfer authorial identity from himself to the masters he imitates, distilling the *handelingh* of Barocci by emulating as he did, and so casting emulation itself as his object of imitation. Rather than emulating Barocci, Goltzius

impersonates him, appropriating from masters whom Barocci considered canonical. Emphasizing this point, Schoneus characterizes Goltzius as servitor, comparing him to Proteus who transformed himself in service to Pomona, as he now transforms himself in service to Wilhelm, and, we might extrapolate, as he transforms himself in service to those masters whose *handelinghen* are the true subjects of the *Life of the Virgin*. In the "Life of Goltzius," Van Mander develops this conceit, showing how thorough was the master's impersonation of Dürer and Lucas, and praising his consummate ability to fold himself into that which he imitates.

Although the Proteus-Vertumnus metaphor and the imitative mode it embodies may at first seem unprecedented, there is in fact a context within which to position it—the discourse of penmanship purveyed in Dutch writing manuals and calligraphic model books familiar to Schoneus, Van Mander, and Goltzius.[65] It is worth considering these sources by way of a closing excursus, since they provide a rich fund of critical terms pertinent to the study of reproductive engraving. The most celebrated of the calligraphic model books, known as *exemplaer boecken*, was Jan van den Velde's *Spieghel der schrijfkonste*, published in Rotterdam in 1605 with a title-page designed by Van Mander and engraved by Goltzius' step-son Jacob Matham (fig. 7).[66] In addition to poems of praise addressed to Van den Velde by Van Mander, who characterizes writing as a pictorial art, the *Spieghel* also contains demonstration folios dedicated to famous *schilders* (picturers), among them Goltzius (fig. 8).[67] Drawing a parallel between himself and Goltzius, Van den Velde commends the latter's superior penmanship, which he deems worthy of a golden pen.

Like earlier model books such as Clemens Perret's *Exercitatio alphabetica* of 1569 and Jodocus Hondius' *Theatrum artis scribendi* of 1594, the *Spieghel* consists of virtuosic writing specimens.[68] Engraved by Simon Frisius after modelli supplied by Van den Velde, these specimens are written in the national hands, demonstrating mastery of the varieties of Latin, Dutch,

German, English, French, Spanish, and Italian hands.[69] Known as *handen* or *handelinghen*, these hands were the repertory within which the master penman was expected to operate, displaying his ability to shift deftly from script to script, from the Netherlandish upright running hand to the Roman square hand, for example. Mastery was held to consist not in inventing a hand, but rather in proficiency at deploying the canonical hands, as Van den Velde makes clear in Part III of the *Spieghel*, a treatise on handwriting entitled *Fondement-Boeck* (*Book of Fundamentals*): "I know well that what I teach here will be examined scrupulously by many fastidious souls, who will gravely proof my writing specimens as well, preferring to find fault rather than improve; I pray them to observe the good differentiation of hands before blaming the liberality of my pen...."[70] In an earlier publication, the *Lettre defensive* of 1599, Van den Velde states his case more forcefully: "...just as those who teach arithmetic cannot rely simply on two or three rules, but must have a thorough grounding in all the rules, and those who teach French cannot know it only after a fashion, but must grasp it completely in order to render it cogently, so too, the master penman cannot rely simply on one hand or two, but must command diverse hands— the precious and highly wrought, the fleet and swift—in order to satisfy all comers; for he will know that some are moved by Italic and Spanish letters, others by letters of state or business."[71]

The assertion that the penman imitates multifarious hands resonates with the assumption, implicit in the figure of Proteus-Vertumnus, that virtuosity comprises the imitation of multifarious *handelinghen*. In the *Schilder-Boeck*, Van Mander himself invites us to make this analogy, when he insists on the sisterhood of *schrijfconst* and *schilderconst*, the arts of writing and picturing.[72] Just as Van Mander uses the Proteus metaphor to argue that Goltzius' inimitable *teyckenconst* consists of his ability to subsume his hand into prior *handelinghen*, so Van den Velde avers that *schrijfconst* requires the penman to work within the *handelinghen* of the seven national scripts, and

Figure 7.
Karel van Mander:
Title-Page to
Jan van den Velde,
Spieghel der schrijfkonste
(1608 ed.), engraving
by Jacob Matham,
1605, approx. 21 x 32 cm.
Victoria and Albert
Museum, London.

Figure 8.
Jan van den Velde:
*Dedication Folio to
Hendrick Goltzius*
from Part I of the
Spieghel der schrijfkonste
(1608 ed.), engraving
by Simon Frisius, 1605,
approx. 21 x 32 cm.
Victoria and Albert
Museum, London.

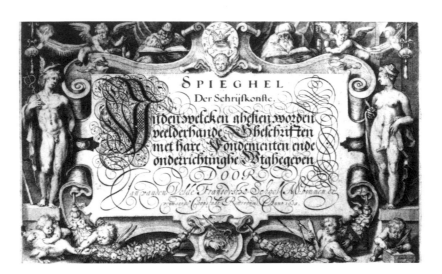

that rather than inventing new hands, the master penman must show his command of the canonical hands. It is within this theoretical nexus that the Proteus-Vertumnus metaphor comes to signify the fullness of Goltzius' accomplishment as reproductive engraver.

Notes

1

See T. Riggs, *Hieronymus Cock: Printmaker and Publisher* (New York and London, 1977), 207-11.

2

On the *Schilder-Boeck*, see W.S. Melion, *Shaping the Netherlandish Canon: Karel van Mander's "Schilder-Boeck"* (Chicago, 1991). In the notes that follow, Book I of the *Schilder-Boeck*, the theoretical poem that opens the text, is designated *Grondt*; Books II-IV, the "Lives" of the ancient, Italian, and Netherlandish picturers, are designated *Levens*.

3

See Van Mander, *Levens*, fols. 273v-274r.

4

See Van Mander, *Levens*, fols. 186v-187r.

5

See Van Mander, *Levens*, fol. 192v. The discussion of Muziano extends the general observations on Italian landscape types in *Grondt*, fol. 36r, stanza 24.

6

See Van Mander, *Levens*, fol. 192v: "Gelijck hy oock de Landtschappen aerdich schilderde, en met de verwe uytnemende handelde: soo was hy oock van ghelijcken uytnemende, de selve te teyckenen met Pen oft crijt. Welcke manier en handelinghe onsen Hoornschen Cornelis Cort seer uytnemende en eygentlijck heeft connen naevolghen, met zijn constigh Graef-ijser: Als te sien is in eenighe Printen, die door desen gesneden, van Muzziano uytcomen, te weten, twee Landtschappen van S. Franciscus, en noch twaelf in de hooght, waer in comen eenige Eremijten, oft Heyligen, die sich in de Woestijn onthielden: dan men sietse weynich uytcomen, oft onder den Schilders. Hier in comen schoon gronden en boomen, met een weynich verschiets."

7

Ibid.

8

See Van Mander, *Levens*, fols. 258v-259r: "Heel overvloedich van ordinantie was hy niet, behielp hem oock wel met d'Italiaensche dinghen: waerom hy niet wel te vreden was op Ieroon Cock, doe hy in Print uytbracht de Schole van Raphael, daer hy zijn studie uyt had, en veel te pas ghebracht in d'Altaer-tafel van den sterf-dagh Mariae tot S. Goelen te Brussel, het welck doe voor alle Man openbaer was." On the print by Giorgio Ghisi after Raphael's *School of Athens*, issued by Cock in 1550, see Riggs, *Hieronymus Cock*, 77-79, and S. Boorsch, M. Lewis, and R. E. Lewis, *The Engravings of Giorgio Ghisi*, exh. cat. (New York, 1985), 61-63.

9

On Cocxie's mnemonic prowess, see Van Mander, *Levens*, fol. 259r.

10

For the text of this letter, see J. H. Hessels, ed., *Abrahami Ortelii et virorum eruditorum ad eundem et ad Jacobum Colium Ortelianum epistulae* (Cambridge, 1887), 379-92, and J. Puraye, *Dominique Lampson humaniste 1532-99* (Bruges, 1950), 101-11.

11

See Hessels, ed., *Epistulae*, 381-83, and Puraye, *Dominique Lampson*, 101-3. On the critical history of the *linea summae tenuitatis*, see H. van de Waal, "The *linea summae tenuitatis* of Apelles: Pliny's Phrase and Its Interpreters," *Zeitschrift für Aesthetik und allgemeine Kunstwissenschaft* 121 (1967), 5-32.

12

See Hessels, ed., *Epistulae*, 383-84, and Puraye, *Dominique Lampson*, 103-4.

13

On the term *graphice*, here associated with the burin and stylus, but used earlier by Politian to signify the kind of painting concerned with mathematical relations, see C. Dempsey, "*Michelangelo and the Language of Art*," *The Burlington Magazine* 125 (1983), 624-27, esp. 625. Lampsonius would have known Hermolao Barbaro's *Castigationes Plinianae*, which cites Pliny's reference to *graphice, hoc est picturam in buxo*, identifying *buxum* as both a writing tablet and a painting tool.

14

See Hessels, ed., *Epistulae*, 382, 385; and Puraye, *Dominique Lampson*, 102-3, 105.

15

See Hessels, ed., *Epistulae*, 385-86, and Puraye, *Dominique Lampson*, 105-6: "Lequel Durer, à la verité, a esté grand homme, et merueilleusement fondé *in graphice*; ainsij quil a monstré, par excellence, et vsque ad stuporem, en ses pourtraictures, faictes, ou entaillees de son burin; et autres par luij pourtraictes sur bois, et puis apres en bois entaillees....De moij; combien que je confesse, quil auoit vne main terriblement adroicte (Je ne parle poinct seullement auec son Burin, ou auec son charbon, ou plume, ou toutte autre sorte de greffe, ains aussij à maniër son pinceau à tout son plaisir) touttesfois je ne mettroij grandement à compte d'ainsij peindre comme il à faict, en tant que ses choses, ou ouurages resentent par trop une certaine sienne maniere, et n'expriment droictement le naturel des choses (Je dis, signamment, ses figures humaines, nues, ou vestues, et ses draperies. Car, quant à autres choses, il les exprimà diuinement bien.), comme ont faict, auec tresmeruelleuse addresse, celles desdicts maistres Italiens....esso disegno suo non mi satisfa quanto quello di Rafaël d'Vrbino, et, principalmente, quanto quello di Michel piu che mortal', Angel' divino."

16

Lampsonius cites Varchi, Cellini, and Vasari at several points; see, for example, Hessels, ed., *Epistulae*, 387, and Puraye, *Dominique Lampson*, 106-7.

17

See C. Plantin, *Correspondance* I, 9 vols., ed. M. Rooses, (Antwerp and Ghent, 1883), 133-34: "Pour satisfaire donques à ce que demandés, j'ay cherché par toutes les boutiques de ceux qui vendent en ceste ville les pourtraictures que j'ay trouvées notées en l'autre page de vostre lettre, et n'ay sceu trouver les douze mois de l'an taillés en formes d'airain, parquoy j'en ay incontinent mandé à Paris, là où ils sont taillés fort nettement, et incontinent les avoir receues dudict lieu, je les délivreray à monsigneur vostre frère, ainsi que j'ay faict présentement trois feilles d'Albert Durer, à scavoir le St Eustace, qui me couste 30 patars, le sainct Hiérosme et la Mélancholie (2 fort belles pièces) qui me coustent chaicun 15 patars, qui est le tout ensemble 3 florins. Or, monsigneur, il vous plaira entendre qu'il se trouve bien quelques pièces de St Eustace vielles, qui se vendent bien jusques 6 fls la pièce, d'autres à 4 fls et d'autres à 3 fls la pièce, combien qu'ils soyent d'une mesme planche et main dudict Albert Durer, et ainsi aussi de divers prix par trop différents de l'ung à l'autre, ce qui advient par le jugement ou affection de painctres ou cognoisseurs de telles pourtraictures, qui prisent quelquefois l'une pièce (bien que d'une mesme main, planche, jour et heure imprimée) 2, 3 ou 4 fois au double plus que l'autre, chose qui se trouveroit fort estrange à ceux qui ne l'ont expérimenté et qui par conséquent pourroit faire esmerveiller ceux à qui on les pourroit envoyer san préadvertissement."

18

See Hessels, ed., *Epistulae*, 175-76. "Denckende te rugge om dancbaer te wesen/ Quam my, Jonstige Ortel, v gift gepresen./ Dye ic van bouen tot ondren/ vrolyc doorsach met verwondren,/ om t'constich tekenen en t'geduldich snyden./ Bruegel en Phlips hebben hen zelf overwonnen./ Elc van hen, acht ic, heuet noyt bat geconnen./ Zo heeft hun vrients Abrams jonste/ geprickelt hun luyder conste:/ Dat dit constige stuc constlyc zal verblyden/ Den constlyeuenden Constenaerts t'allen tyden./ Noyt zach ic (dunct my) tekening bequamere/ noch gelyken snee, dan dees droeve camere./ Wat zegge'ic? zach? D'oren hoorden/ (zoot scheen) dye claechlyke woorden,/ Het zuchten, het wenen, het jammerlyc gescal..../ Dye camer sceen dootlyc, noch docht my leefdet al." On the *Death of the Virgin*, see F. Grossmann, "Bruegel's *Woman Taken in Adultery* and Other Grisailles," *The Burlington Magazine* 94 (1952), 218-28; on Ortelius as print collector, see I. Buchanan, "Dürer and Abraham Ortelius," *The Burlington Magazine* 124 (1982), 734-41.

19

See C. Plantin, *Correspondance* 8, ed. J. Denucé (Antwerp and The Hague, 1918), 84: "Touchant l'image de nostre Dame, je desire affectueusement qu'il vous plaise la faire graver par le meilleur maistre que vous trouverez en Anvers, de la mesme grandeur et stature de l'image principale, si le maistre qui gravera l'image, est excellent il pourra aussi graver les ronds qui sont alentour, lesquels au demeurant ne correspondent a l'oeuvre de la principale image, car ilz sont faicts de diverses mains. Je le remects a vostre discrecion, ce qui coustera, je vous ferais incontinent payer. Enladicte image que vous trouverez ung limasson, vous mectrez mon devis avec lectres qui disent tecum habita Joannes Moflin." On this commission, see M. Rooses, *Les frères Wiericx*

à l'imprimerie Plantinenne (Antwerp, 1881), 9-11; and A. J. J. Delen, "Les artistes collaborateurs de Christophe Plantin," in *Sept études publiées à l'occasion du quatrième centenaire du célèbre imprimeur anversois Christophe Plantin* (Brussels and Antwerp, 1921), 87-123, especially 101-2, 117. On Plantin as print dealer, see idem, "Christoffel Plantin als prentenhandelaar," *De gulden passer* 10 (1932), 1-24. On the *Virgin of Sorrows*, among the most expensive plates commissioned by Plantin, see M. Mauquoy-Hendrickx, *Les estampes des Wierix* I, 3 vols. (Brussels, 1978-82), 138, plate 108.

20

On Plantin's difficult relations with the Wierix brothers, see M. Rooses, "De plaatsnijders der *Evangelicae historiae imagines*," *Oud-Holland* 6 (1888), 277-88; and Delen, "Artistes collaborateurs," 116-19.

21

Moflin's criterion, discernible in his letter to Plantin, was to remain unrealized. Responding to Van den Broeck's homogeneous copy after the lost original, Wierix ultimately standardized the roundels. On the Wierix prints after Dürer, see H. Kauffmann, "Dürer in der Kunst und im Kunsturteil um 1600," *Anzeiger des Germanischen National-Museums* (1954), 18-60; G. Langemeyer and R. Schleier, *Bilder nach Bildern*, exh. cat. (Münster, 1976), 98-104; and Mauquoy-Hendrickx, *Estampes*, passim.

22

See C. Plantin, *Correspondance* 6, ed. Denucé (Antwerp and The Hague, 1916), 85-86.

23

See ibid., 1-12: "...car à Vienne, il n'y a pas de maîtres-graveurs." See, too, on the Jesuit order's strenuous efforts to secure a Flemish engraver through Plantin, Rooses, "Plaatsnijders der *Evangelicae historiae imagines*"; M. Mauquoy-Hendrickx, "Les Wierix illustrateurs de la Bible dite de Natalis," *Quaerendo* 6 (1976), 28-63, especially 28-34; M.-B. Wadell, *"Evangelicae historiae imagines": Entstehungsgeschichte und Vorlage* (Gothenburg, 1985), 9-17.

24

See Plantin, *Correspondance* 6, ed. Denucé (Antwerp and The Hague, 1916), 288-94.

25

See C. Plantin, *Correspondance* 5, ed. Denucé (Antwerp and The Hague, 1915), 108-11. On the statutes and protocols governing the Plantin workshop, see M. Sabbe, *De Plantijnsche werkstede: arbeidsregeling, tucht en maatschappelijke voorzorg in de oude Antwerpsche drukkerij* (Antwerp, 1935).

26

For the passages on Heemskerck, Coornhert and Galle, see I.M. Veldman, "Maarten van Heemskerck and Hadrianus Junius: The Relationship Between a Painter and a Humanist," *Simiolus* 7 (1974), 35-54, notes 12 and 13.

27

See ibid., 46-49. For specimens of poetry on prints by Plantin, see M. van Durme, ed., *Supplément à la correspondance de Christophe Plantin* (Antwerp, 1955), 336.

28

On the *Pinaces*, see Veldman, "Heemskerck and Junius," 43-50.

29

See E. McGrath, "Rubens's *Susanna and the Elders* and Moralizing Inscriptions on Prints," in H. Vekeman and J. Müller Hofstede, eds., *Wort und Bild in der niederländischen Kunst und Literatur des 16. und 17. Jahrhunderts* (Erftstadt, 1983), 73-90.

30

See Veldman, "Heemskerck and Junius," 37.

31

On these prints, see Riggs, *Hieronymus Cock*, 279-80, 337.

32

On the burin-hand of Coornhert, Galle, and Cort, see ibid., 72-124; on Cort, see too, W. S. Melion, "Hendrick Goltzius's Project of Reproductive Engraving," *Art History* 13 (1990), 458-87, especially 460-62.

33

See Veldman, "Heemskerck and Junius," 37.

34

See ibid., 36, note 9.

35

See Hessels, ed., *Epistulae*, 386; and Puraye, *Dominique Lampson*, 105-6.

36

On this dialogue, see E. Panofsky, "Erasmus and the Visual Arts," *Journal of the Warburg and Courtauld Institutes* 32 (1969), 200-27, especially 223-27; R. Nash, ed. and trans., *Calligraphy and Printing in the Sixteenth Century* (Antwerp, 1964); and A. S. Osley, ed. and trans., *Erasmus on Handwriting* (Wormley, 1970). On the possible importance of Erasmus' Dürer encomium to the reproductive engraver Aegidius Sadeler, see D. Limouze, "Aegidius Sadeler (1570-1629): Drawings, Prints, and the Development of an Art Theoretical Attitude," in E. Fučíková, ed., *Prag um 1600: Beiträge zur Kunst und Kultur am Hofe Rudolfs II.* (Freren/Emsland, 1988), 183-92, especially 189.

37

See Panofsky, "Erasmus and the Visual Arts," 224-25.

38

See ibid., 226.

39

See M. Winner, "Die Quellen der Pictura-Allegorien in gemalten Bildergalerien des 17. Jahrhunderts" (Ph.D. diss., University of Cologne, 1957); and idem, "Berninis *Verità*," in *Munuscula discipulorum: Hans Kauffmann zum 70. Geburtstag* (Berlin, 1968), 393-413.

40

See H. Mielke, "Antwerpener Graphik in der 2. Hälfte des 16. Jahrhunderts," *Zeitschrift für Kunstgeschichte* 38 (1975), 29-83, especially 36-37.

41

See ibid., 61-62.

42

On the prices paid by Plantin, see Rooses, *Les frères Wiericx*, 20-24; and Delen, "Artistes collaborateurs," 112-17. On reproductive prints as epitomes of Goltzius' *teyckenconst*, see *Levens*, fol. 284r.

43

On these letters, see Melion, "Goltzius's Project of Reproductive Engraving," 467-74.

44

On Lampsonius as biographer, see Puraye, *Dominique Lampson*, 60-64; and J. Hubaux and J. Puraye, eds. and trans., "Dominique Lampson, *Lamberti Lombardi...vita*," *Revue belge d'archéologie et d'histoire de l'art* 18 (1949), 53-77, especially 53-61.

45

See D. Lampsonius, *Lamberti Lombardi apud Eburiones pictoris celeberrimi vita* (Bruges, 1565), 34-35: "...partim verò vt liberalis erat atque ad beneficentiam quantamcunque & vbicunque praestare posset, semper paratus; exemplo non modo excellentissimorum artificum, sed eorundem quoque optimorum & usus publici studiosissimorum virorum Mantenij, Alberti Dureri, Raphaelis Vrbinatis, ad eorum vsum, qui inferioris notae pictores, inuentionis ac delineationis facultate atque artificio destituti eius inuenta coloribus ad quaestum diurnum exprimebant. Quibus, & specularum e vitro fenestrarum pictoribus sciographicis, necnon mediocribus sculptoribus quo prolixiùs ac minore ipsorum impendio subveniret: non pauca inuenta sua aeneis tabellis impressorijs incidi curauit, quarum ectypa in charta passim prostant. Adeóque ipsi potissimùm deberi fatendum est, quòd tum alibi tum verò Anverpiae multi hoc tempore magnorum artificum inuentis in aere incidendis non sine laude incumbunt, quippe qui omnium primus domi suae tanquam in schola adolescentes habuerit, quos in delineandis, incidendísque tum suis tum aliorum inuentis exerceret; longe id quidem maiore sua impensa, quàm fructu, vt vel hinc maximè eius non liberalitatem modò, sed in benefaciendo poene dixerim pertinaciam quandam agnoscas."

46

See ibid., 6-7.

47

See ibid., 8: "...vt perinde ac si vtriusque antiquae linguae difficultates peruicisset."

48

See ibid: "...& vt pro homine eruditarum linguarum praesidio destituto."

49

For the text of this letter, see K. Frey and H.-W. Frey, eds., *Giorgio Vasari: Der literarische Nachlass* 2, 3 vols. (Hildesheim and New York, 1982), 158-63; and Puraye, *Dominique Lampson*, 84-89.

50

For the text of this letter, see G. Gaye, ed., *Carteggio inedito d'artisti dei secoli XIV. XV. XVI.* 3, 3 vols. (Florence, 1840; reprint, Turin, 1961), 242-4; and Puraye, *Dominique Lampson*, 90-92.

51

For the text of this letter, see U. da Como, *Girolamo Muziano 1528-1592: note e documenti* (Bergamo, 1930), 180-83; and Puraye, *Dominique Lampson*, 92-100.

52

On the print by Bonasone, see S. Massari, *Giulio Bonasone* 1, 2 vols. (Rome, 1983), 71, plates 79a and 79b.

53

See Van Mander, *Levens*, fols. 284v-285r. On the *Life of the Virgin*, see O. Hirschmann, *Verzeichnis des graphischen Werks von Hendrick Goltzius 1558-1617* (Leipzig, 1921; reprint, Brunswick, 1976), 6-12; and W.L. Strauss, *Hendrik Goltzius 1558-1617: The Complete Engravings and Woodcuts* 2, 2 vols. (New York, 1977), 574-77, 580-87. See, too, D. Acton, "The Northern Masters in Goltzius's *Meisterstiche*," *Bulletin, Museums of Art and Archaeology, University of Michigan* 4 (1981), 40-53; and W. S. Melion, "Piety and Pictorial Manner in Hendrick Goltzius's *Early Life of the Virgin*," in G. Harcourt, ed., *Hendrick Goltzius and the Classical Tradition*, exh. cat. (Los Angeles, 1992), 44-51.

54

See Van Mander, *Levens*, fols. 283r-284r. For corroboration of Goltzius' strategy of traveling *vermomt en in mascarade* (disguised and in masquerade), see Lampsonius' letter of 24 May 1591, cited in O. Hirschmann, *Hendrick Goltzius als Maler 1600-1617* (The Hague, 1916), 10, note 1: "...having disguised himself, Goltzius visited Jan Sadeler (a blameless artisan), belittling and even contemning his own work, so that he drew a like contempt from Sadeler, whom Goltzius then derided and reproved in letters left at his lodging."

55

See Van Mander, *Levens*, fol. 284r, in which Goltzius is applauded for having counterfeited *verscheyden handelingen der beste Meesters* (various manners of the best masters).

56

See ibid., fol. 285v; see, too, fol. 283r, in which we are told that Goltzius visited Venice, Bologna, and Florence en route to Rome.

57

See ibid., fols. 284v-285r.

58

There is evidence that Goltzius revered Cort: in early plates such as the *Annunciation* (Hirschmann, *Verzeichnis*, 153; Strauss, *Engravings*, 116-17), engraved for Aux Quatre Vents, he emulates Cort's manner of line; and he purchased several of Cort's unsigned plates in 1600, inscribing them with Cort's name prior to reissuing them.

59

"Ut mediis Proteus se transformabat in undis,/ Formose cupido Pomone captur amore:/ Sic varia Princeps Tibi nunc se Goltzius arte/ Commutat, sculptor mirabilis, atque repertor."

60

See *Levens*, fol. 186v.

61

Compare the *Holy Family with the Lamb* of 1507 in Madrid and the *Canigiani Holy Family* in Munich.

62

Compare the gestures of Goltzius's Virgin and Christ to those of Christ and Catherine in Correggio's *Madonna and Child with Saints Jerome and Catherine*, perhaps known to Goltzius in the prints by Cristofano Cartaro and Agostino Carracci.

63

See D. Erasmus, *Dialogus Ciceronianus*, trans. and ed. B.I. Knott, in A.H.T. Levi, ed., *Collected Works of Erasmus: Literary and Educational Writings 6* (Toronto, Buffalo and London, 1986), 381. Van Mander was familiar with this passage, a version of which he incorporated into his "Life of the Brothers van Eyck"; see *Levens*, fol. 199v. On the *Ciceronianus* as a response to Bembo and its place within the humanist debate on imitation, see M. Fumaroli, *L'age de l'éloquence: rhétorique et 'res literaria' de la Renaissance au seuil de l'époque classique* (Geneva, 1980), 101-106; on the relevance of this passage to humanist proponents of the visual arts in the Netherlands, see M. Sullivan, "Bruegel's Proverbs: Art and Audience in the Northern Renaissance," *Art Bulletin* 73 (1991), 431-66, esp. 460.

64

See Erasmus, *Ciceronianus*, trans. and ed. Knott, 441.

65

On Dutch writing manuals and calligraphic model books and their pertinence to Dutch theory and practice of the visual arts, see W.S. Melion, "Memory and the Kinship of Writing and Picturing in the Early Seventeenth-Century Netherlands," *Word & Image* 8 (1992), 48-70.

66

See Jan van den Velde, *Spieghel der schrijfkonste, in den welcken ghesien worden veelderhande gheschriften, met hare fondementen ende onderrichtinghe wtghegeven* (Rotterdam, 1605). On the *Spieghel*, see P. de Keyser, "De schrijfmeester Jan vanden Velde (1568-1623) en zijn beteekenis als schrijfkunstenaar," *De gulden passer* 21 (1943), 225-60, esp. 250-57; and A.R.A. Croiset van Uchelen, *Deliciae: over de schrijfkunst van Jan van den Velde* (Haarlem, 1984), 28-35. In considering the nexus between writing and engraving, it is worth noting that copperplate was favored as the medium best suited to translating the calligraphers' exemplars. Jan van den Velde relied on the engravers Simon Frisius and Gerrit Gauw, and he apprenticed his son Jan van de Velde II to Jacob Matham, undoubtedly hoping to secure Jan's services as collaborator. On writing and engraving, see Croiset van Uchelen, *Deliciae*, 19-21 and 25-28.

67

See Van den Velde, *Spieghel*, fol. 20r.

68

On Perret, see A.R.A. Croiset van Uchelen, "The Mysterious Writing-Master Clemens Perret and His Two Copy-Books," *Quaerendo* 17 (1987), 3-44; on Hondius, see C. P. Burger, Jr., "Jodocus Hondius en het *Theatrum artis scribendi*," *Het boek* 13 (1935-36), 184-90.

69

On the codification of these hands, see A. R. A. Croiset van Uchelen, "Dutch Writing-Masters and the 'Prix de la Plume Couronnée,'" *Quaerendo* 6 (1976), 319-346; idem, *Nederlandse schrijfmeesters uit de zeventiende eeuw*, exh. cat. (The Hague, 1978), 3-28; and idem, "The Mysterious Writing-Master Clemens Perret," 3-28.

70

I quote from the Dutch edition published in Amsterdam in 1608, unfoliated [68r-v]: "Ick weet wel dat vele curieuse

Gheesten op dese myne onderrichtinghe seer nauwe letten,
ende myne Gheschriften met de selven seer ernstelicken
nae speuren sullen, veel eer soeckende eens anders werc te
berispen dan te verbeteren, de welcke ick wil ghebeden
hebben, voor eerst een goet onderscheyt van d'een tot
d'ander willen maken, al eer sy de mildicheyt van myn
Penne berispen...."

71

See Jan van den Velde, *Lettre defensive, pour l'art de bien
escrire* (Rotterdam, 1599), unpaginated [14]: "Pareillement il
ne suffit pas aussi à un Maistre de Plume, de scavoir escrire
simplement une main ou deux, ains faut necessairement
qu'il en sache plusieurs diverses sortes, pour en satisfaire à
tous venants, tant des lettres curieuses & mignardes, que
courantes & depeschives, selon qu'il cognoistra que les
hommes les affecteront diversement, comme nous voyons
que l'un veut une lettre Italique ou Espaignole, & l'autre
une lettre d'Estat ou Marchande." See, too, unpaginated
[4]: "Parquoi ce n'est pas assés d'inventer & d'escrire en
quelque langage, ains faut que celuy qui veut mettre la main
à la plume, ait un fonds de bonnes matieres, un amas de
parolles de choix & d'eslite, & qu'il les mesnage dextrement,
autrement il servira plus de scandale, que d'edification &
de bon exemple." On the *Lettre defensive*, see Croiset van
Uchelen, *Deliciae*, 16-17.

72

See Van Mander, *Levens*, fol. 59r-v, and *Wtleggingh*, fol.
ijr-v. Lampsonius propounds the affinity of writing and
picturing in his letter to Demontiosius discussed above; see
Hessels, ed., *Epistulae*, 388-89, and Puraye, *Dominique
Lampson*, 108. Having praised Dürer, who resembles
Apelles in his mastery of his tools, Lampsonius then com-
pares Dürer and Michelangelo to writing masters: whereas
Dürer is like a calligrapher who writes an excellent hand,
but whose individual letters lack perfection, Michelangelo,
whose letters are perfectly formed, fails to command an
entire hand. In using Goltzius' *Circumcision* in the manner
of Dürer to secure his claim to the title Proteus, Van
Mander positions him as heir to the sort of praise lavished
on Dürer by Erasmus and Lampsonius.

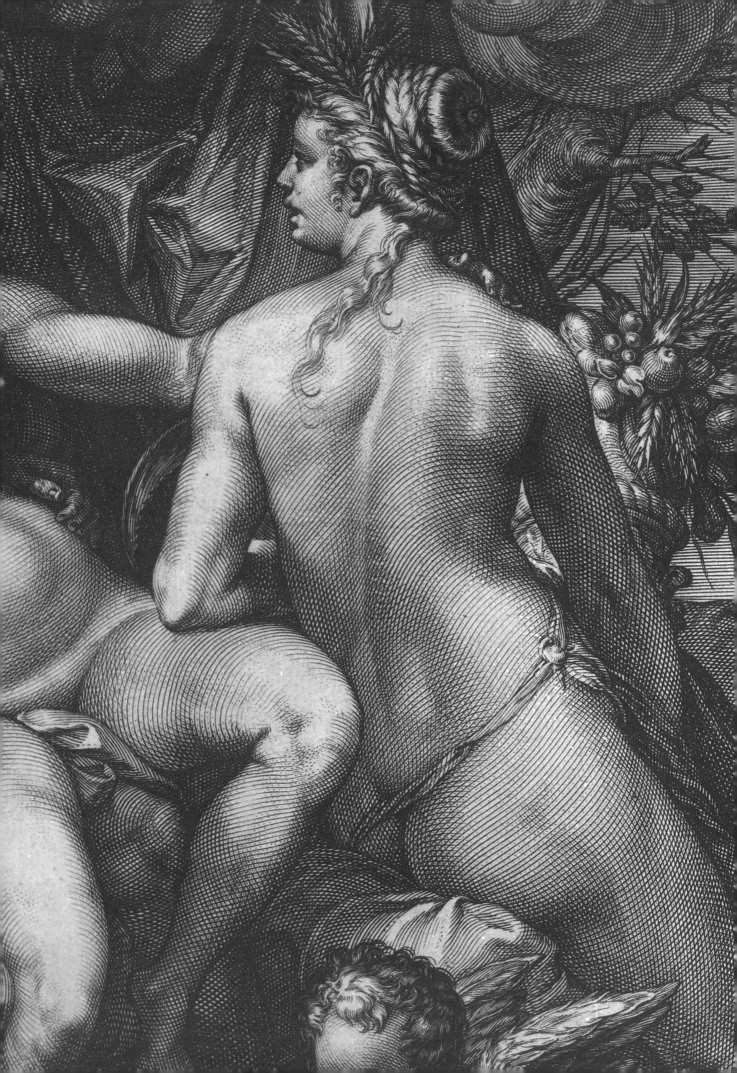

Imitation & Emulation

GOLTZIUS AS

EVOLUTIONARY REPRODUCTIVE ENGRAVER

LARRY SILVER

Dedicated to all the Polish Goltzes,
esp. Annie Goltz Geeteh, favorite aunt of blessed memory,
and Lillye Goltz Silver, beloved grandmother,
together with their wonderful fraternal quartet of
Harry, Joe, Morris, and Isidore Lewis.

Sculpsit: 1576-82

When Hendrick Goltzius (1558-1617) began his printmaking career in his late teens, Hieronymus Cock's workshop, Aux Quatre Vents, was in the hands of Cock's widow, and his former engraver, Philipp Galle, was already active with his own print production house. Cock's contacts with Holland, particularly Haarlem, had always been good. First Dirck Volkertsz. Coornhert and later Galle and Harmen Muller made engravings for Cock after designs by the Haarlem painter Maarten van Heemskerck. It was into that Haarlem branch of printmaking, with its base in Antwerp, that the young Goltzius entered.

Goltzius learned the craft of glass painting when he worked for his father, Jan II Goltz, an able painter who was also the son of a painter, in the Cleves city of Duisburg. Probably around 1575, Hendrick apprenticed as an engraver with Coornhert in nearby Xanten, where in exile as a political radical and independent theologian, the former professional engraver supported himself once more with his craft. Goltzius is mentioned as Coornhert's "discipele Golsen," hence also his theological follower as well as his apprentice, in a letter of 1576.[1] In 1577 Goltzius moved with Coornhert back to Haarlem.[2] In Haarlem he worked for both Coornhert and Galle, and in 1579 he married Margaretha Jansdochter. Widow of Adriaen Matham, Margaretha had an eight-year-old son, Jacob Matham, who would eventually serve his stepfather as a talented engraver and work as a publisher in his own right. Goltzius may well have issued some engravings of his own as early as 1576. A careful portrait of the renowned geographer, *Gerhardus Mercator* (1576; Strauss 1),[3] bears no signature but already shows a format that was to become a favorite of Goltzius: the portrait bust in an inscribed oval (see *Arnoud van Beresteyn*, 1579; cat. no. 60; Strauss 114).[4] This pictorial formula may derive either from Cock's cycle, *Portraits of European Rulers*, begun as early as 1556, or else from an isolated Cock oval portrait with strapwork cartouche from 1555, Frans Huys's engraving after Antonis Mor, *Philip II.*

Portrait tributes to renowned cultural or political figures, often within an oval format, would remain a staple of Goltzius's print output in years to come. (For 1579-80 alone, see Strauss 107-138.) Indeed, until his departure for Italy at the end of 1590, Goltzius was one of the most active producers of portrait prints in the Low Countries.

In 1578 the artist produced a frontal portrait of his father, *Jan Gols II*, in oval with cartouche (Strauss 52), and his greatest portrait, the posthumous frontal tribute to his master and mentor, *Coornhert* (ca. 1591-92; Strauss 287), retains the inscribed oval while adding an elaborate frame.[5] Additional portrait tributes by Goltzius to creative individuals conform to another precedent: the Antoine Wierix and Cornelis Cort engravings for Cock's *Portraits of Eminent Dutch and Flemish Painters* (cat. nos. 47-48); they feature half-length figures, sometimes with landscape backgrounds above a florid inscription. Portrait prints of this kind include *Philipp Galle* (1582; fig. 1; Strauss 156) and *Christopher Plantin* (ca. 1583; Strauss 175).

Of course, portrait engravings are not "reproductive" in the narrower sense of depending upon the prior design of another artist. By their very nature, they depend on life studies of the sitter, and Goltzius was too accomplished a draftsman in his own right to require the drawings of another artist from a model. The source for the engraving of his father is in fact his earliest known drawing (Reznicek 272).[6] However, portrait engravings already suggest the dual nature of Goltzius's activity as a printmaker. Even when the engraving was fully his own, graven by his hand and then published by him, he went on to reproduce his own preliminary drawing as a necessary first stage in the production process. In this respect, Goltzius encapsulated each of the separate elements of printmaking, rationalized and industrialized in the workshop assembly line of Hieronymus Cock and other print publishers after mid-century. Goltzius frequently performed only some part or parts of the full printmaking sequence: design-engraving-printing-publishing. Indeed, the evolution of his career is marked by shifting responsibilities for each of these tasks.

At the beginning of his career, Goltzius primarily engraved plates after the designs of others—a true reproductive printmaker in the literal sense. His technique as well as his figures derived primarily from his design source, and in his prints he followed the precedent of Cock's engravings by distinguishing his own contribution, "sculpsit," from the designer, "invenit." At this time Goltzius was working for Antwerp publishers, chiefly Galle and Aux Quatre Vents. His designers included Jan van der Straet (Johannes Stradanus, 1523-1605; Strauss 6-10, 12-16, 91-105, 154, ca. 1577-79, 1582) and Anthonie van Blocklandt (1532-83; Strauss 90, ca. 1578) for Galle, plus Martin de Vos (1532-1603; Strauss 38-50, ca. 1578) for the Quatre Vents. The choice of artists is significant. These were the visual heirs in Antwerp printmaking to the heritage of the Cock era, dominated by Frans Floris, Pieter Bruegel, and Heemskerck. Blocklandt was a pupil of Floris, de Vos his visual heir in Antwerp (and a frequent print designer for the Wierixes), and Van der Straet, born in Bruges but a resident of Medicean Florence later in his career, a popular designer of series for Antwerp publishers.[7] Moreover, all of these artists shared the prestige of having connections with Italy, and a "high style" suited for biblical or mythological subjects. (Van der Straet was also renowned for his animal subjects, especially exotic hunt scenes; his designs for Goltzius include the aristocratic subject of the Royal Stable of Don John of Austria, governor of the Netherlands.)

Even during the later 1570s, when Goltzius was himself the designer, usually with Philipp Galle as his publisher, the former's visual ideas stemmed from recent Antwerp models in both forms and subjects. Nude allegories in niches depicting the *Seven Virtues* (Strauss 67-73) or clothed, seated allegories of Eternal Life before a landscape (the Virtues and Vices, Strauss 74-81) stand close to analogous sets after Frans Floris, usually issued by Aux Quatre Vents.[8] The mannered figure types, however, stand closer to the work of Floris's followers, particularly Blocklandt, with their small heads and large-hipped

Figure 1.
Hendrick Goltzius:
Philipp Galle, 1582,
engraving, 15.2 x 13.5 cm.
Yale University Art
Gallery, New Haven.

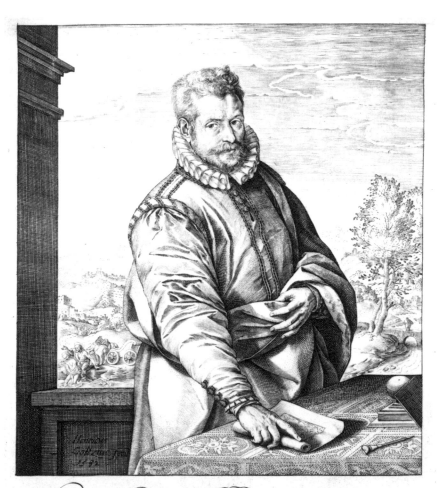

In ære, Lector, ora scalpta quæ vides,
Imaginem eße Gallionis ut scias;
Meo, aut alius indice haud opus tibi:
Modò ante visus ille vel semel tibi.
O erudita lima, o artifex manus,
Beata Gallione Goltzy manus,
Beata Gallionis ora Goltzio.

bodies. What these images strongly suggest is that Goltzius, even when a designer in his own right, was closely supervised by his publisher Galle, who had been his means of access to Antwerp art and printmaking by way of their common Haarlem origins and who was the principal print publisher of Blocklandt designs.[9] Goltzius would go on to replicate Blocklandt designs in his own right as publisher after 1582 (*Lot Leaving Sodom*, 1582; cat. no. 59; Strauss 162), and Reznicek rightly points to his dependence in his own designs, such as *Andromeda*, 1583 (Strauss 170) on the example of Blocklandt in this period. Blocklandt's figural formulas still dominated Goltzius's most ambitious uncompleted engraving, *Massacre of the Innocents* (after 1588; Strauss 206).[10] This particular example of ongoing influence makes clear how much Goltzius's interaction with both an artist-designer and a publisher informed his own work, first as an engraver and subsequently as a designer of figures. In this early phase of his career, Goltzius had already established his own fluid assimilation of visual models, his ability to imitate and then to improvise on the example of leading print designers, such as Blocklandt. What Cock had split asunder in separating design from the craft of engraving by specialists, Goltzius was now slowly reassembling. Soon he would also reintegrate Cock's own job, printing and publishing, into a single enterprise.

Excudit: 1583-90

Two major acts of independence highlighted the phase of Goltzius's career beginning in 1583. First, marked by his grateful engraved tribute, the portrait print *Philipp Galle* (1582; fig. 1; Strauss 156), Goltzius left Galle's shop and embarked on his own publishing venture at Haarlem. Second, Karel van Mander, future biographer of Goltzius and other Netherlandish artists (*Het Schilderboeck*, 1604), returned to Haarlem from Rome and Vienna, site of the court of Emperor Rudolf II, and showed the budding print publisher an entirely new visual repertoire in the drawings of Antwerp-born Bartholomeus Spranger (1546-

1611): "When I came to live at Haarlem in 1583, I met him [Goltzius] and showed him some drawings by Spranger, which he found very interesting."[11] Spranger's powerful influence on Goltzius is one of the most often-discussed aspects of the printmaker's development and need not be elaborated upon here.[12]

What is important and frequently overlooked in terms of Goltzius's print output is that these two opportunities coincided, and Goltzius-the-printer-publisher permitted Goltzius-the-engraver to pursue his own formal experiments, both in the new Spranger figure type and with an original engraving technique of swelling and tapering lines to render volumes as well as nuances of lighting. Both developments must be considered together.

From Spranger's work Goltzius learned the latest in "high style" figuration, a sensual and elongated grace Spranger had developed after a decade of travel in Italy and exposure to artists such as Correggio and Parmigianino as well as the Zuccari and sculptor Giovanni da Bologna. Spranger used such elegant figures for the complex allegories and mythologies at the court of Rudolf II.[13] Such mythologies appear in six Goltzius engravings between 1585 and 1588. Many bear the signs of direct reproduction of Spranger designs: "Bartholomaeus Spranger invenit./ HGoltzius sculpsit et excudit."[14] In the case of the largest of these engravings, *The Wedding of Cupid and Psyche* (1587; cat. no. 61; Strauss 255), the original Spranger drawing is preserved in the Amsterdam Print Cabinet, exactly the size of the engraving and outlined for transfer to the three copper plates.[15] In addition to reproductive engravings after Spranger, Goltzius reproduced one other double-plate, large-scale print in this period: *Venetian Wedding* (1584; fig. 2; Strauss 182) after a drawing of the same size in ink with blue wash by Dirck Barendsz. (Amsterdam).[16]

Goltzius also made his "own" designs after Spranger drawings in a few instances, such as the *Repentant Magdalene* (1585, Strauss 220), whose ultimate source is Spranger's ink, wash, and body color drawing of the same figure in a similar pose;

Figure 2.
Hendrick Goltzius after
Jan Barendsz.i
Venetian Wedding, ca. 1584,
engraving, 43.1 x 73.3 cm.
Rijksmuseum, Amsterdam.

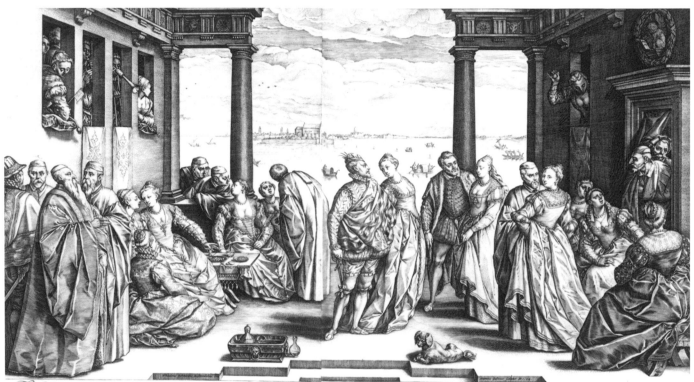

Hic Antenorei Connubia magna Senatus,
Patriciosq; vides coetus, Venetosq; Hymenæos.

Et celebres thalami ritus tædasq; iugales
Solennesq; vrbis pompas, clarosq; triumphos.

Ijsin matronarum cultus, habitusq; superbos,
Squalentesq; auro vestes, gemmisq; nitentes.

Quæ non visa prius, multisq; incognita terris,
Nunc euulgantur totum spectanda per orbem.

this drawing resembles the grisaille oil sketches made by Dirck Barendsz. for engravings by Jan Sadeler.[17] In this and several other cases, Goltzius designates himself as the "inventor" of figures clearly derived from the model of Spranger, sometimes admixed with vestiges of Blocklandt, like the case of the *Massacre of the Innocents*. The 1585 *Mars and Venus Surprised by Vulcan* (Strauss 216), proudly signed by Goltzius in all of his roles ("HGoltzius invenit sculpsit et divulgavit") is a case in point; its original drawing survives (Malibu, Getty Museum; Reznicek 105).[18]

Such drawings mark a turning point in Goltzius's working method as draftsman. Prior to his contact with the Spranger graphic images he had primarily used drawings to record the likenesses of sitters for portraits, often for replication as engravings. After 1585, however, Goltzius, too, composes allegorical and mythological figures as ink drawings, either with wash or with the meticulous imitation in ink of his new technique of burin strokes of engraving. Both kinds of drawing, if intended as careful preparation designs for printmaking, can truly be called modellos. An example of the former technique, still redolent of the swaying poses, oval heads, and lanky bodies of Spranger, is the 1590 ink and wash drawing, *The Judgment of Midas* (New York, Morgan Library), replicated in reverse in an engraving of the same year (Strauss 285).[19] The latter technique is provided by the virtuoso linework of a 1586 study for *Marcus Curtius* (Copenhagen), a print in the series of ten *Roman Heroes* (Strauss 234, series 230-39).[20]

At the same time that Goltzius was experimenting with the Spranger figural style and subject matter in his prints after 1585, he also boldly expanded his burin technique towards a virtuoso display of swelling and tapering line, or *taille*, as the *Marcus Curtius* shows. Longer and darker lines swirl decoratively in the curling clouds of the horse's mane; intersecting, they form a net around the depicted musculature of both horse and hero. Those dense intersections, however, take on an abstract vitality of their own, a "zebra-stripe" reversal of positive and negative that

seems to flicker over the surfaces of such volumes. Some of this experimentation had already taken place with finer lines in the horse figures of Goltzius's *Royal Stable of Don John of Austria* (ca. 1579; Strauss 91-105), after designs by Van der Straet. The analogous subject suggests that Goltzius chose a non-human subject to explore technique and then used his virtuosity to enliven his repeated subjects of horses in landscapes.

Creating his own cycle of *Roman Heroes* enabled Goltzius to experiment further with his new technique in the laboratory of a theme and variations on muscular humans and horses in energetic action, together with the heroic historical subjects appropriate to the new Spranger idiom. For Goltzius, then, Spranger's figural types and elevated themes permitted, even complemented, virtuoso technical elaboration in prints as well as in drawings. A climax of this virtuoso experimentation, still based on Spranger, is the massive 1587 *Wedding of Cupid and Psyche* (cat. no. 61), a showpiece of scale, technique, and figuration of classical figures. Van Mander said of this print that it conferred immortality on draftsman and engraver alike (Van Mander/Floerke, II, 242), perhaps recognizing that it escalates the size and numbers of figures of famous precedents, such as Marcantonio Raimondi's reproductive engravings after Raphael designs (ca. 1517/20): *Judgment of Paris* and *Parnassus*.[21]

If we consider further the meanings of Goltzius's major mythological prints of this Spranger-dominated period, 1585-90, a consistent pattern emerges in which moralizing inscriptions contradict the seemingly seductive sensuality of the images themselves.[22] In the 1585 *Mars and Venus*, a Latin inscription castigates the lewdness of Mars and the scandalous secrecy of Venus as it warns that, like Phoebus Apollo, a watchful God sees the hidden guilt of a sinful life. In the *Wedding of Cupid and Psyche*, a learned Latin inscription dedicates the print to Wolfgang Rumpf, chancellor to Rudolf II. Here the text first recalls how the fury of Venus and the envy of Psyche by her sisters lessened their participation in the celebratory divine meal, then goes on to extract a

moral lesson from the pagan fable, citing the analogy of how bees collect honey and the spider makes a web from slime. Thus, Psyche is an allegory of the soul that reaches divine honor despite the bad counsel of fleshly Venus and the privations of "cold and sickness, hunger, wars and crises" as well as the final destiny of death. Because of the steadfastness of holy Cupid, divine love, her rewards are the eternal bliss of nectar and ambrosia for a blessed life. In the case of the *Judgment of Midas*, the Latin inscription was composed by Franco Estius, and it draws lessons about the nature of art: those who are foolish do not recognize true art and judge only the gross effects, whereas true art is modest and silent. In all three cases, the artist's pictorial and technical achievements are matched with his elevated, Latin, didactic inscriptions, indicating his ambition to create in prints an art of the highest moral seriousness.[23] Moreover, the implied progression is from an initial visual attraction of seductive sensuality towards a subsequent intellectual, verbally stated moral truth, thereby situating the beholder ambiguously in between, midway between earthly sense and godlike intellect.[24] Such morals were readily derived from Ovid already at the time of the late medieval *Ovide moralisée*, but they received a renewed importance in Haarlem at this time from Van Mander, who published his "Wtlegghingh" (Interpretation) of the *Metamorphoses* with his lives of the painters in 1604 but was already at work on it by the late 1580s alongside his colleague in Haarlem.

Spranger was not the only artist whose work profoundly shaped Goltzius's figures and themes in the late 1580s. Closer to home his Haarlem colleague, Cornelis Cornelisz., also offered him models for reproductive engravings of the loftiest mythological subjects. In 1588 Goltzius adopted from paintings of Cornelisz. a series of prideful punished titans, *The Disgracers* (see *Tantalus*, fig. 3; Strauss 257-60), plus *The Dragon Devouring the Companions of Cadmus* (Strauss 161), horrific works produced in his most extravagant virtuoso burin technique.[25] Based upon the prevalent knotty musculature of Cornelisz.'s male

nudes, which are based in turn on the Haarlem Italianate precedent of Heemskerck, Goltzius also crafted his own anatomical experiments of excess: *Apollo* (1588; Strauss 263) and the grotesque *Large Hercules* (1589; Strauss 283).[26] One of the four Disgracers, *Ixion*, survives in its original painted version in Rotterdam (Museum Boymans-van Beuningen, in reverse from the sense of the print); the *Cadmus* painting is in London (National Gallery), but Goltzius consistently credits his colleague Cornelisz. as "pictor" rather than "inventor."[27] Once again, the presence of Goltzius's own original inventions after the example of his principal pictorial model, here Cornelis van Haarlem, shows that his activity as a designer and as a reproductive engraver of other men's designs cannot be separated.

The *Disgracers* series shows a fascination for the potential abstract composition of the muscular male body within the round tondo format of both painting and prints. In similar fashion, both artists' delight in mannered torsions of the human body, akin to the twists and turns of Goltzius's burin line, is evident in the complexity of the *Cadmus*. All of these works, especially the *Hercules*, make clear that these are works of the imagination much more than any study from life, despite claims to the contrary on behalf of a "Haarlem Academy" by Van Mander.[28]

These scenes also have implicit morals warning of moderation and suppression of pride. The falls of Icarus and Phaeton followed from their hybris, while the torments of both Tantalus, epitome of gluttony, and Ixion, of lust, resulted from their rebellion against the authority of the Olympian gods. Even Cadmus violated the sanctity of a consecrated site. Here again, the moralizing vision of Ovid promulgated by Van Mander was surely formative for Goltzius; Lowenthal credits Van Mander with stimulating the series of 52 prints by Goltzius from the *Metamorphoses*, beginning in this period.[29] Inscriptions around the margins of the *Disgracers* reveal their moral instruction through negative example. Tantalus: "How miserable is he who lives badly, poor in the midst of wealth!" Icarus: "It is a divine wish to

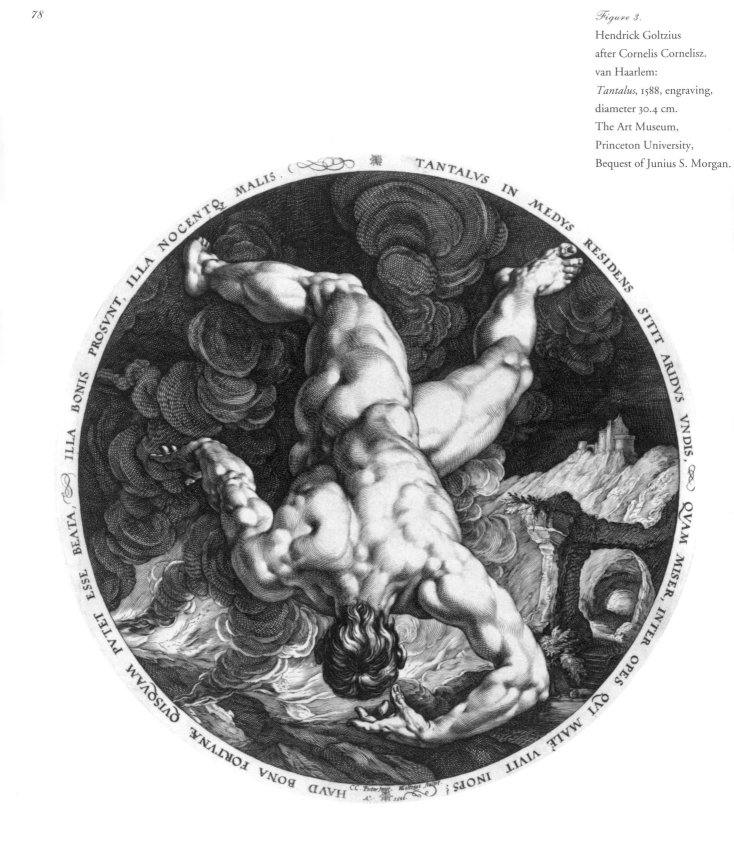

know, but it is right to have kept oneself within one's limits." Phaeton: "The Phaetonian fall teaches that overly rash desires finally lack a good end." And most explicitly for Ixion: "To him whose heart itches, applauding itself because of popular favors, whom in his folly the empty glory of fame delights, let Ixion be an example . . ."[30] Lowenthal made the formal as well as the thematic connection between the falling nudes of Cornelis van Haarlem's figures and the presentation of the 1549 allegory by Heemskerck, produced as a print by Coornhert, *Allegory of Human Ambition* (See Silver, "Visual Models," fig. 3).[31]

By the time of his departure for Italy at the end of 1590, the year Coornhert died, Goltzius had assimilated all of the leading current artistic "high styles" with which he had come into contact, beginning with the Antwerp art world in the wake of Frans Floris, continuing with the Rudolfine elegance of Bartholomeus Spranger, and ending with the lumpy virility of Cornelis van Haarlem. He had also taken control of the production of his own prints, enabling him to experiment with both the imitation—reproduction from design—and the emulation—original designs in the spirit of his sources—of his favored models. In every case, however, Goltzius had turned to the art of living masters, even local colleagues. His future assimilations, both imitation and emulation, would derive from the past.

Imitarit (1590-1599)

In November 1590 Goltzius departed for Rome by way of Germany. He stayed in Munich with the Bavarian court printmaker, Jan Sadeler (see previous essay), who had produced numerous reproductive engravings after both Martin de Vos and Dirck Barendsz and whose work must have been well known to Goltzius.[32] His ambitions in visiting Italy doubtless related to his study with Cornelis van Haarlem of the ideal human body and classical subjects through the mediation of sculptures and casts. Of course, both Van Mander and Spranger had spent extended time in Rome, as had numerous Netherlandish artists since the

1508 visit of Jan Gossaert and the 1532 trip of Heemskerck. (Significantly, though, Cornelis van Haarlem had never traveled to Rome.)

Goltzius spent half a year in Rome, making 43 surviving drawings after antique sculpture (and Michelangelo's *Moses*), preserved today in the Teyler Museum, Haarlem.[33] Three of the drawings were engraved (ca. 1592-93) after his return to Haarlem, and surely others were planned, but the only impressions date from after Goltzius's death in 1617.[34] Both the drawing and the engraving of the *Farnese Hercules* not only suggest the physicality of the marble substance of the sculpture but also evoke an almost palpable presence, often presented from a low viewpoint as larger than life. Many of the drawings originated in a sketchy black-and-white chalk study on blue Venetian paper, incised with stylus for transfer; then followed a second, more precise study in red chalk on white paper with archaeological exactitude as well as vivid lighting. The red chalk study in turn was transferred to the copper plate by means of an intermediate darkened paper, so that the reversal inevitable in the printing process could itself be reversed and the prints oriented in the same direction as the careful drawings. The final prints utilized the full range of Goltzius's burin syntax of the preceding decade both for descriptive and expressive effects, but always maintained a discipline of conveying the sculptures' powerful overall physicality. After the excesses, some even comical (*Large Hercules*), of the Spranger and Cornelis van Haarlem figures, these ancient statues have a dignified monumentality.

This antique statues series exemplifies "reproductive" engraving of the most exacting sort, akin to what Rubens would require of the engravings made after his originals in the next century; of course, Goltzius made his own fastidious drawings after the antique models. Once more, like the case of portrait likenesses before the trip to Rome, the usual definitions of "original" and "copy" are blurred in the working process of the draftsman-printmaker.[35] However, here the responsibility of the artist has shifted significantly, from a basic dependence on his contempo-

raries and a derivation from their visual ideas as the source for his own to a new authority, a desire to transmit the greatness of the ancient world to his contemporaries and thereby to instruct. One senses here the artist's new, more intensive absorption of his models in the interest of an ultimately original, creative independence from his contemporaries. In two of the three printed images, sketching or gazing artists are represented before the sculptures.

As if a test case of his ability to learn from ancient statuary, Goltzius produced an engraving in 1593 about the classic myth in which a paragon marble is brought to life: *Pygmalion and Galatea* (Strauss 315).[36] Dense networks of cross-hatched lines mark the background space before which these two figures, a standing female and a seated male, rest. Each figure is modeled in the virtuoso linework that Goltzius brought to such sculptures as the *Farnese Hercules* from his Cornelisz. nudes. Like statues, neither one has pupils visible in the eyes, though the male is interrupted in the acts of extending a flower and holding a chisel.

Careful ink drawings on blue paper, shaded with wash and heightened with white body color, attest to the importance attached to the modeling in a set of other Goltzius drawing copies after Roman monuments, this time a painted monument of the Renaissance. Specifically, his source consisted of eight antique gods in niches by Polidoro da Caravaggio, one of Raphael's followers, from the courtyard of the cloister of Saint Paul's on the Quirinal.[37] Six of the eight original drawings survive, again in Haarlem (Teyler Museum; Reznicek 239-44), and the engravings made after them (Strauss 289-96) designate their purpose as the one theorized for the engravings after antique sculptures: "engraved for the use of novices" (*caelati postmodum in Tyronum gratiam*). The inscription on the *Saturn* also helps explain the reason for the technique of the drawings as well as the choice of these frescoes: "distinguished by the excellence of their chiaroscuro effects" (*lucide et subumbrose*). Comparing these deities in niches to Goltzius's earlier allegories of the Virtues reveals that both the framing niche and the standing figures have attained a new solidity, energy, and spatial relief, all conveyed through mastery of graphic variety for shadows, planes, and substances.

Several other important 1592 engravings after Renaissance paintings of Rome exemplify Goltzius's interest in both classical figuration and the simulation of ancient subjects with classical vocabulary. His *Two Sibyls* (Strauss 297) was based on another Polidoro fresco, near the Porta di San Angelo; its stola drapery in a shallow relief space provides a female equivalent to such statuary as the *Apollo Belvedere* (Strauss 314). Moreover, as was the case with Blocklandt and then Spranger, Goltzius went on to emulate the very figures that he had been imitating within his own print cycle, the *Nine Muses* (1592; cat. nos. 63-64; Strauss 299-307), a series dedicated to Jan Sadeler.[38] Two other 1592 engravings after Raphael complete Goltzius's homage to painted classicism: *Isaiah* (Strauss 298) after the San Agostino fresco, a variant on Michelangelo's enthroned Sistine prophets, and a remarkable reproduction of the Farnesina *Galatea* (cat. no. 62; Strauss 288), with verses again by Franco Estius.[39] Once more this is reproductive engraving of the most exacting and traditional kind, and it should be noted that Goltzius emphasized both his source and his careful transcription in his inscription: "Opus hoc depictum est suis coloribus Rome ad parietem per Raphaelem D'Urbin, in palatio Augustini Chigi, et ibidem ab HGoltzio adnotatum et deinde eri insculptum." It should also be noted that Goltzius was producing a second replica of the *Galatea*, rivaling a famous print by Marcantonio Raimondi (ca. 1515-16).[40] Moreover, his project of copying for Northern students a classic Raphael fresco had already been anticipated by Giorgio Ghisi's reproductive engravings, produced by Hieronymus Cock at Aux Quatre Vents four decades earlier.[41]

Goltzius's return to the antique and Renaissance, then, quickly led him to return to the classics in his own medium of engraving, through the examples of Marcantonio Raimondi and Giorgio Ghisi. Quite naturally, his visual interests

might also have turned to the preceding generation's leading Antwerp engraver of Italian art, Cornelis Cort.[42] That Goltzius was already aware of Cort's reproductive engravings after important Italian models was already evident in 1589, when his *Rest on the Flight to Egypt Under a Cherry Tree* (Strauss 264) offered an original variation, still with overtones of Spranger for the Madonna, on the 1575 Cort print after Barocci (cat. no. 58).[43] In addition, the trip to Italy brought Goltzius into contact with Girolamo Muziano, who attempted to have the printmaker engrave his landscapes designs the way Cort had done previously and surely renewed Goltzius's awareness of Cort's achievements.[44]

In 1593, however, Goltzius was in a new frame of mind. His experience of imitation followed by emulation led him to attempt an original graphic creation once more, but with a difference. This time he was operating on his home playing field of engraving, so he attempted to make the neo-Cort simulation as close to a facsimile of the original as possible while still offering new motifs. The result was *Holy Family with the Infant Saint John, in the Manner of Federico Barocci* (cat. no. 65; Strauss 317), which became part of a new series on the traditional printmaking theme of the Life of the Virgin. Goltzius's new engraving utilized not only the outdoor setting (especially the dramatically contrasted shading of foliage) of Cort's *Rest on the Return from Egypt*, but also utilized the figure types and poses as well as the motif of a cat from Cort's other engraving after Barocci, *Madonna del Gatto* (1577).[45] Particularly close adaptations, reversed, of the almond-eyed Madonna and the fine-featured Baptist mark Goltzius's triumph of both motifs and techniques in absorbing the work of his predecessor.

Yet the resulting engraving is not a Cort but a Cort clone, brought into existence only through the eye and hand of Goltzius. Here a new middle ground was established between reproductive engraving and original design, and Goltzius was able to claim parity with or superiority over an "old master" of his medium because his works

could so fully replicate Cort's forms and technique, even when they were different from Goltzius's own. This was a new, retrospective form of virtuosity, informed by the experience of classics of antiquity and the Renaissance in Rome and no longer tied to artistic engagement with the latest high styles of his own day. Moreover, this absorptive creativity in the spirit of an older master signaled Goltzius's ability to work in any pictorial idiom, to be what Van Mander called a "Proteus," after the classical god of constantly shifting shapes: "All these things I have related, prove Goltzius to be a rare Proteus or Vertumnus of art, capable of refashioning himself in the form of all the species of rendering."[46] The key verb, referring to what Goltzius realized in his rendering after Cort, is *herscheppen*, or "recreation," that is, an intensified and creative form of the concept of engraved "reproduction."

Within the framework of the *Life of the Virgin* series, Goltzius went on to explore the forms and techniques of earlier masters of engravings. The entire series was dedicated to Jan Sadeler's patron in Munich, Duke Wilhelm V of Bavaria, obviously a discerning patron and a participant in the self-conscious revival at the end of the century of the master works of earlier artists.[47] In Italy overdependence on the works of earlier artists was often considered repetitive and unnatural unless enlivened through creative invention.[48] Of course, Goltzius's Master Engravings perfectly exemplify working practice (Van Mander's *teyckenconst*) and imagination (Van Mander's *inventie*).[49] A measure of Goltzius's inventiveness and originality is that his remaining Italianate compositions from the *Life of the Virgin* series have various models assigned to them: the *Visitation* (1593; see Melion, fig. 4; Strauss 318) derives generally from Parmigianino, *Adoration of the Shepherds* (1594; Strauss 319) from a Jacopo Bassano painting (see Melion, fig. 5; the painting was reported by Van Mander as in Amsterdam; also engraved by Jan Sadeler), and an *Annunciation* (1594; see Melion, fig. 3; Strauss 321) loosely associated with Federico Zuccaro, but obviously also related to the etching of

the same subject produced by Federico Barocci (ca. 1585) and—for the angels and dove above—Cort after Titian.[50]

The most frequently studied segments of the 1594 *Life of the Virgin* series are the remaining two prints after Northern masters of the first quarter of the sixteenth century: Lucas van Leyden (*Adoration of the Magi*, cat. no. 66; Strauss 320) and Albrecht Dürer (*Circumcision*, see Melion, fig. 6; Strauss 322). In these instances, the original models are quite evident. Lucas's 1513 engraving of the same subject (B. 37) has a horizontal format rather than Goltzius's vertical, but the figure types, especially of Madonna and Child, and the costumes with Lucas's characteristic exotic hats, are retained closely. [51] In addition, Goltzius captured Lucas's fine burin technique in the rendering of cracked masonry as well as the cross-hatched delicacy of soft shadows on walls or within folds.

The Dürer source is a woodcut from that master's prior series of the Life of the Virgin (ca. 1505; B. 86, M. 198), with specific quotations of the bearded high priest and the capped figure at the far right with candlestick. Goltzius, however, updated the image with topical personal references: the chapel setting is based on Saint Bavo's in Haarlem, and the witness in the doorway is a self-portrait. Another Dürer reference is the rounded glass window with reflections at the left, derived from the 1514 Dürer "master engraving," *Saint Jerome in His Study* (B. 60, M. 59a; see cat. no. 46). Once more, Goltzius captured Dürer's burin technique, especially its tendency in the *Engraved Passion* (1512, whence some of the more grotesque faces are derived) to suggest highlights on dark grounds of costume. According to Van Mander, Goltzius even passed off a darkened version of this print as a Dürer original (Van Mander/Floerke II, 245), much as Michelangelo, according to his biographers, succeeded in presenting his *Bacchus* as a recent archaeological discovery.[52]

As in the case of Michelangelo, the accomplishment of Goltzius is at once affirming of his own all-encompassing talents as well as self-effacing in the larger assertion that his was a new golden age, standing on the shoulders of the giants who went before. This is precisely the historical consciousness of Netherlandish art as a pictorial tradition with long roots that Van Mander was in the process of inventing and recording in his lives of the painters, part of his projected comprehensive program of art history and theory in the *Schilderboeck* (lives of ancient, Italian, and Netherlandish artists, including living artists, plus the "Interpretation" [*Wtleggingh*] of Ovid; published in 1604) and *Den Grondt der Edel vry Schilder-const*. Of course, Italy already had provided a model both for art history in Vasari's *Lives*, summarized by Van Mander in his Italian lives, and for art theory.[53] However, as his creative emulations of both Dürer and Lucas van Leyden attest, Goltzius had eyes for his Northern roots, especially in the graphic arts, besides the Italian heritage of antiquity and the Renaissance.

The fascination with Dürer was a widespread phenomenon. In the Prague of Rudolf II, Aegidius Sadeler (see essay above) and a host of painters and sculptors were utilizing the model of Dürer as the ancestor of a great national tradition in a charged atmosphere of collecting, in short as the foundation of an artistic canon.[54] At the same time, engravers in various countries, including the Low Countries with the Wierixes in the forefront, continued to make literal copies after Dürer prints, sometimes with their own signatures and sometimes anonymously, perhaps with the intention of forgery.[55] A landmark copy in this vein is Hieronymus Wierix's 1566 replica of Dürer's *Saint Jerome* (cat. no. 46) or his 1602 replica of Dürer's 1514 *Melencolia I*, with no reversal, out of some fifty copies after Dürer by the Wierixes. But of course this literalness, however skillful, is the polar opposite of Aegidius Sadeler's or Goltzius's creative inventions in the Dürer idiom.

The climax of Goltzius's experimentation in the manner of Dürer is his 1596 *Pieta* (cat. no. 67; Strauss 331). This work clearly derives from the late engraving of *Madonna with Swaddled Child* (1520; B. 38, M. 40a), from which Goltzius took

the dark sky with radiating lines, against which the unmarked white of the paper glows with radiance for haloes, both round and cruciform.[56] Goltzius even retained the relatively bleak, open landscape as well as Dürer's favorite motif of a stone bench in the foreground. However, Goltzius's Madonna has the full-faced features of a 1514 Dürer engraving, *Virgin and Child Seated by a Wall* (B. 40, M. 36b), and the heroic, martyred body of Christ on her lap derives from the "Throne of Grace" figure of the Man of Sorrows in Dürer's 1511 woodcut *The Trinity* (B. 122, M. 187b), another work that contrasts white paper with radiating dark lines. Here, too, Goltzius masterfully, almost uncannily, replicated the burin work of his predecessor, including the distinctive short strokes against the main parallels for substances such as stone and earth and the simulation of curving grasses. However, in one respect—size—Goltzius's prints assertively differ from his Dürer (and Lucas) models. The *Pieta* is only slightly larger than its sources, but the *Adoration of the Magi* and the *Circumcision* are about twice as large as theirs, despite their fine burin work.

Dürer's own mastery of heroic bodies, fusing the traditions of Northern precision graphics and naturalism with Italian ideality, corresponded with Goltzius's own development (and might well have been anticipated by Michelangelo's Roman *Pieta*, grafting a Northern theme of pathos, the *Vesperbild*, onto his own materials of marble and human beauty).[57] In this respect, then, Goltzius incorporated yet reversed Michelangelo's accomplishment, reinfusing the theme with its German heritage while retaining its Renaissance figural character, which he had recently explored at its Roman source. At the same time, like the Flemish engraving family of the Sadelers in Munich and Prague or like the Flemish emigré, Cornelis Cort, in Venice and Rome (see previous essay), Goltzius brought other national styles of Europe back to his native soil while producing prints that would in turn enjoy a European circulation. Just as his emulations collapsed the previous distinctions between imitation and originality, Goltzius also collapsed the boundaries between past and present, national and international art, as he fashioned his own synthesis for sophisticated collectors. After being rewarded in 1594 with a gold chain by the dedicatee of his *Life of the Virgin* series, Duke Wilhelm V, Goltzius also received the honor of an imperial privilege from Aegidius Sadeler's art-loving patron, Rudolf II, in 1595.

Also beginning in 1596, Goltzius made a final, extended (1596-98; Strauss 332-34, 339-43, 353-56) tribute to Lucas van Leyden. A set of twelve silvery, small-scale prints simulated both the effects and the figure types of their Lucas models. The subject, too, was a Lucas favorite: the Passion of Christ, engraved in roundels in 1509 (B. 57-65) and in individual events, but revisited as a cycle in this same, small rectangular format around the time Lucas met Dürer in Antwerp in 1521 (B. 43-56).[58] Even more than in the Master Engravings, Goltzius assimilated the figures, the burin work, and the historical imagination of Lucas, but his sources cannot be pinned down with precision, inasmuch as he freely constructed his scenes anew. Van Mander already called attention to this creative synthesis: "In regard to the movement of the figures and also in other respects Goltzius followed his own concepts (Van Mander/Floerke, II, 247)." Once more, the series was intended for a discerning connoisseur of Netherlandish art, in this case the patron of Jan Brueghel in Milan, Archbishop Federigo Borromeo, from whom Goltzius received yet another tribute, a medal and chain, in 1599.

In almost every instance, Goltzius retained the ample spaces of the Passion roundels together with Lucas's crowded figural compositions; yet a sophisticated use of diagonals energizes Goltzius's scenes in a novel way. The 1596 *Christ Before Pilate* (Strauss 332) follows the compositional dictates of Van Mander (see above, *Judgment of Midas*) in opening up past framing figures of Christ and a well-dressed onlooker in modern dress (of Lucas's day; a religious commentary?) to Pilate's elevated throne in the middle ground. In similar fashion, *The Resurrection* (1596; Strauss

333) places the main event behind foreground soldiers and shows a lanky Christ (with a unique three-cornered trinitarian nimbus) rising at a most dynamic angle. In the *Deposition* (1596; Strauss 334), the lamenting figures closely resemble their source in the 1521 engraving (B. 54), but their number has been increased, as has the height of the vault of the tomb in which they pause. Goltzius added Lucas types in the pious peasants at the arched doorway and in the grieving children looking on from above. (Compare the foreground children in Lucas's large *Ecce Homo* of 1510, B. 71; or in his *Virgin in the Basket*, 1525, B. 136.)

As mentioned above, Lucas van Leyden held a special place in the art history of the Netherlands, particularly in the field of graphics, where he was the only contemporary of Dürer capable of being compared to the German master. For Goltzius, Lucas would have held a special prestige by virtue of his versatility, warmly praised by Van Mander, in painting and graphics, as well as in stained glass.[59] Moreover, Goltzius's own interest as a collector in Lucas is attested in Van Mander's biography of the Leyden artist. He tells us that Goltzius owned one of the celebrated triptychs of Lucas, the *Healing of the Blind Man* (1531; today in St. Petersburg, Hermitage), purchased in 1602, shortly after Goltzius himself took up painting, "because he had through his expertise in art, great desire and love for Lucas's works."[60]

Goltzius was not alone in prizing his ownership of a rarity of the early Netherlandish school, a painting by Lucas. In 1603 Rudolf II attempted in vain to buy this picture for his own collection (letter of 7 June 1603), but he succeeded in acquiring the smaller triptych of the *Madonna and Child with Donor* (1522; Munich, Alte Pinakothek), as Van Mander relates: "This little painting is at the moment with Emperor Rudolphus, the greatest art-lover of this time..."[61] Rudolf, described by Van Mander as an "important foreign prince," also attempted to buy Lucas's Leyden *Last Judgment* (1526; Leyden, Lakenhal), but in this case the city fathers decided to hold on to their Leyden patrimony.[62] Rudolf

used his court painter, Hans van Aachen, as well as the Dutch engraver, Jan Harmensz. Muller, as intermediaries, but both Van Mander and Goltzius rose to the occasion to prevent the painting's departure. Hence Rudolf along with Archbishop Borromeo can be numbered with Goltzius as fervent collectors of Lucas van Leyden works at the turn of the century.

Goltzius's revival of earlier styles was not confined to his finished engravings; he also produced separate drawings studies in the manner of Lucas van Leyden as well as Pieter Bruegel, whom he never imitated in engravings. Goltzius produced an ink variant on a favorite Lucas theme from the "Power of Women" series, an *Idolatry of King Solomon* (Paris, Lugt coll.; ca. 1596, Reznicek 13), based on the themes of Lucas's engraving (B. 30) and woodcut (B. 8) but presented at half-length.[63] In similar fashion, Goltzius adapted the popular early sixteenth-century subject of the *Ill-matched Pair* in the style of Lucas's chalk drawings of around 1521 for a dated ink drawing of 1596 (Reznicek 192; formerly Berlin).[64] From the chalk heads of Lucas, Goltzius also developed the interest in producing bust-length "fantasy portraits," one of his favorite areas of experimentation in drawing for the rest of his career.[65] Usually of portly (old) men, verging on caricature, these bust figures may have been intended as character studies for the apprentice painter, akin to Dürer's own variations on physiognomy, albeit less "scientific" or systematic.[66] As if to underscore a continuing dependence on Lucas, their costumes still resemble the fashions of around 1520. A final fantasy head, a refined ink drawing dated 1614 (Reznicek 332), shows a young man holding a skull and a tulip and bears the *memento mori* inscription, "Quis evadet/ nemo."[67] The drawing presents a final variation on Lucas, specifically his 1519 engraving, *Young Man with Skull* (B. 174), where the same foppish feathered cap and slashed garment fashion marks a curly-haired youth in meditation on life's brevity. Two years before his death Goltzius, the aging artist, turned to the model of Lucas and a figure of youth for his own meditations on art and mortality.

Variations on the Pieter Bruegel landscape motifs of towering Alpine mountains became a favorite Goltzius drawing topic during this period of retrospection. Beginning in 1594 with dated examples (Reznicek 396, 399), Goltzius imitated the technique of repetitive, fine, scratchy pen-work and the themes of cliffs or riversides from Bruegel drawings.[68] Both artists, of course, had traversed the Alps en route to Italy, and a Bruegel revival was at full flood in the Netherlands in the 1590s, particularly in the drawings of the brothers Jacob and Roelandt Savery.[69] Unlike works of the Saverys, however, which sometimes bear Bruegel "signatures" and dates and remained unchallenged as authentic originals until very recently, Goltzius's fantasies could never pass for Bruegel forgeries to the modern eye (any more than his Dürer emulations could be confused with the literal re-creations of the Wierixes). They are clearly exaggerations, meant to impress with their superhuman scale, evoking the fearful-ness of the sublime found in eighteenth-century art without even as much suggestion of actuality as their Bruegel models. With these drawings, Goltzius seems to have been filling in missing elements and subjects for his overall program of assimilation of the masterworks of the past. His days of imitation—except of nature herself in studies of plants or animals—were drawing to a close.[70]

Invenit/Delineavit (1588-1599)

Although Goltzius had managed to consolidate his own production of prints through control of both design and publishing, he also showed an increased willingness to delegate the task of en-graved reproduction to trusted associates. In 1586, Goltzius had his first designs engraved by some-one else, when his series of biblical Annunciations was realized by Adriaen Collaert (1560-1618), son-in-law and apprentice of his own former publish-er, Philipp Galle, in Antwerp.[71] Just before his departure for Italy, Goltzius had become increas-ingly dependent on his stepson and apprentice, Jacob Matham (1571-1631), and his pupils Jacques

de Gheyn II (1565-1629) and Jan Saenredam (1565-1607).[72]

Matham's earliest attributed engravings origi-nated in 1588, without the name of the engraver but with the designation "H Goltzius invenit."[73] This was precisely the moment when Goltzius was perfecting his own responses to both Sprang-er and Cornelis van Haarlem and developing his own virtuoso technical vocabulary of the sweep-ing line. At the same moment, of course, he first produced the simulated engravings in ink, begin-ning with the 1586 *Marcus Curtius* (Reznicek 142) and the *Head of Mercury* (1587, Reznicek 119). It was a small step from making his own prepara-tory studies for engravings to entrusting them to someone whose burin skills he could respect as equivalent to his own. Indeed, one set of Golt-zius's surviving drawings from around 1588 are executed not in the prescriptive linear modello style but rather in chiaroscuro technique with wash and highlights, like the drawings he made for his own prints. One example is the *Old Testa-ment Heroines and Heroes* (Reznicek 16-19, 21-23), for 1589 engravings ascribed to Matham and published by Goltzius.[74] Another example in the alternate medium of red chalk is *Athena and Hermes* (Reznicek 134), engraved nonetheless by Matham with all of Goltzius's virtuoso linework in the print of 1588 (no. 258, B. 281), part of a series of eight mythic and allegorical figures.[75] Moreover, the muscular male figures of Goltzius after the models of Spranger and Cornelis van Haarlem inform the allegories of the *Four Seasons* engraved by Matham in 1589 (nos. 130-33, B. 140-43).[76] Altogether, Goltzius is easily the most constant source of engravings by Matham (nos. 90-147 and 217-84, B. 100-162 and 240-307; see cat. no. 73).[77] In addition, it was Matham who produced the commemorative epitaph print of Goltzius shortly after the artist's death in 1617, based on a small self-portrait drawing of 1615 (Berlin).[78] His engraving of a beached whale (no. 51, B. 61) adapted Goltzius's own large drawing (Reznicek 419), made as documentation on the beach site (3 February 1598); even this specific scientific curiosity goes back to the precedent of

Albrecht Dürer, who caught a fatal disease while journeying to Zeeland to witness a similar event in late 1520.[79]

Matham's overall print output also conforms to the interests generated by Goltzius in the models of other artists' designs. In addition to making his own trip to Italy in 1593-97, from which he engraved copies after Michelangelo (*Moses*, *Risen Christ*), Matham also produced prints after Cornelis van Haarlem, Karel van Mander, and Spranger.[80] Matham worked, too, as a reproductive engraver after younger artists whose forms continue the fusion of Italy and the Netherlands begun by Goltzius: Bloemaert (cat. no. 72; nos. 53-67, B. 63-77) and Rubens (*Samson*, no. 179, B. 194).

De Gheyn, son of a stained-glass painter, arrived in Goltzius's workshop after his family emigrated from Antwerp in 1585 and left as a trained engraver, probably in 1588.[81] His first project for Goltzius was a set of military figures (H. 353-64) after Goltzius designs to complement Goltzius's own engraved striding 1587 *Captain* and *Standard-Bearer* (Strauss 252-53).[82] After engraving a set of the *Four Evangelists* (H. 349-52) after Goltzius designs, de Gheyn seems to have left the workshop and set up his own engraving business, since prints by him after Van Mander are already dated 1588.[83] In addition to his own designs, de Gheyn made engravings primarily after the compositions of Van Mander and the Utrecht artist so popular with both Matham and Saenredam, Abraham Bloemaert.[84] His more painterly, less virtuoso engraving technique sets him apart from Goltzius and most of the engravers after Goltzius designs.

The names of both Goltzius ("invent. et excud.") and Jan Muller ("sculptor") on an engraved cycle of the *Creation of the World* (cat. nos. 74-75; nos. 475-81, B. 35-41) confirm the collaboration of these two master engravers, later rivals.[85] In this case the surviving drawings are only preliminary sketches rather than finished modellos (Reznicek 1-8; Leyden), but the prints show both the bold, zebra-stripe hatchings of Goltzius as well as a distinctive, undulating long parallel line in the clouds (and the cloud-like form of God the father in the first print). The muscular male

figures and sturdy females most closely resemble Spranger and the contemporary Goltzius engraving, *Apollo* (1588, Strauss 263; see above).

Jan Muller (1571-1628) followed in the train of Goltzius and realized many of the latter's earlier ambitions during the period after Goltzius returned from Italy.[86] Son of the engraver Harmen Muller (ca. 1540-1617), who had worked after Heemskerck for Hieronymus Cock and who acted as Jan's publisher, Jan Muller became a principal engraver after Cornelis van Haarlem. He also continued to work after Spranger long after Goltzius had moved on to new interests, and he went on to produce engravings after additional artists from the court of Rudolf II at Prague, rivaling even Aegidius Sadeler with his prints after Hans von Aachen and Adriaen de Vries (cat. no. 77; nos. 510-20, B. 77-87) as well as Spranger (cat. no. 78; nos. 497-509, B. 64-76).[87]

An example of the virtuoso style used to render the Cornelis van Haarlem sculptural figure type is Muller's large *Fortuna*, two plates after Cornelisz. (1590; fig. 4; dedicated to four Haarlem burgomasters by the painter).[88] Here the sprawling muscular nudes recall Goltzius's earlier *Disgracers* after Cornelisz., although the technique already displays the finer, undulating lines and attention to rippling shadows that mark Muller's figures as distinct from Goltzius'.

Even more than he copied Cornelisz., Muller utilized Spranger for his most ambitious prints. In 1597 he produced a Spranger epitaph portrait in an oval with allegories and inscriptions after a drawn portrait by Hans von Aachen.[89] Among his allegories after Spranger, the Hermathena theme appears prominently, as does the clear association of civilization with the arts of the court of Rudolf II. In 1604 Muller reproduced Spranger's *Perseus Armed by Athena and Hermes*, where the elegance of the mythic hero embodies and symbolizes the power of the arts and the triumph of reason over passion.[90] A similar allegory of 1597 portrayed, through nude personifications ascending to a cloudy Olympus with deities, the theme of *The Arts in Flight from the Barbarians into Olympus*, an indictment of the lack of civilization

Figure 4.
Jan Muller after Hendrick
Goltzius. *Fortuna*, 1590,
engraving, two plates,
each 45 x 50 cm. Museum
Boymans-van Beuningen,
Rotterdam.

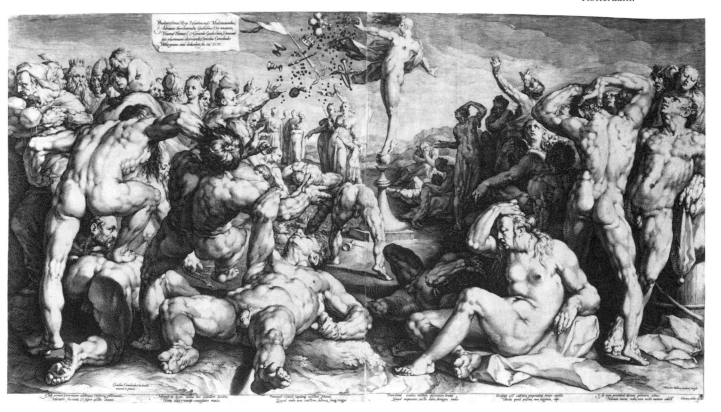

among the victorious Turks, who had conquered the Greeks.[91] At the lower left the arts flourish under the protection of emperor and pope, but at the right the armed Turks threaten and disperse the arts heavenward. A massive allegory of *Bellona* (no. 508, B. 75) shows Muller after Spranger, extending an earlier contentious allegory of *Anger* by Matham (no. 251, B. 274) after Goltzius.[92] However, Muller followed the Goltzius lead even more literally in one case, where he produced a deceptive replica after Lucas van Leyden's entire fourteen-print cycle of the *Passion* (1521), even tempering his own long lines to imitate Lucas's short, thin strokes.[93]

In the long run, the most important engraver after Goltzius (nos. 356-419, B. 40-103) was Jan Saenredam (1565-1607), who probably supplanted Matham when the latter was away on his study trip to Italy (1593-97).[94] Saenredam began as Goltzius's apprentice and produced his first engravings in 1589, but he soon left after harsh Goltzius criticism to work with his fellow apprentice de Gheyn in Amsterdam for a couple of years. He then set up his own production shop in 1592 for prints after Goltzius and other, younger designers, especially Bloemaert (cat. no. 70), in the small community of Assendelft, home of the Saenredam and de Jonge families. Saenredam followed the Goltzius lead in making prints after similar designers: Polidoro da Caravaggio (nos. 340-49, B. 31-33h), Cornelis van Haarlem (nos. 351-55, B. 34-39) including the theme of *Vertumnus and Pomona* (1605; no. 354, B. 38; see also *Plato's Cave*, cat. no. 69), and an elaborate variant of his own on Goltzius's beached whale (1602; no. 320, B. 11).[95] Saenredam, too, promoted the Lucas van Leyden revival in his prints. He made engravings in 1600 after two surviving Lucas drawings of biblical heroines: *Jael* (no. 423, B. 107) and *Judith* (no. 424, B. 108).[96] A third engraving by Saenredam after Lucas preserves a lost composition, *The Hymn of the Daughters of Israel to David* (1600; cat. no. 68). The image depicts the young hero as he returns to the gates of the city with the head of Goliath atop a sword; Van Mander reports in his biography of Lucas

that Goltzius himself owned a stained-glass window of this subject by Lucas van Leyden, which formed the basis of Saenredam's engraving: "for example Goltzius, who is very enthusiastic about his [Lucas's] work, has a narrative on glass: the dancing women [who] came to meet David, that is made wondrously beautifully; and there is also a print of it, very well engraved by Jan van Saenredam."[97]

Saenredam's first dated work after Goltzius is an allegory, *Vanitas*, of 1592 (no. 439, B. 123), and his Polidoro engravings are actually based on Goltzius's Italian drawings. His work for Goltzius (nos. 356-419, B. 40-103) extended for almost a full decade and frequently included cycles, particularly allegories of the *Four Seasons*, *Times of Day*, *Five Senses*, *Seven Planets*, and even *Three Kinds of Marriage*.[98] In addition, Saenredam also frequently produced images of mythic deities after Goltzius, sometimes with an emblematic or allegorical message.

In some cases the workmanship of the engraving has been variously attributed to either Saenredam after Goltzius or to Goltzius himself. This confusion pertains especially to two cycles of deities produced during the mid-1590s, which Bartsch attributed to Saenredam despite the presence of Goltzius's name alone as designer (often engravers were not credited, although by this time Goltzius was usually explicit about delegated burin work): *Three Deities* in ovals (1596; Strauss 328-30) and *Three Deities* at half-length (Strauss 336-38). For these series Goltzius's careful original drawings (ink, wash, and chalk) for half-length figures (but not the ovals and frames) survive (Reznicek 137-139), though this does not assure Saenredam's activity, inasmuch as Goltzius often made careful preparatory studies for his own work as engraver; in 1597 the chalk drawings in the manner of Lucas van Leyden's Passion provide a major instance.

Moreover, these figures have been altered between drawing and print, at least in their faces. However, the unvarying regularity of the grids in the frames of this group and the patterned consistency of shading do point to the work of

Saenredam at the height of his powers but without the dramatic effects of lighting or virtuoso technique for its own sake achieved by Goltzius in the Master Engravings. The half-lengths offer more spectacularly varied linework, and their dedication to Cornelis van Haarlem suggests a personal significance.[99] Nonetheless, in contrast with Goltzius's delicate atmosphere and description of landscape in a contemporary work, *Frederick de Vries* (1597; Strauss 344), these deities again appear more notable for their patterned clarity and consistency of rendering. That there could be such a connoisseurship controversy suggests further the degree to which Saenredam had assimilated the Goltzius technique of sweeping line for sculptural effects on figures as well as the more delicate broken line for descriptive effects of objects and textures. The subjects are noteworthy for their close scrutiny of the characters and attributes of classical gods. The first cycle, for a political adviser, provides an ominous gathering of the deities most associated with the Olympian jealousies and rivalries that sparked and prolonged the Trojan War: Athena, Aphrodite, and Hera. Inscriptions underscore the universal powers of these three great, rival goddesses. The second cycle, for a colleague of both Goltzius and Saenredam, is associated with abundance and pleasure—Venus, Bacchus, and Ceres—and illustrates the maxim that "without Ceres and Bacchus Venus freezes" (engraved in 1600 by Saenredam after Goltzius; see below).

During the same period, Saenredam engraved a number of other series after Goltzius designs, and the credits on those prints explicitly separate the designer and the engraver roles. One series of 1596 shows the powers of the same three gods of indulgence encountering their human devotees: Bacchus with three drinkers, Venus with a loving couple, and Ceres with country folk.[100] A series of the planets on pedestals with their human followers underneath, actively engaged in a variety of activities, appeared in 1596 (nos. 389-95, B. 73-79); in this case the surviving drawings in ink and wash (Reznicek 143-46) reveal how closely Saenredam followed the designs of Goltzius.[101]

For the cycle of the *Four Times of Day* (undated; nos. 407-10, B. 91-94), human activities dominate fully, with only the hint of the celestial body visible in the heavens to recall the traditions of allegory.[102] In 1601 Goltzius employed Saenredam to produce a series of the *Four Seasons*, using pairs of children to enact the seasonal activities (nos. 403-06, B. 87-90).[103] An adult equivalent of the *Seasons* (nos. 435-38, B. 119-22), based on a pair of surviving drawings (ca. 1597; Reznicek 155-56), and a *Five Senses* with paired amorous adults (nos. 411-15, B. 95-99; cf. Reznicek 167-71) show how systematically Goltzius was developing these overarching cycles of time and temperament around 1600, akin to the cycles initiated by Cock from designers such as Frans Floris and Maarten van Heemskerck and continued by later Antwerp artists, such as Martin de Vos (see previous essay).[104] At that time, in addition to Saenredam, Goltzius also employed Matham to execute the *Seven Planets* and the *Seven Virtues*.[105]

In a final example, Saenredam's *Bacchus, Ceres and Venus* of 1600 (fig. 5; no. 385, B. 69) carefully replicates a finished Goltzius modello in oils (London, British Museum; Reznicek 130).[106] Here the three deities illustrate literally the classical maxim (Terence) that "without Ceres and Bacchus, Venus freezes."[107] Saenredam's print captures the rich variety of painterly tones and shadows found in the Goltzius original. Regular, repeated strokes provide a consistency and clarity that retain the virtuosity of Goltzius's burin yet tame it sufficiently to make technical means respond to the image's greater representational end.

By this time in his career Goltzius had given up printmaking entirely. At the turn of the century, after fully mastering all aspects of graphic media, the protean virtuoso of the burin had performed his final transformation—to become a painter.[108]

Conclusion

The career of Hendrick Goltzius as a printmaker truly incorporates all aspects of the production process. Initially, the aspiring engraver worked

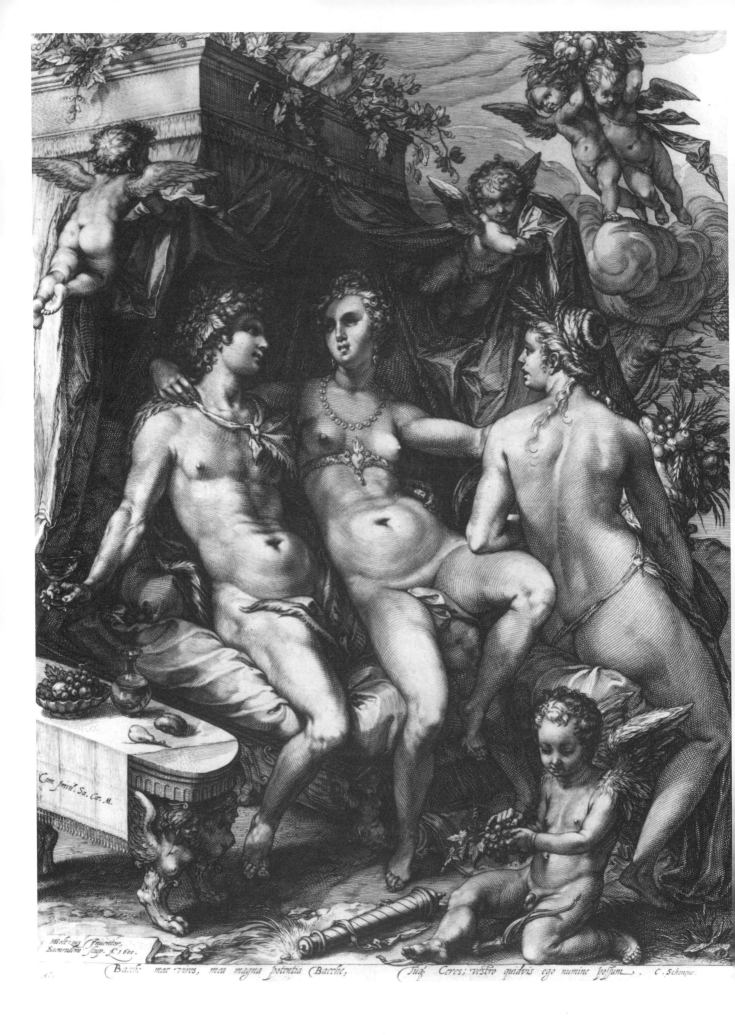

Bacch: meæ vires, mea magna potentia Bacche, Tuæ Ceres; vestro quidvis ego numine possum. C. Schonæus

principally after the designs of others in the same capacity as other professional engravers from mid-century onwards, especially for Cock and later Philipp Galle in Antwerp. Even in his early prints, however, Goltzius showed a capacity for making his own designs; his figural types and compositions also turned naturally towards the leading print designers of the day, such as Blocklandt and other continuators of the Floris style in Antwerp.

When Goltzius eventually attained publisher's status in 1582, he was able to turn his attention to more local Haarlem developments, including the new international figural inventiveness devised by Cornelis Cornelisz. and (by means of Karel van Mander after 1583) Spranger. The increasing importance of Italy and Italy-based theory (again via Van Mander) for classical subjects and for the training of Spranger and Van Mander led Goltzius to depart Haarlem for a southern journey in 1590.

Just before then he had amassed a talented crew of professional engravers within his own workshop: his stepson Matham, his epigone de Gheyn, and his eventual right hand, Jan Saenredam. The works of these apprentices would form the basis of his published cycle after his return from Italy. Goltzius as publisher could thus pass on to his successors the technical training and responsibilities of professional engraving that he had received earlier from Coornhert and Galle. Soon de Gheyn and Matham would assume publishing duties in their own right.

If Goltzius had already been the designer of prints for his own execution or for engraving by others, he nonetheless did not finally develop his own independent pictorial projects until after he had visited Italy and had followed the historiographical lead of Van Mander into the pictorial heritages of Italy and the Netherlands. Through his drawings and subsequent prints after leading classical sculptures as well as selected Renaissance paintings, he showed a capacity for self-instruction plus the dissemination of his research to younger artists. At the same time, Goltzius was reviving

the accomplishments of earlier Northern graphic artists, principally Lucas van Leyden. As a result, Goltzius was able to turn his lifelong desire, to emulate the leading styles of contemporary artists in his own designs, into a new sense of invention, based on intensive studies of the art of the past. This project crystallized in the Master Engravings of 1594, when Goltzius the publisher was able to "invent," yet to remain true to, the varied individual forms and graphic techniques of the past—from Dürer and Lucas to Barocci and Parmigianino, simultaneously.

Thereafter, he was able to devise his own original and comprehensive cycles of seasons, senses, and planetary cycles like the great mid-century designers, Floris and Heemskerck, and their successors. The reproduction of his earlier visual models, Cornelis van Haarlem and Spranger, he left to others, chiefly Jan Muller and the Prague engraver from Antwerp, Aegidius Sadeler. The reproduction of his own designs now largely fell to Matham and Saenredam, who shared his own interest in Lucas van Leyden, while they also found new, younger visual desigers, such as Bloemaert. Those cycles already spoke to the new century in their combined use of traditional allegorical figures with natural, daily activities.

The confident artist was showered now with honors and titles by European rulers and dignitaries, and like them he had amassed a considerable collection of his own, including works by Lucas van Leyden (whose portrait drawings continue to stimulate fantasy portraits from Goltzius in his final decades). His last dated prints stem from 1598, and his final works after 1595 bear the imperial privilege granted him by Rudolf II. In view of the importance accorded to design and painting in Italian art theory over the manual crafts so basic to print publishing, it is little wonder that Goltzius now gave up his former love, the world of printmaking, altogether.

Goltzius's career, however, always was marked by his orientation towards the printmaking process, particularly as practiced in the industrial organization of reproductive publishing after the mid-sixteenth century. Though without neat borders to demarcate his shifts in practice, Goltzius's career essentially recapitulates in reverse the past century in the history of his profession. He began as the specialized professional engraver, "sculpsit." Then like his own employer, Galle, he graduated to the role of publisher, "excudit" or "devulgavit." Increasingly his designs took on their own inventiveness for others to engrave, "delineavit" or "invenit." Finally, Saenredam took a new Goltzius model of mixed media painting, "pinxit" and produced an engraving "cum privilegio." As if at the end of a devolution, Goltzius had thus attained the status of what Bartsch and the nineteenth century celebrated as the *peintre-graveur*, the designer-engraver-publisher all in one, like Dürer or Lucas van Leyden at the beginning of his century in the North (rather than the specialization of roles first developed in Italy, as in Marcantonio Raimondi's collaboration with Raphael).

In the process, Goltzius reopened all of the options for a painter-designer in his dealings with professional printmakers and publishers. For in the Low Countries in the seventeenth century artists could either work in singular isolation, like Rembrandt and other etchers, or, like Rubens (cat. nos. 85-89), delegate fully their designs for others to reproduce.[109] To appreciate the richness of print production during the century after Goltzius, the modern scholar must follow the complex example of this artist's evolution, to be reminded once again to investigate *all* participants in the printmaking process: designer, engraver or etcher, and publisher. The accomplishment of Hendrick Goltzius demands nothing less.

Notes

1

Quoted in E. K. J. Reznicek, *Die Zeichnungen von Hendrik Goltzius* (Utrecht, 1961), 3 n. 8. (hereafter cited as Reznicek). The letter is by Hendrick Gulick van Berch, and is dated 9 January 1576.

2

H. Bonger, *Leven en werk van Dirk Volkertsz. Coornhert* (Amsterdam, 1978).

3

Numbers of Goltzius's own engravings will be listed according to the chronological catalogue by Walter Strauss, *Hendrik Goltzius 1558-1617. The Complete Engravings and Woodcuts* (New York, 1977), hereafter cited as Strauss.

4

The early history of engraved portraits in the Low Countries remains to be written. For the contributions of Cock to this category, see Timothy Riggs, *Hieronymus Cock* (New York, 1977), 191-94, figs 141-43. For the Italian equivalent and some intellectual context, Paul Ortwin Rave, "Paolo Giovio und die Bildnisvitenbücher des Humanismus," *Jahrbuch der Berliner Museen* I (1959), 119-54. An important milestone in portrait prints was the series, planned by Cock but published posthumously, the *Portraits of Eminent Dutch and Flemish Painters* (1572), accompanied by verses by Lampsonius but omitting the ovals of the *Rulers* series. See also Marie Mauquoy-Hendrickx, *Les Estampes des Wierix III.1* (Brussels, 1982), plate 245, nos. 1741-49, with other portraits by the Wierix brothers in that volume.

5

For the *Jan Gols II*, see *Kunst voor de Beeldenstorm*, exh. cat. (Amsterdam, 1986), 444-45, no. 341. For *Coornhert*, Clifford Ackley, *Printmaking in the Age of Rembrandt*, exh. cat. (Boston, 1980), 9-11, no. 5.

6

Reznicek, 360, no. 272, fig. 3. *Kunst voor de Beeldenstorm*, 444-45, no. 340. For Goltzius's portrait drawings, including self-portraits, Reznicek, 349 ff., nos. 254-390.

7

For drawings by these artists and further references, see *The Age of Bruegel: Netherlandish Drawings in the Sixteenth Century*, exh. cat. (Washington, 1986), 66ff. (Blocklandt), 303ff. (de Vos). The basic monograph on Blocklandt remains Ingrid Jost, "Studien zu Anthonis Blocklandt," Ph.D. diss. (University of Cologne, 1960); *Kunst voor de beeldenstorm*, exh. cat. (Amsterdam, 1986), 419-28, nos. 311-324. On de Vos, Armin Zweite, *Marten de Vos als Maler* (Berlin, 1980). Designs by de Vos and Van der Straet remain to be studied systematically, but see G. Thiem, "Studien zu Jan van der Straet, genannt Stradanus," *Mitteilungen des Kunsthistorischen Institutes in Florenz* 8 (1957-59), 88-111, and for Wierix after de Vos, Mauquoy-Hendrickx.

8

Carl van de Velde, *Frans Floris (1519/20-1570). Leven en werken* (Ghent, 1975), cat. nos. P 80-P 139.

9

Reznicek, 61-62; for additional Galle prints after Blocklandt, *Kunst voor de beeldenstorm*, nos. 311, 316, 317, 318. Note also the *Resurrection* by Goltzius after Blocklandt, no. 318a (=Strauss 90 as ca. 1578).

10

Hans Mielke, *Manierismus in Holland um 1600*, exh. cat. (Berlin, 1979), 53-54, no. 70 (hereafter cited as Mielke), which convincingly uses technical considerations (Goltzius's use of swelling line) and formal comparisons to situate the print to the later, Spranger-dominated period of Goltzius's career (see below), despite the presence of vestiges of Blocklandt's figure types.

11

Cited by Reznicek, 62 (=Van Mander/Floerke II, 241). On Spranger drawings, *The Age of Bruegel*, 274-81, nos. 107-09. Konrad Oberhuber, "Die stilistische Entwicklung im Werk Bartholomäus Sprangers," Ph.D. diss. (U. of Vienna, 1958), to be supplemented with the work of Thomas Kaufmann, *Drawings from the Holy Roman Empire 1540-1680*, exh. cat. (Princeton, 1982), 138-43, nos. 48-50; idem, *The School of Prague* (Chicago, 1988), 249-79.

12

See especially Reznicek, 68-72, who sees the influence of Spranger appearing in the drawings around 1585, in view of the lack of drawings from 1583-84.

13

Kaufmann, *The School of Prague, passim*, esp. 56-63, 90-99.

14

See Strauss nos. 217 (*Adam and Eve*, 1585), 218 (*Judith with the Head of Holofernes*), 219 (*Holy Family Before the Column*, 1585), 254 (*Body of Christ Supported by an Angel*, 1587), the giant 255 (*Wedding of Cupid and Psyche*, 1587), 262 (*Mars and Venus*, 1588), and 281 (*Holy Family*).

15

K. G. Boon, *Netherlandish Drawings of the Fifteenth and Sixteenth Centuries* (The Hague, 1978), 152-53, no. 418.

16

Boon, 14-15, no. 26; *Kunst voor de Beeldenstorm*, 415-16, no. 308.

17

On the Barendsz.-Sadeler collaboration, *Kunst voor de Beeldenstorm*, 412ff., nos. 303-07; *The Age of Bruegel*, 59ff., nos. 9-10. On the Spranger drawing (Besancon), *The Age of Bruegel*, 274-76, no. 107. This relationship was first pointed out by Reznicek, 68-69.

18

Reznicek, 271-72, fig. 47. Lee Hendrix, "Conquering Illusion: Bartholomeus Spranger's Influence in *Venus and Mars Surprised by Vulcan* by Hendrick Goltzius," in *Hendrick Goltzius and the Classical Tradition*, ed. Glenn Harcourt, exh. cat. (Los Angeles, 1992), 66-72.

19

Reznicek, 18-19, 75, 273-74. *The Age of Bruegel*, 159-60, no. 56. Reznicek points out the interaction in this drawing between Van Mander and Goltzius, whereby the printmaker-designer conforms to the principles of the theorist

concerning preferred compositions, with standing figures at the sides and seated figures in the center foreground, opening a view to the middle ground, where the main action transpires.

20

Reznicek, 295, no. 142, fig. 74, in this case a simulation of the engraving in the same orientation but not a study, according to Reznicek. See also the 1587 Oxford *Mercury*, not directly associated with an engraving; *The Age of Bruegel*, 154-55, no. 54. See also Sherrie Ray, "Roman Republican Heroes," in *Hendrick Goltzius and the Classical Tradition*, 28-31.

21

Innis Shoemaker, *The Engravings of Marcantonio Raimondi*, exh. cat. (Lawrence, Kan.; 1981), 146-47, 155-57, nos. 43, 48. The fullest discussion of Goltzius's ambitious print is Mielke, 24-25, no. 3.

22

Translations of the Latin texts on these prints are given by Mielke, 23-25. See also *Eros und Gewalt, Hendrik Goltzius und der Niederländische Manierismus* [sic], exh. cat. (Zurich, 1982). Similar observations are made for the broader context of Netherlandish mythologies in the era of Goltzius by Eric Jan Sluijter, "Some Observations on the Choice of Narrative Mythological Subjects in Late Mannerist Painting in the Northern Netherlands," in *Netherlandish Mannerism*, ed. Görel Cavalli-Björkman (Stockholm, 1985), 61-72.

23

Thomas Kaufmann, "The Eloquent Artist: Towards an Understanding of the Stylistics of Painting at the Court of Rudolf II," *Leids Kunsthistorisch Jaarboek* (1982), 119-49, but drawing a distinction between Goltzius's increasing interest in figure drawing from life, exemplified by a 1588 drawing, *Mercury and Minerva* (Reznicek no. 134, fig. 80), and the mannered, imaginative Spranger aesthetic that preceded it in his art.

24

Sluijter, *Netherlandish Mannerism*.

25

Mielke, 28-29, nos. 8, 9. Anne Walter Lowenthal, "The Disgracers: Four Sinners in One Act," *Essays in the Northern European Art Presented to Egbert Haverkamp-Begemann on His Sixtieth Birthday* (Doornspijk, 1983), 148-53.

26

For the *Hercules*, Mielke, 26-27, no. 6; for *Apollo*, Ackley, 4-6, no. 2.

27

Pieter J. van Thiel, "Cornelis Cornelisz. van Haarlem—his first ten years as a painter, 1582-1592," in *Netherlandish Mannerism*, 77-78. On the Rotterdam painting, Jeroen Giltay, "Hemelbestormers," *Openbaar Kunstbezit* 26 (1982), 26-29; on the London painting, Christopher Brown, "A Rediscovered Painting by Cornelis van Haarlem," *Burlington Magazine* 119 (1977), 564-67.

28

Refutation of the uncritical belief in a Haarlem Academy, led by Cornelis van Haarlem, Van Mander, and Goltzius, was first expressed by Reznicek, 24, as well as Pieter J. van Thiel, "Cornelis Cornelisz. van Haarlem as a Draughtsman," *Master Drawings* 3 (1965), 128-29; idem, "Cornelis Cornelisz.," 75-76, who claims that the studies derive from sculptures, "bronzes and casts," rather than either life or the imagination (but see Lowenthal, 149: "They may have indeed begun *naar het leven*, with studies of casts or statuettes in the "Haarlem Academy," but moved on to elaborate nature *uyt den geest*.")

29

Lowenthal, 149; Reznicek, 194-95.

30

Full citations in Lowenthal, 150.

31

Ilja Veldman, *Leerrijke reeksen van Maarten van Heemskerck*, exh. cat. (Haarlem, 1986), 18-20, no. 1, with an inscription of similar message: "All who strive for lofty things tumble down head over heels in a mighty whirl. As the highest of the high fall, so it is with everything. Happy is he who has met with a modest lot, for he rejoices in a smooth road through life." Lowenthal, 151, points to the influence of Coornhert not only on Heemskerck for this print and, as pointed out by Veldman on so many occasions, but also via Goltzius on Cornelis van Haarlem for the *Disgracers*.

32

Jan's nephew, Aegidius Sadeler (1570-1629), who produced numerous prints after Spranger in his own right as the court engraver for Rudolf II in Prague, owes an obvious debt to Goltzius for his own virtuoso burin work. See Dorothy Limouze, "Aegidius Sadeler," *Philadelphia Museum of Art Bulletin* 85 (Spring, 1985). Of course, the use of Spranger designs for prints continued in the Goltzius circle at the same time as Aegidius Sadeler's works, through the extraordinary engravings of Jan Muller (see Part IV, below).

33

Reznicek, 89-94, 321-46, nos. 200-48; *From Michelangelo to Rembrandt. Master Drawings from the Teyler Museum*, exh. cat. (New York, Morgan Library; 1989), 95-101, nos. 60-63. *Age of Bruegel*, 165-66, no. 58, *Hercules Farnese*. Inger Feeley, "Goltzius and the Netherlandish Interest in Classical Art," *Hendrick Goltzius and Classical Tradition*, 32-35.

34

Mielke, 35, no. 24; Ackley, 11, no. 6, *Farnese Hercules*. For other Goltzius prints in the context of other studies after the antique, see *Bilder nach Bilder*, exh. cat. (Münster, 1976), 120-49, nos. 98-99 (*Hercules Farnese, Commodus as Hercules*) and 111-12 (*Apollo Belvedere*).

35

Goltzius also made several meticulous trois-crayons portrait studies while in Italy. Those that are identified are valued artistic peers: Stradanus (1591, Reznicek 286), Giovanni da Bologna (1591, Reznicek 263), Palma il Giovane (Reznicek 281), Jan Sadeler (1591, Reznicek 282), as well as a self-portrait (Reznicek 255). See Reznicek, 84-89. Also, *Age of Bruegel*, 162-63, no. 57, suggesting that this series might also have been intended for eventual publication. This would have situated Goltzius's portrait prints midway between the Cock series of 1572, engraved by Cort and Wierix (see above) and Van Dyck's *Iconographia* in the following century.

36

Elizabeth Nesbitt, "An Artist Picturing Art: Goltzius's *Portrait of the Painter Hans Bol* and *Pygmalion and Galatea,*" *Hendrick Goltzius and the Classical Tradition,* 52-55.

37

Rose Reifsnyder, "The Eight Roman Gods: Goltzius and Polidoro," *Hendrick Goltzius and the Classical Tradition,* 36-39.

38

JoAnne Severns Northup, "The Muses Series of Engravings," *Hendrick Goltzius and the Classical Tradition,* 40-43.

39

Estius first provided Latin verses for the *Roman Heroes* series of 1586 as well as the 1590 *Judgment of Midas.* See Strauss 370, n. 1, for a listing of the other Goltzius prints with Estius inscriptions: nos. 230-39, 254, 264, 285, 288, 299-307, 315, 318, 320, 321, 323.

40

Shoemaker, 122-24, no. 33. In a few details, such as the rendering of clouds or figural expressions as well as the lower margins of the fresco, Goltzius is in fact more meticulous than Marcantonio, though most commentators agree that Raimondi also worked from the completed fresco. See also Feeley, 35.

41

Suzanne Boorsch, *The Engravings of Giorgio Ghisi,* exh. cat. (New York, 1985), 61ff., nos. 11 (*School of Athens*), 12 (*Disputa*). Note also Ghisi's ongoing production of massive reproductive engravings after Renaissance painted masterworks, such as his earlier *Last Judgment* after Michelangelo's Sistine Fresco (ibid., 53ff., no. 9) and the Prophets and Sibyls of the Sistine Ceiling (ibid., 151ff. nos. 44-49). Ghisi also produced a frontal version of the *Farnese Hercules* (ibid., 189ff., no. 58) only a dozen years before Goltzius's own eccentric posterior view; one can speculate that the reason why this statue only of Goltzius's surviving drawings after the antique is drawn from the rear might be due to the accuracy and recent date of Ghisi's version, whose shallow niche with cast shadow was also a model to Goltzius.

42

J.C.J. Bierens de Haan, *L'oeuvre gravé de Cornelis Cort* (The Hague, 1948).

43

The Graphic Art of Federico Barocci, exh. cat. (New Haven, 1978), 106-07, no. 76; Bierens de Haan, no. 43. The Barocci original painting, *Rest on the Return from Egypt,* now in the Vatican, dates from 1573.

44

Bierens de Haan, nos. 59-60, 77, 81, 83, 86-87, 113-19, 128-29, 136.

45

Barocci, 107, no. 77; Bierens de Haan, no. 44.

46

I am indebted for much of what follows to Walter Melion, "Karel van Mander's 'Life of Goltzius': Defining the Paradigm of Protean Virtuosity in Haarlem around 1600," *Studies in the History of Art* (1989), 113-33, as well as the more recent reworking of these ideas in Melion, "Piety and Pictorial Manner in Hendrick Goltzius *Early Life of the Virgin,*"

Hendrick Goltzius and the Classical Tradition, 44-51. Of course, it should also be clear that the construct of this essay, "Imitation and Emulation," indicates that an analogous process had been going on in Goltzius's adoption of contemporary artist's styles within his work since his earliest prints and cannot simply be defined only through his "Master Engravings," though those are the sharpest experiment of protean virtuosity. As Van Mander himself states: "...from an early age he aimed not simply to transcribe the beautiful and diversified things of nature: but applied himself wonderfully well, too, to portraying the varied renderings of the best masters, such as Heemskerck, Frans Floris, Blocklandt, Federigo Zuccaro, and finally Spranger, whose spirited manner he followed closely..." (cited by Melion, 119, n. 31, emphasizing the importance of *naebootsen,* figuring after earlier masters). Compare also the theoretical dictates of Federigo Zuccaro, *Idea de'pittori, scultori et architetti* (published 1607), a familiar of Van Mander and later of Goltzius in Rome, who urged the artist to be as multi-faceted and inventive as Vertumnus, Pomona's lover (cited in Strauss, 508; see Van Mander/Floerke II, 41; Reznicek, 222). More generally on Zuccaro, who also was engraved by Cort (Bierens de Haan 10-12, nos. 1, 18, 20, 26, 34, 38-41, 48, 51/52, 57, 70, 75, 78, 101, 107, 109-10, 112, 141, 219, 223), see Erwin Panofsky, *Idea,* trans. Joseph Peake (New York, 1968), 85-95; E. James Mundy, *Renaissance into Baroque,* exh. cat. (Milwaukee, 1989). See also H. Noë, *Carel van Mander en Italie* (The Hague, 1954), 132-35. For the popularity of the theme of Vertumnus and Pomona in contemporary Haarlem art, though without relating it to this art-theoretical metaphor, Eric Jan Sluijter, *De 'heydensche fabulen' in de Noordnederlandse schilderkunst circa 1590-1670,* Ph.D. diss. (U. of Leiden), 243-64 (including two Goltzius paintings of 1613, 1615, figs. 85-86).

47

For discussion of related revivals, especially through the medium of prints, Dorothy Limouze, "Aegidius Sadeler (1570-1629): Drawings, Prints, and the Development of an Art Theoretical Attitude," *Prag um 1600. Beiträge* (Freren, 1988), 183-92. For the specific phenomenon of the Dürer or Lucas van Leyden revival, see below. It should be noted that Goltzius greatly affected the career of Aegidius Sadeler, both through his personal contact on the visits to and from Italy in 1590-91 (after which Aegidius himself went on a visit to Italy and made engraved copies after Barocci and other artists) but also through his efforts to be a protean engraver, adapting his burin technique to the different subjects and styles of the artists of the Prague court of Rudolf II. Pointing out, 185, that he was only a "Goltzius style" printmaker in works after designs by Spranger or Italians, Limouze also cites drawings of Aegidius after ancient statues as well as related information from Sandrart's biography. Like Melion, Limouze refers to a dominant "concept of artistic imitation," derived from the training of Italian artists of this era. See also Bernhard Decker, "Dürer-Nachahmungen und Kunstgeschichte—ein Problem am Rande?" in *Dürers Verwandlung in der Skulptur zwischen Renaissance und Barock,* exh. cat. (Frankfurt, 1981), esp. 447-56, on Goltzius, using the term *Verwandlung* for the transformations of the artist observed here (a reference cited and criticized in Limouze

191, n. 20). On the larger context of Italian art theory, in relation to instruction and practice, Hessel Miedema, "On Mannerism and *maniera*," *Simiolus* 10 (1978-79), 19-45.

48

Miedema, 35-36. See also the warnings against "slavish copying" cited by Jeffrey Muller, "Rubens's Theory and Practice of the Imitation of Art," *Art Bulletin* 64 (1982), 229-46, esp. 233-335, 238-39.

49

Melion, 113, *passim*. Melion cites the protean metaphor underlying the dedicatory inscription to Duke Wilhelm on the 1594 *Annunciation*:
"Ut mediis Proteus se transformabat in undis,
Formose cupido Pomone captus amore:
Sic varia Princeps Tibi nunc se Goltzius arte,
Commutat, sculptor mirabilis, atque repertor."

50

Barocci, 105-06, no. 75; Sue Welsh Reed and Richard Wallace, *Italian Etchers of the Renaissance and Baroque*, exh. cat. (Boston, 1989), 96-98, no. 44. Obviously, the sky phenomena of clouds and angels derive from a second source: Titian's *Annunciation* from the Church of San Salvador, Venice, engraved by Cort before 1566, when Titian received a monopoly on reproduction of his work by the Council of Ten. See *Titian*, exh. cat. (Washington, 1990), 318-21, no. 56. A similar disposition occurs, along with an analogous still-life basket in the foreground, in Francesco Villamena's *Annunciation* engraving, but this was only published in Rome in 1603, so clearly postdates the Goltzius (*Renaissance in Italien. 16. Jahrhundert*, exh. cat., Vienna, Albertina, 1966, no. 356, fig. 64, citing influence on the technique of this print from Dutch engravers in the circle of Goltzius, such as Jan Muller).

51

The Prints of Lucas van Leyden and His Contemporaries, exh. cat. (Boston, 1983), 126-27, no. 41.

52

Melion, 119.

53

Goltzius's role in producing "art which hides all art" might be related to the end-of-the-century reforms of art by the Carracci of Bologna. See Charles Dempsey, "The Carracci Reform," *The Age of Correggio and the Carracci*, exh. cat. (Washington, 1986), 237-54. The phrase "l'arte che tutto fa, nulla si scopre" is Tasso's (cited, 244). On the Carracci synthesis of earlier artists (which used to be disparaged as eclecticism) and the resulting Academy, 247-48. With Goltzius' considerable interest in the antique and in Italy and presenting them as instructional in his prints in addition to Van Mander's claims about figural drawing by Goltzius and Cornelisz. in the "Haarlem Academy," the analogies deserve much further scrutiny than can be pursued here, though obviously the contrast between the Zuccari and Carracci, so often asserted in writing concerning Italian art in the age of Goltzius, would need to be collapsed and studied as a totality.

54

Thomas Kaufmann, "Hermeneutics in the History of Art: Remarks on the Reception of Dürer in the Sixteenth and Early Seventeenth Century," in Jeffrey Chipps Smith, ed., *New Perspectives on the Art of Renaissance Nuremberg* (Austin, 1985), 25-28, with extensive references to the literature in notes 14 and 24. See also Kaufmann, "Eloquent Artist." For Aegidius Sadeler after Dürer, see Limouze, "Attitude," 189, fig. 9, representative of "a second group of prints which are entirely of Sadeler's invention, but which emulate Dürer in burin technique and in composition."

55

Dürer Through Other Eyes, exh. cat. (Williamstown, Mass.; 1975); *Vorbild Dürer*, exh. cat. (Nuremberg, 1978).

56

Ackley, 12-14, no. 7; Mielke, 54, no. 72.

57

Ackley, 14, while acknowledging the likely inspiration of the Michelangelo *Pieta*, cites as a possible direct source a 1579 engraving by Agostino Carracci, which replicates the figures of Michelangelo but situates them in a barren landscape analogous to the one utilized by Goltzius. See Diane DeGrazia Bohlin, *Prints and Related Drawings by the Carracci Family*, exh. cat. (Washington, 1979), 82-83, no. 9.

58

On this theme and on Lucas engravings in general, see the outstanding catalogue, Jan Piet Filedt Kok, *Lucas van Leyden—grafiek*, exh. cat. (Amsterdam, 1978), esp. 62-65.

59

On van Mander on Lucas, Rik Vos, "The Life of Lucas van Leyden by Karel van Mander," *Nederlands Kunsthistorisch Jaarboek* 29 (1978), 459-507.

60

Beeldenstorm, 151-53, no. 38; N. Nikulin, "Some Data Concerning the History of the Triptych 'The Healing of the Blind Man' by Lucas van Leyden," *Nederlands Kunsthistorisch Jaarboek* 29 (1978), 299-310. Rik Vos, *Lucas van Leyden* (Maarsen, 1978), 88-92.

61

Vos, Lucas van Leyden, 81-85. See also Jan Piet Filedt Kok, Peter Eikemeier, and J.R.J. van Asperen de Boer, "Das Diptychon des Lucas van Leyden von 1522. Versuch einer Rekonstruction," *Nederlands Kunsthistorisch Jaarboek* 26 (1974), 229-258.

62

Vos, Lucas van Leyden, 115-19.

63

For the Lucas theme, Filedt Kok, Grafiek, 60; *Lucas van Leyden and His Contemporaries*, 113-14, no. 35; 136-37, no. 46. For the Lugt drawing, *L'époque de Lucas de Leyde et Pierre Bruegel*, exh. cat. (Florence-Paris, 1980-81), 119-20, no. 83.

64

For the general theme, Alison Stewart, *Unequal Lovers* (New York, 1977). Lucas never literally depicted this subject like his contemporary in Antwerp, Quinten Massys, but he did play upon it in secular subjects, such as the *Fool and the Girl* (1520; B. 150) engraving or the love triangle in his painted *Card Game* (Lugano, Thyssen coll.), or in the incest of *Lot and His Daughters* (1530, B. 16).

65

Discussed by Reznicek, 125-26, nos. 160, 178, 292, 299, 301, 307, 318-320, 324, 329, 333, 341, and the woman, no. 365.

66

For Dürer's study of human faces in profile, related to his work on the human body for the *Four Books on Human Proportion*, see the four heads, ca. 1513, in Kansas City (Nelson Gallery-Atkins Museum) in *Dürer in America*, exh. cat. (Washington, 1971), 70-72.

67

"Who [can] evade it? No one." *Rubens and Rembrandt in Their Century*, exh. cat. (New York, Morgan Library; 1979), 75-76, no. 39. For a related theme, see Goltzius's engraving, 1594, *Allegory of Transience* (Strauss 323), with the inscription "Quis evadet?" See H. W. Janson, "The Putto with the Death's Head," *Art Bulletin* 19 (1937), 446-47.

68

Reznicek, 107-08; From Michelangelo to Rembrandt, 101-02, no. 64. An Italianate landscape in the Venetian manner of Titian or Campagnola is Reznicek 393, and it appropriately contains a classical figure of Mercury in its clouds. The later influence of these formulas for Goltzius's more pastoral woodcuts is evident; see Reznicek, 109; Ackley, 27-29, nos. 14-15 (cf. also 50-51, nos. 27-28). Even the Bruegel drawings show some trace of the Titian model. As the Teyler catalogue also points out, 101, the "undulant, parallel calligraphic lines in Goltzius's Alpine fantasy may be seen as reminiscent of those in the landscape woodcuts design by Titian and recommended as landscape models by Goltzius' friend Karel van Mander." One can also see the emulation of Titian as well as Muziano (whom Goltzius met during his stay in Rome) in the 1596(?) *Landscape with Venus and Adonis* (Reznicek 407; Vienna, Albertina), in combination with distant Bruegelesque peaks.

69

Age of Bruegel, 251ff., 260 ff. It is worth noting that Roelandt Savery was patronized by none other than Rudolf II, who sent him to the Alps to make art out of those "rare marvels of nature." On the Bruegel revival in general, Terez Gerszi, "Bruegels Nachwirkung auf die niederländische Landschaftsmalerei um 1600," *Oud Holland* 90 (1976), 201-29.

70

On the nature studies, *Age of Bruegel*, 174-75, no. 62; Reznicek, 105-06, 111-12.

71

Konrad Oberhuber, *Graphik der Niederlande 1508-1617*, exh. cat. (Munich, 1979), 43-44, no. 66. This catalogue is also a useful source for the Goltzius followers in the discussion that follows, 61ff.

72

On de Gheyn, the recent study by Jan Piet Filedt Kok, "Jacques de Gheyn II (1565-1629) as Printmaker: Engraver, Designer, and Publisher—I," (*Print Quarterly*, forthcoming) is essential; I am enormously grateful to Dr. Filedt Kok for generously sharing his research with me prior to publication. The biographical data are assembled in J.Q. van Regteren-Altena, *Jacques de Gheyn—Three Generations* (The Hague, 1983); see also *Jacques de Gheyn II—Drawings*, exh. cat. (Rotterdam-Washington, 1985-86). On Saenredam, see the recent monograph on his son by Gary Schwartz and Marten Jan Bok, *Pieter Saenredam* (The Hague, 1990), esp. 15-27 as well as volume 23 of Hollstein. On Matham, little scholarly work exists, though he is included with Saenredam in a volume of the Illustrated Bartsch, no. 4, as well as Hollstein. Matham made a trip to Italy (1593-97) like Goltzius, and then settled in Haarlem. See Mielke, 45, no. 47.

73

Strauss, 442-43.

74

Reznicek, 241-44. For the entire set of prints by Matham after Goltzius, see the illustrations in the Illustrated Bartsch, vol. 4 (Matham, Saenredam, and Muller). The Old Testament Heroines and Heroes are nos. 217-21 and 228-31 (old Bartsch 240-44; 251-54). See also the *Seven Cardinal Virtues* (Reznicek 81; Munich), same technique, replicated by Matham in a dated 1588 engraving (no. 259 [formerly B. 282]).

75

Reznicek, figs. 80-81. See also the *Three Graces* (Reznicek 133), replicated by Matham as no. 262 (B. 285) and the comparable engravings of Matham for which the Goltzius drawing modello does not survive: *Four Elements*, no. 255 (B. 278), and *Five Senses*, no. 256 (B. 279). A series of paired erotic mythic couples in landscapes or interiors, ca. 1590, was prepared in the tonal manner, with ink and wash: *Jupiter and Europa* (Reznicek 135; Matham no. 141., B. 156) and *Hercules and Deianira* (Reznicek 136; Matham no. 144, B. 159), *Apollo and Leucothea* (Reznicek 104; Matham no. 142, B. 157). The significance of the subject of the fusion of Hermes and Athena into the figure of Hermathena is well discussed by Kaufmann, "Eloquent Artist," 123-30.

76

Compare *Spring* to Goltzius' 1588 *Apollo* (Strauss 263; Ackley, 4-6, no. 2). For discussion of the iconography of this series and its relation to other cycles of the Seasons, Ilja Veldman, "Seasons, planets and temperaments in the work of Maarten van Heemskerck," *Simiolus* 11 (1980), 149-76, esp. 154-55.

77

On Matham as an engraver after Goltzius and the dates of his activity, see Reznicek, nos. 9, 15-19, 21-23 (1589), 26-27 (1589), 32, 48 (1602), 72 (ca. 1587-89), 77, 81 (1588), 82-96 (1593), 106 (1597), 118 (ca. 1589), 132 (1587), 133 (1588), 134 (1588), 104 and 135-36 (ca. 1590-91), 143 (1596), 147-53 (1597), 160 (1599), 419 (1598).

78

Illustrated Bartsch, no. 29 (B.22). For the Berlin drawing, Mielke, 45-46, no. 48.

79

J.-A. Goris and G. Marlier, *Albrecht Dürer. Diary of His Journey to the Netherlands 1520-1521* (Greenwich, Ct.; 1971), 79: "Early on Monday we started again by ship and went by the Veere and Zierikzee and tried to get sight of the great fish, but the tide had carried him off again." However, such events were usually received not as occasions of scientific

objectivity but rather as omens or portents. See Simon Schama, *Embarrassment of Riches* (New York, 1987), 130-50; also on a variant print of a 1601 beached whale by Saenredam, Ackley, 44, no. 24; Linda Stone-Ferrier, *Dutch Prints of Daily Life*, exh. cat. (Lawrence, Kan.; 1983), 189-94, nos. 54-55; Mielke, 39-40, no. 35.

80

The *Moses*, no. 71 (B. 81), which should be compared to Goltzius's black chalk drawing (Reznicek 232) doubtless stands closer to his lost fine red chalk complement. The *Risen Christ* from Santa Maria Sopra Minvera is no. 72 (B. 82). After Cornelis van Haarlem come both biblical (*Susannah*, no. 82, B. 92) and mythical (*Diana* and *Apollo*, nos. 84-85, B. 94-95) subjects; from Van Mander a pair of cycles, Prodigal Son (nos. 157-60, B. 172-75) and Times of Day (nos. 156-65; B. 171-80), plus Spranger (nos. 187-89; B. 202-04). Other single sheets include Raphael's *Parnassus*, another "correction" to Marcantonio Raimondi's precedent (no. 184, B. 199). Another legacy of Rome, closer to Cort than to Goltzius, is Matham's engravings after Taddeo Zuccaro (nos. 209-16; B. 232-39).

81

Filedt Kok, de Gheyn, following Van Mander.

82

Filedt Kok, de Gheyn, n. 9. "HGoltzius invent. et excud. Ao. 1587/ Jacques de Gheyn sculp." See also Ackley, 4-5, no. 2. De Gheyn went on to make a pair of his own prints in 1589 (H. 144-45), plus later illustrations (H. 146-262) for a 1607 training manual on the exercise of arms, *Wapenhandelinghe*.

83

Published in Amsterdam by Joos de Bosscher (*Allegory on the Government of a Childish King*, H. 428) and Jan Pitten (*Perseus and Andromeda*, H. 422), respectively.

84

See Ackley, 20-25, 43, 46, nos. 11-12, 23, 25. Mielke, nos. 38, 56, 77.

85

Mielke, 56-57, nos. 79-80.

86

On Muller, Ackley, 15-17, no. 8; also Reznicek, "Jan Harmensz. Muller als tekenaar," *Nederlands Kunsthistorisch Jaarboek* 7 (1956), 65-120. Also Mielke, *passim*; *Prag um 1600*, exh. cat. (Essen, 1988), nos. 300, 315-20.

87

See Mielke nos. 10, 12, 13, 14, 19-21, 22-23, 39, 40, 64-65, 69, 78.

88

Mielke, 30-31, no. 13.

89

Prag um 1600, 414, no. 300. Proof in Amsterdam (no. A 10486).

90

Mielke, 32-33, no. 19; Prag um 1600, 422, no. 315.

91

Mielke, 33, no. 20.

92

Mielke, 36, no. 27.

93

Renger, *Grafik der Niederlande*, 66-67, no. 117, figs. 35-36.

94

Ackley, 44-46, no. 24. See volume 23 of Hollstein and the biography in Schwartz and Bok, 15-27.

95

The *Vertumnus* is Mielke, 29, no. 11. The whale is Ackley, 44-46, no. 24.

96

Age of Bruegel, 212-13, no. 79 for *Jael* (Rotterdam). The *Judith* is in the British Museum, London. See Wouter Kloek, "The Drawings of Lucas van Leyden," *Nederlands Kunsthistorisch Jaarboek* 29 (1978), 444-45, 454, nos. 10-11. See also Ger Luijten and A.W.F.M. Meij, *From Pisanello to Cezanne*, exh. cat. (Rotterdam, 1990), 54-56, no. 15.

97

Pisanello to Cezanne, 56, n. 10, fig. d. Also Rik Vos, "The Life of Lucas van Leyden by Karel van Mander," *Nederlands Kunthistorisch Jaarboek* 29 (1978), 474-75, 503-04, notes 117-18. Elise Smith, *The Paintings of Lucas van Leyden* (Columbia, Mo., 1992), 97-98, 301.

98

Saenredam engravings after surviving Goltzius drawings include the following, listed according to Reznicek numbers, with dates: 10 (1597), 12 (1597), 20 (ca. 1590), 82-88 (1593), 127-130 (1600), 137-39 (1596), 143-46 (1596), 155-56, 167-71 (ca. 1596).

99

The 1596 cycle of deities is dedicated with imperial privilege to the Hofrat and secretary of Rudolf II, Johannes Baruitius. Mielke, 32, nos. 17-18, accepts both cycles as by Goltzius himself after his own design.

100

Mielke, 31-32, no. 16.

101

Mielke, 36-37, no. 28. Veldman, "Seasons, planets and temperaments," 175, stressing the departure of this series in emphasizing the earthly setting to this extent of naturalism.

102

Mielke, 37, no. 29.

103

Mielke, 37, no. 30.

104

Veldman, "Seasons, planets, and temperaments," 162-63. See also Carl Nordenfalk, "The Five Senses in Flemish Art before 1600," in Görel Cavalli-Bjorkman, ed., *Netherlandish Mannerism* (Stockholm, 1985), 135ff., with note on Saenredam after Goltzius 154, n. 66.

105

Another cycle of the Senses was designed by Goltzius and executed in 1596 by Nicolaus Clock, published by Petrus Overait (Bartsch, 116, nos. 1-4) as well as Cornelis Drebbel, published by Conradt Goltz (ibid., no. 5; *Touch* only).

106

Age of Bruegel, 171-73, no. 61, dated 1599. See the prepara-
tory drawings for this oil study, Reznicek 127 (Brussels; Age
of Bruegel, fig. 2). Now see for other Goltzius "pen works,"
particularly on the theme of Venus, Ceres, and Bacchus,
Lawrence Nichols, *The 'Pen Works' of Hendrick Goltzius*
(*Bulletin. Philadelphia Museum of Art*, Winter 1992), where
the London modello is fig. 27.

107

On this theme around 1600, Nichols, *ibid.*, passim; Konrad
Renger, "Sine Cerere et Baccho friget Venus," *Gentsche
Bijdragen tot de Kunstgeschiedenis* 24 (1976-78), 190-203.
The same subject was designed by Spranger and engraved
by Muller; Mielke, 31, no. 14, and it was a favorite of
Rubens in the teens.

108

Melion, 124-26, stresses the degree to which Goltzius aspir-
ed to produce multi-media creations for connoisseurs, such
as Rudolf II, which would demonstrate simultaneously his
capacities in calligraphic penwork, burin engraving, as
well as brushwork and washes. He also points, p. 121, to the
adoption of painting as a further fusion of Northern and
Southern traditions of representation. See also Reznicek's
discussion of these "Federkunststücke," 128ff.

109

Of course most surveys of seventeenth-century Dutch art
still conform to the *peintre-graveur* model of printmaking,
and they highlight Rembrandt and other etchers. This
is true of even the best overviews, such as Ackley or Konrad
Renger, *Graphik in Holland*, exh. cat. (Munich, 1982).
There are signs of a shift of orientation towards other ele-
ments of production and other media, such as engraving.
The recent dissertation (NYU) by Nadine Ornstein focuses
sagely on Hondius as a publisher, even as thematic exhibi-
tions, such as Stone-Ferrier, *Dutch Prints of Daily Life*, take
on neglected (e.g. engravings by Cornelis Visscher) as
well as familiar prints to make larger cultural points. And of
course, reproductive engravings in their own right are be-
ginning to be appreciated as worthy objects of study: *Bilder
nach Bildern*, exh. cat. (Münster, 1976); *Das gesto-chene Bild*,
exh. cat. (Braunschweig, 1987). On Rubens as a graphic
designer, see the following basic studies: Konrad Renger,
"Rubens dedit dedicavitque. Rubens' Beschäftigung mit der
Reproducktionsgrafik," *Jahrbuch der Berliner Museen* 16
(1974), 122-75, 17 (1975), 166-213; *Peter Paul Rubens 1577-
1640 II. Maler mit dem Grabstichel*, exh. cat. (Cologne,
1977); *Rubens in der Graphik*, exh. cat. (Göttingen, 1977).

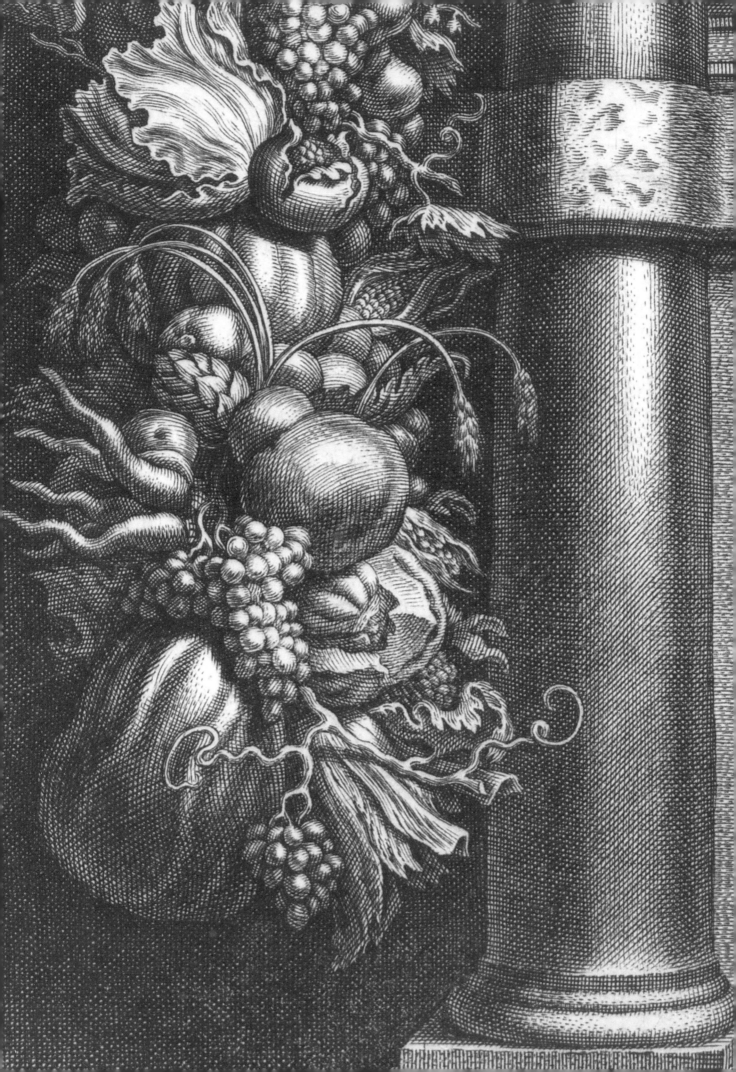

Graven Images

A GUIDE TO THE EXHIBITION

TIMOTHY RIGGS

The prints in this exhibition have been arranged and selected to tell the story of a particular kind of engraving and etching, as it was practiced in the Netherlands over a period of about a hundred years. It was a time when engravers saw their main task to be the interpretation of the drawings, paintings and sculpture of other artists, the creation of languages of parallel and criss-crossing line to translate the multitudinous colors and shadings of light and dark that they found in the works they were reproducing. Elsewhere in this book Larry Silver and Walter Melion examine in detail some of the issues faced by the engraver who interprets the art of another artist. This essay aims to provide a more general guide to the exhibition as a whole—to tell in words the story that the exhibition tells in pictures.

The story began, in the late fifteenth and early sixteenth century, when people began wanting to have the drawings and paintings of certain artists reproduced in many copies.[1] The best technique available for such a task, engraving, was a laborious process of cutting lines in a metal plate, a craft practiced extensively in goldsmiths' workshops but not part of the normal training of a painter. A few great painters, most notably Albrecht Dürer and Lucas van Leyden, were also masters of engraving, but in the long run it was natural that a division of labor should take place: that a gifted artist ignorant of the craft of engraving should furnish designs to a talented engraver who might be deficient in the ability to invent those designs.

Although this concept had roots in Northern Europe, it was first articulated clearly in Italy when the painter Raphael and the engraver Marcantonio Raimondi joined forces to create prints that neither could have produced alone. The term "professional printmaker" in the title of this exhibition refers to artists like Marcantonio, people whose work was focused on the process of printmaking, not as an independent artistic expression but as a means of producing engraved or etched equivalents to works of art in other media.

In the 1530s and 40s the Italian way of working came to the North. It was practiced and

modified there over eighty years in Antwerp (which became the printmaking capital of Europe,) and reexported to Italy through the work of the Netherlandish engraver Cornelis Cort. Toward the close of the sixteenth century a group of engravers from Haarlem in the Northern Netherlands brought this kind of engraving to a peak of international acclaim. Then, at the beginning of the seventeenth century, the styles of engraving that had been developed in Antwerp and Haarlem were transformed under the direction of a great painter, Rubens, who practiced printmaking little and who may never have engraved a single line. The emergence of the "Rubens school" of engraving marks on the one hand a perfection of engraving as a reproductive technique; on the other, it marks the end of a period of dynamic evolution in that technique. There would be excellent professional engravers for another three centuries, but increasingly their excellence would be measured by the degree to which their own personalities were subordinated to that of the artist whose work was to be reproduced.

Technical Note on Print Processes

Sixteenth-century prints belong to two families of print processes, named for the way the block (plate, etc.) receives the ink and transfers it to paper:

In a **relief** process the ink is carried by the surface of the block and the rest of the block is carved away. (A rubber stamp is a good example).

In an **intaglio** process the ink is carried by grooves or pits in the surface of a metal plate. To print the plate, a sticky ink is rubbed all over it and then the surface is wiped clean; the ink stays in the grooves, and when paper is forced against it in a high-pressure press, the ink is pulled out of the grooves by the paper. The lines in the finished print stand up slightly above the surface of the paper.

The names of the individual processes come from the way the surfaces have been prepared to receive the ink.

Woodcut (relief). The artist makes a drawing on a piece of wood, and then he or another person carves away the surface **around** the lines of the drawing with knives or gouges. The lines of a woodcut are comparatively broad, and may be impressed into the paper slightly.

Engraving (intaglio). The artist pushes a burin, a sharpened steel tool, through the surface of a metal plate, cutting v-shaped grooves. Engraved lines can be broad and deep or very fine, and an engraved line can be made to vary in width, swelling or tapering according to the angle at which the engraver holds the burin. Engraved designs are usually painstakingly controlled and highly finished.

Etching (intaglio). The artist covers a metal plate with wax or varnish, and scratches through it. The plate is put into an acid bath that etches grooves into the plate wherever the wax has been scratched away. Etched lines may be fine or heavy, depending on how long they are "bitten" in the acid. Etchings are usually more freely drawn and sketchy than engravings, but some etchers imitate the high finish of engraved designs.

Drypoint (intaglio). Drypoint is like engraving, but less controlled: the artist scratches his design into the plate. Drypoint lines are not very heavy, but a burr raised up on the copper along the edge of the scratched line adds a "shadow" to the line when the plate is printed. When drypoint lines are massed together a very black, velvety patch of shading can result. Drypoint may be used by itself or to "touch up" an etching or engraving.

Prologue: Cornelis Bos, Dirck Volkertsz. Coornhert, and Lambert Suavius
(cat. nos. 1-10)

Italian art affected the painters and engravers of the Netherlands in similar ways. Early sixteenth-century painters like Hans Memling and Quentin Massys picked up motifs from Italian art but executed them in a painting technique that derived from their Flemish predecessors, Jan van Eyck

and Roger van der Weyden. In the same way the Flemish printmakers of the early sixteenth century, such as Dirck Vellert and Frans Crabbe, made use of figures and ornamental motifs that derived from Italian art, but the systems of line that they used to depict these Italianate forms came from the Northern engraving tradition of Dürer and Lucas van Leyden.

The Flemish painters and printmakers of the next generation, however, began to adopt Italian techniques as well as motifs and simultaneously a new style of engraving began to evolve.[2] Painters like Jan van Scorel, Maarten van Heemskerck and Frans Floris abandoned the meticulously finished, enamel-like surfaces traditional in Flemish painting for a more fluid, brushy style, suited to the broad suggestion of sculptural forms rather than the meticulous rendering of surface textures. Similarly, printmakers began to adopt the simplified shading that was characteristic of Italian prints, emphasizing volume and mass rather than surface detail. Nicolas Hogenberg's etchings are among the first in the Netherlands to show a thoroughly Italianate style, as in the *Jeremiah* of 1525 (cat. no. 1) where similar systems of uniform shading lines render the massive rocks and the equally massive figure of the prophet.

Cornelis Bos and Dirck Volkertsz. Coornhert not only derived their styles from the simpler, more open shading systems used by the Italians, but also modeled themselves on Italian practice in following the designs of other artists for most of their prints. Bos' *Leda and the Swan* (cat. no. 2) is apparently a faithful reproduction of Michelangelo's lost painting (known from old descriptions and painted copies). In some respects it is an unusually detailed engraving for Bos; Leda's body is modeled with a multitude of fine, carefully controlled shading lines. The broad, simplified shading of the children and drapery in the background is more characteristic of Bos' work, and similar broad patterns of shading appear in *The Trinity* (cat. no. 3), after Frans Floris. Both engravings share a concern with rendering massive, sculptural forms in an even light.

Dirck Volkertsz. Coornhert, who knew Bos and collaborated with him on more than one series of prints,[3] worked at times in a very similar style, as can be seen in the engraving *Hercules and Cacus* (cat. no. 4) after Floris. But Coornhert's prints after Maarten van Heemskerck show a different adaptation of the Italian tradition. Coornhert practiced both etching and engraving, and he was associated with one artist in particular, Maarten van Heemskerck, who may well have occasionally etched himself, and who certainly made drawings with the specific purpose of having them etched or engraved. Coornhert imitated Heemskerck's line with such fidelity that it has long been disputed whether certain etchings, like *Judith Killing Holofernes* (cat. no. 5) are by Heemskerck himself or by Coornhert after drawings by Heemskerck.[4] Even in engraving, Coornhert's aim seems to be not the careful building up of systems of shading so much as the imitation of a free pen line: the engraved *Judith and Holofernes* (cat. no. 6; from a series of prints on the power of women) is an example. This light, wiry style may owe something to the etchings done in France by the artists of the school of Fontainebleau, but it is also surely related to the linear style of drawing that Heemskerck practiced; when Bos worked from drawings by Heemskerck his style is almost indistinguishable from Coornhert's.

Coornhert's collaboration with Heemskerck was unusual in that Coornhert, who was not only an engraver but also a scholar and theologian, played an active part in the creation of the images, suggesting subjects which Heemskerck embodied as drawings and which Coornhert then engraved. The set of prints *The Unrestrained World* (cat. nos. 7 and 8) shows the result of this collaboration. Coornhert's allegorical scenario of "the world" (humanity) throwing off the restraints of justice and of knowledge and love is embodied in energetic compositions that border on caricature.[5]

At about the same time that Coornhert and Heemskerck were collaborating, a rather different relationship was developing between the Liège

painter Lambert Lombard and his pupil, the engraver Lambert Suavius. Suavius' figure style derived closely from the Italianate, classicist models of his teacher, but the engraving technique of *The Raising of Lazarus* (cat. no. 9), with its shimmering effects of light and shade, owes little to either Northern or Italian traditions. Suavius is said to have used a diamond point to engrave the fine, dense hatchings of prints like this, more like drypoint than engraving.[6] A print from a series depicting the Sibyls (cat. no. 10) shows Suavius engraving in a more conventional style derived from Italian engraving, rendering areas of shadow in straight parallel hatchings. But the scale is so much finer than in the engravings of Bos and Coornhert that the effect is quite different; the individual lines are scarcely noticed, and the areas of shadow read as patches of tone.

The broad, schematic, Italianate technique of Coornhert and Bos was eminently suited to the suggestion of three-dimensional form and the fine, delicate shading of Suavius to the rendition of light and shade. Both were to influence successive generations of engravers, sometimes one dominating and sometimes the other, according to whether the engraver was more interested in form or in light effects.

The Circle of Hieronymus Cock, 1550-1570
(cat. nos. 11-41)

Up to 1550 engraving in the Netherlands had been a matter of individual engravers working by themselves, and occasional collaborations like those of Bos and Coornhert or a habitual association between a painter and an engraver, like Coornhert and Heemskerck. By contrast, the publishing house of Hieronymus Cock, "The Four Winds," was big business. Paying engravers to produce prints, and most probably commissioning artists to make drawings for them, Cock assumed the financial risks of printing and marketing, and the results made him a rich man. Between 1550 and 1570 he published more than eleven hundred prints by more than twenty engravers and etchers.[7]

The success of the "Four Winds" provided a center for Dutch and Flemish engraving. Even artists and engravers who did not live in Antwerp supplied Cock with designs, or engraved plates which he printed and distributed—Lambert Lombard in Liège (cat. no. 13) and Maarten van Heemskerck in Haarlem (cat. nos. 21-23). (It is worth noticing that whereas before 1550 Heemskerck's drawings had been engraved primarily by Coornhert, and occasionally by Cornelis Bos, in the later 1550s and 60s Cock issued prints after him by a number of different artists). It is not likely that all these engravers worked together in the same building, or even the same town, but they must have been aware of each others' work, and although there is plenty of variety among their styles, there is a general family resemblance in most of the prints that were published by Cock.

Giorgio Ghisi and His Influence
The Italian Giorgio Ghisi, who produced five large prints for Cock in the early 50s, was probably crucial to both the growth of the publishing house and the development of a common style among engravers who worked for it. Ghisi's monumental engraving after Raphael, *The School of Athens* (cat. no. 11) was unprecedented in Flemish printmaking, not for its size (Bos and Coornhert had produced prints of comparable size) but for the combination of weight and control in its systems of shading lines, appropriate to the large scale of the print, and for the sculptural solidity of the figures. Ghisi's systems of shading have the broad simplicity characteristic of Italian engraving, but they are more disciplined than in the versions of the Italian style practiced by Bos and Coornhert, and his work includes a richer play of light and shade. It offered an inspiring model to the young Netlandish engravers who began their careers about this time working for Cock, and who may well have had personal contact with Ghisi.

Cornelis Cort and Hans Collaert the Elder were beginning to produce prints for Cock at the time Ghisi's prints appeared. Together with the older Coornhert, these men developed versions of

what might be called a Ghisi-esque style, adapted to the rendering of hard, clearly defined three-dimensional forms, but each of the Northern engravers picked up a different aspect of the style. Cort emphasized above all the firm delineation of sculptural form. Although his prints for Cock are far smaller than Ghisi's, his line is equally bold. In prints after Frans Floris like *The Sense of Smell* (cat. no. 12) and *Hercules and the Hydra* (cat. no. 25) systems of shading lines that swell and taper create the illusion of gleaming, almost metallic surfaces. Cort frequently suggests a contour without a contour line, by stopping a series of hatching lines at the edge of a form; the face of the woman in *The Sense of Smell*, for example. Bos and Coornhert had already occasionally adopted this technical trick from their Italian models, but compared to their earlier prints after Floris (cat. nos. 3 and 4), Cort's figures have a new solidity; if Ghisi's figures seem carved in stone, Cort's seem cast in bronze. The most Italianate of the Flemish engravers influenced by Ghisi, Cort was to immigrate to Italy in 1565 and work directly with Titian and other Italian artists (cat. nos. 56-58).[8] Hans Collaert, who reproduced numerous drawings by Lambert Lombard, used an equally disciplined but more delicate system of fine parallel hatchings to simulate Lombard's drawing technique of precisely drawn contours and flat wash shading. The technique has affinities to Suavius' *Sibyl* engraving, but the even balance of light and dark in a print like Collaert's *The Raising of Lazarus* (cat. no. 13) probably owes something to Ghisi as well.[9]

In the course of the 1550s Coornhert's style of engraving evolved to render metallic surfaces and flashing light and shade that has affinities to the work of Cort and Ghisi on the one hand and of Suavius on the other. *The Capture of Francis I* (cat. no. 21) from a series of prints depicting the victories of the Emperor Charles V, is characteristic of this later style.[10] Lighter and more delicate than Cort's work, it is connected to the change in Heemskerck's style of drawing that took place during the same period.

Suavius, although he never worked for the "Four Winds", seems to have been influenced by Ghisi in an engraving of 1553, *The Healing of the Paralytic* (cat. no. 14), which combines the strong play of light and shade of Suavius' earlier work with an increase in scale and strongly sculptural figures that recall Ghisi's *School of Athens*. Ghisi's style may in turn have been influenced by Suavius in *The Nativity* (cat. no. 17) after Bronzino; the large size and spectacular light effects of this print must have made it a sensation when it appeared in 1554, and *The Resurrection* (cat. no. 18), an etching issued by Cock three years later, seems to have been intended as a pendant to it, by Flemish rather than Italian artists.

Philipp Galle, who began his career in Antwerp too late to have known Ghisi directly, nevertheless seems to have absorbed his influence through the example of Coornhert (with whom Galle probably studied) and Cort.[11] Galle's style, like Coornhert's, builds on Ghisi's mastery of light and shade. In *Gladiatorial Games at the Funeral of a Great Man* (cat. no. 16) the nude bodies of the fighting gladiators are delineated with shorter, finer strokes than Cort used, and the figures in the background are less substantial and sculptural than Cort's. By contrast, the play of light and shade on these background figures, and the shadowy figure seen through the smoke of the funeral pyre, are effects that Cort never attempted.

Although Cort and Galle each emphasized a different aspect of the Ghisi-esque style, they could at times come very close to one another. It is a measure of the similarity with which different engravers could work that there are unsigned engravings published by the "Four Winds" that have never been definitively assigned to one engraver. *The Horatii and the Curiatii* (cat. no. 15) after Frans Floris is an example, probably engraved by Cort, but possibly by Galle or even Coornhert.[12] In the long run, however, Galle's finer, more luminous style diverges from Cort's bolder, more sculptural one, and when Cort left Antwerp for Italy it was Galle's style that came to dominate later engraving in Antwerp.

The Change in Heemskerck's Drawing Style

Perhaps the most dramatic example of Ghisi's influence was the transformation of the already established partnership of Coornhert and Heemskerck. Not only did Coornhert's style change dramatically in the mid-1550s, but simultaneously Heemskerck abruptly modified the style of drawings that he had been using in designs for prints. *Simeon the Patriarch* (cat. no. 19) is typical of the early drawings, a bold, almost sketchy style, emphasizing contour with a minimum of shading, which lent itself to line-for-line reproduction in etching, engraving, or a combination of the two as in Coornhert's print (cat. no. 20). In the later drawings, like *Joseph and Potiphar's Wife* (cat. no. 22), shading takes precedence over contour and decorative surfaces are meticulously rendered.

The change is heralded by Coornhert's dazzling series of prints after Heemskerck, depicting the victories of the Emperor Charles V (cat. no. 21), but it is most striking when we compare sets of prints depicting biblical stories. In the 1540s Heemskerck and Coornhert had produced a number of these series, uniform in size and in the use of a vertical format (cat. nos. 5 and 6). Figures are large and fill the foreground of the composition. This format changes abruptly in the mid-1550s; the new biblical drawings and the prints after them, whether by Coornhert or by other engravers (cat. nos. 22 and 23), are about the same size, but horizontal rectangles instead of vertical ones. The new format is congenial to scenes with larger numbers of smaller figures and to elaborate architectural or landscape settings. This change could be seen as a turning away from the Italianate style that Coornhert and Heemskerck had practiced in the 1540s, a return to the old Northern preference for surface decoration over structural form. But these later prints are not only more detailed in their surfaces than the earlier ones; they are also more solidly three-dimensional. It seems plausible that it was the development of engraving styles based on Ghisi, combining sculptural solidity with a brilliant sense of light and shade, that enabled Heemskerck to envision a new kind of drawing for prints. Whatever their genesis, these later prints of Heemskerck seem to have been far more popular than the earlier ones; they were reprinted into the seventeenth century and imitated by numerous later artists and engravers.

It is interesting that although Heemskerck continued to draw in pure line, the engravers who reproduced the later drawings did not copy them line for line, but devised equivalent systems of engraved shading lines. His new style of pen drawing was less directly imitable in engraving than his old one had been, and it is the existence of a set of standardized engraving conventions of shading that enabled Coornhert, Galle, and other engravers like Harmen Muller (cat. no. 23) to reproduce them successfully.

Prints After Paintings; Drawings Made for Prints

The engravings issued by Cock's publishing house can be divided between those reproducing works of art that had been made for their own sake and those reproducing drawings that had been made specifically to be multiplied through printmaking. But the division is not a clear one, and often it is only the survival of the original drawing or painting that reveals to which group a print belongs.

In reproducing a painting, the engraver and publisher did not hesitate to alter it to suit the print medium, whether by reinterpreting the subject matter in an inscription or changing the format of a composition. *The School of Athens* (cat. no. 11) was intended by Raphael to represent the assembled philosophers of ancient Greece, centered on Plato pointing upward to the heavens and Aristotle who gestures toward the earth. But the inscription on Ghisi's engraving identifies the heavenward-gesturing figure as Saint Paul preaching in Athens, accidentally or deliberately misinterpreting the subject to give it an overtly Christian meaning. The composition of Raphael's fresco, with its arched top, was also modified to make it conform to a rectangular copper plate, changing the proportions of the architecture, and the relative distances between the figures.

The Nativity (cat. no. 17) is more faithful to Bronzino's original painting, to which it is nearly identical in size, but the elaborate landscape in the background and the dramatic burst of light in the sky are additions, probably by Ghisi.[13] In the painting these areas are relatively simple fields of color which could have been rendered only as rather monotonous patches of shading; the detailed landscape and radiant light are more appropriate to a design carried out entirely in line. Another departure from exact reproduction is that the engraving is a mirror image of the painting, a natural reversal inherent in the printing process but one for which the engraver could compensate if he chose.[14]

Cornelis Cort's *Hercules and the Hydra* (cat. no. 24), is part of a set of engravings, *The Labors of Hercules*, based on a series of paintings by Frans Floris, owned by the wealthy banker Nicolaes Jongelingh. But Cort's engravings are not based directly on the paintings; a second artist, Symon Janszoon Kies, made drawings for the prints. The paintings varied in format; some were vertical compositions, others square, and the one surviving painting reveals that the spacious landscape backgrounds of the prints are inventions added by Kies or Cort to adapt the compositions to a horizontal format[15]. Clearly the intent was not to provide a series of reproductions of the paintings in the modern sense, but to create a uniform series of prints that could stand on their own as works of art.

Two engravings by Philipp Galle after Pieter Bruegel illustrate the different ways that a single engraver might approach similar works of art at different times. *The Resurrection* (cat. no. 25) probably engraved in the early 1560s, reproduces a drawing in wash that is effectively a monochrome painting, and Galle's treatment of it parallels on a small scale Ghisi's of the Bronzino *Nativity*. Galle even emphasizes the painting-like quality of the original by providing a simulated frame for the composition. Like the *Nativity*, too, the engraving is in reverse to the original, even though this results in the highly unorthodox image of Christ blessing with his left hand. It is interesting that Hieronymus Cock, who knew Bruegel well and who issued *The Resurrection* during the artist's own lifetime, cared so little about whether the composition was correctly oriented. A later engraving by Galle, reproducing another monochrome painting by Bruegel, *The Death of the Virgin* (cat. no. 26), was commissioned by the owner of the painting, Abraham Ortelius.[16] In this case Galle took the trouble to reproduce the composition right way round, perhaps at Ortelius' instigation.

In fact, the "Four Winds" issued few if any prints that exactly reproduce paintings. *The Last Judgment* (cat. no. 28) may be one, reproducing a triptych, complete with frame, that is similar to known paintings by Hieronymus Bosch.[17] No surviving painting corresponds to the print, but the preparatory drawings (cat. no. 27) for the left and right wings of the print may give a clue. They are neat and sure without being particularly distinguished, the sort of drawings that one might expect to result if a competent but uninventive artist was copying a pre-existing work.[18] By contrast, there are a considerable number of surviving drawings that were clearly made specifically to be reproduced as engravings, identifiable because the reversal of the composition is taken into account in advance through drawing figures left-handed, clock faces and lettering in reverse, and the like.

Besides Heemskerck, Pieter Bruegel was the artist who worked most extensively in this way for the "Four Winds." Like Heemskerck, Bruegel made line drawings that give the engraver a guide for developing systems of shading, but Bruegel's line work has little to do with the systems of shading that Cort or Galle were developing. Pieter van der Heyden, one of the less brilliant engravers who worked for Cock, was comparatively successful at interpreting these drawings, perhaps just because he had no style of his own to impose upon them and was willing merely to follow Bruegel's pen lines in such prints as *Anger* (cat. no. 29) (from the series *The Seven Deadly Sins*), or *Christ in Limbo*, (cat. no. 30). Philipp Galle's engraving *Prudence* (cat. no. 31) (from the series

The Seven Cardinal Virtues) is executed in the same brilliant style of light and shade that Galle used for *The Resurrection*, but it is a matter of debate whether Galle's brilliance is preferable to Van der Heyden's rather pedantic fidelity in rendering the homely simplicity of Bruegel's line work. Frans Huys was perhaps Bruegel's best interpreter, more skilled as an engraver than Van der Heyden but more faithful to the spirit of Bruegel's line than Galle. In Huys' *Armed Four-Masted Ship* (cat. no. 32) there is no uniform language of line: The shading of the smooth, billowing sails evokes Ghisi, but the choppy waves and puffy clouds are rendered in a much more irregular fashion that suggests Huys was following Bruegel's pen work (since drawings of this type by Bruegel do not survive, this can only be deduced). The similarity to pen drawing is reinforced by Huys' use of etching to render parts of the sky and the foam on the waves.

The engraving *Spring* (cat. no. 33), is based on one of Bruegel's later drawings for a print, and its massive figures are shaded in a way that more closely approaches the usual style of the "Four Winds." The drawing shows that Van der Heyden was still following Bruegel's pen lines closely; it was Bruegel whose style had changed. Ironically, however, this drawing dates from a time (1565) when Bruegel was no longer closely associated with Cock and was making fewer and fewer drawings for prints. He completed only *Spring* and *Summer* for what was obviously meant to be a series of four seasons, and when Cock published the series in 1570, after Bruegel's death, he had to have drawings for *Autumn* (cat. no. 34) and *Winter* supplied by Hans Bol.

Etching: Cock and the Doetechum Brothers

In theory, there was a technique that would produce far greater fidelity to the pen line than engraving—etching, which allows the printmaker to draw on a plate much as he would with a pen on paper. Bruegel made one etching, a single experiment perhaps instigated by Hieronymus Cock, who was himself an etcher rather than an engraver. Cock contributed a number of etchings

to the early output of the "Four Winds," primarily sets of landscapes and architectural studies like the *Third View of the Colosseum* (cat. no. 35) and *Mercury with the Head of Argus* (cat. no. 38). Based on drawings by Hieronymus himself or by his brother Matthys, they are in a free, scratchy style very like Hieronymus' surviving pen drawings. *Landscape with the Temptation of Christ* (cat. no. 37), after a pen drawing by Bruegel (now in the Národní Galerie in Prague) displays a more disciplined line that closely follows Bruegel's own pen lines, although in details of shading Cock made no attempt to duplicate Bruegel's work line-for-line.[19]

The majority of etchings issued by the "Four Winds," however, were the work of two brothers, Jan and Lucas van Doetechum, whose style is more akin to engraving than to pen drawing.[20] The Doetechums were praised in their own time for having invented a method of etching that was indistinguishable from engraving, praise that is confirmed by the persistent misdiagnosis of their prints well into the twentieth century.[21] By carefully systematizing their shading lines (frequently, it would seem, using a straightedge), varying the weight of lines by control of the etching process, and occasionally using engraving for finishing touches, they were even able to imitate the monumental scale and dramatic light effects of Ghisi's *Nativity* (cat. no. 17) in *The Resurrection* after Frans Floris (cat. no. 18). Although confronting the two prints suggests the comparison between a bunch of grapes and a handful of raisins, the control of light and shade displayed by the Doetechums on such a large scale is remarkable for an etching of the time.

More usually the brothers applied their technique to branches of subject matter where etching was already in common use. They took over from Cock the production of prints of architecture (cat. no. 36) and produced a series of landscapes after Pieter Bruegel on the same scale as Cock's etching. Comparing *Resting Soldiers* (cat. no. 39) to *Landscape with the Temptation of Christ* shows how the Doetechums took advantage of the ability of etching to delineate the jagged,

irregular contours of mountains or foliage, while introducing areas of controlled, regular shading that give the print the look of an engraving.

The architectural and ornament designs of artists like Cornelis Floris and Hans Vredeman de Vries were another important subject for the brothers. Their mechanically ruled lines were well-suited to the straps and trellises of a print like Floris' *Ornament Design with Laocoön* (cat. no. 40), and their gnarled, knotty style of figure drawing was equally appropriate to the grotesque human and animal figures that populate it. They were likewise successful at rendering another kind of grotesque fantasy; designs like *Saint Martin with His Horse in a Ship* (cat. no. 41) in the manner of the late fifteenth-century painter Hieronymus Bosch. Cock issued a number of these, prints; although often inscribed with Bosch's name, none of them is a direct copy of any surviving work by the artist, and some are known to have been designed by Bruegel. It is a measure of the uniformity imposed by the style of etching practiced by the Doetechums that one cannot judge on stylistic grounds whether the work on which *Saint Martin* is based was a drawing by Bruegel or by some other artist.[22]

Just as the later engravings after Heemskerck reflect his drawing style more indirectly than Coornhert's early prints, the etchings of the Doetechum brothers were less faithful to Bruegel's pen line than Cock's etching. The large number of prints that they produced for the "Four Winds" is an indication that the finished look of an engraving was considered more desirable than the suggestion of an artist's individual handwriting.

The Later Sixteenth Century (cat. nos. 42-84)

Numerous rivals and successors to Hieronymus Cock created a flourishing industry of print production in Antwerp from 1560 to 1600. The market was no longer dominated by a single publisher: the descendants of Philipp Galle and Hans Collaert and the Wierix, Sadeler and De Passe families formed dynasties of engravers who often published their own work or that of other family members. In Antwerp Martin de Vos succeeded Marten van Heemskerck as the leading producer of religious and allegorical scenes intended for engraving. *The Sense of Sight* (cat. no. 42) is typical: One of a series of drawings illustrating the five senses, it centers on an allegorical figure holding a mirror while in the background scenes from Genesis (God showing the Tree of Knowledge to Adam and Eve) and from the New Testament (Christ healing a blind man) provide religious allusions to sight.[23] Crispin de Passe's *Saint Elizabeth of Hungary* (cat. no. 45), based on his own drawing, is part of a similar series depicting nine notable women from pagan, Jewish and Christian history; a maiden, a married woman and a widow from each tradition.[24] Like De Vos' series it illustrates the contemporary delight in compiling, classifying, and correlating examples. Enormous numbers of prints such as these were produced, in a facile style that grows somewhat monotonous when seen in quantity. But the uniformity of style guaranteed a fairly high average quality of product, and by the end of the century commissions for engraved work were coming to Antwerp from as far away as Rome.[25]

In the 1580s and 90s the city of Haarlem in the Northern Netherlands emerged as a center of printmaking to rival Antwerp. In part this was fostered by political and religious issues. As the Spanish government tightened its grip on Antwerp and the Southern Netherlands, and as the Northern Netherlands became increasingly independent, commercial links between Antwerp and the North were broken. Artists of the Northern provinces were less likely to deal with Antwerp publishers than they had been in the past, and Protestant artists and engravers migrated north from the increasingly intolerant, Catholic South. The presence in Haarlem of the brilliant engraver Hendrick Goltzius helped to confirm this city as a second capital of engraving.

Although interaction between the northern and southern Netherlands was reduced, in general print production was more international than ever, as can be seen in the career of the

painter Bartholomeus Spranger. Born in Antwerp Spranger travelled to Italy and in the 1570s became court painter to the emperor Rudolph II in Vienna and Prague, where his hyper-elegant version of mannerism was highly appreciated. But though Spranger spent the rest of his life far from the Netherlands, his drawings traveled across Europe to Antwerp, Haarlem and Amsterdam, where they were reproduced as engravings (cat. nos. 61 and 78). These prints in turn circulated internationally. A good example is *Bellona* (cat. no. 78): designed in Prague, engraved and published in Amsterdam, and dedicated to the Austrian archduke Matthias, the brother and political rival of the emperor.

The New Style of Drawing for Prints

The Sense of Sight (cat. no. 42) is typical of the drawing style used by De Vos in designing for prints. The predominance of a standardized engraving style meant that he could work largely in wash, indicating only contour lines in pen and trusting the engraver (Adriaen Collaert in this case) to translate the shading into a predictable network of lines (cat. no. 43). It may indicate how natural the conversion of a wash drawing to a system of engraved hatchings had become that at the beginning of the seventeenth century Crispin de Passe, making a drawing that he himself would engrave, would use wash rather than line to render *Saint Elizabeth of Hungary* (cat. no. 44); even the occasional hatching lines that appear in the drawing bear no relation to the lines of De Passe's engraving (cat. no. 45). Similarly Hendrick Goltzius, although a virtuoso pen draughtsman, chose to work primarily with chalk in a preliminary study (cat. no. 63) for his engraving *Urania* (cat. no. 64).

"Fine Engraving"

The Dutch term *fijnschilder*—"fine painter"—has been applied to a group of Dutch seventeenth-century painters who produced small-scale paintings with a meticulous finish. By analogy, the dominant engravers of late sixteenth-century Antwerp might be called *fijngraveurs*; makers of

extremely delicate, finely engraved prints, often miniature in scale. The most prolific engravers of this type were the Wierix brothers, who were virtuoso engravers from their youth. Hieronymus Wierix proudly recorded his age, 13, on an accurate copy of Dürer's *Saint Jerome in His Study* (cat. no. 46). His ability to imitate the styles of other artists probably gained him the job of finishing a project that Cornelis Cort had begun for Cock and then abandoned when he emigrated to Italy—a series of portraits of Dutch and Flemish artists. Cort's powerful metallic modeling of the face of *Joachim Patinier* (cat. no. 47) is successfully imitated by Wierix in a portrait of *Jan Vermeyen* (cat. no. 48) done when he was still in his teens. But as mature artists Hieronymus Wierix and his brother Antoine practiced a delicate silky engraving technique, which they applied with equal facility to reproducing drawings, like the *Saint Michael* (cat. no. 49) after Martin de Vos, or to their own inventions, like Antoine's *Cain and Abel* (cat. no. 51). In both prints the remarkable skill at rendering surface textures and effects of light is combined with a facile grace that belies the seriousness of the conflicts they depict—the ultimate struggle between Good and Evil in Hieronymus' print and the first murder in Antoine's. The brothers' talent is perhaps best shown in engravings on a miniature scale like *The Empire of Death* (cat. no. 50). Hans Collaert the Younger, the son of the engraver who had worked for Hieronymus Cock, rivalled the Wierix brothers in prints like *Truth Revealed by Time* (cat. no. 52).

Ornament continued to be an important sub-theme of Antwerp engraving, and the meticulous style of the "fine engravers" suited itself particularly well to designs for jewelry and goldsmith's work. Both Hans Collaert the Younger and his brother Adriaen were prolific engravers of ornament, and their father was not only an engraver but a designer of jewelry: a *Pendant* (cat. no. 53) is part of a series designed by Hans the Elder and engraved by one of his sons, probably Adriaen.[26] In contrast to the ornament designs of Cornelis Floris (cat. no. 40) which seem to be fantasies

conceived with little thought of a specific practical application, the later ornament engravings are commonly oriented towards a particular purpose. Jan Theodor de Bry's *Design for a Knife Handle* (cat. no. 54) could have been copied line for line on gold or silver to make an actual knife handle. The central scene is a triumph of miniaturization: An engraving by Jan Saenredam that measures about eight inches high is copied in the space of about half an inch.[27]

Nicolaes de Bruyn, like De Bry and the Collaerts, was a brilliant engraver of miniature ornamental prints, but he also produced a significant group of landscape engravings on a larger scale. In these prints, such as *The Finding of Moses* (cat. no. 55) his meticulous technique is devoted less to minute surface detail than to rendering nuances of light and shade and delicate transitions of atmospheric perspective.

In some respects "fine engraving" was a return to the older northern tradition of Dürer and Lucas van Leyden (whose prints were deceptively copied by some of these engravers) and Lambert Suavius, but it descends more directly from the refined, small-scale version of the Ghisiesque style practiced by Philipp Galle and Hans Collaert the Elder. The bolder, more vigorous version of the style was meanwhile being propagated by Cornelis Cort in Italy and Hendrick Goltzius in Haarlem.

Cornelis Cort in Italy

When Cort arrived in Italy he brought with him a style that was essentially Italian, yet codified and standardized in a way that no Italian engraver had equaled up to that time. The painter Titian (who had previously sponsored the production of woodcut versions of his compositions) took Cort into his house, and Cort became, in a sense, Titian's official engraver. One of his first prints after Titian, *Landscape with Roger Rescuing Angelica* (cat. no. 56), is based on a drawing similar to the ones from which woodcuts earlier had been made.[28] The woodcuts copied Titian's bold pen work literally. But where Titian's drawing was free and informal, the woodcut translations

look untidy. Cort by contrast created linear systems as bold as Titian's but more regular. The result is an equivalent to Titian's drawing appropriate to the more laborious print medium.

Titian had executed two paintings of *The Martyrdom of Saint Lawrence* (cat. no. 57), one for a church in Venice and a second for King Philip II of Spain. Cort's print is dedicated to Philip. The main group of figures and the statue and pedestal are based closely on the painting in Venice (although they have been reversed in the print). The two angels, however, derive from the Spanish version. Furthermore, the angels are *not* reversed in the print, creating a relation between them and the saint that does not exist in either of the painted versions. This drastic reworking, effectively a third version of the composition, must have been done by Titian, and presumably it was also Titian who substituted rolling clouds of smoke for the architectural backgrounds he had created in the paintings. Under Titian's guidance Cort mastered dramatic light effects surpassing anything he had done in Flanders; he was able to translate Titian's monumental painterly style into monumental, sculptural engravings.

Cort's direct connection with Titian is documented, and there are other instances of close collaboration with an artist from the Italian portion of Cort's career. However, he also reproduced the work of artists of a previous generation with whom he could have had no connection, such as Raphael and Correggio. There is no evidence that Federico Barocci was personally involved with Cort's engraving of his painting, *The Holy Family Resting on the Return from Egypt* (cat. no. 58). The print is a fairly faithful reproduction of one of the two surviving versions of the painting, but Cort probably added the distant landscape, just as Ghisi added landscape to Bronzino's *Nativity*.

Hendrick Goltzius

Goltzius was a pupil of Coornhert, and his early work is much in the style of "Four Winds" engravers, such as Philipp Galle. *Lot's Flight from Sodom* (cat. no. 59) is not much different from

many Antwerp engravings of the time, and one of Goltzius' early specialties, miniature portraits, such as *Arnoud von Beresteyn* (cat. no. 60), was a frequent theme of engravings by the Wierix brothers. But Goltzius emerged from the crowd of late sixteenth-century reproductive engravers because of his technical skill and artistic ambitions. In the early 1580s he was introduced to Spranger's work by the painter Karel van Mander, and *The Wedding of Cupid and Psyche* (cat. no. 61), engraved in 1587 after a drawing by Spranger, displays a handling of line wholly appropriate to the large scale of the print and to Spranger's Mannerism. The exaggerated muscularity of the male figures and the unnatural grace of the females is rendered with shading that comparably exaggerates the swell and taper of Cort's engraved line.

By the early 1590s Goltzius had retreated from the extreme mannerism of Spranger, and a trip to Italy had brought him into direct contact with ancient art and the art of the High Renaissance. *The Triumph of Galatea* after Raphael (cat. no. 62) can be seen as a deliberate attempt to rival Cort's major engravings after Italian paintings such as the *Saint Lawrence* (cat. no. 57). Goltzius' line, more assertive than Cort's, gives a flamboyance to the engraved surface alien to the calm brushwork of Raphael. Apart from that the engraving is a remarkably faithful rendering of the painting, maintaining its proportions according to a much stricter standard than Ghisi had felt necessary in reproducing *The School of Athens* (cat. no. 11) four decades earlier. Goltzius' own compositions enter a Raphaelesque phase at this time, exemplified by a series of engravings of the nine muses. The figure in a preliminary study for the muse *Urania* (cat. no. 63), with her elongated oval face and self-consciously elegant pose, still recalls Spranger, but in the engraving (cat. no. 64) the figure has the rounded head and classical proportions of Raphael's *Galatea*.

In the final phase of his career as an engraver Goltzius made several prints that emphasize his ability to emulate the style of other artists: These are no longer direct reproductions but are com-

positions of his own that might be taken for the work of others. *The Life of the Virgin*, six prints each in the style of a different artist, is discussed at length by Silver and Melion elsewhere in this book. The first print Goltzius engraved for this set, *The Holy Family, in the Manner of Federico Barocci* (cat. no. 65), confronted not only the art of an Italian painter but also the engraving style of Cornelis Cort, since it was engravings such as Cort's *The Holy Family Resting on the Return from Egypt* (cat. no. 58) that Goltzius used as sources for his re-creation of Barocci's art.[29] In *The Adoration of the Magi, in the Manner of Lucas van Leyden* (cat. no. 66) Goltzius could base his work on the artist's own prints: Taking figures from Lucas' engraving of the same subject he treats them as if they were live models, moving them about, rearranging the composition, and executing his print using the engraving style Lucas himself had used, but on a significantly larger scale. A later engraving, *The Pieta, in the Manner of Dürer* (cat. no. 67), is still more deceptive, imitating the earlier artist on a scale Dürer would have employed for such a print.

The Goltzius Style: From Haarlem to Prague

The mainstay of Goltzius' style—lines that swell and taper, organized into patterns of shading conspicuously graceful in themselves—formed the basis for a school of engraving that flourished in Haarlem, in the nearby city of Amsterdam, and as far away as Prague. His pupils (Jan Saenredam or Jacob Matham), or those influenced by his example (Jan Muller and Aegidius Sadeler), practiced a multitude of variations on his style. Goltzius followers might emphasize contour or chiaroscuro, suggest the richness of painting or the lightness of drawing. They might work on a monumental or a miniature scale. Although one can characterize the basic style of each engraver, each was capable of working in a variety of manners depending on the type of work to be reproduced.

Saenredam's *The Hymn of the Daughters of Israel to David* (cat. no. 68) reproduces a design Lucas van Leyden created as a stained-glass

window.[30] Unlike Goltzius in *The Adoration of the Magi* (cat. no. 66), Saenredam does not imitate the linear conventions Lucas used in engraving. But Saenredam's comparatively light, evenly weighted line does suggest Lucas' style as a draughtsman and engraver. By contrast *Plato's Cave* (cat. no. 69) uses a broader range of line, appropriate to the muscular style of the late sixteenth-century painter Cornelis van Haarlem. It is also a virtuoso rendition of light, appropriate to Plato's parable about the perception of reality: nuances of shade for the group at the right, whose only notion of reality is the shadows cast upon the wall; strong contrasts of light and dark for the men at the left, who perceive the artificial light that casts the shadows; and in the full light of day in the distance, a glimpse of brilliantly illuminated figures.[31] But Saenredam's most characteristic engraving style, similar to Goltzius' but more delicate, with silver tones and silky textures, is exemplified by such prints as *The Expulsion from Eden* (cat. no. 70) after Abraham Bloemaert and *The Foolish Virgins* (cat. no. 71), after his own design.

One wonders whether Jacob Matham became an engraver because of an innate gift or because of his family connections (he was Goltzius' stepson). Prolific but comparatively unimaginative, he reproduced over three hundred drawings and paintings by his stepfather and other artists, both Northern and Italian, in a pale and neutral style. But Matham also responded to different models with distinctly different techniques of engraving. *Abraham Dismissing Hagar* (cat. no. 72) and *Daedalus and Icarus* (cat. no. 73) are almost identical in size and depict similar landscape subjects, but one print is tonal, the other aggressively linear. *Abraham Dismissing Hagar*, after a painting or drawing by Abraham Bloemaert, employs comparatively fine lines in a variety of shading systems to suggest different surfaces and light conditions. In *Daedalus and Icarus*, after Goltzius, there is far less cross-hatching, and shading depends more on variations in the weight of a line heavier than those in the print after Bloemaert. It is very like the line used by Goltzius in his pen drawings of landscape. One suspects Matham was reproducing such a pen drawing,[32] emulating the spirit of Goltzius' line much as Cock had emulated Bruegel's in *Landscape with the Temptation of Christ* (cat. no. 37).

If Jan Muller was not Goltzius' pupil he was closely associated with him. When not yet twenty he engraved *The Creation of the World* (cat. nos. 74 and 75) after drawings by Goltzius (who also published the prints). The shading is harsher than in Goltzius' or Saenredam's prints, but strong and vigorous, and in the *Creation of Sun and Moon* (cat. no. 75) in particular a heavy line is used to convey remarkably subtle light effects. Muller later created several spectacular nocturnal scenes, such as *Belshazzar's Feast* (cat. no. 76), where the effects of light and shade are so dramatic that the brilliance of the line work is noticed only at second glance. But more frequently he magnified the Goltzius line to a heroic scale. *Hercules and the Hydra* (cat. no. 77) turns the sculptural quality of the engraver's line to the rendition of an actual piece of sculpture, a genre of engraving Cort and Goltzius had occasionally practiced, but never on so large a scale. A still more spectacular print is *Bellona Leading the Armies of the Emperor Against the Turks* (cat. no. 78). Roughly the same size as Ghisi's *Nativity* (cat. no. 17), this print is radically different in concept: Where Ghisi had inserted a landscape full of minute detail, Muller enlivens a similar area with oversize patterns of shading, creating an image that seems intended to be viewed from a distance.

In the work of Aegidius Sadeler the Antwerp tradition of "fine engraving" is infused with the Goltzius tradition.[33] Aegidius began his career in Antwerp where his uncles, Jan and Raphael Sadeler, were engravers. In 1586 the three Sadelers left Antwerp, eventually settling in Munich, and in 1597 Aegidius was called to the court of the Emperor Rudolph II in Prague. Goltzius had visited the Sadelers in Munich; even if he had not, Aegidius could hardly have been unaware of his work. Two prints after Bartholomeus Spranger from around 1600 are brilliant exercises in the

Goltzius style. *The Triumph of Wisdom over Ignorance* (cat. no. 79), similar to a painting by Spranger but probably based on a drawing, combines a swelling and tapering line with the mastery of a broad range of light and shade. *The Artist and His Wife* (cat. no. 80) is a less monumental and more private print, expressing through a multitude of symbolic attributes Spranger's grief at the recent death of his wife. Sadeler's skillful massing of light and shade articulates a composition that easily could have become a mere tangle of objects and shapes.

Yet for Aegidius Sadeler the mainstream Goltzius style seems to have been one of several options, appropriate for reproducing a painting by Spranger but seldom used otherwise. In prints after other artists he often approaches the style of Cort's Italian period more closely than that of Goltzius. To reproduce a pen and watercolor drawing by Albrecht Dürer, *The Madonna with the Many Animals* (cat. no. 81), Aegidius employs two linear languages, neither of which copies the pen lines of Dürer's drawing. Where there is a ready precedent in Dürer's engravings—the figure of the Madonna or the hollow tree stump hiding an owl—he follows Düreresque conventions of shading. But where a Dürer precedent is less obvious—the distant landscape rendered in broad washes of watercolor—he builds up patches of shading using fine parallel hatchings. These have less to do with Dürer than with the fine engraving of Nicolaes de Bruyn.

Goltzius, in his late prints, had set the precedent for this polymorphous shifting from style to style. The variety of linear languages enabled the engraver to harmonize his technique with the styles of different artists, while still displaying his own mastery of line.

Drawing, Etching and Engraving

In the late sixteenth and early seventeenth century etching continued to be what it had been in the time of the "Four Winds"—a medium used occasionally by artists who did not wish to learn the craft of engraving, or a method of imitating pen drawing. The ambivalence printmakers seem to have felt about etching as a reproductive medium is suggested by a group of prints by and after Abraham Bloemaert.

A successful painter in the late Mannerist style of Spranger, Bloemaert supplied many models for prints by the Goltzius school. *Juno* (cat. no. 82) is one of the few etchings he made. At some point this single print was turned into a series by the engraver Boetius Bolswert. The series was presumably based on drawings Bloemaert made for translation. As can be seen from *Mary Magdalen* (cat. no. 84), Bolswert was perfectly capable of mimicking Bloemaert's pen work in etching. He chose, however, to create two engravings, *Venus* (cat. no. 83) and *Minerva*, following the conventions of the Goltzius style.

Once again, it would seem, the look of an engraving was preferred to an imitation of the free line of a drawing, even at the expense of destroying the stylistic unity of the series. At the same time, paradoxically, the very fact that two engravings were created as companions to Bloemaert's etching indicates a value placed on work from the artist's own hand. Perhaps the series was intended—as it does so successfully—to contrast forms of expertise in the manipulation of line.

Epilogue: Rubens and His Time
(cat. nos. 85-91)

This survey of engraving might have ended with the international triumph of the Goltzius style, but Jacob Matham, Jan Muller, and Aegidius Sadeler lived to see Dutch and Flemish engraving altered once again, as radically as it had been by the engravers of the "Four Winds." It seems appropriate to glance at this transformation. As an artist Peter Paul Rubens is incomparably more important than Hieronymus Cock, but like Cock he was a shrewd businessman fully aware of the advantages of engraving for reproducing his paintings.[34] As an admirer of Titian, Rubens also must have been aware of the success of Titian's work with Cornelis Cort.[35]

Rubens could commission engravings from members of the Goltzius school such as Matham

(who reproduced an early painting of Samson and Delilah by Rubens) or Jan Muller. Muller was capable of abandoning his ostentatious, calligraphic line in favor of a virtuoso rendition of surfaces in prints such as *Ambrosio Spinola* (cat. no. 85) after Michiel van Miereveld (Muller engraved Rubens' portraits of Archduke Albert of Austria and his wife in a similar style.) But Rubens was not satisfied evidently with virtuoso linear performances that called as much attention to the skill of the engraver as to the beauty of the work being reproduced. His ideal was probably the relationship between Titian and Cort: an engraver skilled in interpreting a painter's compositions but less assertive than the Haarlem engravers.

Rubens stated he would rather have a young engraver working under his direction than a famous artist who would inject his personality into the print.[36] Lucas Vorsterman, who began to make engravings after Rubens when barely twenty, was a generation younger than Muller and Matham. Vorsterman engraved *The Descent from the Cross* (cat. no. 86) in a style derived from that of Cort and Goltzius. But given the large size of the print it is as if the style had been miniaturized. One is conscious of the play of light and shade, yet one scarcely notices the variations of the individual lines that create it. This is not the "fine engraving" of the Wierix brothers or Nicolaes de Bruyn; the contrasts of light and shade are as vigorous as those in Rubens' painting.

Schelte Bolswert's *Landscape with a Rainbow* (cat. no. 87) is engraved in a similar style. Bolswert convincingly rendered atmospheric effects and aerial perspective. Even the colors of the painting are suggested; there is a distinction, for example, between the conventionally pale skin of the women and the men's tanned skin. If one compares Vorsterman's and Bolswert's work to Sadeler's *Triumph of Wisdom over Ignorance* (cat. no. 79), it becomes clear how the engravers' art under Rubens has changed from ostentatious display to self-concealment. The range in weight of Bolswert's line is almost as great as Sadeler's, but where Sadeler juxtaposes very thick and very thin

lines, Bolswert segregates light and heavy lines in individual patches of tone, and modulates their transitions. The similarity in style between the prints by Vorsterman and Bolswert, though engraved more than a decade apart, is evidence that although Rubens may never have engraved a line, he successfully imposed his wishes on the engravers working under his direction.

Rubens oversaw the production of nearly one hundred prints based on his designs.[37] The engraver did not usually work directly from a painting; Rubens or one of the assistants in his studio prepared a small-scale painted or drawn model. (The drawing for Vorsterman's engraving of *The Descent from the Cross*, for example, has been attributed to Van Dyck).[38] But the prints whose production Rubens oversaw directly are only a portion of those issued by engravers who worked for him. The complexities behind the creation of a print in Rubens' circle are suggested by a drawing, *Putti Decking a Niche with Fruit* (cat. no. 88). The drawing, perhaps by the engraver Cornelis Galle, perhaps in part by Rubens' associate Frans Snyders,[39] is based on a painting (now in the Hermitage Museum in Saint Petersburg) made by Rubens in collaboration with Snyders. Snyders painted the garlands of fruit.[40] But the niche in the painting contains a figure of Ceres, the Roman goddess of the harvest. In the print after the drawing (cat. no. 89), a figure of the Virgin and Child is substituted for the goddess, transforming an allegory of natural fruitfulness into a religious image. The print was issued in Rubens' lifetime (it is dedicated to Rubens' friend, Nicolas Rockocx, who died in the same year as the painter) but was not published by him. It is not clear whether Rubens designed the figure of the Virgin and Child that appears in the engraving, or whether he took any role at all in producing it.

Yet one could argue that this is irrelevant. Rubens had set up a system for the production of a certain kind of engraving, and it worked so well it functioned by itself. The Rubens style of engraving was to have a far longer life than the Goltzius style. In Northern Europe it would per-

sist almost without modification to the end of the seventeenth century. Well into the nineteenth century it would continue to influence the way engravers reproduced works of art.

Rubens' talents as painter and businessman had no parallel in the northern Netherlands, and the primary feature of printmaking in Haarlem and Amsterdam over the next fifty years was the growth of etching, in particular landscape etchings.[41] One aspect of late sixteenth century engraving, the production of prints depicting night scenes with spectacular light effects, continued into the early seventeenth century. Hendrick Goudt specialized in reproducing the paintings of his friend Adam Elsheimer, and in prints such as *Jupiter and Mercury at the House of Philemon and Baucis* (cat. no. 90) he massed fine hatchings to produce on a small, homely scale the dramatic effects of light and shade Muller had achieved in *Belshazzar's Feast* (cat. no. 76). Similarly, Jan van de Velde, a prolific landscape etcher, made a secondary specialty of etchings and engravings of nocturnal scenes. Most were landscapes or interior scenes. The *The Sorceress* (cat. no. 91), however, gave him the chance to exploit a variety of natural and very unnatural light effects.

Looking backward over the century, one could trace the ancestry of these prints through Jan Muller, Philipp Galle's prints after Bruegel's *Resurrection* and *Death of the Virgin*, and Ghisi's *Nativity*—even as far back as Lambert Suavius. In the seventeenth century prints would have a more remarkable series of descendants: the nocturnal etchings and drypoints of Rembrandt, and an entirely new printmaking technique—the mezzotint—that would become the greatest rival of engraving as a means of reproducing paintings.[42]

Notes

1

To explain *why* this happened would go far beyond the scope of this essay and exhibition, although the essays by Larry Silver and Walter Melion deal with some aspects of the question. I believe that the desire for reproductions of a work of art is connected with a shift from the medieval notion that a work of art is common property (to be copied and adapted at will), to the modern notion that the composition invented by an artist *belongs* to that artist, and that to copy it directly is both a kind of stealing and an admission of failure in one of the essential qualities of an artist. Paradoxically, as the casual borrowing of the medieval workshop tradition became less respectable, the idea of the reproduction, as an *especially faithful* copy, gained currency. But the relations of cause and effect here are still obscure, and I am not aware of a thorough study of the issue. General studies of the nature of the reproductive print include: William M. Ivins, *Prints and Visual Communication* (Cambridge, Mass.: Harvard University Press, 1953). Gerhard Langemeyer and Richard Schleier, *Bilder nach Bildern: Druckgrafik und die Vermittlung von Kunst* (Münster: Westfälisches Landesmuseum für Kunst und Kulturgeschichte Münster, 1976). Christian von Heusinger, *Das Gestochene Bild: von der Zeichnung zum Kupferstich* (Braunschweig: Herzog-Anton-Ulrich-Museum, 1987).

2

A.J.J. Delen, *Histoire de la gravure dans les anciens pays-bas et dans les provinces belges: deuxième partie, le XVIe siècle; les graveurs d'estampes* (Paris: les Éditions d'art et d'histoire, 1935) is a basic history of printmaking in the Netherlands during this period, though often inaccurate in detail. Konrad Oberhuber, *Zwischen Renaissance und Barock: das Zeitalter von Bruegel und Bellange* (Vienna: Graphische Sammlung Albertina, 1967) covers all of Northern Europe and is somewhat limited by its restriction to prints from one (superb) collection, but is much more reliable on the material covered than Delen.

3

Sune Schéle, *Cornelis Bos: A Study of the Origins of the Netherlands Grotesque* (Stockholm: Almqvist and Wiksel, 1965), 117-118; 159-161. In the first example, Bos published a series of prints that was probably engraved entirely by Coornhert; in the second both men produced prints for a single project.

4

Thomas Kerrich, *A Catalogue of the Prints Which Have Been Engraved after Martin Heemskerck* (Cambridge: J. Rodwell, 1829), 20-21. Oberhuber, *Zwischen Renaissance und Barock*, 83-86. Ilja Veldman, the most recent cataloguer of Coornhert's work (*The Illustrated Bartsch* 55), attributes these etchings to Coornhert.

5

Ilja M. Veldman, *Maarten van Heemskerck and Dutch Humanism in the Sixteenth Century* (Maarssen: Gary Schwartz, 1977), 56-57 and 70-74.

6

Jean Puraye, "Lambert Suavius, graveur liégeois du 16e siècle," *Revue belge d'archéologie et d'histoire de l'art* 16 (1946),

29, documents Suavius' purchase of a diamond point and speculates that this was used for engraving. Whether it was actually an engraving tool remains to be substantiated.

7

Timothy Riggs, *Hieronymus Cock, Printmaker and Publisher* (New York: Garland Publishing, Inc. 1977).

8

J.C.J. Bierens de Haan, *L'oeuvre gravé de Cornelis Cort, graveur hollandais* (The Hague: Martinus Nijhoff, 1948), 12-3.

9

Riggs, *H. Cock*, 85-87.

10

According to Karel van Mander's life of Heemskerck (published in 1604) the entire set of prints of the Victories of Charles V was engraved by Coornhert, *except* for *The Capture of Francis I,* which was engraved by Bos. Karel van Mander, *Het Leven der Doorluchtighe Nederlandtsche en Hoogduytsche Schilders/Das Leben der niederländischen und deutschen Maler* (edited and translated by Hanns Floerke from the 1617 edition) (Munich and Leipzig: Georg Muller, 1906) 1: 353. In the 1540s Bos and Coornhert had worked in very similar styles, particularly when collaborating on series of prints after Heemskerck. There is no other print by Bos, however, that remotely resembles this, whereas it is characteristic of later engravings by Coornhert. Although the question is complicated by the fact that Heemskerck's drawing style was changing radically at this time, it seems to me more likely that Van Mander was misinformed than that Bos, at the very end of his life, produced a single example of a print radically different from all his previous work.

11

Riggs, *H.Cock*, 100.

12

Delen, *Histoire/2e partie; estampes,* 81 attributed the print to Cort. Bierens de Haan, *Cort,* 4-5, rejected the print without explanation. Riggs, *H. Cock,* 120, note 29.

13

Michal and R. E. Lewis, catalogue in *The Engravings of Giorgio Ghisi* (New York: The Metropolitan Museum of Art, 1985), 71-73.

14

The print from an engraved plate is always a mirror image of the design on the plate. Therefore, if the engraver copies his model faithfully on the plate, his print will be in reverse.

15

The surviving painting and its relation to the engraving are discussed in Carl van de Velde, "Hercule en Antaeus, een teruggevonden schilderij van Frans Floris," in *Album Amicorum J. G. van Gelder* (The Hague: Martinus Nijhoff, 1973), 333-336.

16

A. E. Popham, "Pieter Bruegel and Abraham Ortelius," *Burlington Magazine* 54 (1931), 184-188.

17

If the print does reproduce a painting it does not follow automatically that it was a painting by Bosch. F. Grossman,

"Notes on Some Sources of Bruegel's Art," *Album Amicorum J. G. van Gelder* (The Hague: Martinus Nijhoff, 1973), 149, attributes the design to Pieter Bruegel. See also Gerd Unverfehrt, *Hieronymus Bosch: die Rezeption seiner Kunst im frühen 16. Jahrhundert* (Berlin: Gebr. Mann Verlag, 1980), 241.

18

It has been suggested, in fact, that these drawings are copies of the engraving, because they follow it so faithfully and because they are not in reverse to it. But close examination of the drawings shows that they have been traced over on the reverse with a stylus; evidently part of a process to transfer the designs in reverse on to the engraving plate. It is not clear exactly how this process worked, but it was evidently current at the "Four Winds"; drawings by Cock for his own etchings have similar signs of tracing from the back. Indeed it is possible that these drawings are by Cock himself.

19

Karl Arndt, "Unbekannte Zeichnungen von Pieter Bruegel d. Ae.," *Pantheon* 24 (1966), 206-216.

20

It is impossible to separate the work of the two brothers, because during the time that they worked for Cock they signed only one print, jointly. The technique they used is distinctive and easily recognized, but although there is some variation among the prints they produced, it is not enough to allow a distinction between two hands. See Riggs, *H. Cock*, 140-149.

21

Matthias Quad von Kinkelbach: *Teutscher Nation herligkeit* (Cologne: 1609), 431-432. Riggs, *H. Cock*, 140-141. Delen, *Histoire/2e partie; estampes,* 62 described the Doetechums' landscape prints after Bruegel as "burin engravings."

22

On Bruegel's authorship of Boschian compositions, see F. Grossman, "Notes on Some Sources of Bruegel's Art," *Album Amicorum J. G. van Gelder* (The Hague: Martinus Nijhoff, 1973), 147-154. Grossmann attributes the *Saint Martin* to Bruegel. See also Gerd Unverfehrt, *Hieronymus Bosch: die Rezeption seiner Kunst im frühen 16. Jahrhundert* (Berlin: Gebr. Mann Verlag, 1980), 230.

23

Carl Nordenfalk, "The Five Senses in Flemish Art before 1600," in *Netherlandish Mannerism: Papers given at a Symposium in Nationalmuseum Stockholm* (Stockholm: Nationalmuseum Stockholm; Nationalmusei skriftserie N.S. 4, 1985), 135-154.

24

Thomas DaCosta Kaufmann, *Drawings from the Holy Roman Empire, 1540-1680: A Selection from North American Collections* (Princeton: The Art Museum, Princeton University, 1982), 70-71.

25

Max Rooses, "De Plaatsnijders der Evangelicae Historiae Imagines," *Oud-Holland* 6 (1888), 277-288, gives a notable example of a major project commissioned from Rome.

26

Peter Jessen, *Der Ornamentstich: Geschichte der Vorlagen des Kunsthandwerks seit dem Mittelalter* (Berlin: Verlag für Kunstwissenschaft, 1920), 97.

27

The Saenredam engraving is reproduced in *The Illustrated Bartsch* 3: 402, no. 86.

28

David Rosand and Michelangelo Muraro, *Titian and the Venetian Woodcut* (Washington: International Exhibitions Foundation, 1976) 138-153.

29

Goltzius actually used two Barocci compositions as source material, both available through engravings by Cort. Barocci's *Madonna of the Cat* (Bierens de Haan 43) is the model for the figures, but the outdoor setting is related to *The Holy Family Resting on the Return from Egypt*. Otto Hirschmann, *Verzeichnis des graphischen Werks von Hendrick Goltzius*, (Leipzig: Klinkhardt und Biermann, 1921), 76; Walter Strauss, *Hendrick Goltzius, 1558-1617: The Complete Engravings and Woodcuts* (New York: Abaris Books, 1977), 438.

30

Van Mander (Floerke edition) 1: 126-127.

31

The iconography of the composition is discussed at greater length in P. J. Vinken, "H. L. Spiegel's Antrum Platonicum: A contribution to the Iconology of the Heart," *Oud-Holland* 75 (1960), 125-142. See also P. J. J. van Thiel, "H. L. Spiegel en het Orgel van Euterpe: een Hertspiegel-probleem" *Album Amicorum J. G. van Gelder* (The Hague: Martinus Nijhoff, 1973), 312-320.

32

See for example E.K.J. Reznicek, *Die Zeichnungen von Hendrick Goltzius* (Utrecht: Haentjes, Dekker & Gumber, 1961), cat. nos. 393, 406-07.

33

On Aegidius Sadeler see Dorothy Limouze, Aegidius Sadeler, Imperial Printmaker," *Philadelphia Museum of Art Bulletin* 85, no. 362 (Spring 1989).

34

The literature on Rubens and his printmakers is vast. Some of the more recent studies (with earlier bibliography) are: Konrad Renger, "Rubens dedit dedicavitque: Rubens' Beschäftigung mit der Reproduktionsgrafik, I. Teil: Der Kupferstich; II. Teil: Radierung und Holzschnitt - Die Widmungen," *Jahrbuch der Berliner Museen* 16 (1974), 122-75; and 17 (1975), 166-213. Didier Bodart, *Rubens e l'incisione nelle collezioni del Gabinetto Nazionale delle Stampe* (Rome: De Luca Editore, 1977). Konrad Renger and others, *Rubens in der Grafik* (Göttingen: 1977). Ingeborg Pohlen, *Untersuchungen zur Reproduktionsgraphik der Rubenswerkstatt (Beiträge zur Kunstwissenshaft 6)* (Munich: Richard A. Klein, 1985). One of the few surveys in English is Frances Huemer and others, *Prints after Rubens; A Loan Exhibition* (Chapel Hill, NC: Ackland Art Center, 1968).

35

On Rubens' complex response to Titian, see Mary Crawford Volk, "On Rubens and Titian," *The Ringling Museum of Art Journal* (1983), 140-149.

36

Ruth S. Magurn, ed. and trans., *The Letters of Peter Paul Rubens* (Cambridge, Mass.: Harvard University Press, 1955), 69, no. 36. "I should have preferred to have an engraver who was more expert at imitating his model, but it seemed the lesser evil to have the work done in my presence by a well-intentioned young man, than by great artists according to their fancy."

37

Renger and others, *Rubens in der Grafik*, 4.

38

The drawing is in the Louvre. Frits Lugt, *Musée du Louvre; inventaire générale des dessins des écoles du nord; école flamande* (Paris: Musées nationaux, palais du Louvre, 1949) 2: 40, no. 1140. The attribution to Van Dyck is rejected by Horst Vey, *Die Zeichnungen Anton van Dycks* (Brussels: Verlag Arcade, 1962) 1: 35. What is certain is that it was made under Rubens' supervision, but not by Rubens himself.

39

Jan Albert Goris and Julius Held, *Rubens in America* (New York: Pantheon, 1947), 57, A.105. In 1990 Anne-Marie Logan suggested in conversation that the drawing of the garlands might be by Snyders, on the basis of its similarity to a drawing then on the market.

40

Hella Robels, *Frans Snyders, Stilleben- und Tiermaler, 1579-1657* (Munich: Deutscher Kunstverlag, 1989), 88, 356 (no. 262). The painter of the garlands had earlier been identified as Jan Bruegel the Elder. The attribution of the painting to Rubens and Snyders offers additional support to the idea that the drawing is by Snyders.

41

On the development of landscape in the early seventeenth century around Haarlem, see Wolfgang Stechow, *Dutch Landscape Painting of the Seventeenth Century* (London: Phaidon, 1968), esp. 15-35; and Cliff Ackley, *Printmaking in the Age of Rembrandt* (Boston: Museum of Fine Arts/New York Graphic Society, 1981), esp. 50-72.

42

On the development of tonal printmaking in the seventeenth century in the Netherlands, see Ackley, "Printmaking in the Age of Rembrandt: the Quest for Printed Tone," *Printmaking in the Age of Rembrandt*, xix-xxvi.

Artists & Engravers

The following list includes all artists represented in the exhibition, both as printmakers and as artists in other media whose work was reproduced in prints. Prints by an artist are indicated by the Latin word *fecit* (made it) following the entry numbers; prints reproducing the artist's work are indicated by the word *invenit* (invented it). During the period covered by this exhibition these words, together with the word *sculpsit* (engraved it) and *excudebat* (published it) were commonly used on the prints themselves to designate the part played by different people in their creation.

In general, catalogue references have been given only for the artist who actually engraved or etched the prints in the exhibition. However, when there is no adequate reference for a printmaker (as with the Doetechum brothers) or where detailed catalogues exist of the prints made after an artist (Bruegel, Heemskerck), references are cited for the artist whose work is reproduced.

Several general catalogues of prints are referred to by abbreviations:

B.
Adam von Bartsch, *Le Peintre graveur* (Vienna: J. V. Degen, 1803-1821)

H.
F. W. H. Hollstein and others, *Dutch and Flemish Etchings, Engravings and Woodcuts, ca. 1400-1700* (Amsterdam: Menno Hertzberger, 1949-)

Il.B.
Walter Strauss and others, *The Illustrated Bartsch* (New York: Abaris Books, (1978-)

Riggs
Timothy Riggs, *Hieronymus Cock: Printmaker and Publisher,* (New York: Garland Publishing, Inc., 1977). (Used for prints published by Hieronymus Cock when no other adequate reference exists.)

Federico Barocci
(Urbino 1535—Urbino 1612)
No. 58 (invenit)

Anthonie van Blocklandt
(Montfoort 1532—Utrecht 1583)
No. 59 (invenit)

Abraham Bloemaert
(Dordrecht 1574—Utrecht 1651)
Nos. 82 (fecit); 70, 72, 83, 84 (invenit)
H. II, pp. 60-69

Hans Bol

(Malines 1534—Amsterdam 1593)

No. 34 (invenit)

Boetius Bolswert

(Bolsward 1580—Antwerp 1633)

Nos. 83, 84 (fecit)

H. III, pp. 61-70

Schelte Bolswert

(Bolsward 1586—Antwerp 1659)

No. 87 (fecit)

H. III, pp. 71-92

Cornelis Bos

('sHertogenbosch about 1510—
Groningen 1556)

Nos. 2, 3 (fecit)

H. III, pp. 120-127; Sune Schéle,
*Cornelis Bos: A Study of the Origins of
the Netherlands Grotesque* (Stockholm:
Almqvist and Wiksell, 1965)

Hieronymus Bosch

('sHertogenbosch about 1450—
'sHertogenbosch 1516)

Nos. 27?, 28?, 41? (invenit)

H. III, pp. 129-148

Agnolo Bronzino

(Florence 1503—Florence 1572)

No. 17 (invenit)

Pieter Bruegel

(Brueghel 1525-30—Brussels 1569)

Nos. 19, 25, 26, 29-33 (invenit)

René van Bastelaer, *Les estampes de Peter
Bruegel l'ancien* (Brussels: G. van Oest, 1908);
Louis Lebeer, *Catalogue raisonné des
estampes de Bruegel l'ancien* (Brussels:
Bibliothèque royale Albert Ier, 1969)

Nicolaes de Bruyn

(Antwerp 1571—Rotterdam 1656)

No. 55 (fecit)

H. IV, pp. 11-25

Jan Theodor de Bry

(Liège 1561—Frankfurt 1623)

No. 54 (fecit)

H. IV, pp. 27-44

Michelangelo Buonarotti

(Caprese 1475—Rome 1564)

No. 2 (invenit)

Hieronymus Cock

(Antwerp about 1510—Antwerp 1570)

Nos. 27?, 35, 37, 38 (fecit); 36? (invenit)

H. IV, pp. 175-191; Riggs, pp. 255-306

Matthys Cock

(Antwerp about 1509—Antwerp about 1548)

No. 38 (invenit)

Adriaen Collaert

(Antwerp 1560—1618)

Nos. 43, 53 (fecit)

Isak Collijn, *Katalog der Ornamentstichsam
mlung des Magnus Gabriel De la Gardie in der
Kgl. Bibliothek zu Stockholm* (Stockholm, Uppsala:
Almqvist und Wiksell, 1933); H. IV, pp. 201-207

Hans Collaert the Elder

(Antwerp 1530—Antwerp 1582)

Nos. 13 (fecit); 53 (invenit)

H. IV, pp. 209-210

Hans Collaert the Younger

(Antwerp 1566—Antwerp 1628)

No. 52 (fecit)

H. IV, pp. 211-215 [H. refers to this artist as
Hans (Jan Baptist I) Collaert]

Gillis van Coninxloo

(Antwerp 1544—Amsterdam 1607)

No. 55 (invenit)

Dirck Volkertsz. Coornhert

(Amsterdam 1519—Gouda 1590)

Nos. 4, 5?, 6-8, 20, 21 (fecit)

H. IV, pp. 227-231; Il.B. LV

Cornelis Cornelisz. van Haarlem

(Haarlem 1562—Haarlem 1638)

No. 69 (invenit)

Cornelis Cort

(Hoorn 1533-1536—Rome 1578)

Nos. 12, 15?, 24, 56-58 (fecit)

J. C. J. Bierens de Haan, *L'oeuvre gravé
de Cornelis Cort, graveur hollandais*
(The Hague: Martinus Nijhoff, 1948);
H. V, pp. 40-60; Riggs, pp. 309-394; Il.B. LII

Jan van Doetechum

(Deventer 1530—Haarlem 1606)

Nos. 18, 36, 39-41 (fecit)

H. V, pp. 250-254; Riggs, pp. 309-394

Lucas van Doetechum
(Deventer, active 1554—about 1580)
Nos. 18, 36, 39-41 (fecit)
H. V, pp. 250-254; Riggs, pp. 309-394

Albrecht Dürer
(Nuremberg 1471—Nuremberg 1528)
Nos. 46, 47, 81 (invenit)

Adam Elsheimer
(Frankfurt 1578—Rome 1610)
No. 90 (invenit)

Cornelis Floris
(Antwerp 1514—Antwerp 1575)
No. 40 (invenit)
Robert Hedicke, *Cornelis Floris und die Florisdekoration* (Berlin: Julius Bard, 1913); H. VI, pp. 249-250

Frans Floris
(Antwerp about 1518—Antwerp 1570)
Nos. 3, 4, 12, 15, 18, 24 (invenit)

Cornelis Galle the Elder
(Antwerp 1576—1650)
No. 88?, 89 (fecit)
H. VII, pp. 49-61

Philipp Galle
(Haarlem 1537—Antwerp 1612)
Nos. 16, 25, 26, 31 (fecit)
H. VII, pp. *74-83*; Il.B. LVI

Giorgio Ghisi
(Mantua 1520—Mantua 1582)
Nos. 11, 17 (fecit)
B. XV; Michal and R.E. Lewis, catalogue in *The Engravings of Giorgio Ghisi* (New York: The Metropolitan Museum of Art, 1985); Il.B. XXXI, pp. 28-152

Hendrick Goltzius
(Mühlbrecht 1557—Haarlem 1617)
Nos. 59-67 (fecit); 73-75 (invenit)
B. III, Otto Hirschmann, *Verzeichnis des graphischen Werks von Hendrick Goltzius*, (Leipzig: Klinkhardt und Biermann, 1921); H. VIII, pp. i-138; Walter Strauss, *Hendrick Goltzius, 1558-1617: The Complete Engravings and Woodcuts* (New York: Abaris Books, 1977); Il. B. III.

Hendrick Goudt
(Utrecht 1585—Utrecht 1630)
No. 90 (fecit)
Henry Scipio Reitlinger, "Hendrik, Count Goudt," *Print Collector's Quarterly* 8 (1921), pp. 230-245; H. VIII, pp. 151-157

Maarten van Heemskerck
(Heemskerk 1498—Haarlem 1574)
Nos. 5?, 19, 22 (fecit); 5-8, 20, 21, 23 (invenit)
Thomas Kerrich, *A Catalogue of the Prints Which Have Been Engraved after Martin Heemskerck* (Cambridge: J. Rodwell, 1829); H. VIII, pp. 228-248

Pieter van der Heyden
(Antwerp about 1530—Antwerp? after 1570)
Nos. 29, 30, 33, 34 (fecit)
H. IX, pp. 26-32

Nicolas Hogenberg
(Munich 1500—Malines 1539)
No. 1 (fecit)
H. IX, pp. 57-64

Frans Huys
(Antwerp 1522—Antwerp 1562)
No. 32 (fecit)
H. IX, pp. 162-168; Isabelle de Ramaix, "Catalogue de l'oeuvre gravé de Frans Huys," *Le Livre et l'estampe* Nos. 55-56 (1968) pp. 258-293; Nos. 57-58 (1969) pp. 23-54

Lucas van Leyden
(Leyden 1494—Leyden 1533)
No. 68 (invenit)

Lambert Lombard
(Liège 1506—Liège 1566)
No. 13 (invenit)

Jacob Matham
(Haarlem 1571—Haarlem 1631)
Nos. 72, 73 (fecit)
B. III, pp. 131-213; H. XI, pp. 215-251; Il.B. IV, pp. 9-309

Michiel van Miereveld
(Delft 1567—Delft 1641)
No. 85 (invenit)

Harmen Muller
(Amsterdam about 1540—Amsterdam 1617)
No. 23 (fecit)
H. XIV, pp. 101-104

Jan Muller

(Amsterdam 1571—Amsterdam 1628)

Nos. 74-78, 85 (fecit)

B. III, pp. 263-294; H. XIV, pp. 105-115; Il.B. IV, pp. 444-520

Crispin de Passe the Elder

(Arnemuiden 1564—Utrecht 1637)

Nos. 44, 45 (fecit)

H. XV, pp. 129-296

Luca Penni

(Florence; died 1556)

No. 16 (invenit)

Raphael

(Urbino 1483—Rome 1520)

Nos. 11, 63 (invenit)

Peter Paul Rubens

(Siegen, Westphalia 1577—Antwerp 1640)

Nos. 86-89 (invenit)

C.G. Voorhelm Schneevogt, *Catalogue des estampes gravées d'après P.P. Rubens* (Harlem: Les Heritiers Loosjes, 1873); Frans van den Wijngaert, *Inventaris der Rubeniaansche prentkunst* (Antwerp: De Sikkel, 1940)

Aegidius Sadeler

(Antwerp 1570—Prague 1629)

Nos. 79-81 (fecit)

H. XXI, pp. 7-82; H. XXII, pp. 5-96

Jan Saenredam

(Zaandam 1565—Assendelft 1607)

Nos. 68-71 (fecit)

B. III, pp. 217-260; H. XXIII, pp. 5-106; Il.B. IV, pp. 310-443

Frans Snyders

(Antwerp 1579—Antwerp 1657)

Nos. 88? (fecit); 88, 89 (invenit)

Bartholomeus Spranger

(Antwerp 1546—Prague 1611)

Nos. 61, 78-80 (invenit)

Jan van der Straet (Johannes Stradanus)

(Bruges 1523—Florence 1605)

No. 52 (invenit)

Lambert Suavius

(Liège about 1510—Frankfurt 1574-76)

Nos. 9, 10, 14 (fecit)

J. S. Renier, *Catalogue de l'oeuvre de Lambert Suavius, graveur liégeois* (Liège: H. Vaillant-Carmanne, 1878); H. XXXIII, pp. 7-168

Titian

(Pieve di Cadore 1488-89—Venice 1576)

Nos. 56, 57 (invenit)

Jan van de Velde

(Delft 1593—Enkhuizen 1641)

No. 91 (fecit)

D. Franken and J. Ph. van der Kellen, *L'oeuvre gravé de Jan van de Velde* (Amsterdam: Frederik Muller et Cie; Paris: Rapilly, 1883); H. XXXIII, pp. 7-168; H. XXXIV

Lucas Vorsterman

(1595—1675)

No. 86 (fecit)

Henri Hymans, *Lucas Vorsterman: catalogue raisonné de son oeuvre* (Brussels: Bruylant Christophe et Cie, 1893)

Martin de Vos

(Antwerp 1532—Antwerp 1603)

Nos. 42 (fecit); 43 (invenit)

Adriaen de Vries

(The Hague about 1550—Prague 1626)

No. 77 (invenit)

Antoine Wierix

(Antwerp 1552—Antwerp 1624)

No. 51 (fecit)

Louis Alvin, *Catalogue raisonné de l'oeuvre des trois frères Wierix* (Brussels: T. J. I. Arnold, 1867); Marie Mauquoy-Hendrickx, *Les estampes des Wierix* (Brussels: Bibliothèque royale Albert Ier, 1978-83)

Hieronymus Wierix

(Antwerp 1553—Antwerp 1619)

Nos. 46, 48-50 (fecit)

Louis Alvin, *Catalogue raisonné de l'oeuvre des trois frères Wierix* (Brussels: T. J. I. Arnold, 1867); Marie Mauquoy-Hendrickx, *Les estampes des Wierix* (Brussels: Bibliothèque royale Albert Ier, 1978-83)

Catalogue

8 **Dirck Volkertsz. Coornhert**
after Maarten van Heemskerck:
The World Carrying away Knowledge and Love,
plate 3 from the series *The Unrestrained
World*, 1550, etching, 19.3 x 24.5 cm (Coornhert:
Il.B. 057.3) (Heemskerck: Kerrich, p. 94). Lent
by The Fine Arts Museums of San Francisco,
Achenbach Foundation for Graphic Arts

9 **Lambert Suavius:**
The Raising of Lazarus, 1544, engraving, 20.9 x
32.3 cm (Renier 15; H. 2). Lent by The Metro-
politan Museum of Art, The Elisha Whittelsey
Collection, The Elisha Whittelsey Fund, 1956

10 **Lambert Suavius:**
A Sibyl, from the series *Sibyls*, engraving,
18.7 x 8.4 cm (H. 32). Lent by The Philadelphia
Museum of Art, Charles M. Lea Collection.
Photographed by Lynn Rosenthal, 1992

THE CIRCLE OF
HIERONYMUS COOK, 1550-1570

Giorgio Ghisi and His Influence

11 **Giorgio Ghisi** after Raphael:
The School of Athens, 1550, engraving from 2
plates on 2 sheets, each 51.5 x 81.3 cm (B. 24;
Lewis 11; Il.B. 24). Lent by the Museum of Fine
Arts, Boston, Museum Purchase, 1984

12 **Cornelis Cort** after Frans Floris:
The Sense of Smell, from the series *The Five
Senses*, 1561, engraving, 20.5 x 26.9 cm (Bierens
de Haan 235; H. 235; Il.B. 235). Lent by the
National Gallery of Art, Washington, Andrew
W. Mellon Fund

13 **Hans Collaert the Elder**
after Lambert Lombard:
The Raising of Lazarus, engraving, 27.3 x 38 cm
(H. 27). Lent by The Philadelphia Museum
of Art, Charles M. Lea Collection. Photo-
graphed by Lynn Rosenthal, 1992

14 **Lambert Suavius:**
The Healing of the Paralytic, 1553, engraving,
31 x 43 cm (Renier 22; H. 23). Lent by
The Philadelphia Museum of Art, Smith, Kline
and French Foundation Fund. Photographed by
Lynn Rosenthal, 1992

15 **[probably Cornelis Cort]** after Frans Floris:
Battle of the Horatii and the Curiatii, engraving,
31.2 x 40.6 cm (Bierens de Haan, p. 5; Riggs,

p. 331, no. 84). Lent by the National Gallery of
Art, Washington, Andrew W. Mellon Fund

16 **Philipp Galle** after Luca Penni:
*Gladiatorial Games at the Funeral of a Great
Man*, 1562, engraving, 34.1 x 47 cm
(H. 383; Il.B. 100). Lent by The Baltimore
Museum of Art, Garrett Collection

17 **Giorgio Ghisi** after Agnolo Bronzino:
The Nativity, 1553, engraving, two sheets,
each 35.1 x 50.8 cm (B. 3; Lewis 14). Lent by
The Saint Louis Art Museum, Museum
Purchase, The Sidney S. and Sadie Cohen Print
Purchase Fund

18 **Jan van Doetechum** and/or Lucas van
Doetechum after Frans Floris:
The Resurrection of Christ, 1557, etching,
67 x 46 cm (Riggs, p. 331, no. 85). Lent by
The Art Institute of Chicago, Charles Greene
Fund

The Change in Heemskerck's Drawing Style

19 **Maarten van Heemskerck:**
Simeon the Patriarch, about 1550, pen and brown
ink, 19.7 x 28.1 cm. Lent by the National
Gallery of Art, Washington, Ailsa Mellon Bruce
Fund

20 **Dirck Volkertsz. Coornhert**
after Maarten van Heemskerck,
Simeon the Patriarch, from the series *The Twelve
Patriarchs*, 1550, etching and engraving,
21.1 x 27.1 cm (Coornhert: H. 58; Il.B. 009.3)
(Heemskerck: Kerrich, p. 15). Lent by The
Metropolitan Museum of Art, The Elisha
Whittelsey Collection, The Elisha Whittelsey
Fund, 1949

21 **Dirck Volkertsz. Coornhert** (or Cornelis Bos?)
after Maarten van Heemskerck:
The Capture of King Francis I at Pavia, plate 2
from the series *The Victories of Charles V*,
1555-56, engraving, 15.7 x 23.1 cm (Coornhert:
H. 217; Il.B. 070.2) (Heemskerck: Kerrich, p.
109). Lent by the Museum of Fine Arts, Boston,
Bequest of William P. Babcock

22 **Maarten van Heemskerck:**
*Thou Shalt Not Covet Thy Neighbor's Wife
(Joseph and Potiphar's Wife)*, 1566, pen
and brown ink, 20.8 x 26.1 cm. Lent by The
Fine Arts Museums of San Francisco,
Achenbach Foundation for Graphic Arts

23 Harmen Muller
after Maarten van Heemskerck:
*Thou Shalt Not Covet Thy Neighbor's Wife
(Joseph and Potiphar's Wife)*, plate 9 from the
series *The Ten Commandments*, about 1566,
engraving, 21.1 x 24.8 cm (Muller: H. 25).
Lent by the Museum of Fine Arts, Boston,
Bequest of William P. Babcock

***Prints after Paintings; Drawings
Made for Prints***

24 Cornelis Cort after Frans Floris:
Hercules and the Hydra, plate 5 from the series
The Labors of Hercules, 1565, engraving,
21.6 x 28.5 cm (Bierens de Haan 176; H. 176;
Il.B. 176). Lent by The Fine Arts Museums
of San Francisco, Achenbach Foundation for
Graphic Arts

25 Philipp Galle after Pieter Bruegel:
The Resurrection of Christ, engraving, 43.5 x 30.3
cm (Galle: H. 106; Il.B. 044) (Bruegel: Bastelaer
114; Lebeer 84). Lent by The Art Institute of
Chicago, Charles Greene Fund

26 Philipp Galle after Pieter Bruegel:
The Death of the Virgin, 1574, engraving,
31 x 41.6 cm (Galle: H. 155; Il.B. 060) (Bruegel:
Bastelaer 116; Lebeer 86). Lent by The Baltimore
Museum of Art, Garrett Collection

27 Hieronymus Cock(?)
after Hieronymus Bosch(?):
Heaven and *Hell*, pen and brown ink and
gray wash, traced over with stylus on the reverse,
30.3 x 10.8 cm (*Heaven*), 30.3 x 11 cm (*Hell*).
Lent by The Art Museum, Princeton Univer-
sity, Museum Purchase, Laura P. Hall Memorial
Fund

28 Anonymous engraver
after Hieronymus Bosch(?):
The Last Judgment, engraving, 33.7 x 50 cm
(Bosch: H. 7; Riggs, p. 315, no. 17).
Lent by The Art Museum, Princeton Univer-
sity, Gift of Dr. James H. Lockhart, Jr.

29 Pieter van der Heyden after Pieter Bruegel:
Anger, from the series *The Seven Deadly
Sins*, about 1558, engraving, 22 x 29.1 cm (Van
der Heyden: H. 30) (Bruegel: Bastelaer 125;
Lebeer 18). Lent by The Cleveland Museum
of Art, Mr. and Mrs. Lewis B. Williams
Collection

30 Pieter van der Heyden after Pieter Bruegel:
Christ in Limbo, about 1558, engraving,
26.3 x 33.3 cm (Van der Heyden: H. 14)
(Bruegel: Bastelaer 115; Lebeer 38). Lent by
The Baltimore Museum of Art, Blanche Adler
Memorial Fund and Gift of Alfred R.
and Henry G. Riggs in Memory of General
Lawrason Riggs, By Exchange

31 Philipp Galle after Pieter Bruegel:
Prudence, from the series *The Seven Virtues*,
about 1559, engraving, 22.4 x 29.7 cm
(Galle. Il.B. 070.5) (Bruegel: Bastelaer 136;
Lebeer 35). Lent by The St. Louis Art Museum,
Museum Purchase, The Sidney and Sadie
Cohen Foundation Inc., Print Purchase Fund

32 Frans Huys after Pieter Bruegel:
*Armed Four-Masted Ship Sailing Toward a
Harbor*, from the series *Sailing Ships*, about
1560-63, etching and engraving, 28.3 x 21.6 cm
(Huys: H. 17) (Bruegel: Bastelaer 99; Lebeer 42).
Lent by The Philadelphia Museum of Art,
Museum Purchase, Print Revolving Fund.
Photographed by Graydon Wood, 1992

33 Pieter van der Heyden after Pieter Bruegel:
Spring, from the series *The Four Seasons*, 1570,
engraving, 22.5 x 29.2 cm (Van der Heyden:
H. 63) (Bruegel: Bastelaer 200; Lebeer 77). Lent
by The Philadelphia Museum of Art, Gift of
Henry P. McIlhenny. Photographed by Lynn
Rosenthal, 1992

34 Pieter van der Heyden after Hans Bol:
Autumn, from the series *The Four Seasons*, 1570,
engraving, 20.8 x 28.6 cm (H. 65). Lent by
The Philadelphia Museum of Art, Gift of Henry
P. McIlhenny

Etching: Cock and the Doetechum Brothers

35 Hieronymus Cock:
Third View of the Colosseum, plate 4 from the
series *Views of Roman Ruins*, 1551, etching,
24.3 x 34.3 cm (H. 25; Riggs 4). Lent by The
Philadelphia Museum of Art, Purchased with
Allocated Funds. Photographed by Lynn
Rosenthal, 1992

36 Jan and/or **Lucas van Doetechum**
after Hieronymus Cock(?):
*Interior of an Amphitheater, Probably the
Colosseum*, from the series *The Small Book of
Roman Ruins*, 1562, etching and engraving,

20.5 x 15.5 cm (plate) (Cock: Riggs III).
Lent by the Worcester Art Museum, Worcester,
Massachusetts, Eliza S. Paine Fund

37 **Hieronymus Cock** after Pieter Bruegel:
Landscape with the Temptation of Christ, about
1555, etching, 30.9 x 44.1 cm (H. 2; Riggs 36).
Lent by the Museum of Fine Arts, Boston,
Katherine Eliot Bullard Fund

38 **Hieronymus Cock** after Matthys Cock:
Mercury with the Head of Argus, from the series
*Landscapes with Biblical and Mythological
Scenes*, 1558, etching, 22.5 x 33.2 cm (H. 13;
Riggs 43). Lent by The Philadelphia Museum of
Art, Museum Purchase. Photographed by Lynn
Rosenthal, 1992

39 **Jan** and/or **Lucas van Doetechum**
after Pieter Bruegel:
(Milites Requiescentes) Resting Soldiers, from the
series *The Large Landscapes*, about 1555-60,
etching and engraving, 33.1 x 42.7 cm (Bruegel:
Bastelaer 17; Lebeer 12). Lent by the National
Gallery of Art, Washington, Rosenwald
Collection

40 **Jan** and/or **Lucas van Doetechum**
after Cornelis Floris:
Ornament Design with Laocoön, from the series
*Many Varieties of Grotesques and Fantasies,
Made for the Use of All Who Love or Practice the
Arts*, 1556, etching, 30.5 x 20.3 cm (Floris:
Hedicke pl. V-1; H. 14-26). Private Collection

41 **Jan** and/or **Lucas van Doetechum**
after "Hieronymus Bosch":
Saint Martin with His Horse in a Ship,
engraving and etching, 33.7 x 42.9 cm (Bosch:
H. 16). Lent by the National Gallery of Art,
Washington, Rosenwald Collection

THE LATER SIXTEENTH
CENTURY

The New Style of Drawing for Prints

42 **Martin de Vos:**
The Sense of Sight, about 1580-90, pen and
brown ink and brown wash, 19.2 x 25.4 cm.
Lent by the Ackland Art Museum, The
University of North Carolina at Chapel Hill,
Ackland Fund

43 **Adriaen Collaert** after Martin de Vos:
The Sense of Sight, from the series *The Five*

Senses, about 1580-90, engraving, 21.3 x 26.1 cm
(H. 437-440). Lent by The Metropolitan
Museum of Art, The Elisha Whittelsey
Collection, The Elisha Whittelsey Fund, 1956

44 **Crispin de Passe the Elder:**
Saint Elizabeth of Hungary, about 1602, pen
and brown ink, brown wash, heightened with
white, 20.5 x 16.5 cm. Lent by The Art Mu-
seum, Princeton University, Museum Purchase,
Laura P. Hall Memorial Fund

45 **Crispin de Passe the Elder:**
Saint Elizabeth of Hungary, from the series *Nine
Worthy Women*, 1602, engraving, 26.4 x 19 cm
(H. 366). Lent by The Art Museum, Princeton
University, Bequest of Junius S. Morgan

"Fine Engraving"

46 **Hieronymus Wierix** after Albrecht Dürer:
Saint Jerome in His Study, about 1566,
engraving, 23.9 x 18.5 cm (Alvin 991-92;
Mauquoy-Hendrickx 1205). Lent by the
Ackland Art Museum, The University of North
Carolina at Chapel Hill, Burton Emmett
Collection

47 **Cornelis Cort** after Albrecht Dürer:
Joachim Patenier, plate 8 from the series *Portraits
of Eminent Dutch and Flemish Painters*, about
1565 (published 1572), engraving, 20.3 x 12.7 cm
(Bierens de Haan 211, H. 211, Il.B. 211). Lent
by the Archer M. Huntington Art Gallery,
The University of Texas at Austin, Archer M.
Huntington Museum Fund, 1991. Photograph-
ed by George Holmes

48 **Hieronymus Wierix:**
Jan Cornelisz. Vermeyen, plate 15 from the
series *Portraits of Eminent Dutch and
Flemish Painters*, about 1570 (published 1572),
engraving, 20.1 x 12.1 cm (Alvin 2047;
Mauquoy-Hendrickx 1743). Anonymous Loan

49 **Hieronymus Wierix:**
Saint Michael Overcoming Satan, 1584,
engraving, 29 x 20.1 cm (Alvin 1048;
Mauquoy-Hendrickx 1260). Lent by The
Baltimore Museum of Art, Garrett Collection

50 **Hieronymus Wierix:**
The Empire of Death, engraving, 9.8 x 7 cm
(Alvin 1184; Mauquoy-Hendrickx 1488ii).
Lent by The Metropolitan Museum of Art,
The Elisha Whittelsey Collection, The Elisha
Whittelsey Fund, 1953

51 **Antoine Wierix:**
Cain and Abel, engraving, 27.9 x 19.9 cm
(Alvin 82; Mauquoy-Hendrickx 57).
Lent by The Baltimore Museum of Art,
Garrett Collection

52 **Hans Collaert the Younger**
after Jan van der Straet (Johannes Stradanus):
Truth Revealed by Time, engraving,
24.9 x 18.4 cm (H. 112). Lent by The Baltimore
Museum of Art, Garrett Collection

53 **Adriaen Collaert** after Hans Collaert the Elder:
*Pendant with Neptune, Nymphs, and a Sea
Monster*, from the series *Skillfully Designed
Patterns for Golden Pendants*, 1582, engraving,
17.6 cm x 12.9 cm (not in H.; Collijn, p. 37,
no. 44). Lent by the National Gallery of Art,
Washington, Rosenwald Collection

54 **Jan Theodor de Bry:**
*Design for a Knife Handle with an Allegory of
Christian Marriage*, engraving, 10.4 x 2.7 cm
(sheet) (H. 291). Lent by the National Gallery of
Art, Washington, Rosenwald Collection

55 **Nicolaes de Bruyn** after Gillis van Coninxloo:
Landscape with the Finding of Moses, 1601,
engraving, 41.3 x 65.4 cm (H. 25). Lent by the
Mary and Leigh Block Gallery, Northwestern
University

Cornelis Cort in Italy

56 **Cornelis Cort** after Titian:
Landscape with Roger Rescuing Angelica, 1565,
engraving, 30.3 x 44.7 cm (Bierens de Haan
222; H. 222; Il.B. 222). Lent by the National
Gallery of Art, Washington, Ailsa Mellon
Bruce Fund

57 **Cornelis Cort** after Titian:
The Martyrdom of Saint Lawrence, 1571,
engraving, 49.6 x 35 cm (Bierens de Haan 139;
H. 139; Il.B. 139). Lent by The Metropolitan
Museum of Art, The Elisha Whittelsey
Collection, The Elisha Whittelsey Fund, 1949

58 **Cornelis Cort** after Federico Barocci:
*The Holy Family Resting on the Return
from Egypt*, 1575, engraving, 43.7 x 28.5 cm
(Bierens de Haan 43; H. 43; Il.B. 43).
Lent by the Mary and Leigh Block Gallery,
Northwestern University

Hendrick Goltzius

59 **Hendrick Goltzius**
after Anthonie van Blocklandt:
Lot Leaving Sodom, 1582, engraving, 33.9 x 39.6
cm (B. 263; Hirschmann 293; H. 293; Strauss
162; Il.B. 263). Lent by the National Gallery of
Art, Washington, Ailsa Mellon Bruce Fund

60 **Hendrick Goltzius:**
Arnoud van Beresteyn, 1579, engraving, diameter
4.2 cm (B 192; Hirschmann 175; H. 175;
Strauss 114; Il.B. 192). Lent by the National
Gallery of Art, Gift of Ruth and Joseph
Bromberg in memory of their son, Michael

61 **Hendrick Goltzius**
after Bartholomeus Spranger:
The Wedding of Cupid and Psyche, 1587,
engraving, 43.2 x 85.7 cm (3 sheets) (B. 277;
Hirschmann 322; H. 322; Strauss 255; Il.B. 277).
Lent by The Minneapolis Institute of Arts,
The John R. Van Derlip Fund, 1968

62 **Hendrick Goltzius** after Raphael:
The Triumph of Galatea, 1592, engraving,
55.5 x 40.1 cm (B. 270; Hirschmann 313; H. 313;
Strauss 288; Il.B. 270). Lent by The Art
Museum, Princeton University, Bequest of
Junius S. Morgan. Photographed by Clem Fiori

63 **Hendrick Goltzius:**
Urania, 1592, gray and brown chalk with pen
and brown ink, 24.1 x 16.4 cm. Lent by the
National Gallery of Art, Washington, Ailsa
Mellon Bruce Fund

64 **Hendrick Goltzius:**
Urania, from the series *The Nine Muses*, about
1592, engraving, 24.7 x 16.8 cm (B. 154;
Hirschmann 156; H. 156; Strauss 307; Il.B. 154).
Lent by the National Gallery of Art, Washing-
ton, Rosenwald Collection

65 **Hendrick Goltzius:**
*The Holy Family with the Infant Saint John,
in the Manner of Federico Barocci*, from the series
The Life of the Virgin, 1593, engraving, 47.1 x
34.9 cm (sheet) (B. 20; Hirschmann 14; H. 14;
Strauss 317; Il.B. 020). Lent by The Minneapolis
Institute of Arts, The Ladd Collection, Gift of
Hershel V. Jones, 1916

66 **Hendrick Goltzius:**
*The Adoration of the Magi, in the Manner of
Lucas van Leyden*, from the series *The Life of the*

Virgin, 1594, engraving, 47 x 34.9 cm (sheet)
(B. 19; Hirschmann 13; H. 13; Strauss 320;
Il.B. 019). Lent by the Minneapolis Institute of
Arts, The Ladd Collection, Gift of Hershel
V. Jones, 1916

67 **Hendrick Goltzius:**
The Pieta in the Manner of Dürer, 1596,
engraving, 17.8 x 12.9 cm (B. 41; Hirschmann
50; Strauss 331; Il.B. 041). Lent by the Ackland
Art Museum, The University of North Carolina
at Chapel Hill, Gift of Dr. W. P. Jacocks

The Goltzius Style: From Haarlem to Prague

68 **Jan Saenredam** after Lucas van Leyden:
The Hymn of the Daughters of Israel to David,
1600, engraving, 28 x 19 cm (B. 109; H. 11;
Il.B. 109). Lent by the Mary and Leigh Block
Gallery, Northwestern University

69 **Jan Saenredam**
after Cornelis Cornelisz. van Haarlem:
Plato's Cave, 1604, engraving, 33 x 45.2 cm
(B. 39; H. 116; Il.B. 039). Lent by the Prints
Collection, Miriam and Ira D. Wallach
Division of Art, Prints and Photographs,
The New York Public Library, Astor, Lenox
and Tilden Foundations

70 **Jan Saenredam** after Abraham Bloemaert:
The Expulsion from Eden, from the series
The Story of Adam and Eve, about 1604,
engraving, 27.7 x 19.9 cm (B. 16; H. 4; Il.B.
016). Lent by the Minneapolis Institute of Arts,
The Ethel Morrison Van Derlip Fund, 1984

71 **Jan Saenredam:**
The Foolish Virgins, plate 2 from the series
The Wise and Foolish Virgins, 1605-06, engrav-
ing, 26.6 x 37 cm (B. 3; H. 29; Il.B. 003).
Lent by The Art Institute of Chicago, William
McCallin McKee Fund

72 **Jacob Matham** after Abraham Bloemaert:
Abraham Dismissing Hagar, 1603, engraving,
46.8 x 36.1 cm (B. 63; H. 2; Il.B. 063). Lent by
the Museum of Fine Arts, Boston, Harvey D.
Parker Collection

73 **Jacob Matham** after Hendrick Goltzius:
Daedalus and Icarus, engraving, 45.8 x 36 cm
(B. 307; H. 356; Il.B. 307). Lent by the
Museum of Fine Arts, Boston, Bequest of
William P. Babcock

74 **Jan Muller** after Hendrick Goltzius:
The Spirit of God upon the Face of the Waters,
plate 1 from the series *The Creation of
the World*, 1589, engraving, diameter 26.5 cm
(B. 35; H. 1; Il.B. 035). Lent by The Saint
Louis Art Museum, Museum Purchase, Friends
Fund

75 **Jan Muller** after Hendrick Goltzius:
The Creation of the Sun and Moon, plate 5 from
the series *The Creation of the World*, 1589,
engraving, diameter 26.5 cm (B. 39; H. 5; Il.B.
039). Lent by The Saint Louis Art Museum,
Museum Purchase, Friends Fund

76 **Jan Muller:**
Belshazzar's Feast, about 1600, engraving,
33.7 x 39.5 cm (B. 1, H. 11; Il.B. 001). Lent
by the Yale University Art Gallery, Everett V.
Meeks, B.A. 1901, Fund

77 **Jan Muller** after Adriaen de Vries:
Hercules and the Hydra, about 1602, engraving,
51.5 x 36.8 cm (B. 87; H. 53; Il.B. 087). Lent
by the Yale University Art Gallery, Everett V.
Meeks Fund

78 **Jan Muller** after Bartholomeus Spranger:
*Bellona Leading the Armies of the Emperor
Against the Turks*, 1600, engraving, 70.3 cm x
50.8 cm (B. 75; H. 50; Il.B. 75). Lent by
the Minneapolis Institute of Arts, The Ethel
Morrison Van Derlip Fund, 1974

79 **Aegidius Sadeler** after Bartholomeus Spranger:
The Triumph of Wisdom over Ignorance,
about 1600, engraving, 50.8 x 35.8 cm (H. 115).
Lent by the Ackland Art Museum, The
University of North Carolina at Chapel Hill,
Ackland Fund

80 **Aegidius Sadeler** after Bartholomeus Spranger:
The Artist and His Wife, 1600, engraving,
29.2 x 41 cm (H. 332). Lent by the Yale
University Art Gallery, University Purchase,
A. Conger Goodyear, B.A. 1899, Fund

81 **Aegidius Sadeler** after Albrecht Dürer:
The Madonna with the Many Animals,
engraving, 33.7 x 24.4 cm (H. 72). Lent by the
Mary and Leigh Block Gallery, Northwestern
University

Drawing, Etching and Engraving

82　**Abraham Bloemaert:**
Juno, from the series *Three Goddesses*, etching,
14.1 x 11.2 cm (H. 4). Lent by The Art Museum,
Princeton University, Museum Purchase,
Laura P. Hall Memorial Fund

83　**Boetius Bolswert** after Abraham Bloemaert:
Venus, from the series *Three Goddesses*,
engraving, 14 x 10.9 cm (H. 285). Lent by
The Art Museum, Princeton University,
Museum Purchase, Laura P. Hall Memorial
Fund

84　**Boetius Bolswert** after Abraham Bloemaert:
Saint Mary Magdalene with the Crucifix,
etching, 13.6 x 8.9 cm (H. 95). Lent by the
Print Collection, Miriam and Ira D. Wallach
Division of Art, Prints and Photographs,
The New York Public Library, Astor, Lenox
and Tilden Foundations

Epilogue: Rubens and His Time

85　**Jan Muller** after Michiel van Miereveld:
Ambrosio Spinola, 1615, engraving, 41.6 cm x
29.5 cm (sheet) (B. 59; H. 96; Il.B. 059). Lent
by the Minneapolis Institute of Arts, The Ladd
Collection, Gift of Hershel V. Jones, 1916

86　**Lucas Vorsterman** after Rubens:
The Descent from the Cross, 1620, engraving,
57.7 x 43.5 cm (Vorsterman: Hymans 34)
(Rubens: Voorhelm Schneevogt, p. 49, no. 342;
Van den Wijngaert 718). Lent by The Phila-
delphia Museum of Art, Charles M. Lea
Collection. Photographed by Lynn Rosenthal,
1992

87　**Schelte Bolswert** after Rubens:
Landscape with a Rainbow, from the series
The Small Landscapes, about 1633, engraving,
33.4 x 45 cm (Bolswert: H. 314) (Rubens:
Voorhelm Schneevogt, p. 234, no. 53-10; Van
den Wijngaert 98). Lent by the Ackland Art
Museum, The University of North Carolina at
Chapel Hill, Burton Emmett Collection

88　**Anonymous (Cornelis Galle the Elder? Frans
Snyders?)** after Rubens (and Frans Snyders):
Cupids Decking a Niche with Fruit, pen and
brown ink, brown and gray wash, squared
(traced over with stylus?), 53.2 x 40.3 cm. Lent
by The Art Museum, Princeton University,
Gift of Frank Jewett Mather, Jr.

89　**Cornelis Galle the Elder**
after Rubens (and Frans Snyders):
*The Virgin and Child in a Niche Adorned with
Garlands by Angels*, engraving, 55.1 x 40.4 cm
(Galle: H. 106) (Rubens: Voorhelm Schneevogt,
p. 92, no. 156; Van den Wijngaert 201). Lent
by The Art Museum, Princeton University,
Gift of Charles Scribner III. Photographed by
Clem Fiori

90　**Hendrick Goudt** after Adam Elsheimer:
*Jupiter and Mercury in the House of Philemon
and Baucis*, 1612, engraving, 21 x 21.9 cm (sheet)
(Reitlinger 5; H. 6). Lent by the Minneapolis
Institute of Arts, The Hershel V. Jones Fund,
By Exchange, 1972

91　**Jan van de Velde:**
The Sorceress, 1626, engraving, 21.2 x 27.9 cm
(Franken and Van der Kellen 114; H. 152).
Lent by The Baltimore Museum of Art, Garrett
Collection

Reproductions

Cat. No. 1

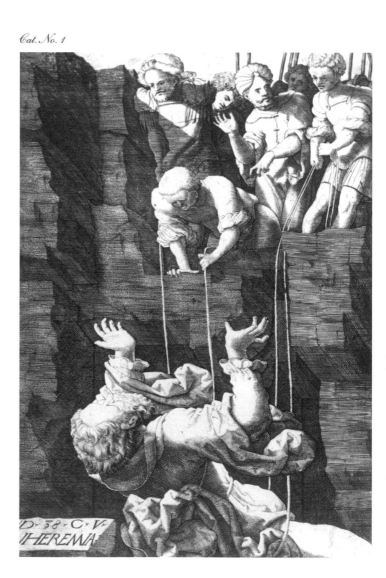

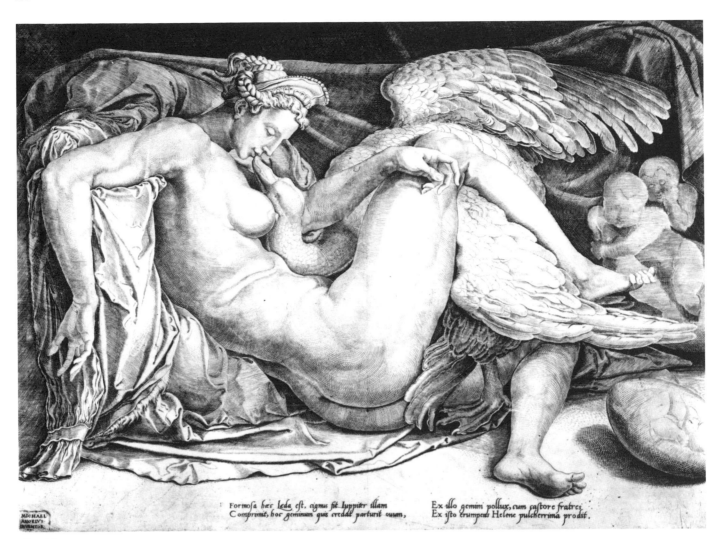

Formosa hæc leda est, cignus sit Iuppiter illam Ex illo gemini pollux, cum castore fratres
Comprimit, hoc geminum quis credat parturit ouum, Ex isto erumpens Helene pulcherrima prodit.

MICHAEL
ANGELVS
INVENTOR

Cat. No. 2

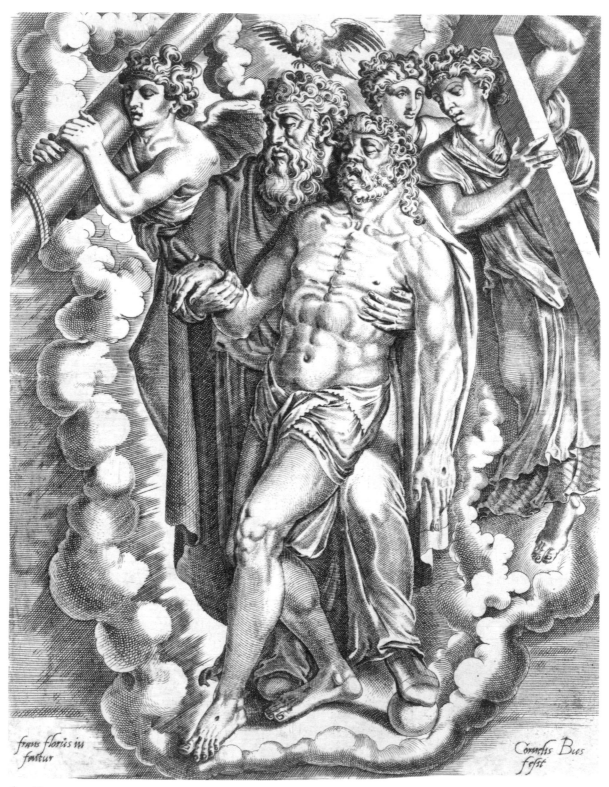

frans floris in
fecttur

Cornelis Bus
fecit

Cat. No. 3

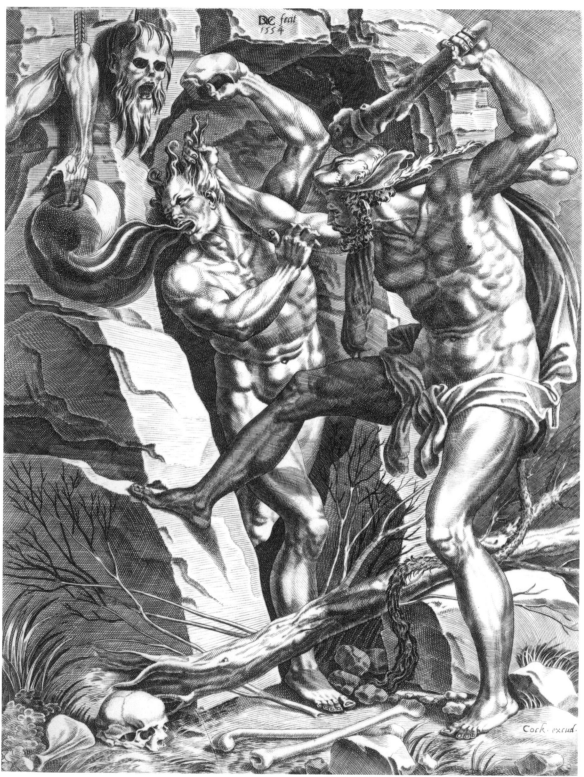

Cat. No. 4

Cat. No. 5

Cat. No. 6

Cat. No. 7

Cat. No. 8

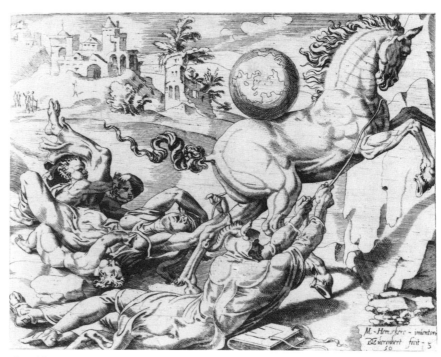

Cat. No. 9

L S

Cat. No. 10

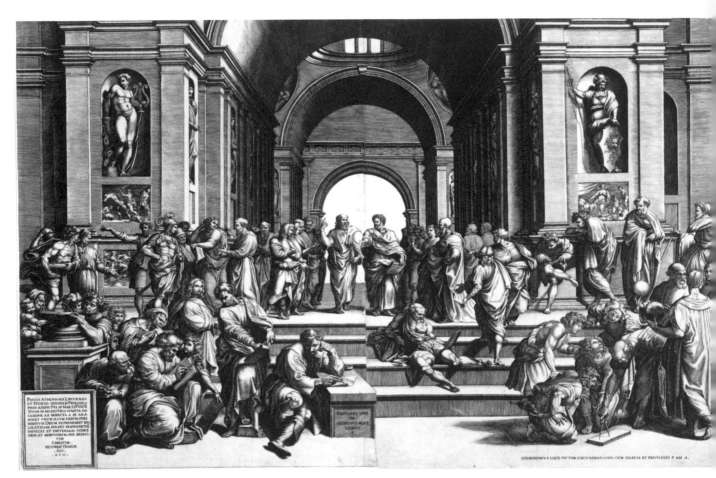

Cat. No. 12

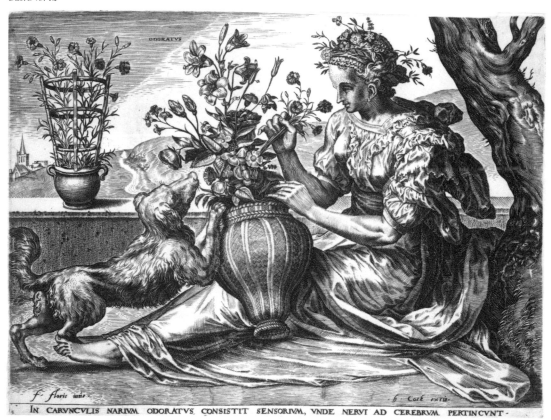

IN CARVNCVLIS NARIVM ODORATVS CONSISTIT SENSORIVM, VNDE NERVI AD CEREBRVM PERTINCVNT·

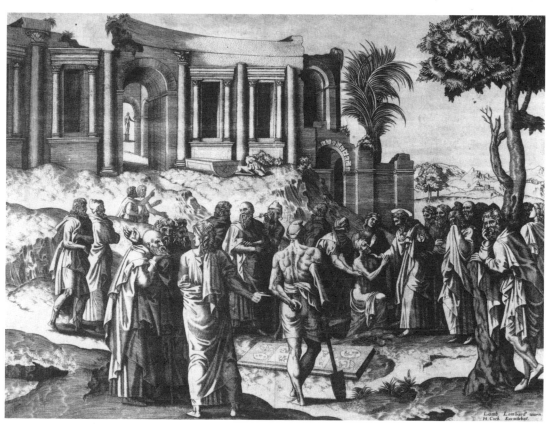

Cat. No. 13

Cat. No. 14

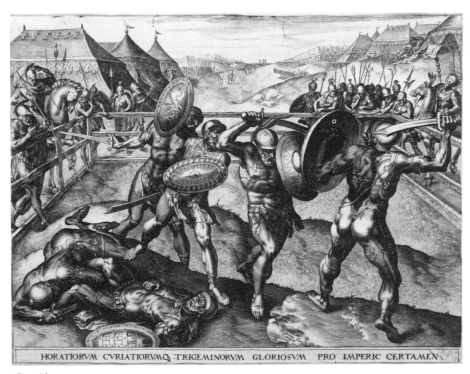

Cat. No. 15

Cat. No. 16

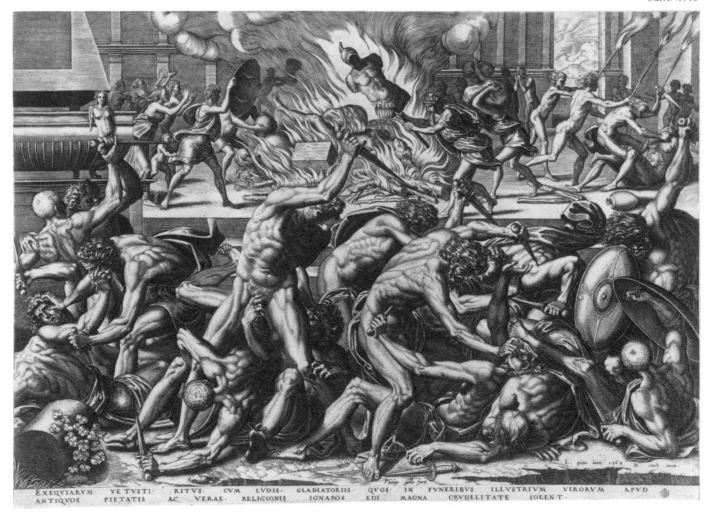

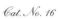

EXEQVIARVM· VE·TVSTI· RITVS· CVM· LVDIS· GLADIATORIIS· QVOS· IN· FVNERIBVS· ILLVSTRIVM· VIRORVM· APVD·
ANTIQVOS· PIETATIS· AC· VERAE· RELIGIONIS· IGNAROS· EDI· MAGNA· CRVDELITATE· SOLENT·

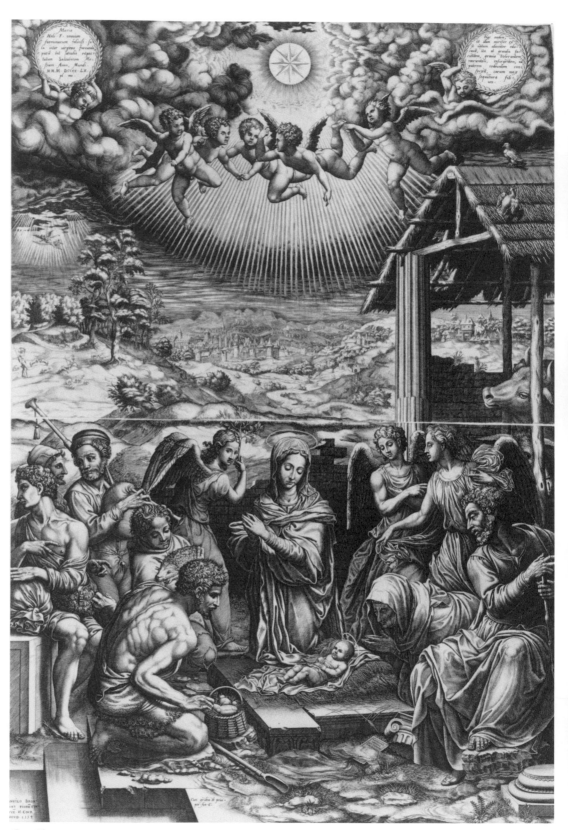

Cat. No. 17

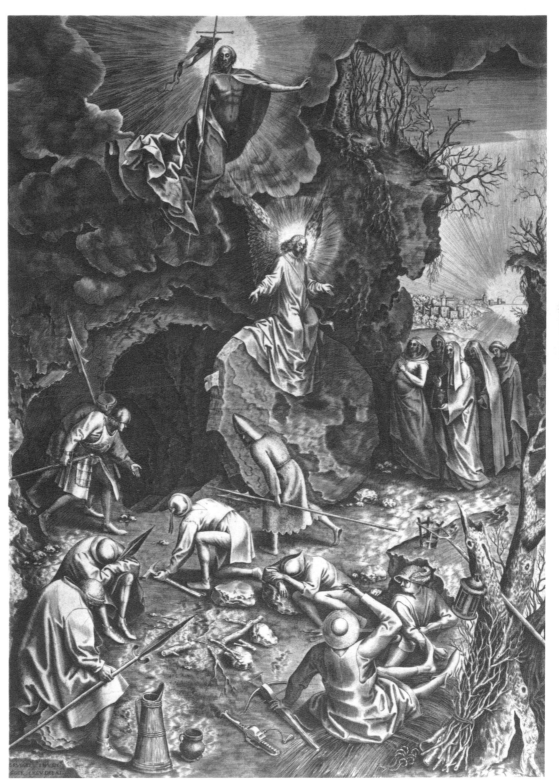

Cat. No. 18

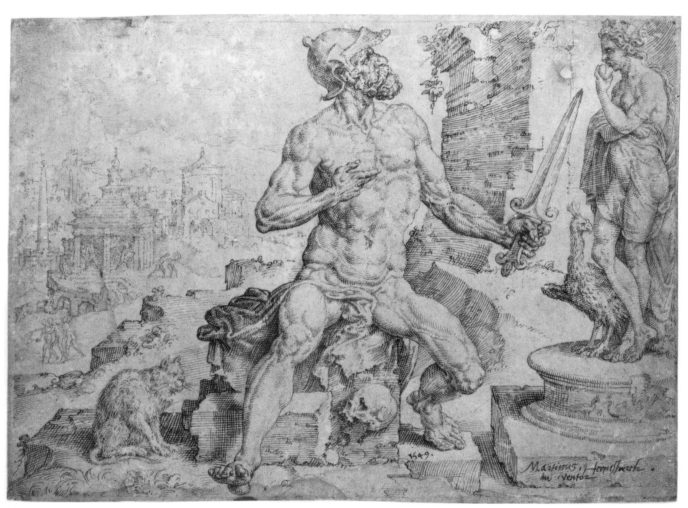

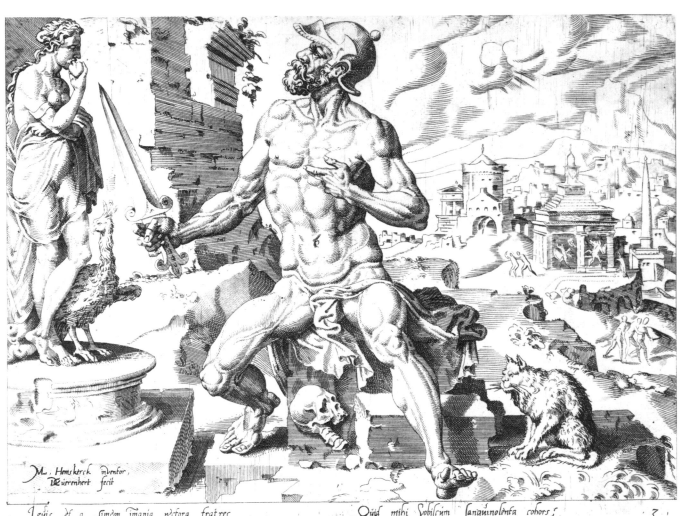

M. Hemskerck inventor,
DVuirrenhert fecit

Leuis et o Simeon Timania pectora fratres Quid mihi vobiscum sanguinolenta cohors? 3
Van Simeon en Leui, met haren versaemden raedt, Onthoude hem mijn sicle verbloeft sij haer gramschap quaet,

Cat. No. 20

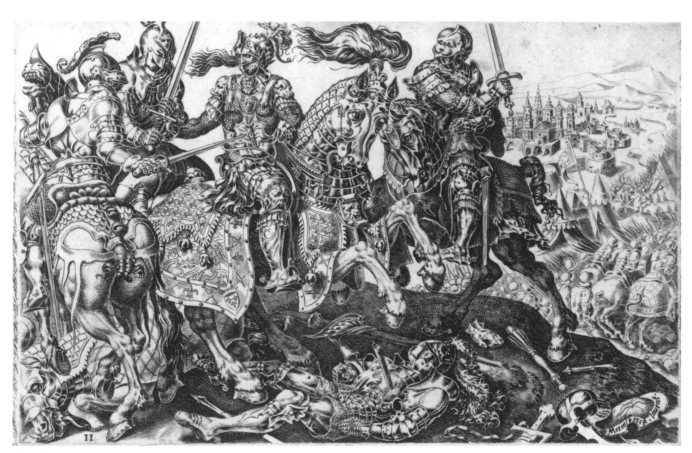

II.

Cat. No. 21

Cat. No. 22

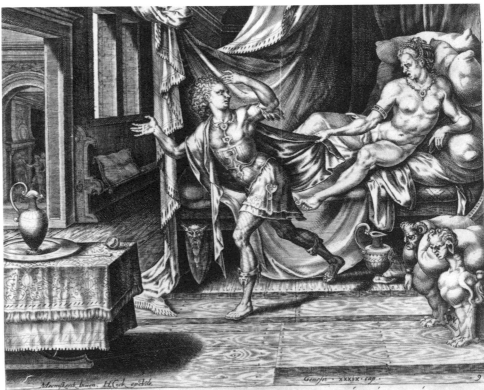

NON CONCVPISCES VXOREM PROXIMI TVI DEVT·V·

Cat. No. 23

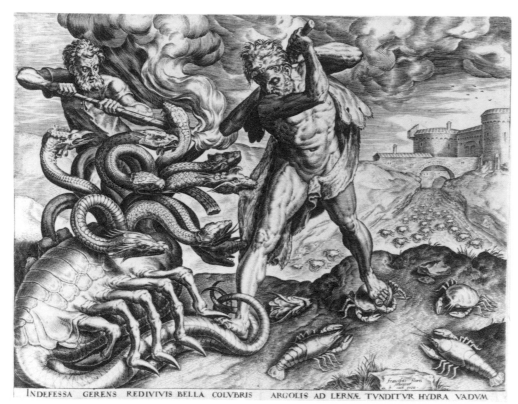

INDEFESSA GERENS REDIVIVIS BELLA COLVBRIS ARGOLIS AD LERNÆ TVNDITVR HYDRA VADVM

Cat. No. 24

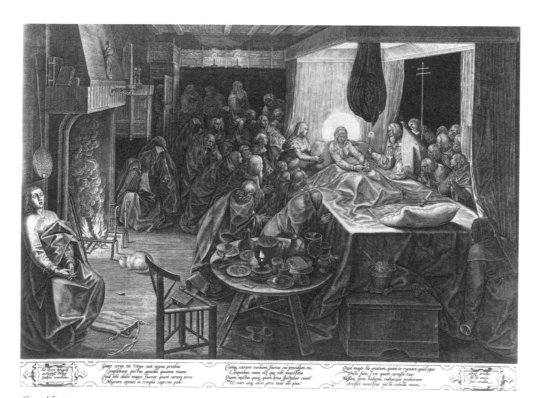

Cat. No. 26

Cat. No. 25

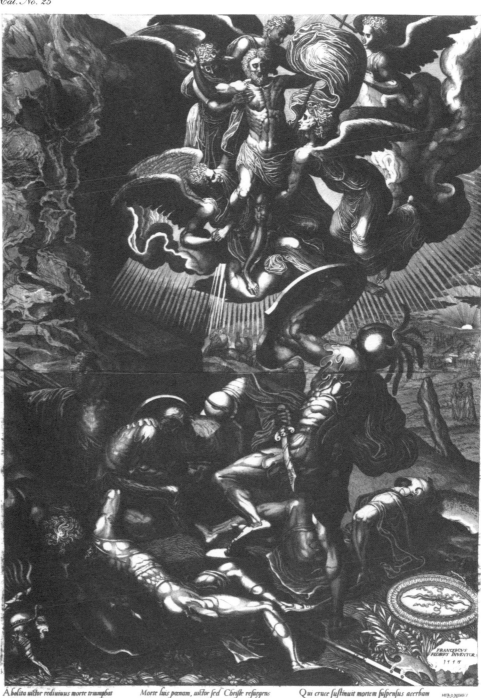

Abolita uictor rediuiuus morte triumphat Morte luis pœnam, uictor sed Christe resurgens Qui cruce sustinuit mortem suspensus acerbam HIERONIMVS
Partu redit miseris gratia, uita, salus Das uitam mundo, iustitiamque nouam Surrexit tumulo, uiuus et astra petit. COCK
 EX CVDEBAT

Cat. No. 27

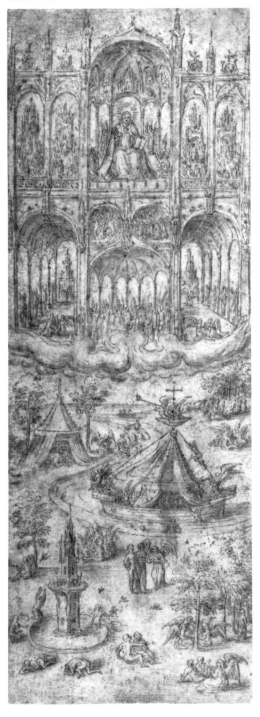
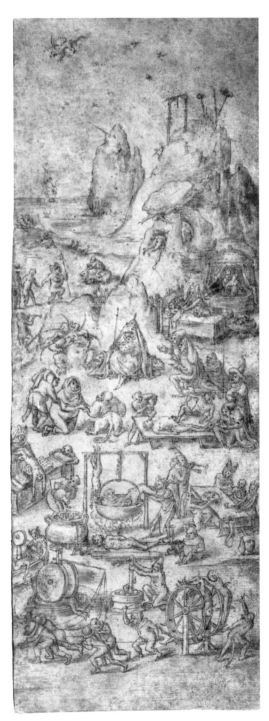

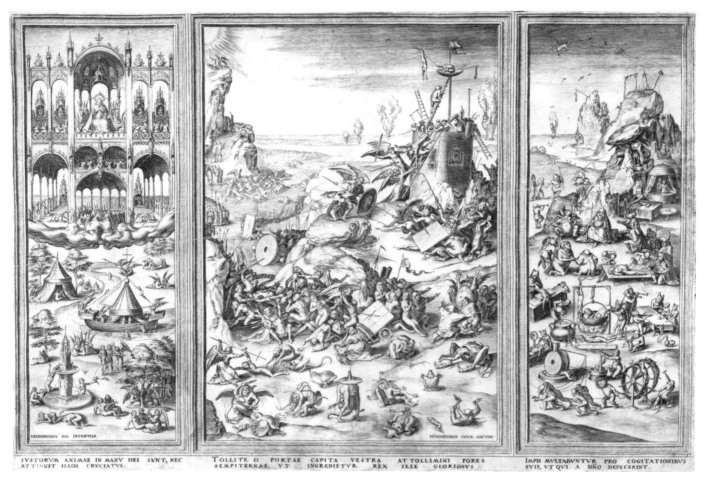

IVSTORVM ANIMAE IN MANV DEI SVNT, NEC ATTINGIT ILLOS CRVCIATVS.

TOLLITE O PORTAE CAPITA VESTRA ATTOLLIMINI FORES SEMPITERNAE, VT INGREDIETVR REX ILLE GLORIOSVS

IMPII MVLTABVNTVR PRO COGITATIONIBVS SVIS, VT QVI A DÑO DEFECERINT.

Cat. No. 28

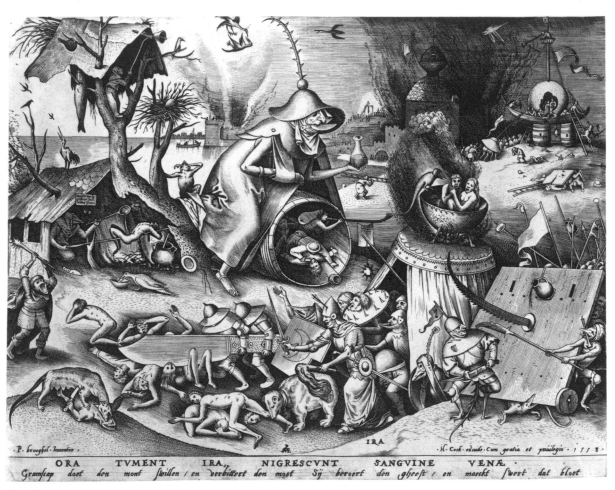

IRA

ORA TVMENT IRA, NIGRESCVNT SANGVINE VENÆ.
Gramſcap doet den mont ſwillen / en verbittert den moet Sy beroert den gheeſt / en maeckt ſwert dat bloet

Cat. No. 29

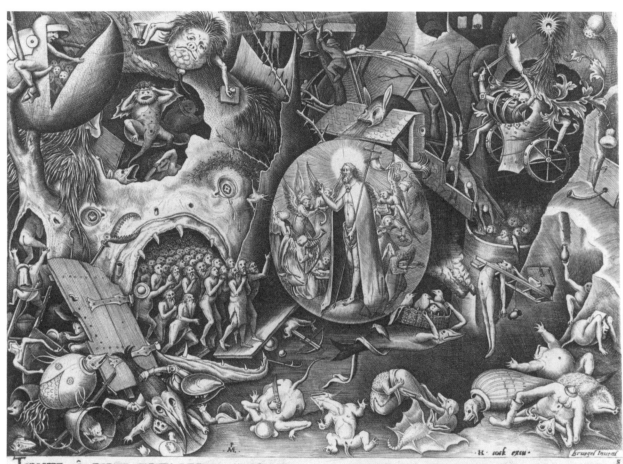

TOLLITE Ô PORTE CAPITA VESTEA ATTOLLIMINI FORES SEMPITERNE ET INGREDIETVR REX ILLE GLORIOSVS

Cat. No. 30

154

Cat. No. 31

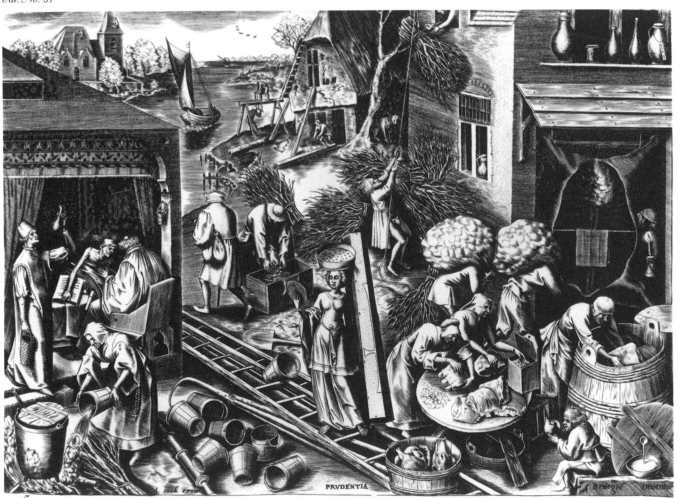

PRVDENTIA

SI PRVDENS ESSE CVPIS, IN FVTVRVM PROSPECTVM OSTENDE, ET
QVAE POSSVNT CONTINGERE, ANIMO TVO CVNCTA PROPONE

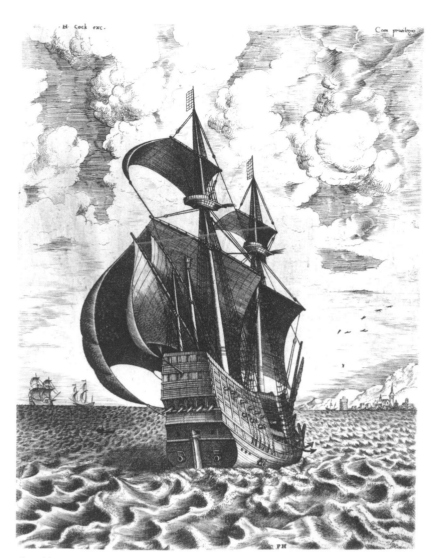

Cat. No. 32

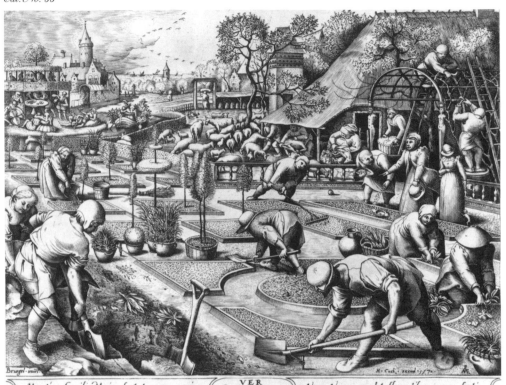

Martius, Aprilis, Maius, sunt tempora ueris · VER Puerilig compar · Vere Venus gaudet florentibus aurea sertis ·

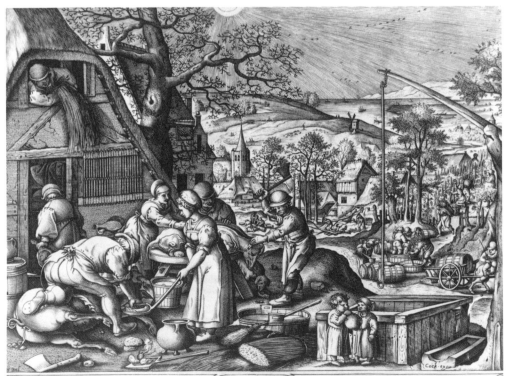

Septembri, Octobri Autumnus, totóq̃ Nouembri · AVTVMNVS Virilitatis typus · Dat musto grauidas Autumnus pomifer uuas ·

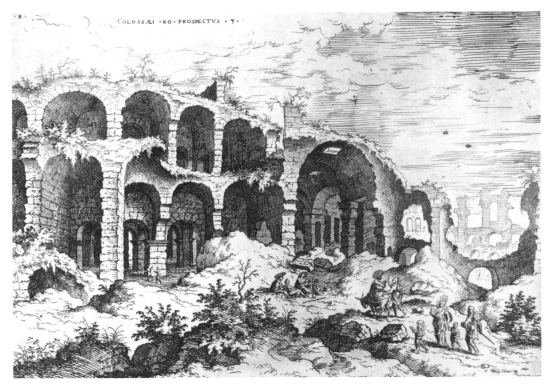

Cat. No. 35

Cat. No. 36

NON IN SOLO PANE VICTVRVS EST HOMO, SED OMNI VERBO QVOD DIGREDITVR PER OS DEI MAR 4 DEVT 8

Cat. No. 37

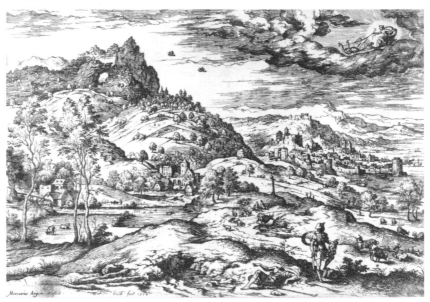

Cat. No. 38

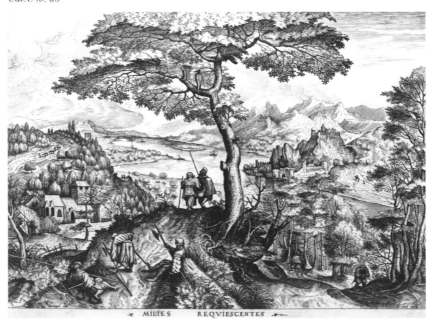

MILITES REQVIESCENTES

Cat. No. 39

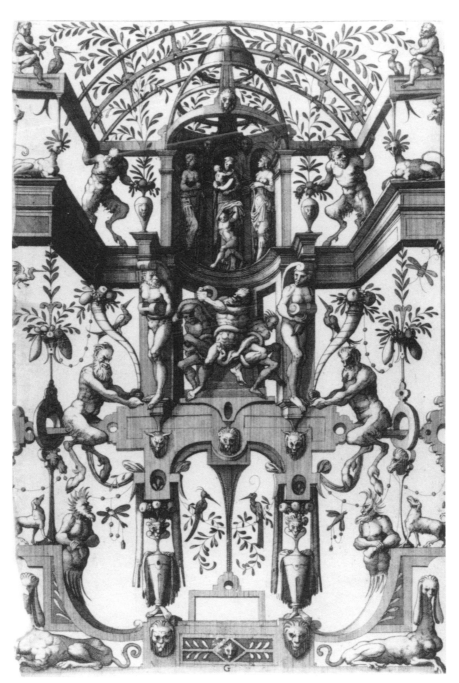

Cat. No. 40

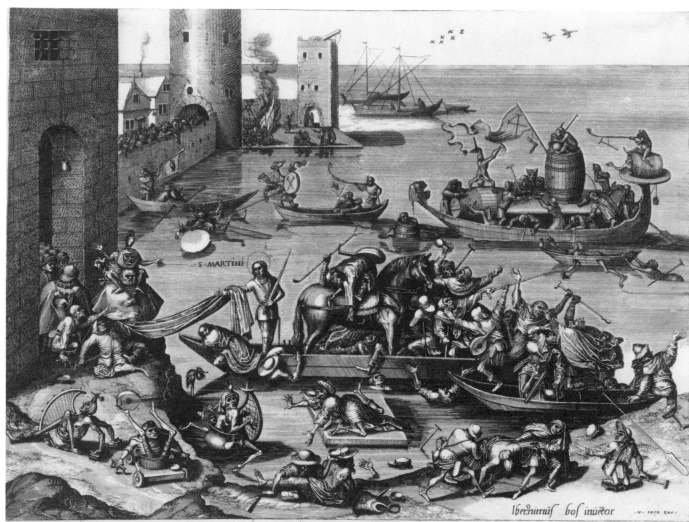

· S · MARTINI ·

Iberhinuis bos inuetor · H · COCK EXC ·

Dē goedē Sinte Marten is hier gestelt : onder al. dit Crūe Vuijl arm gespuijs : haer deijlende sijnen mantele inde stedt Va̅ gelt : nou verhiese om de proije dit quaet gedruijs

Cat. No. 42

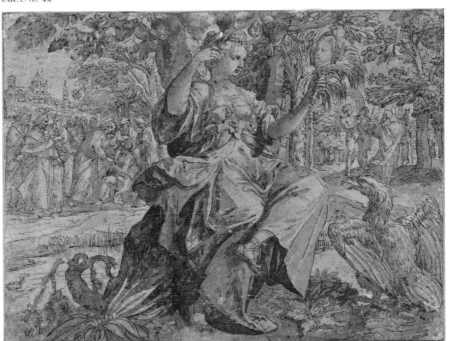

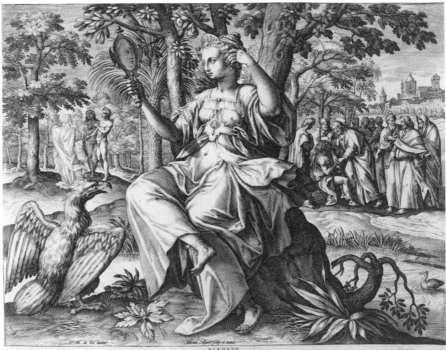

VISVS.

VISV Aquila excellit, Solis radiantia spectat Nos oculo mentis lumen speculemur Olympi:
 Lumina, et illæsis fulgura fert oculis. Luce Dei exorta vt diffugiant tenebræ.

Cat. No. 43

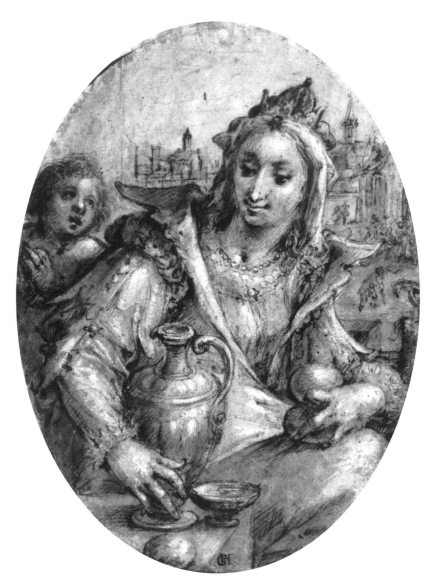

Cat. No. 44

Cat. No. 45

Cat. No. 46

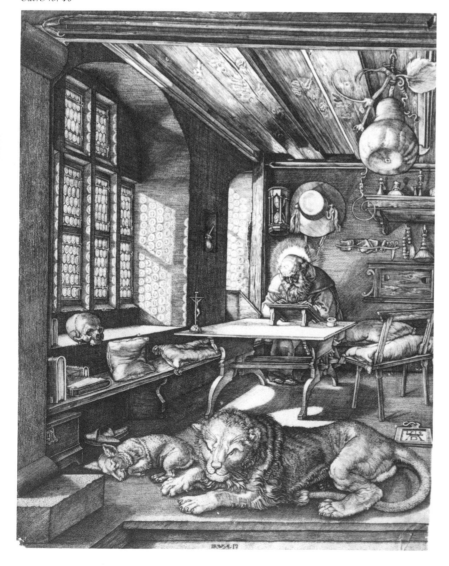

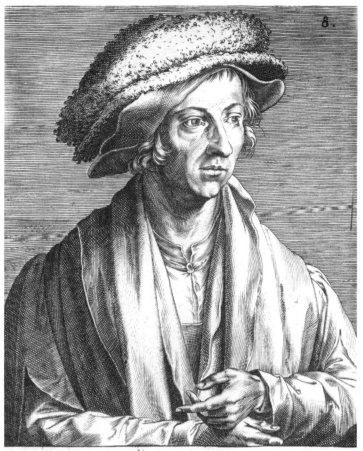

8.

IOACHIMO DIONATENSI PICTORI.

Has inter omnes nulla quòd viuacius,
 Ioachime, imago cernitur
Expressâ, quàm vultus tui: non hinc modò
 Factum est, quòd illam Curtij
In æra dextra incidit, alteram sibi
 Quæ non timet nunc æmulam:

Sed quòd tuam Durerus admirans manum,
 Dum rura pingis, et casas
Olim exarauit in palimpsesto tuos
 Vultus ahena cuspide.
Quas æmulatus lineas se Curtius,
 Nedum præiuit ceteros.

Cat. No. 47

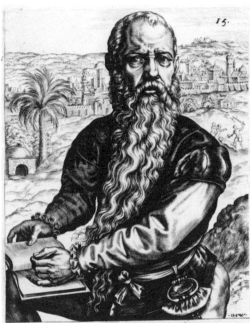

15.

DE IOANNE MAIO, PICTORE.

Quos homines, quæ non Maius loca pinxit, & vrbes,
 Visendum latè quicquid & Orbis habet;
Dum terra sequiturque mari te, Carole Cæsar,
 Pingeret vt dextræ fortia facta tuæ;
Quæ mox Attalicis fulgerent aurea textis,
 Materiem artifici sed superante manu.
Nec minùs ille sua spectacula præbuit arte
 Celso conspicuus vertice grata tibi,
Iussus prolixæ detecta volumina barbæ
 Ostentare suos pendula ad vsque pedes.

15 C iij

Cat. No. 48

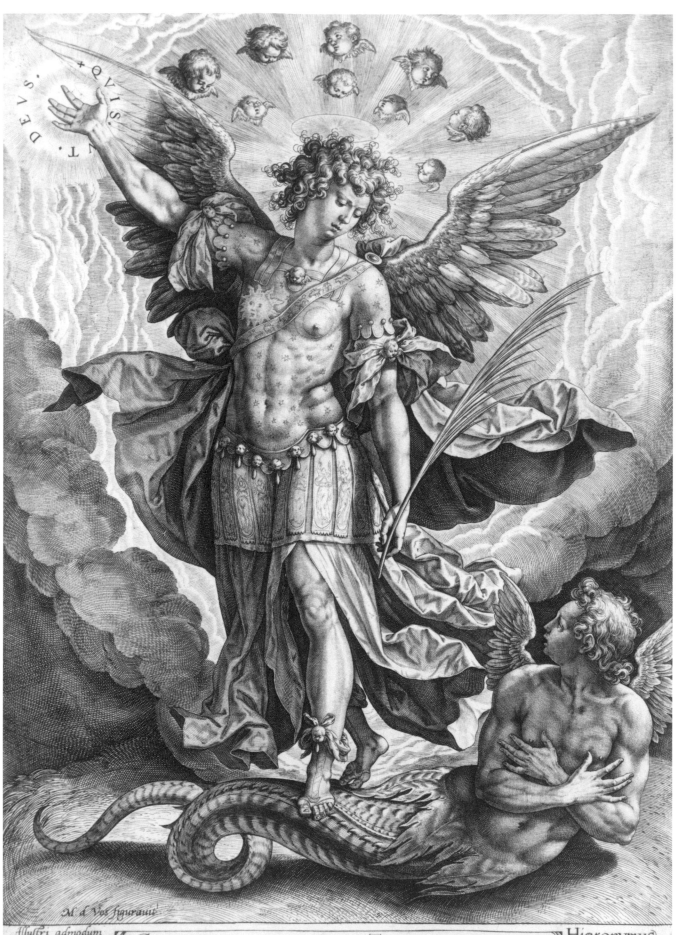

+ QVIS VT. DEVS.

M d Vos figurauit

Illustri admodum
viro D. Benedicto
Ariæ Montano S.
Theologæ Doctori
clariss. Adr. Huberti
et Hiero.W.D.D. 1584

GRANDIA SPIRANTES SVMŌ DE VERTICE CŒLI
REX SVMVS PŒNA PRÆCIPITAVIT ACRI.

Hieronymus
Wiericx.fec.
Adrianus
Huberti

Cat. No. 49

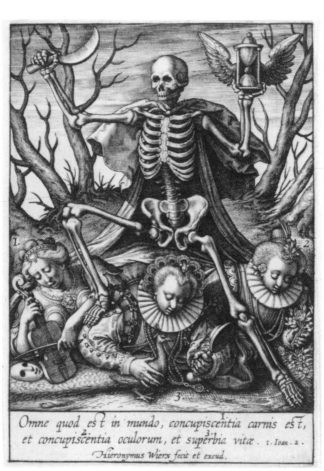

Omne quod est in mundo, concupiscentia carnis est,
et concupiscentia oculorum, et superbia vitæ. 1. Ioan. 2.
Hieronymus Wierx fecit et excud.

Cat. No. 50

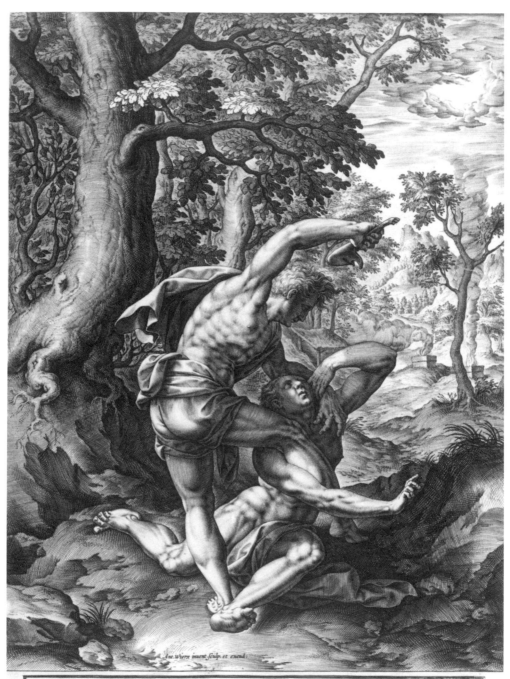

CRVDELIS LIVORE CAIN, DVM SVRGIT ABELI
VICTIMA, GERMANVM STERNIT, ET OSSE NECAT.

Cat. No. 51

169

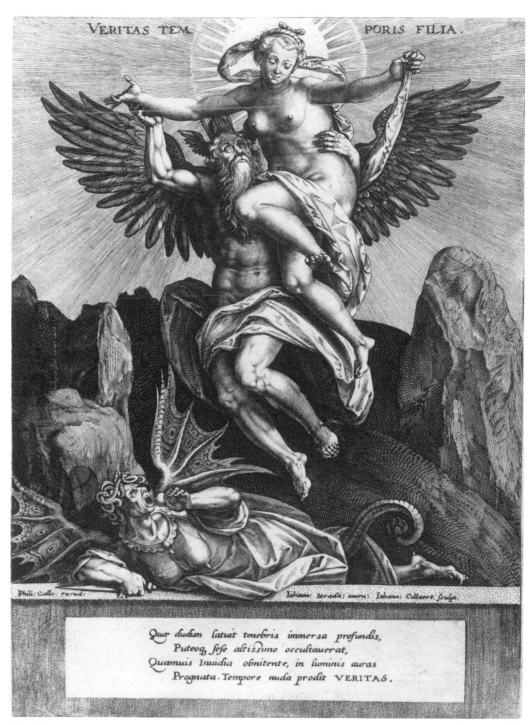

Cat. No. 52

Cat. No. 53

dori de Bry fe. et.

Cat. No. 54

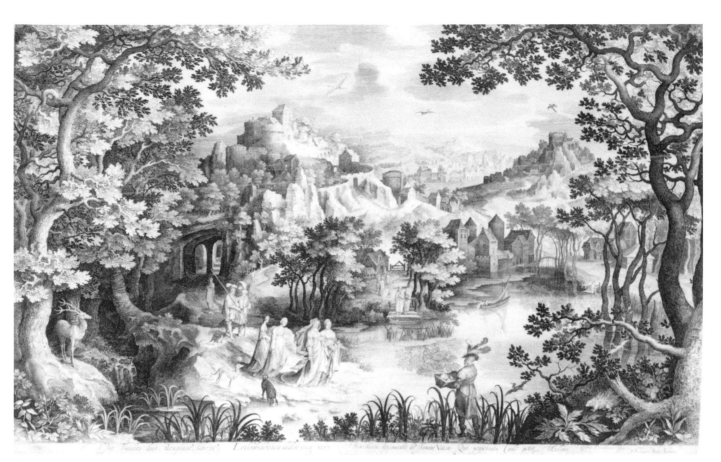

Cat. No. 55

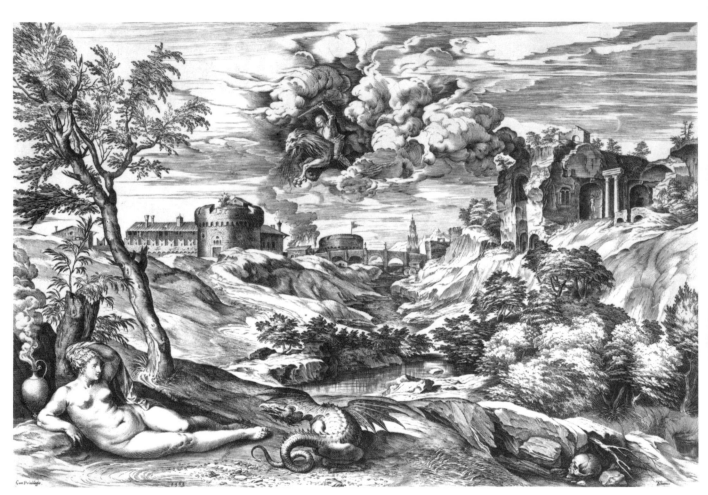

Cat. No. 56

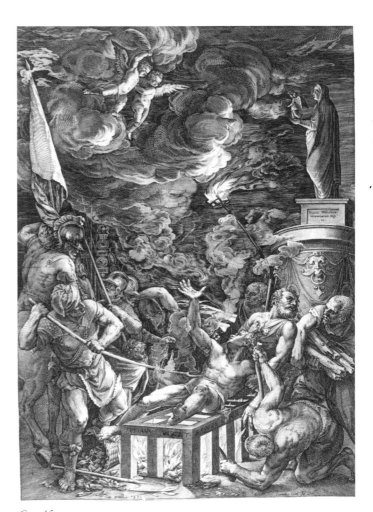

Cat. No. 57

Cat. No. 58

Federicus Baroijus Vrbina
inuenicor

Virgo quid hauris aquas, Natone datura petenti Arboris vt fructus tibi dulces, Chryste, videntur, Virginis et pueri (vestos, no tecta subintras? AMPL. Cardinali et Ill. DOMINO
Ah sitit, vt nostro pellat ab ore sitim Sic tua (crux mundo dulcia poma dabit Hospittone, Orbis rector, in orbe, caret. IACOBO SABELLO S.™ VICARIO
 Romæ An. Iub 1575 deuotionis ergo
 Laurentius Vaccarius D.D.

NE IVVS PEREAT REPROBIS SOCIATVS, EDACI PARCITVR OPPIDVLO, SIBI QVOD SELEGERAT HOSPES: SIS PIVS, & NVLLO TREPIDA IN DISCRIMINE, QVAM
E FLAMMA MANIBVS DVCITVR ANGELICIS. IN SAXVM VERSA CONIVGE SOLLICITA . VNDIQ VICINOS POENA CRVENTA TRAHAT.

Cat. No. 59

Cat. No. 60

Cat. No. 61

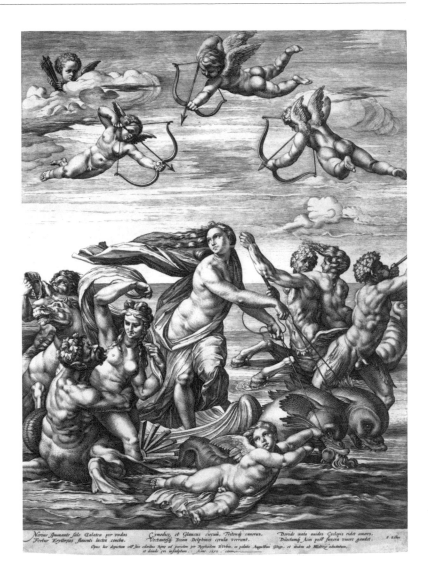

Cat. No. 62

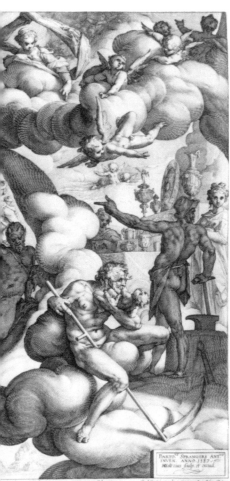

Cat. No. 63

9 Holtius Inuent. et sculpt.

Vranie cęli motus, et ſydera monſtrat, Quid portendat Hyas, et quid nimboſus Orion,
Quid Iouis, et placidę promittat Cypridos aſtrum Feraliſq coma ſignum ferale Cometes.

 F.E.

Cat. No. 64

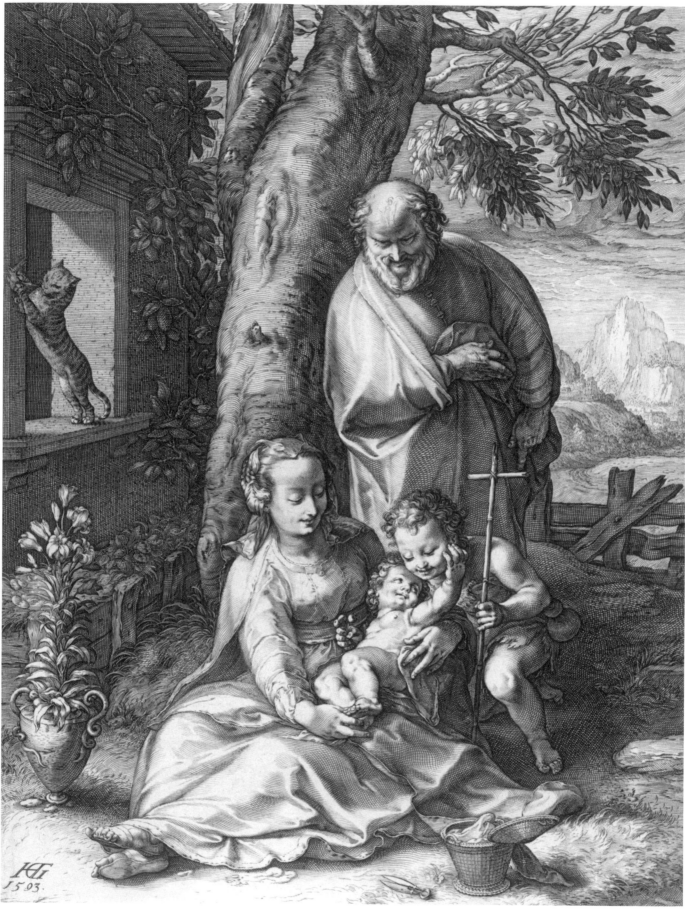

HG
1593.

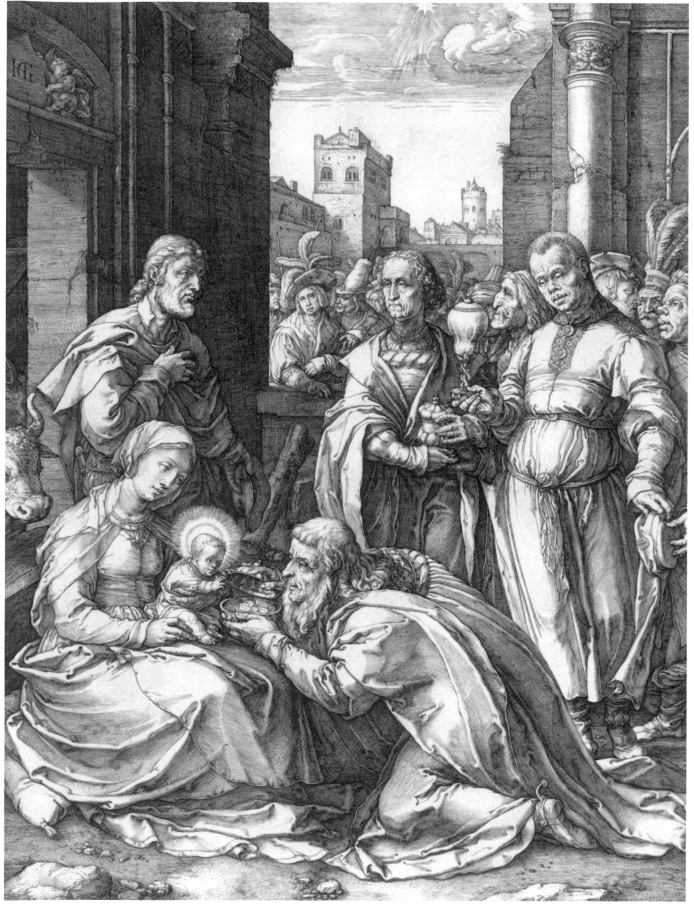

Cat. No. 66

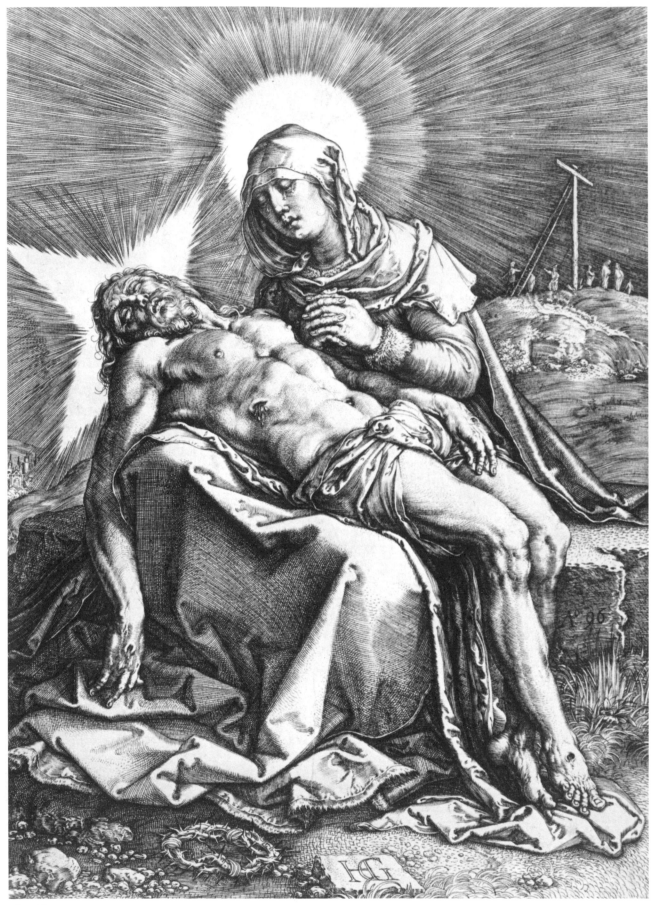

Cat. No. 67

Cat. No. 68

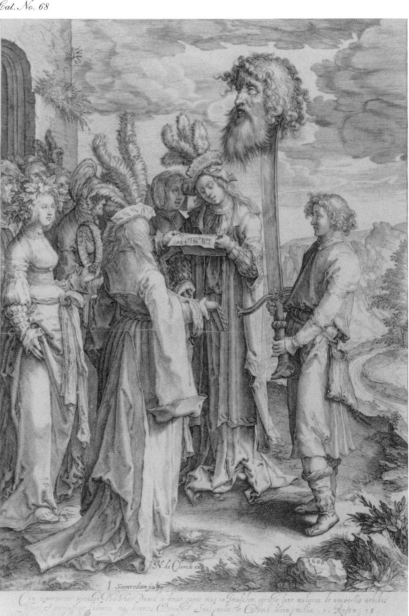

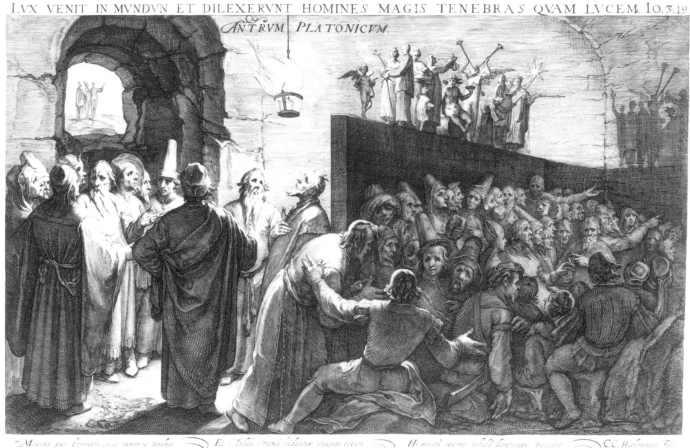

LVX VENIT IN MVNDVN ET DILEXERVNT HOMINES MAGIS TENEBRAS QVAM LVCEM. IO. 3. 19.

ANTRVM PLATONICVM.

Maxima pars hominum cæcis immersa tenebris
Voluitur; auctaque eo s Iudio lætatur inani,
Advincæ ut ibiær. Tot cæteris in breuat umbris,
Vt VERI simulacra omnes miratur amentq,

Ecce d Isidis banà ludantur imagine rerum
Quam pauci meliore fato, qui in lumine puro
Secreta a e iscidā cæcâ audiùra cernunt
Rerum umbras rectae excendunt omnia læce

Hi positâ erroris nebulâ dignoscere possunt
Vera bona, atque diem ipsa lâ nô te latentes
Extendere in claram lucem conantur, at illi
Nullus amor lucis, tanta eis s rationis cæcitas

CC. Harlemensis Jus.
Sanc dum S. Cuur.
Hinc B cha exudat

HL. SPIEGEL FIGVRARI ET SCVLPI CVRAVIT AC DOCTISS. ORNATISSQ. D. PET. PAAW IN LVGDVN. ACAD. PROFESSORI MEDICO DD.

Cat. No. 69

185

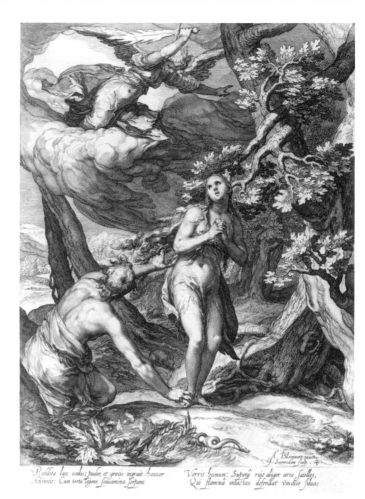

Reddita lux oculis; pudor, et gravis ingruit horror
Asinino: Cum torta tegens sinuamina serpens
Verrit humum: Superâ ruit aliger arce satelles,
Qui flammâ intactas defendat vindice siluas

Cat. No. 70

Cat. No. 71

Exultant fatua lascivo in Amore juuellæ.
Hæc amat amplexus, alterna̧q braccia versus:
Pars pedibus plaudunt choreas, et carmina dicunt:
Parcæ coronatæ per roscida pascua curru
Effusis rapiuntur equis; hic illa ingruntur
Porcibus, lascivæ serunt genialibus horas.
Illa tumet geste molli, castiq̧ pudoris:
Prodiga Palladios effundit stulta lecores:
Contemptu subeunte levi legiq, Deiq.

J. Saenredam fe.

Cum privil. Sa Cæ M.
Abrahamus Bloemaert Inven. I. Matham sculp.
et excudit A.1603.

Dum petulans Dominæ non insultare veretur,
Cum nato Iussa est vertere serva solum.

Sic, Christo, Christique gregi dum illudere certant,
Iudæos meritò par quoque pœna premit.

Cat. No. 72

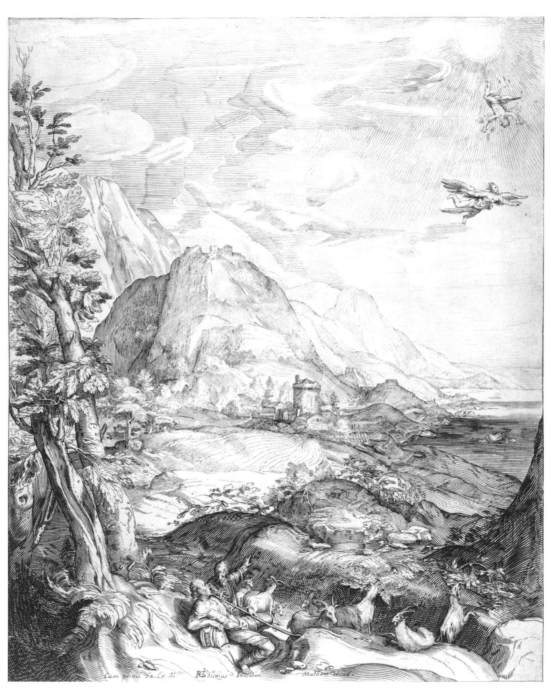

Cum priuil. Sa. Ca. M.ᵗⁱˢ H. Golzius Inuentor. Matham excud.

Cat. No. 73

Principio Omnipotens immensi conditor orbis
Esse polum iussit terreq; immobile pondus.
Hinc lucem tenebris remouet, noctemq; diemq;
Nuncupat; et longis spacys max segregat vndas,
Aequora secernit terris; vos Lunaq; solq;
Prefectos dedit; hinc animalia cuncta creauit.
Post hec natus homo est celesti afflatus ab aura,
Diuine consors mentis, dominusq; priorum.

F. Estius. Aº 1589.

Cat. No. 74

189

Cat. No. 75

Cernite Chaldæi viuá sub imagine Regis,
Horresco referens, diuini numinis iram.

Scilicet hac decuit plecti ratione, superbâ,
Numine contemptô, lingua qui Idôla crepabat.

Qui simili peccare modo præsumitis, isto
Discite ab exemplo, similis ne pœna sequatur.

Cat. No. 76

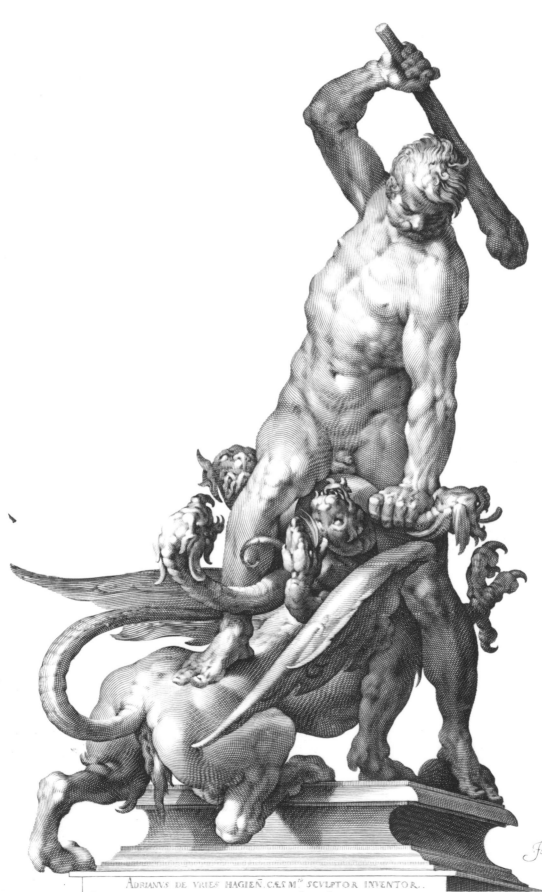

Jeannes Müller sculpsit.

ADRIANVS DE VRIES HAGIEÑ. CÆS. M^{tis} SCVLPTOR INVENTOR.

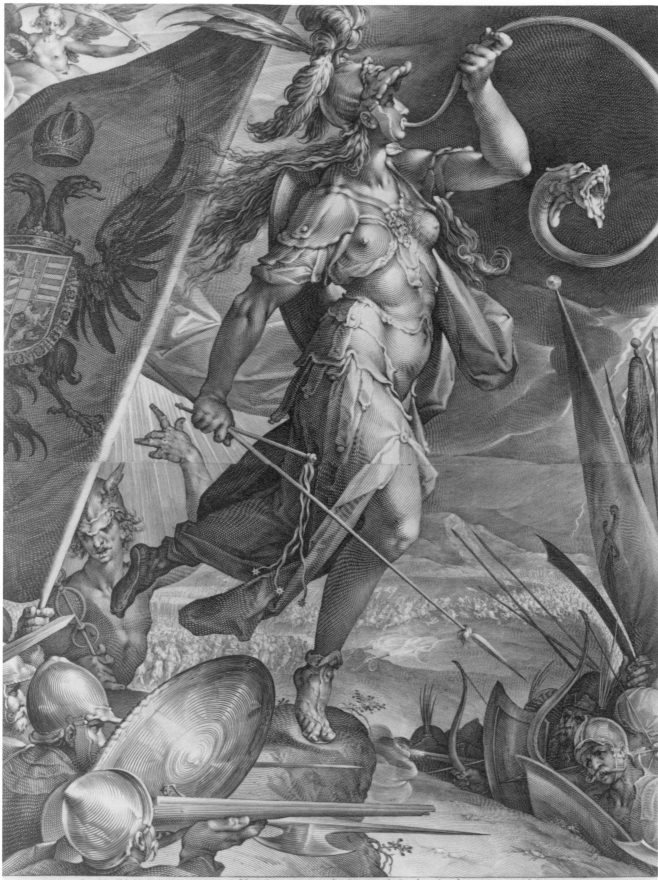

B. Spranger inuent.

Ioann Muller sculp.

Hamin Muller excu
.hu feci

Serenissimo Principi Domino Deo MATHIÆ, Archiduci Austriæ, Duci Burgundiæ, Stiriæ, Carinthiæ, Carniolæ et Wirtenbergæ, &c. Comiti Tirolis &c. Nec non
Generali et inuictissimo Christiani exercitus contra Turcas Duci ac Prefecto, inuictissimo. His insolentissimo, Bartholomæus Spranger S. C. M. Pictor, D. D.

En Bellona ciet turmas, prosilit arc'e, canens, Nec mora, feruet opus, Iouis ales prælia miscet, Exere tu modo vim, facto ægmine Romula pubes, Non ergo differ pacis, Germania, sedes,
Spicula Marte vibrat dextra, iacentilia flagris Quid dubites? Bona causa facit. Galuus, hic inquit Terriçamq Turca fulmen, victoria vobis Presidio maiora sinu a Iouis aditus austus,
Bella ciebit, trepidanda ruet gaudetq pirate Militie animus, causarum sum'Deus ipse bonorum. Nube velans prælia &c. nihil impedit, exere vires, Sic sternes Mahomet, victrix tua causa triumphet.

Cat. No. 78

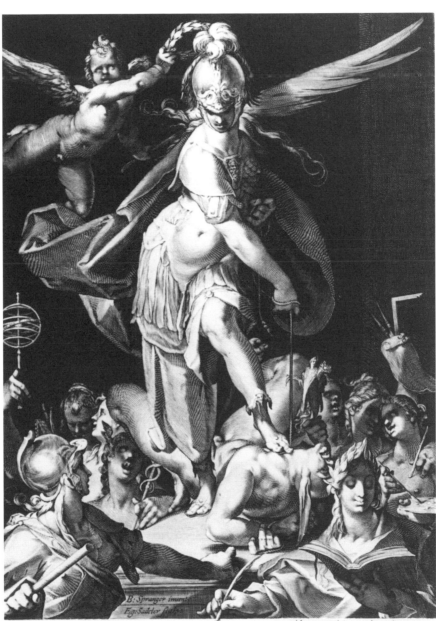

Non datur, eximias veneret, ut INSCIVS ARTES,
Solus eas quærens noscere gestit AMOR.

INSCIVS NON HONORABITur.

Sed datur, ne spretâ taceat calcatus ab ARTE
INSCIVS. et solido capitis honore ruat

Cat. No. 79

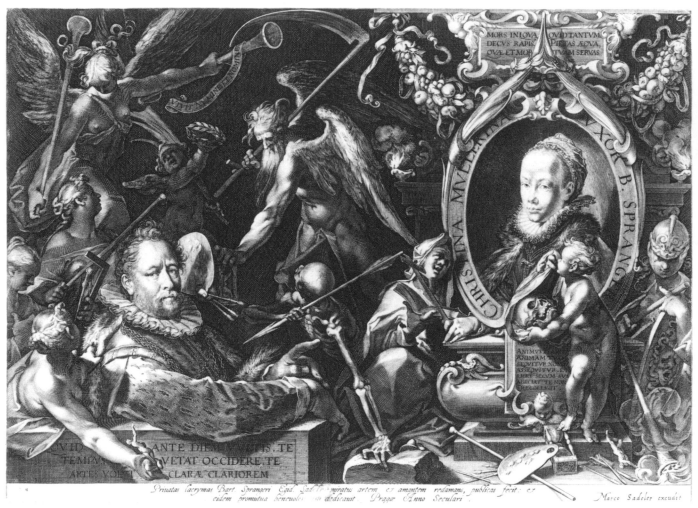

Cat. No. 81

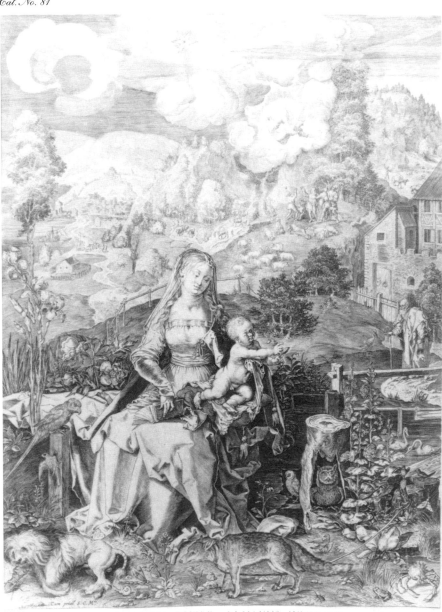

ALBERTVS·DVRER·ALMANVS·INVENTOR

Cat. No. 82

Cat. No. 83

Cat. No. 84

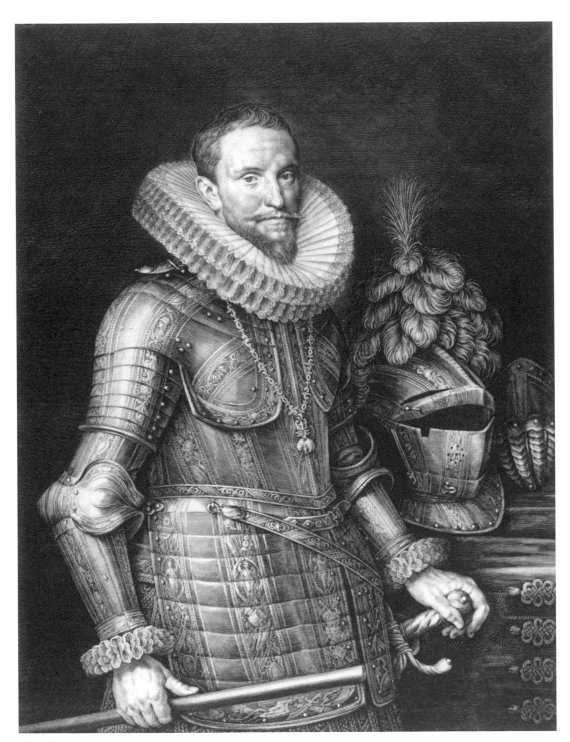

Cat. No. 85

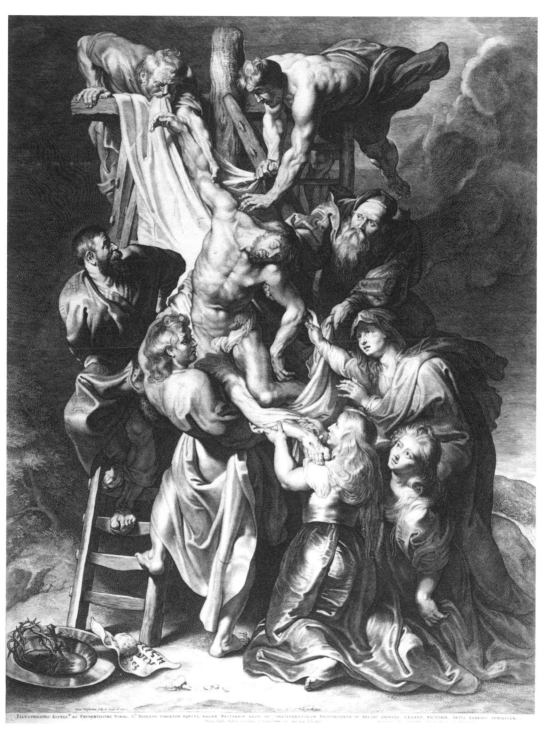

Cat. No. 86

200

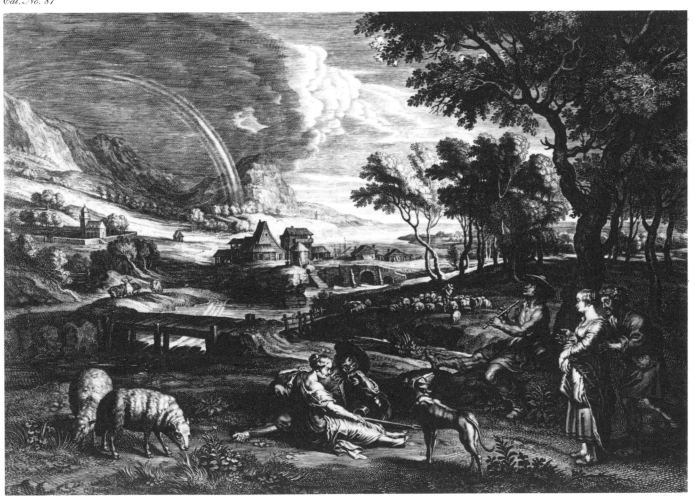

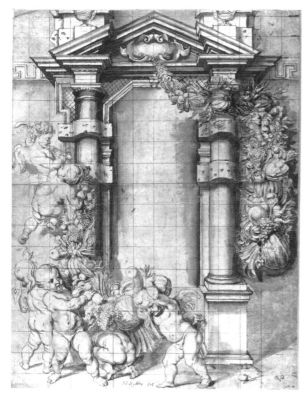

Cat. No. 88

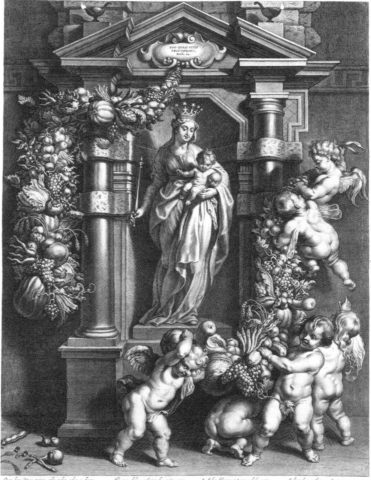

Cat. No. 89

Iuppiter atque Hermes (specie mortales utrumque) *Hospitium inveniunt gratum, cum paupere mensa*
Lustrantes Phrygiam, sub amoena crepuscula noctis *Baucidis, iis gaudent Divi, et sua dona rependunt.*

A Joues Palat. Comes, et Aur. Mil. Eques, Nob. vir D.D. Goudt
fratri suo Picturae et cum ingenuum actium amatori D.D.D. 16..

Cat. No. 90

Quantum malorum clausa nullo limite Puriſsimas mortalium mentes rapit Vitam brevem breve gaudium Mors occupat;
Cogit libido, quamque dulci Carmine Furias in omnes: sed cito quam fallimur. Momentulum quod ridet, æternum dolet.

LAF